The Gender of Photography

The Gender of Photography

How Masculine and Feminine Values Shaped the History of Nineteenth-Century Photography

Nicole Hudgins

BLOOMSBURY VISUAL ARTS
LONDON • NEW YORK • OXFORD • NEW DELHI • SYDNEY

BLOOMSBURY VISUAL ARTS
Bloomsbury Publishing Plc
50 Bedford Square, London, WC1B 3DP, UK
1385 Broadway, New York, NY 10018, USA

BLOOMSBURY, BLOOMSBURY VISUAL ARTS and the Diana logo are trademarks
of Bloomsbury Publishing Plc

First published in Great Britain 2020

Cover design by Eleanor Rose
Cover image: *The Wedding Photo*, 1879 by Pascal Dagnan-Bouveret (1852–1929).
(© G. DAGLI ORTI/De Agostini via Getty Images)

A catalogue record for this book is available from the British Library.

A catalog record for this book is available from the Library of Congress.

ISBN: HB: 978-1-4742-7156-1
 ePDF: 978-1-4742-7158-5
 eBook: 978-1-4742-7157-8

Typeset by RefineCatch Limited, Bungay, Suffolk
Printed and bound in Great Britain

To find out more about our authors and books visit www.bloomsbury.com
and sign up for our newsletters.

For all the independent scholars who add to our knowledge, and in homage to the early women photographers who received acknowledgment neither by their peers nor by twentieth-century historians. And to Brian: a boy from Tidewater who, instead of choosing someone sweet and unchallenging, married a feminist.

Contents

Illustrations

Preface and Acknowledgments

In 2014, Manohla Dargis, film critic at the *New York Times*, wrote a three-part series of articles investigating the paucity of female directors in Hollywood.[1] These articles revealed a legacy in the history of photography (film being, in its physical form, but a series of photographs producing the illusion of motion). In interviewing production company presidents, Dargis reported on the ambivalence, incomprehension, and, at times, downright hostility toward women working behind a camera. There have been many reasons for such feelings, ranging from cultural and psychological to social and economic. Traditionally, the role of film director has had romantic associations with notions of artistic genius and mastery, typically gendered male rather than female. The present book traces those beliefs back to the earliest of photography's institutions.

Dargis also wrote about the opinions and achievements of the American women who, despite the obstacles they faced, became professional directors. Contemporary Hollywood, then, follows the historical pattern perfectly. Just as a number of women defy the odds in Hollywood with scant encouragement, so a significant number of Victorian women too, defied social expectations to become photographers, with little acknowledgement by their peers. Historians are trained to study the past in order to understand the present. In this case, the present offers clues to the past. This book investigates why the early camera operator, whether amateur or professional, came to be assumed male by the writers, cartoonists, journalists, and fellow enthusiasts who spoke and wrote about the new medium of photography in the nineteenth century.

In some ways, this book is a belated companion piece to my doctoral dissertation, which discussed early photographic scenes in industrializing Europe. As a young woman in graduate school, I was eager to intervene in the historiography of photography by pointing out the importance of so-called provincial centers to the invention, development, and popularization of photographic technologies. I focused on what I called the "renaissance men" of the Victorian age, fascinated at how men in manufacturing milieus made such significant contributions to chemistry, optics, fine art, and other disciplines, though I never identified them as having a gender. I confess, I was utterly blind to the gendered dimensions of these regional photographic communities, which were fraternally linked to societies in Paris, London, and beyond.

Growing up in the 1980s and well into my callow graduate school years, one might say that I was suffering from a kind of false consciousness. A silent assumption that women's history was not where the important action of history lay had settled in my mind after years of reading school textbooks, watching historical documentaries, going to museums, and seeing movies. I had largely conformed to a socio-intellectual regime that gave women's history what sociologists would describe as "low status." In fact, I had completely internalized the equation, established during the eighteenth-century Enlightenment and remaining in force through most of the twentieth century, that

men's history was universal history, while women's history was history at the margins. Not only did I fail to see and take notice of women's photographic stories in the regions covered by my dissertation, I failed to realize that the Victorian photographic societies that provided my sources had been workshops where members (all learned men) formulated for themselves how industrial-age masculinity would be defined.

How could I have missed the fact—so clear to me now!—that the photography clubs of France in the 1890s and 1900s were, like so much cultural production of the period, reacting to the appearance of *la nouvelle femme* (the "New Woman"), she who demanded access to fine arts education, professional careers, and the vote? European men had spent 300 years building the identity of "the artist" as a man of creative genius, and serious photographers struggled to claim a similarly honorable status. What happened when the presence of women photographers interfered with their campaign to promote a modern, knowledge-based masculinity? How did men react when women pointed their cameras at objects, rather than contenting themselves with the role *of* object (as models)? I ignored these questions (if they occurred to me at all), because I did not yet realize the full implications of gender "as a useful category of historical analysis."[2]

This book, then, is an investigation into how early institutions, images, and language gendered photography. By "gendered," I mean the ongoing labor of construction, or reconstruction, of spaces, objects, and human activities as masculine or feminine. As mentioned, observations in the present assisted me with my historical work. Besides the methods of social and cultural history, I have employed the insights of sociology, anthropology, psychology, and literary criticism to help me understand how human groups used their bodies and their languages to enforce a regime of gender expectations. At the same time, my creative aim has been to retain a plain, non-technical mode of writing, so that students and non-professional readers interested in early photography will, I hope, find the story absorbing. Having some knowledge about photography's history will be helpful in reading this book, but readers coming to the book with an interest mainly in women's history will not find any serious obstacles to understanding the content.

Research for a work like this relied on the help of numerous women and men of many specialties. Many people, by doing their jobs with intelligence and compassion, helped in the research and production of this book. I thank Deans Laura Bryan and Chris Spencer at the University of Baltimore for several years of institutional support, along with Provosts Joseph Wood and Darlene Smith. The editorial team at Bloomsbury Academic kept me on track. I thank all the librarians and staff at UB's Langsdale Library, the Library of Congress, the National Gallery of Art, the Bibliothèque Historique de la Ville de Paris, the Bibliothèque Marguerite Durand, the French Photographic Society, and Beinecke Library at Yale University. I also want to acknowledge the kindness of the many collectors, experts, academic colleagues, photo club members, bloggers, photo historians, and authors, from all over Europe and America, who responded to my emailed queries. These independent scholars and professionals, spread out in France, Italy, Germany, Canada, England, Ireland, and the United States, not only made their amazing collections accessible online, they were happy to share their knowledge with a total stranger.

Abbreviations

Beinecke Library Beinecke Rare Book and Manuscript Library, Yale University (Palmquist Collection)

BJP *British Journal of Photography*

BSFP *Bulletin de la Société Française de Photographie*

HOP *History of Photography* (journal)

JPSL *Journal of the Photographic Society of London.* This was the original name of what would be known later as *The Photographic Journal* as the society changed from that of London to Great Britain to (in 1894) the Royal Photographic Society. The RPS has made a complete digital archive of the journal available on its website.

PN *The Photographic News*

Introduction

Some years ago now, art historian John Tagg concluded that photography's history "has no unity." Photography, he said, is "a flickering across a field of institutional spaces. It is this field we must study, not photography as such."[1] In following Professor Tagg's advice, this book will deconstruct rather than add to the conventional structure of photography's history. Specifically, it will investigate how gendered behavior and concerns shaped photographic institutions in the first few decades of the medium's existence. We will be looking at what became "masculine" and what became "feminine" about photography in the nineteenth century.

I place those words in quotation marks in recognition of the fact that human beings *construct* notions of femininity and masculinity, and these notions never stop evolving.[2] Placing the concepts in quotation marks also reminds us that, often in the past, labeling a practice as "feminine" was to give it, in sociological parlance, a low status. The chapters in this book will argue that in order to create a richer, truer history of photography, we need to identify the "masculine" bias that distorted photography's early history. And, to correct that imbalance, we must accord equal status to the "feminine" and the "masculine" in the early development of photography.

Spokesmen in the North Atlantic metropoles introduced photography in 1839–40 as a "universal" blessing that would benefit "mankind." We know that at the moment of its appearance, women across the region showed avid interest in this new technology. But if that was so, how was it that by the mid-1850s photographic discourse had become so masculine, shaped overwhelmingly by male actors? This book tries to answer that question from several different angles. It also synthesizes twenty-five years' worth of scholarship in Europe and North America that shows that, in defiance of nineteenth-century discourse, women were *not* absent from the early amateur or professional scene. Rather, the male-dominated photographic press obscured their presence. And although a lively feminist press developed in Britain, France, and America after 1850, women photographers did not establish their own journals. This suppressive obscuring on the one hand, and women photographers' refusal to document themselves on the other, was an important part of the process of making photography—its institutions, its profession, and the medium itself—take on a "masculine" identity. Nevertheless, we may yet retrieve the "femininity" of photography's first few decades regardless of the period's tendency to block it.

To tell this story I have used sources from what I will refer to as the North Atlantic world (primarily Britain, France, and the United States) to show how male, and

"masculine" domination of photography marginalized female, and "feminine" contributions to the new medium. Readers should understand that the book is not a generalized attack on the Victorian men who excluded women, or the women who excluded themselves. On the contrary (as I hope I showed in past work),[3] we may admire the success with which men in the nineteenth century organized associations and the accompanying press to promote photographic technology and its professions, establishing a modern, cultural tradition that has endured to the present day. The problem was, and is, a matter of imbalance. Women (and men, as I will show) time and again expressed a "feminine" perspective on photography, but that perspective did not properly partner with the "masculine" perspective that dominated photographic discourse and display; the feminine perspective was hidden under the weight of masculine text.

In comparison to previous works on women photographers, I intend the present book to be a broader corrective to the imbalance of values still prevalent in the history of photography. Despite the impressive corpus of biographies and exhibition catalogues dedicated to the work of women photographers of all eras, the knowledge it offers has not led to real change in the format of our surveys, textbooks, or museum exhibits.[4] Such accounts of photography's history and its many uses will be improved by correcting the historical imbalance of values, not simply by adding women's names and achievements to conventional accounts.[5] To paraphrase Cambridge anthropologist Henrietta Moore, the "add-women-and-stir method" will not repair a deeply-rooted bias.[6] To correct the imbalance inherent in the structure of photography's history, I propose employing the phenomenon of gender "as a useful category of analysis"—as a lens with which to look at the human records of photography's past.[7]

One of the most interesting aspects of this story is how deceptive appearances can be. Male dominance of early photographic associations did not prevent a good number of women from engaging with, producing, and writing about the new technology, despite the obstacles. So, if half of this book analyzes the reasons behind masculine dominance of photographic institutions and technology, the other half of this book looks at where women, and "femininity," found space in the realm of Victorian photography, and how they did so. One of the most important goals for this book is to explore what the "feminine" in early photography may have consisted of, and how we might reintegrate it into what remains a largely "masculine" perspective on the medium's history.

To begin the rebalancing act, I ask readers to bear with me, keeping an open mind to a borrowed concept that, despite its distance from the realm of photography, will be useful for our purpose. I have borrowed an ancient concept from Chinese philosophy and medicine to help us think about the relationship between masculine and feminine values.[8] In this philosophy (originating in Chinese Taoism but appearing widely in Asian thought), the dual cosmic forces of *yin* and *yang*, and the Chinese Taijitu symbol representing them (Figure A), are (it turns out) useful for thinking about how "feminine" and "masculine" values entered photography during its formative years, and how they continue to weave their way through the world of art and creativity. They are useful for discovering how those values became imbalanced; and suggestive for how we might restore a healthy balance going forward, in order to create a better historical model.

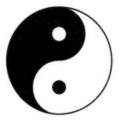

Figure A "Esoteric" Taijitu symbol created by Kenny Shen for Wikimedia Commons (February 21, 2007).

The ninth century B.C.E. *Classic of Changes* (*Yijing*) asserts that the reciprocal processes of *yin* and *yang* in the universe is called "the Way."[9] According to this theory, the Way (*Tao*) is the flow of forces in the universe that produces all change. It is the play of *yin* (the feminine) and *yang* (the masculine) that allows for transformation in the body, the world, and the cosmos. Now interestingly, at first glance we see in the Asian sources the familiar masculine and feminine stereotypes: *yang* as heat, brightness, the sun; *yin* as coolness, darkness, the moon. However, these qualities are separated out this way in Taoist philosophy only to show that both are required for cosmic and human health. Neither the *Yijing* nor subsequent commentaries defined men as *yang* or women as *yin*.[10] Just as importantly (as the image shows), all *yang* contains some *yin* and all *yin* contains some *yang*, and Taoism suggests that wisdom follows from being in touch with this structure underlying all things. So, that dot of *yin* (black) in the *yang* field (white) reminds us to see the feminine in the otherwise masculine; the ever-present dot of *yang* (white) in the *yin* field (black) reminds us of the reverse. Note that cosmic balance in the symbol requires *yang* and *yin* fields of equal size and weight.

Especially useful in the Taijitu symbol is that it allows us to recognize masculine and feminine values while avoiding a Western-style dichotomy, wherein everything "masculine" must stay neatly on one side of the balance sheet, and everything "feminine" stay segregated on the other side—what we might think of as the Enlightenment-Victorian regime of gender expectations. More importantly, the health of the world and of the human body, according to this principle, depends on the constant transformation of one into the other, the constant interplay between masculine and feminine. To repair the historiographical imbalance in photography, then, a traditional Chinese physician might prescribe that we unblock the flow of *yin* in our historical accounts.

The dyads I am using to describe the values and the actors in photography—feminine/masculine and male/female—are not interchangeable. Male/female describes two biological sexes, while feminine/masculine describes historically evolving, contingent characteristics. During the nineteenth century, but arguably up to today, females were encouraged by their communities and by the media to adopt "feminine" characteristics (that is, virtues and constraints prescribed for them), but we know that individuals were not always inclined to do that, and of course a female could often

display or perform "masculine" characteristics. Equally, as John Tosh and others have shown, men were/are encouraged by family, friends, and mentors to adopt "masculine" postures and behaviors, and likewise, the individual man does not always oblige, and might display or perform "feminine" qualities.[11] In both cases, individuals might be punished to varying degrees for their gender transgressions.

Readers will probably be well aware of this difference between the two sets of terms, but I felt it important to mention as we get underway, because throughout this book we will encounter examples of men displaying what I will call "feminine" photographic values, and women displaying "masculine" photographic values (as I will define them for the period under discussion). Although for the nineteenth century we most readily think of gendered stereotypes of appearance and behavior as the "norm," there were photographers of both sexes whose creativity and disposition departed from that norm.

Photography's literature

Several sources on the subject of women photographers, though, have questioned whether we can really attribute "masculinity" or "femininity" to photographers' works. Abigail Solomon-Godeau suggested that the photographer's biological sex may not mark her subjectivity, but gender—the sum total of the social, political, and economic restraints and privileges that accompany masculinity and femininity—often does.[12] I will address this question in some detail in the chapter to follow. Briefly, I would say here that sometimes photographers (of either sex) employ gendered values in their photographs, and sometimes they do not, at least not obviously. What has happened in the past is that historians and curators have taken "masculine" values as "universal" (i.e., non-sexed or generic). By identifying "masculine" and "feminine" values, my aim is to abandon the use of masculine values as "universal," and rehabilitate femininity as an integral force in the history of photography, including its nineteenth-century history.

Five key texts published over the past couple of decades have made the synthesizing goals of this book possible.[13] The first was Naomi Rosenblum's breakthrough survey, *A History of Women Photographers*.[14] Rosenblum provided a detailed account of European and American women's photography from the invention of the daguerreotype to twentieth-century digital art. Here, for the first time, students and historians had a resource for discovering photographers left out of the "standard" texts; for launching their own investigations; and for thinking about both the obstacles and advantages that femininity brought to women's professional and amateur practice. In a sea of monographs that recognized a tiny handful of women photographers working before 1900, Rosenblum was one of the first scholars to expose the myth of women's absence for what it was. Subsequent scholars, such as Margaret Denny, deepened the recovery of early women in the industry, adding sophisticated analyses of how gender norms inhibited as well as offered opportunities to women.[15]

Working on the opposite coast in California, photographer-collector Peter E. Palmquist, too, systematically dismantled the myth of women's absence in early photography. His Women in Photography International Archive, begun in 1971, is now

housed at Yale University's Beinecke Library, along with his books, articles, and unpublished data on women's photography and photography in the western United States.[16] Although our college textbooks on the history of photography have not caught up to Palmquist, his collection of *cartes-de-visite*,[17] cabinet cards, and other artifacts clearly show that women photographers plied their trade across the United States, in England, France, and Canada, throughout the early photographic period. What women did not do with as much frequency was present their views at the meetings of photographic societies or in the pages of photographic journals before about 1890. In subsequent chapters, I will proffer reasons why that was so.

Using Rosenblum and Palmquist's insights and new archival discoveries, the authors of *Ambassadors of Progress*, the scholarly catalogue that went with a 2001 Franco-American exhibit, produced the third key text to which the present book is indebted.[18] Drawing from American, French, and Russian sources, Bronwyn Griffith and her co-authors traced the extraordinary exhibition of American women photographers' work at the 1900 Universal Exposition in Paris. The authors not only detailed how the famous American photographer Frances B. Johnston collected work from all over the country for the Paris exhibition, they included appendices that reproduced original articles and reviews relevant to the women photographers' work. It was this superb publication that convinced me to take 1900 as an approximate endpoint for my book, not simply because of Paris' bow to the women's talent, but because the historical forces bringing the New Woman to prominence at the turn of the century, if only temporarily, meant that female camera enthusiasts were no longer invisible within the profession or its new clubs. Photographic institutions, a bit like the fine arts academies at the time, now accepted the fact that women were serious about their photography.

Elizabeth Siegel and her team of specialists organized the blockbuster exhibition, *Playing with Pictures: The Art of Victorian Photocollage*, in 2009. This eye-opening exhibit and stunning catalogue formed a watershed moment in the history of photography. Here Victorian lady amateurs' mixed media albums were, for the first time, taken seriously as significant artifacts by a global audience. In *Playing with Pictures*, it became painfully apparent that the classical historians of photography— Beaumont Newhall, Helmut Gernsheim, Heinz Henisch, and Michel Frizot—had left out a major source of the feminine in photography, even as they all included the usual canonized female photographers in their works. The scholarly analysis in Siegel's book was for me a crucial starting point. It struck me that these photo-collages, curiously surrealistic, hybrids in both the sense of blurring public and private and mixing media (drawing, painting, photographs), provided crucial clues for where to find the "feminine" in early photography.

Finally, the fifth key, and most recent text is another exhibition catalogue, *Qui a peur des femmes photographes?* (in English: *Who's Afraid of Women Photographers?*), produced jointly by the Musée d'Orsay and the Musée de l'Orangerie in Paris.[19] In this work, a number of scholars and curators contributed essays on the history of women photographers, including France, whose early women photographers had been entirely ignored in the historical record. This provocatively named exhibition began to reverse the invisibility of early female workers, and it admitted that French scholars had been delinquent when it came to documenting women's photography in their country and

beyond. Whether deliberatively or not, the exhibition worked as a corrective to the biennial Mois le la Photo festival in Paris, whose Salon-like structure fed the myth that Julia Margaret Cameron was the only notable early woman photographer.[20]

In the preface to the *Qui a peur* catalogue, Guy Cogeval, president of both exhibition museums, admitted that 20 years ago, "gender studies didn't really interest me. Today, it seems essential to me. Was it me who changed, or have these questions themselves become central to public debate?"[21] Cogeval's rhetorical question indicated that the need to integrate gender awareness into our study of photography had reached its tipping point. Supplementing the official discourse with monographs that make female creators visible adds to our knowledge, but is ultimately inadequate. He was saying that we need to reframe the discourse itself. The prestigious contributors to this exhibition catalogue, which included French, British, and American scholars and museum directors, took a confident step forward toward the goal of reintegrating femininity into the history of photography.

Throughout this book, readers will also see mentioned the biographies of women like the Comtesse de Castiglione, Alice Austen, and Hannah Maynard, intrepid "rescue operations," produced in print and online, which have saved such creative women from historical oblivion. One of the challenges of this "uncovering" labor was nineteenth-century women's non-existence in official records. Sometimes, a woman photographer's birth date or death date remains unknown,[22] or the only date we have for reference is her date of marriage, an outcome of North Atlantic legal or customary coverture.[23] Abbie Sewall gave an example of this problem in her book about her great-great-grandmother, the Maine photographer Emma Sewall (1836–1919). Sewall stated that her ancestor's obituary proved unhelpful to her research, since it "tells nothing more than who her father, husband, and sons were."[24] This, despite the fact that Emma Sewall was an accomplished photographer who won prizes for excellence from the Boston Camera Club and the Photo-Club of Paris. The laws and customs of coverture applied equally to photographers as they did to other women of the period.

Other important sources for the present work contained the insights of social scientists, such as Pierre Bourdieu and Janet Chafetz, on the structure of male domination, its psychology and rituals. I felt it was important to incorporate their explanatory insights, because our students sometimes assume an eternal gender equality, and are unfamiliar with how recently the church, the academy, the professions, and the law produced an environment in which most women accepted their subordination to men, whether in the family or in the workplace. Social science studies were important sources for explaining, for example, why women, even when they were camera club members, remained silent during meetings. The sociology of silence, and the psychology of group dynamics, helped me to interpret the transactions of early photographic societies in fresh ways.

Last but definitely not least, the unpublished graduate theses of scholars across the North Atlantic world provided treasure troves of knowledge.[25] This book would be impoverished without the benefit of their insights on nineteenth-century albums, photo clubs, and women photographers. I was glad to discover that several of these former graduate student writers went on to illustrious academic or curatorial careers. Other times, a graduate thesis stood by itself as a voice in what may have been a hostile

wilderness at the time that it was written. I am humbly thankful for these instances of courageous and painstaking scholarship.

Geography

In an era when photo-historical scholarship has become global, why limit a gender study to the North Atlantic world? Why not Germany, Italy, or India for that matter? The selected region covered by this book is neither arbitrary, nor an argument for that region's superiority where sources are concerned. It is based on three considerations, partly practical, and partly philosophical. First, the areas of North America, Britain, and France *shared* a photographic culture and discourse, which while including several other countries, enjoyed especially busy commerce and communication with each other, as information crossed the Atlantic Ocean throughout the nineteenth century.

Secondly, I think what the spread of world history scholarship and teaching has shown us is the difficulty, even impossibility, of creating adequate depth when we expect ourselves to cover the entire globe.[26] Arguably, the turn toward a global model of history, which has rightly displaced "Western Civilization" and "West and the Rest" pedagogical models at the college level, has generated a greater, not a lesser, need for updated specializations. Therefore, I situate the present book within a broader story that requires many regional or thematic specialists.

And thirdly, the focus on the North Atlantic world reflects the limitations of my own scholarly training, which included only the mastery of the English and French languages. The gender of photography in Germany, Russia, or Japan awaits scholars with those language competencies. I would argue that the gender of Central European photography, for example, to include Germany, Austria, as well as Italy, Hungary, and Bohemia, requires a separate, in-depth analysis of a photographic region that, admittedly, overlapped the one in this book.[27]

It is important for readers to know that I realize the racial meanings of photography have as important a need for analysis as its gendering. Even as the scholars mentioned above and I insisted upon retrieving early women's photography, early photography by women of color remains, for the most part, hidden.[28] However, a varied literature on photography and race has become available. Excellent work by scholars like Christopher Pinney, Shawn M. Smith, and Tanya Sheehan has exposed how Europeans and Americans used photography to control subaltern communities, and how those communities resisted that control.[29] By demonstrating that the language of early photographic literature is as important for our understanding of social power as the images themselves, perhaps this book can make a small contribution to the photo-historical research performed by colleagues such as these.

Although a number of scholars have shown that multiple tinkerers around the world were experimenting with different aspects of photo-sensitive and optical technology in the 1820s and 1830s, a small handful of male experimenters in the imperial nations of Britain and France jealously laid (and lay) claim to what scholars have called the "paternity" of the earliest processes: to wit, photogenic drawing (salted paper photograms and related sun images), metal plate daguerreotypes, and collodion-

treated glass negatives. The former British and French colonies that became the United States and Canada in the late eighteenth century eagerly participated in the discussion that traveled back and forth across the Atlantic from 1839 onward. Participants became members of each other's photographic societies, contributed to and exchanged each other's journals, and attended each other's exhibitions throughout the period. In the present book, I am making an argument for a distinct North Atlantic community based on the historical, linguistic, demographic, geographical, and cultural links between Britain, France, and North America during the nineteenth century.

Timeline

Why end a gender history of photography at 1900, when arguably it was after that date that North Atlantic women began getting sustained attention for their work in greater numbers? The main reason was because I wished first to participate in the overturning of the myth of women's rarity in photography's earlier period; and second, because I wanted to trace the origins of that myth. But just as importantly, we might recognize the greater acceptance of women in the public sphere after 1900 while avoiding a "Whig interpretation" of women's history, whether in photography or otherwise. I have no intention of making the fallacious assertion that at some arbitrary end-date, whether 1890, 1900, or 1914, stakeholders suddenly mellowed when it came to gender power dynamics, and the council chairs of the region's photographic societies were vacated for women to occupy. Certainly not. One can argue, nevertheless, that the 1890s brought evidence of greater acceptance of women with cameras, commencing an exciting era for North Atlantic women that would halt with the onset of the First World War, then restart sometime between the wars.

By 1900, we see several signs that women had become more comfortable joining photographic societies, participating in industry debates and contributing to the fine art movement in photography. The acceptance of female students at the French School of Fine Arts in 1897 after many years of sexist resistance, was symbolic: The Academy had conceded that women could be artists. Activists in Britain and America, too, gained concessions for women seeking formal educational opportunities. The 1890s also brought acceptance among middle-class families throughout the North Atlantic world, following decades of published debate, that their "surplus" daughters needed to earn a dignified living. Patricia Marks explained:

> The population imbalance that created the "redundant women" changed marital expectations of the middle class; that so many women tried to enter the labor market produced a scarcity of socially acceptable jobs. The resulting crisis generated pressure on other fields, so that eventually it was not only need but inclination that caused women to enter professions other than teaching or nursing.[30]

In a memoir about organizing the Columbian Exposition in Chicago, Laura Hayes persuades President Grant's widow of the need for some women to work:

[S]uppose a case: A young brother and two strong sisters; the young man makes a good salary but can't get ahead because all his earnings are consumed in taking care of the girls. Hadn't they better go to work and give him a chance to get ahead and have a house of his own, they being as able to work as he?[31]

Mrs. Grant had to concede Hayes' point. Never mind that these hypothetical sisters would be working solely, it seems, for their brother's benefit. The deeper argument Hayes and her contemporaries were making, as much by their actions as by their words, was against the "parasitism," the complete dependence, of middle-class girls' existence.

A conglomeration of social and political changes at the end of the century led more women to channel their creativity, skill, and restlessness into photography. Additional forces of change included the following:

- The arrival of Kodak cameras after 1888, which were explicitly, and aggressively, marketed to women and girls.
- The appearance of women photographers as judges at photographic exhibitions and competitions, notably Americans Catharine Weed Barnes Ward and Frances Benjamin Johnston, both of whom championed women's photography on both sides of the Atlantic after 1890.
- The establishment of women's prestige studios, such as Charlotte "Lallie" Charles in London, and Gertrude Käsebier's in New York City.
- The popularity of the bicycle: The symbolic and practical importance of a woman wearing unconstraining "rational dress," commanding the roads on her bicycle, cannot be underestimated. She not only used her bicycle on photographic excursions, she was asserting her independence and experiencing freedom of movement. Henceforth, traveling along the roads, even without an approved companion, would not compromise the reputations of single women. Railway advertisements, too, indicated that a woman could safely travel alone—an important consideration for the ambitious photographer.

Those accumulating moments of change, and many more, made 1900 both a numerically convenient and culturally appropriate date for me to end my story as the new century dawned. My focus on the 1840s to the 1890s aims to combat the ongoing misperception that women were absent from early photography with the exception of "eccentrics" like Julia Margaret Cameron. Women throughout the North Atlantic world were interested in many aspects of early photography, and they expressed their interest in a variety of ways, as will be recounted in the following chapters.

The chapters in this book are partly thematic, partly chronological. Using period sources, I will discuss incidents and "language moves"[32] that revealed the "femininity" or "masculinity" of photography from the first decade of the medium to the first decade of the twentieth century. References to women in early photographic discourse (1840s and 1850s) is significant, because it reminds us that from the medium's inception, women were interested in the camera, making, or using photographic images.[33] Although most often marginalized or invisible in the photographic literature, working-class, middle-class, and upper-class women all worked with photography in various ways throughout the period covered by this book.

Our task is not only to make the presence of women historically visible, as an increasing number of scholars have done, but to point out that "masculine" values were not the only values infusing early photographic technology. In other words, "mankind" is not, after all, synonymous with "humankind." We are deconstructing the assumption that the individual subject ("the artist" or "the photographer") is male.[34] This book will discuss the "feminine" values of photography over the course of its first six decades, in the hopes that photography's future historians may rebalance the gender of photography, the *yin* and the *yang*, in their accounts.

Chapters

The chapters in this book will examine the *yin* and *yang* of nineteenth-century photography as these forces ebbed and flowed over time. Part One, "The 'Femininity' of Photography," begins with a detailed discussion of what we might mean by these "feminine" and "masculine" values in photography, from roughly 1840 to 1890. During that fifty-year period, *yang* was ascendant and almost overwhelmed the feminine. Yet, as mentioned above, we know that neither *yin* nor *yang* is ever completely extinguished in a living body. So, while "masculine" values dominated the earliest photographic societies, publications, and exhibitions of the period, "feminine" values poured forth in the amateur photo-collage work of the 1850s, 1860s, 1870s, and beyond. We also see feminine assertiveness in the softer focus of artists like Julia Margaret Cameron, and the flair for theatricality and dress-up in the photography of Clementina Hawarden and Lewis Carroll. Arguably, "feminine" values generated some of the most beautiful and experimental photography of the early period. However, in focusing attention on techniques and behaviors that would make photography "manly," male-dominated photographic societies missed the opportunity to acknowledge a rich "feminine" perspective.

Part Two, "A Medium of Victorian Masculinity," investigates how it was that "masculinity" came to dominate the profession and institutions of photography in the North Atlantic world. Men's rapid conquest of photography occurred despite a good deal of female interest in the new invention. Why was this so? How did this occur, and where? In this section, I have borrowed insights from the fields of psychology, sociology, and anthropology to help me work out why it was so important that the original photographic societies establish themselves as spaces for men, and why members therefore chose to obscure the femininity (and the women) of photography. Moreover, what was it about femininity during this period that led most women to remain silent, keeping their opinions to themselves, and choosing not to establish their own camera clubs? It is important to repeat: In Britain, France, and America, early female practitioners *were there* in undeniable (if smaller) numbers as we will see. But the new institutions did not encourage their participation. This curious obscuring continued far into the twentieth-century historicizing of photography.

Part Three, "Women in the Studio," looks more closely at how the new profession of photography was tied up with the gendering of "the artist," so that male operators, writers, and club councils gendered the professional studio masculine, too. In Chapter

thirteen, I look at the adjective "charming" as a code word used by exhibition reporters to dismiss (politely) women's photography. From the camera's earliest days, observers had been proposing photography as an excellent activity for women, owing to their supposedly "natural" sense of taste, tact, and patience.[35] Then, in response to women's entry into the profession, early syndicates made the tactical concession of welcoming women as receptionists, finishers, and retouchers (workers who corrected flaws in the prints and negatives) in men's studios. In this proposed hierarchy, the "artist" photographing the sitter had to remain male owing to the supposed masculine gender of creativity and, more practically, because the operator was the figure who reaped the prestige and financial gain from the business. But I repeat: Despite this rhetorical move in the photographic literature, hundreds of women did direct their own studios throughout the second half of the century, and they won medals at photographic exhibitions, too. Part Three will also explore how and where they were able to do so.

Several chapters throughout this book will show how North Atlantic men used tools of communication—oral, written, and visual—in an attempt to claim photography as a spatial and professional field for themselves, for the cultivation of modern masculinity. In this book, the identification of certain values as "masculine" rather than as universal (i.e., best for everyone) will have, hopefully, an unblocking effect on our photo-historical perspective. We will also see that men's and women's actions during the period did not necessarily conform to the accumulating rhetoric of masculinity in the sources. While photographic discourse mostly made it appear that all photographers were male, there were at the same time living communities of human beings— husbands, brothers, uncles, and fathers—who avidly encouraged their intelligent daughters, wives, and sisters who expressed an interest in photography. Fathers bought cameras for them, encouraged them to take lessons, conveyed what they had learned at photo club meetings, or simply stayed out of their way. Male family members' subscriptions to the same journals that all but ignored the existence of female photographers provided women with the chemical recipes and procedures needed to make photographs of their own. Going forward, we might include more stories about men and women learning, working, and creating together in our history of photography.

Part One

The "Femininity" of Photography

1

What was the Problem with Femininity?

In the arts as in the sciences, masculine perspectives have until recently been confused with universal experience. Thus "the" human history of Europe, the United States, the history of art, and the history of photography have actually recounted the history of mainly men's "masculine" activity, with women's activities, whether conforming to or transgressing their "feminine duties," relegated, sometimes literally on the page, to the margins.

The convention of masculine "universality" in texts, wherein the masculinity of actors and concerns goes unmentioned yet overwhelmingly dominates, has been identified by few historians, except feminist scholars. Women's desires, and their insistence on their own subjectivity (in other words, their existence as ends-in-themselves rather than as objects of male interpretation or as men's acolytes), have nevertheless disrupted masculine "universality" at many points in history. Since the eighteenth century, the production of historical texts has adapted to these disruptions in a number of ways, from the assertion of "natural" female subordination by philosophers like Pierre-Joseph Proudhon and John Ruskin in the nineteenth century, to the partial acknowledgement of female subjectivity in twentieth century texts.

Acknowledgement of women "masters" has appeared in photographic histories that include the contributions of, for example, Julia Margaret Cameron, Frances B. Johnston, and Diane Arbus, while yet preserving a "masculine" perspective as universal. By a "masculine" perspective here I mean one that focuses on the "paternity" of photography (as I will discuss in some detail in later chapters), and the triumph of Modernism in the hands of a post-First World War American avant-garde, by way of classically "masculine" genres such as street photography, documentary photography, landscape, war photography, and female nudes.

An intriguing example of how this perspective persists may be found in Ian Jeffrey's provocatively titled *Revisions: An Alternative History of Photography*, which accompanied the reopening of Britain's National Museum of Photography, Film & Television in 1999.[1] Jeffrey made a point of mentioning Julia Margaret Cameron in his preface, as one of the "major artists" of photography.[2] Ironically, though, his "alternative" history reinforced the masculinist perspective by recreating a scientific history of the medium wherein women participants are utterly absent. Photo illustrations in his preface include the following: a calotype of volcanic explosions,[3] a glass negative showing the polarization of light through the mineral calcite, a glass print depicting a labelled collection of birds' eggs, a calotype of a cuneiform fragment in the British

Museum, a Kodak street scene, and a First World War autochrome. Although, as I will show, British women amateurs also delved into "masculine" genres such as scientific classification and exploration, their names are absent from Jeffrey's book (not a single illustration is attributed to a woman). Thus, Jeffrey not only excluded the "feminine" of photography, he doubled the imbalance by ignoring female photographers who chose "masculine" fields, such as Anna Atkins or Rosalind Franklin (if we are restricting ourselves to British examples).

What was the problem with femininity?

Historically, the framing of femininity as a "problem" to be "solved" arose in a number of domains. Beginning in the eighteenth century on both sides of the Atlantic, the so-called Woman Question arose as a critical subject in multiple fields and disciplines, as men and women grappled with the challenging notion that women's individualism, aspirations, and rights were as legitimate as men's.[4] Nineteenth-century writers and lecturers saw the "problem," or paradox, within their republican model of civilization, which prescribed a strictly private sphere for women but which nevertheless produced female authors, painters, actresses, and activists who successfully expressed themselves in public, sometimes to popular acclaim.

This "problem" was even more serious in the domain of work and wages. The post-revolutionary North Atlantic ideal prescribed domesticity for women (i.e., non-waged work at home), but the demographic reality was that many women had neither fathers nor husbands who could support them financially. What to do? This social reality unleashed a flood of literature over several decades proposing possible solutions that, it was hoped, would not alter men's monopoly over either the professions or the fine arts. For as we will see, masculinity after the revolutionary era was bound up in men's professional achievement and creativity.

Femininity was a "problem" in another sense. Nineteenth-century women and girls were under twenty-four-hour surveillance in their communities, for fear of social or sexual impropriety. Bourgeois custom dictated that unmarried women avoid unchaperoned contact with men who were not their relatives. The purpose of this rule was to prevent women (not men) from losing their virginity before marriage. Married women were also under surveillance in their communities, owing to the fear that extramarital sex would lead to illegitimate offspring, which was (and remains) the governing fear of patriarchal societies.[5] Confining rules played an important role in discouraging women from taking up photography, since working with the camera would easily lead to unsupervised contact with non-related men.

As the large "recovery" literature has made clear, beginning with Naomi Rosenblum's *History of Women Photographers*, many women embraced photography as professionals and amateurs from the 1840s, despite being under surveillance. Nevertheless, middle-class women were hyper-aware of situations that could "compromise" their good (i.e., chaste) reputations. There are many examples of these gendered *faux pas* in nineteenth-century literature, from Emily Brontë to Emile Zola to Kate Chopin. For instance, the character of Christine in Zola's *L'Œuvre* (1885–6) poses an interesting example for us

because of the importance in the novel of various image workers (artists). While the male characters in the novel roam the streets of Paris at all hours with impunity, as male photographers would also have done, poor Christine, provided with neither training nor education for any decent employment, worries about how her presence on the streets might be perceived while making her way alone at night to her new job as a lady's companion. Later, she must sneak through the city to meet her secret lover, the painter and hero of the novel. Early women artists and photographers who did outdoor work in urban areas were rare because, as Rosenblum wrote,

> they were not supposed to appear unaccompanied in city streets. Besides the usual fears of being accosted by strange men or coming face to face with prostitutes, there was the problem of attracting too much attention to get on with the work.[6]

Owing to the prevalence of prostitution, a woman alone in the streets might also be accosted by policemen. Although, as we will see, by the 1890s a variety of factors (legal, social, technological) combined to lead North Atlantic women photographers, finally, to reject the idea that they were not supposed to be in the streets.

Contemporaneous with Zola's work was Amy Levy's *The Romance of a Shop* (1888), which is especially relevant to our inquiry. Levy's novel describes a group of sisters who open a photographic studio in London, in defiance of social and family disapproval. The character of Aunt Caroline pronounces the scheme as "dangerous," both because operating a business would bring the girls into promiscuous contact with strange men, and because it would supposedly make them less attractive to prospective suitors. One sister reports, "She spoke freely of loss of caste; damage to prospects—vague and delicate possession of the female sex—and of the complicated evils which must necessarily arise from an undertaking so completely devoid of chaperones."[7] Never mind that the Lorimer sisters face destitution unless they find employment. Although Levy's contempt for her character of Aunt Caroline is plainly drawn,[8] Caroline nevertheless represents the conventional reaction to women asserting their right to creativity and independence during the period.

Sometimes such literary scenarios made it seem as if taboos against female liberty were created by women policing each other, rather than men. But more likely, the origins of women's mutual "policing" must have come from their internalizing, first as girls, what was a patriarchal taboo. The reality on the street was that actual vice squads, made up of male police, had powers to arrest women during this period if they suspected them of solicitation. This humiliation was one of the sexist measures of the Contagious Diseases Acts in Britain, against which Josephine Butler and many others campaigned. The Act was repealed in 1886 in Britain, but as late as 1903 in France, the Forissier Affair saw legal fallout from the wrongful (and humiliating) arrest of two middle-class women in Paris.[9]

Whatever the law said, most middle-class women received the intended message from such incidents, ensuring that before 1914,[10] they would think twice before setting up camera tripods in public or working in photographic studios with unrelated men. Likewise, joining a photo club (founded and dominated by men) would be tricky, as would trying their hand at street photography, landscape photography, or any other

genre they could not pursue at home. Early women photographers, then, were confined; but, as we will see, this confinement sometimes gave rise to innovative approaches to their craft. Furthermore, every once in a while, a self-confident woman participated in the above activities outside the home before 1890, convention be damned. It was these figures, like Marcelia W. Barnes (b. 1808, active 1850s–70), Eunice N. Lockwood (1840–1905), and Catharine Weed Barnes (1851–1913), who helped make female leadership in photographic institutions thinkable.[11]

Finally, the "problem" of femininity also characterized much of the twentieth-century historiography of photography. "Feminine" practices, notably mixed-media albums but even the turn-of-the-century Pictorialist movement led by men,[12] were largely rejected by mid-to-late-twentieth-century scholars, collectors, and curators as "impure" practices (that is, undesirably hybrid).[13] This historical aversion to the "feminine" in photography, what we might also describe as the suppression of *yin*, unsurprisingly produced a reaction in the literature. The uncovering of "feminine" work (mainly women's) became an international project over several generations of scholars and collectors since the 1970s, reaching undeniable heights in the key texts described in the Introduction. The challenge now is to integrate our new knowledge of women's presence in the history of photography's earliest decades, and to integrate the "feminine" photographic values that flourished but lay largely outside "masculine" institutions.

What then am I referring to when I say "masculine" and "feminine" photography? In the past few decades, experts have debated whether or not one can actually speak of gendered photographic practices. I put the words in quotation marks because, as historians and social scientists have shown, the meaning of the concepts are always subject to change, reconstruction, and evolution. In other words, "masculinity" and "femininity" are not stable categories. Fifty years of sociology have shown that these terms "are not immutable but rather changeable social creations."[14] In the present book, I will use the terms to indicate values or tendencies that were observable in nineteenth-century North Atlantic communities. These values were very much tied up with the individual and communal work of gender identification that played out in families, men's associations, women's groups, educational and religious institutions, and published discourse during the period. The present book's organization assumes that masculine and feminine perspectives exist, and that they both added value to early photography in its many different forms.

In considering the question of "how the sex of the photographer does or does not impinge upon her work," and whether "that work is necessarily gendered 'feminine' because of her female sex," Women's Studies Professor Carol Armstrong reasoned as follows:

> There are many photographers who happen to be women whose sex seems to count for very little in the work they produce, and who indeed would not care for the designation "woman photographer." There are others, on the contrary, who address the question of their gender head-on, either matter-of-factly, in celebration or in critique. There are still others who fall somewhere in between those two poles.[15]

Armstrong, then, covered all the bases, recognizing that the photographer's femininity or femaleness may or may not inform her creativity. The context of her discussion was an essay introducing an exhibition of photography at Princeton University, featuring mainly twentieth-century work, all by women. Several of the photographers in the exhibit, including Judy Dater, Nan Goldin, Sherrie Levine, and Cindy Sherman, had reacted to misogyny, abuse, or the feminist movement in their contemporary work. Others, such as Sarah Ladd and Berenice Abbot, took either a gender-neutral, "masculine" (and/or *yang*) approach to their work.

For the earlier time period covered in the present book, we almost certainly would not find forthrightly feminist themes in photography before 1900; but I would like to consider Armstrong's spectrum of gender inflection from a different angle. I want to identify "feminine" and "masculine" inclinations, or desires, in nineteenth-century photography, which are *not necessarily tied to the male or female sex*. In likening these inclinations more to the Asian concepts of *yin* and *yang*, I hope to introduce the interplay of tendencies in a wide range of photographers, rather than to categorize photographers as being "either/or."[16] I want to use these concepts mainly to begin reversing an analytical imbalance that has privileged masculinity, and either dismissed femininity or kept it invisible.

2

"Masculine" Photography in the Nineteenth Century

In some ways, a chapter addressing the "masculinity" of photography is unnecessary, since arguably the entire twentieth-century historiography of photography, and into the twenty-first century, showcased "masculine" preferences, desires, practices, and choices.[1] That is not to imply that feminist criticism has not intervened (which it certainly has since the 1970s), or that female photographers are absent from the historical canon, although it is true, few women populate the early-era chapters of our textbooks. Nineteenth- and twentieth-century historical knowledge production succeeded so well in presenting "masculine" photography as "universal" photography, that the sex of the knowledge producer (author, collector, curator, or media historian) rarely affected the classical, masculine point of view. Several of the canonical texts were written by a scholarly husband-and-wife team in this mode.

Promoted most energetically in this canonical library of photographic history was the *yang* of photography, which this chapter will elucidate. In writing those words, I anticipate readers' objections: Surely, great collectors like Helmut Gernsheim, or managers of great collections like the George Eastman House, the Victoria and Albert Museum, or the French National Library, have the right to showcase their collections as they see fit? Indeed, I cannot lodge a complaint against the production of knowledge, any more than a philosopher could lodge a complaint against the cosmic force of *yang*, an eternal component of all existence, whose role in the workings of the world has always and will always be constant. Equally important to recognize, though, is the role of *yin* in producing health and balance. The Way (*Tao*) is dynamic. A balance between stability and change is struck when *yin* and *yang* naturally ebb and flow together.

In Taoism, then, what is meant by *yang*? The ancient system lists five main agents, or elements, that make up the world: wood, fire, soil, metal, and water. Fire and metal are *yang*, wood and water are *yin*, and fertile soil requires a balance of the two. From there, each element and its offshoots express *yin* and *yang* at three different levels of intensity or gestation. The ancient manuscript entitled "Designations" (*Cheng*) and the *Tao Te Ching* name some basic groupings of *yang* and *yin* items, respectively: heaven and earth; above and below; day and night; summer and winter; speech and silence; colors of green/blue/black and red/orange/white. Later commentators and physicians further extrapolated to identify *yin*-ness and *yang*-ness in actions, behaviors, and feelings.

Yang is associated with stereotypically masculine behaviors or tendencies, qualities that dovetail nicely with the behaviors expected of men as described by gender historians like John Tosh, Heather Ellis, and Michael Roper.[2] Masculine ideals, as described in ancient Asian philosophical texts, or literature from modern imperial Europe and America for that matter, demanded bold action, defending one's honor, and the strength and intellectual talents for leadership. In common with these behaviors was a certain level of ruthlessness in the face of competition at school, on the battlefield, or in the corridors of power.

In the nineteenth century, those behaviors were encouraged in men, and discouraged in women. Whether in the context of the Imperial-Republican France, the British Raj, or Manifest-Destiny America, it seems clear that these masculine credentials were linked to empire-building, not just in the sense of distant territories, but empires *of knowledge* as well.[3] In this chapter, we will identify the *yang* of photography as flowing in those practices related to "conquest" in a number of senses. First and foremost, the drive to conquer the unknown and make visible. At the end of the century, the American entrepreneur George Eastman, founder of Kodak, perfectly represented the *yang* of photography in his business philosophy, which combined the drive for conquest with a taste for risk. He vowed that the "manifest destiny of the Eastman Kodak Company is to be the largest manufacturer of photographic materials in the world, or else go [to] pot."[4] Eastman made good on his promise at a time of terrific turbulence in the American commercial environment.

Where in Taoist cosmology we link darkness and the moon to "dreams" (what I will later call the *yin* of photography), *yang*'s association with the sun, heat, and penetration points to the idea of photography as a medium of "reality." The *yang* of photography encourages the belief, held from the first decades of photography up to today, that photographic evidence presents us with an objective truth, by virtue of the fact that the camera captures only what is placed before the lens—an automatic action of light, whether on chemicals or digital sensors. In 1883, H. Baden Pritchard said that photography therefore made the perfect "copying clerk" of which "you can rely implicitly upon the truth and correctness of the result." Photography, he argued, should be employed "in the bureau of the statesman, the counting-house of the merchant, the office of the lawyer, and the workshop of the engineer."[5] This *yang* quality of truthful documentation was what led photographic images, then as now, to be accepted as evidence in the court of law or the court of popular opinion.

The importance of visual clarity might bring to mind the cliché "seeing is believing," which relates to the stereotype that men rely on "visual" stimulation more than women—especially where sex is concerned, but perhaps more broadly.[6] The camera's optical penetration of the world, whether capturing bodies invisible to the naked eye (stars, microscopic organisms or crystals) or exposed bodies (pornographic, ethnographic) was therefore an important pillar of "masculine" photography. For example, Colonel Willoughby Hooper (1837–1912) photographed the impact of the Southern India Famine on victims' bodies in 1878 as part of his photographic duties for the India Office (Figure 2.1).

In the fifty years after 1850, the dominance in the photographic press of the science of photography (its optics, physics, and chemistry), and its material technology, remained pronounced, not only because practitioners were still working out how to

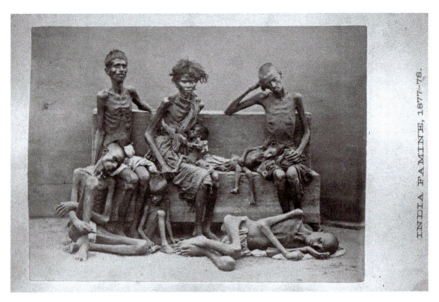

Figure 2.1 Inmates of a relief camp during the famine (1876–8), Madras. Hooper also photographed a series of ethnographical images in the Central Provinces of India, published in eight volumes by subscription between 1868–75. A skilled photographer, he was known for having captured the exact moment that native prisoners were shot at an execution during the British conquest of Myanmar (this would have been a technical feat during the period). Wikimedia Commons: https://commons.wikimedia.org/wiki/File:Inmates_of_a_relief_camp_by_WW_Hooper.jpg.

capture and stabilize the photographic image, but also because those aspects of photography satisfied a *yang* drive to probe—to see or render visible.

Looking at the early literature of photography, including its earliest journals, single-authored manuals, exhibition reviews, and biographies, the dominance of technological experimentation, colonial exploration, topographic surveys, and industrial production emerged rapidly across the North Atlantic world. A "masculine" pursuit of conquest, whether of "Nature" or foreign terrain, was apparent in photographers' columns, reviews, and published letters. For example, an early proponent of the medium, William Crookes, began his editorship of the British *Photographic News* in 1858 by announcing that photography, a "faithful but somewhat capricious servant may now no longer resist the power of human will."[7] For Crookes and his colleagues, photography was the most recent tool to aid in the mastery of "Lady Nature," following a wave of invention since the eighteenth century that included modern navigational technology, the Linnaean system of taxonomic naming, and the periodic table of the elements. Added to those techniques were the century's new mechanical devices that automated tasks, hastening the Industrial Revolution, devices that included the photographic camera.

Across the Channel, too, French photographer Auguste Belloc observed that heretofore, "nature was only reflected in the clouds, in the water," but now nature was:

subservient to our will, and can be reproduced upon substances at our disposal, and that with a permanency, and in such reduced proportions, as to enable us to form a collection, if we may use the term, of all its riches and all its treasures.[8]

The idea of subjecting nature, and photography, to the human will was an expression of the period's scientific optimism. Introducing Talbot's photogenic drawing process to the Royal Institution in 1839, Michael Faraday mused, ". . . what man may hereafter do, now that Dame Nature has become his drawing mistress, it is impossible to predict."[9] Nevertheless, predictions soon rolled off the press. Early expectations of the coming of instantaneous, artificially-lit, and, especially, color photography accompanied innumerable chemical formulae and diagrams illustrating workers' improved exposure, development, and picture printing processes.

Belloc's Parisian colleague Gustave Le Gray, too, demonstrated mastery over the elements, as even light itself came "to work under the brilliant direction of M. Le Gray like a diligent worker who rushes to his task with the rising of the sun."[10] Sometimes, the camera took either a female gender or a servile identity as above. Other times,

n'est plus qu'un écran ou un objet opaque par les divers points qui le constituent.

: » La représentation théorique de cet effet est la suivante : Sur la même ligne d'axe AX se trouve la lentille objective L, l'objet O ayant son foyer conjugué ou son image en I. Je suppose que la lentille éclairante E soit de même foyer que l'objectif, et à la même distance $Oe = Ol$; dans ce cas les rayons éclairants devraient partir du point r d'un corps lumineux rr' ayant la même grandeur et étendue que la plaque en II' et se trouver à une distance $Or = OI$, s'il était facile de se procurer

une telle surface bien éclairée et bien éclairante. Mais comme là

Figure 2.2 Fragment from a report by M. Silbermann on the process of photographic enlargement in the *Bulletin of the French Photographic Society*, t. 6 (April 1860), 89. Silbermann explained, "On the same line of the AX axis is located lens opening L, the object O having its conjoined base or its image in I. Supposing that the illuminating lens E has the same base as the lens, and at the same distance Oe = Ol; in this case the illuminating rays must originate from point r for a lighted body rr[1] . . . [formula continues]." Courtesy of BNF/Gallica.

photography was referred to as a goddess and photographers "her votaries," or priests.[11] Frequently, photography was the "handmaiden" of science or art.[12] All of these metaphors accompanied the photographer's use of the technology as a means of penetrating unseen realms.

Printed articles and announcements, shared among an array of North Atlantic photographic journals consistently along the decades, showed that the central tenet of

Figure 2.3 Portraits of criminals (illustration between pp. 58 and 59) in New York City Inspector of Police Thomas Byrnes' *Professional Criminals of America* (New York: Cassell & Co., Ltd, 1886). HTDC: https://babel.hathitrust.org/cgi/pt?id=cool.ark:/13960/t94750362 &view=1up&seq=83.

photographic discourse "was that the photographic image captures an objective, knowable reality."[13] This axiom encouraged early journalists to predict the new medium's future social-scientific uses, "whether it be a means by which we can the more easily detect a prisoner, or record the rapid light of a cannon ball through the air."[14]

In the United States, M.A. Root described how "Civil Engineering, mining works, and military operations, may profit largely by the art."[15] Photography would indeed accompany the dredging, tunneling, and subduing of the North American continent.

News from the sphere of colonial conquest, too, quickly appeared in the photographic journals. A multi-part letter entitled "Photography in Algeria" in *The Photographic News*, for example, described not the adoption of photography by Algerians, but rather the European reporter's adventures among the uncivilized "Arabs" of the recently conquered French territory.[16] Masculinity mingled with race identity in British and French photographic journals, as well as American publications, which reported on the photography of western expansion and herded Native American communities.[17]

Shortly after the mutiny in India in 1857, a letter arrived to *The Photographic News* from the subcontinent, assuring readers that the camera did "its share in recording the deeds of our brave countrymen here, ay, even in the battle-field."[18] Leaving aside the technical improbability of a photographer capturing action during dangerous fighting in India, the letter, written by a British soldier, told of how a camera operator happened

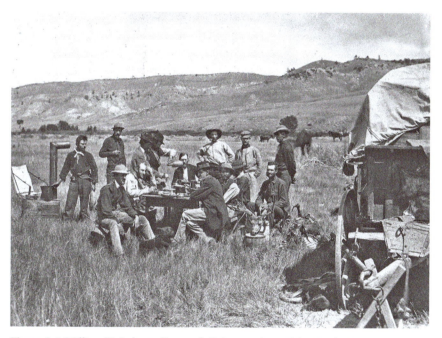

Figure 2.4 William H. Jackson: Group of all the members of the Hayden Survey, Wyoming, 1870. The U.S. Geological Survey took care to document the identities of every figure in the scene. Available at https://library.usgs.gov/photo/index.html#/item/51dc99eb e4b097e4d383a797.

to photograph him rescuing a British woman being abducted by two "native vagabonds." The reporter described how the soldier stabbed one Indian to death with his bayonet, whereupon the other Indian stabbed himself. The witnessing photographer on the scene was armed "with a long sword, a six-barrelled revolver, and a sharp-pointed knife about ten inches long," conjuring the novel image of a warrior-photographer prepared for manly action.[19]

In the American context, James Ryder similarly positioned the field photographer as a tough character. In following the California gold rush of 1849, the photographer (like other prospectors) had to brave an "unknown route, the danger from hostile Indians, the chance of perishing from illness or starvation." Ryder concluded, "There was much heroism to be exercised."[20] As has been shown elsewhere in the history of imperialism, a manly or macho identity was bound up with racial competition and subjugation.

The language of mastery and conquest accompanied an abiding concern with what scholars have described as the "paternity" of photography, that is, the genealogy of its masculine invention.[21]

Safely up to the present, accounts of photography's history begin ritualistically with the evocation of the holy trinity of Messrs. Niépce, Daguerre, and Talbot, arguably the "founding fathers" of photography. I want to discuss the preoccupation with "paternity" more in a later chapter, not in order to downplay those inventors' roles (though various nationalist and scientific objections or inflections have marked historical accounts over the years), but in order to recognize this preoccupation as an important feature of the "masculine" photographic world. The *yang* of claiming, negotiating, or disputing credit for discovery and originality was one of the most dominant topics in the photographic press throughout our period.[22]

"Masculine" values in photography were not exclusive to one sex. Although there were very few female photographic reporters in the 1850s and 1860s, there were women photographers who gravitated to "masculine" genres before 1900, especially the photography of exotic travel and exploration, linked to a Western notion of "conquest." Anna Brassey (1839–87), the English baroness who published *A Voyage in the* Sunbeam (1878) about her eleven-month ocean voyage around South America to Hawaii, Tahiti, and beyond, was an enthusiastic photographer and an early female member of the Photographic Society of London.[23]

Likewise, the Belgian Carla Séréna (1824–84) published articles in the *National Geographic*-like *Tour du Monde* journal in the early 1880s, which featured engravings based on her photographs of Caucasian lands.[24]

A little later, American photographer Septima Collis (1842–1917) published *A Woman's War Record* of Civil War camp life in 1889 with her photo illustrations,[25] and *A Woman's Trip to Alaska* in 1890, showing an interest in war-related and ethnographic photography that was not exclusive to men in the United States or Europe. Another example was in the career of Isabella Bishop (1831–1904), a British explorer and amateur photographer who was perhaps the first woman invited to lecture at the Royal Photographic Society, in 1898.[26] In addition to those female explorers, there were well over 1,000 woman studio proprietors and employees during our period who churned out profitable *cartes-de-visite* across Europe and North America.[27] If the leisured

MODERN AMATEUR PHOTOGRAPHY. 289

DR. R. L. MADDOX.
From a photograph by J. THOMSON, London.

HENRY J. NEWTON.
From a photograph by HUGH O'NEIL.

the use of heat, which was effected by the addition to the emulsion, at a particular stage, of a small quantity of liquor ammonia; the time required to prepare it was very short, while the deterioration of the gelatine by heat, liable to occur in former processes, was entirely avoided. The formula met with immediate success, resulting in greatly simplifying

ing close upon these discoveries, sensitive plates bearing Bennett's name were prepared and sold exclusively, but it was not until about 1880 that their merits and advantages began to be fully appreciated.

In the fall of 1879 Dr. D. Von Monckhoven, of Ghent, Belgium, a German chemist, interested in photography, read before the Belgian Photographic Association his new formula for obtaining an extremely sensitive emulsion without

CAPTAIN W. DE W. ABNEY, R.E., F.R.S., PRESIDENT
OF THE LONDON CAMERA CLUB.
From a photo. by ADAMS AND SCANLAN, Southampton.

the process of preparing sensitive emulsions. At this day, though Monckhoven died in 1882, plates bearing his name are commercially sold. Other amateurs, such as A. L. Henderson, of London, and Dr. J. M. Eder, of Vienna, Austria, should be noted as men who have made minor improvements in the manipulation of the process, all of

which tended to produce high sensitiveness.

Since the preparation of the sensitive emulsion and the coating of plates requires more time and trouble than the average amateur has to spare, very few undertake it. Hence it is that within a very few years immense establishments have been built up in the United States and Europe expressly for the purpose of manufacturing the plates on a large scale, based, it would seem, on the simple fact of their

CHARLES BENNETT.

DR. D. VON MONCKHOVEN.

Figure 2.5 Illustration layout in F.C. Beach, Ph.B. [Bachelor of Philosophy], "Modern Amateur Photography," *Harper's New Monthly Magazine*, vol. 78, no. 464 (January 1889), p. 589. HTDC: https://babel.hathitrust.org/cgi/pt?id=hvd.hnybip&view=1up&seq=305.

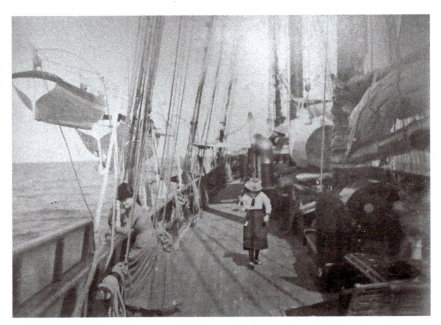

Figure 2.6 Photograph of the *Sunbeam* yacht at sea from Anna Brassey's album. Brassey wrote about her adventures in *A Voyage in the* Sunbeam, *Our Home on the Ocean for Eleven Months* (London: Longmans, Green, and Co., 1879). Although she took photographs throughout the trip, the book is illustrated with engravings from the drawings of A. Y. Bingham. Wikimedia Commons: https://commons.wikimedia.org/wiki/File:Sunbeam_RYS_deck_view.jpg.

amateur photography of the domestic parlor demonstrated the *yin* of photography (as we will see), its opposite—standardized commercial photography on a fiercely competitive basis—expressed the *yang*. Businesswomen such as Hannah Maynard (1834–1918) in British Columbia, Eliza W. Withington (1821–77) in California, and Angélina Trouillet (active 1866–77) in France, to name but three, ran their commercial studios on industrial lines, proving that the *yang* of photography was not restricted to men.[28]

A pioneer of commercial photography who should also be mentioned for exemplifying a "masculine" drive was the northern French businessman Louis Désiré Blanquart-Evrard. Imagining efficient manufacturing of commercial photographic prints long before photo-mechanical reproduction technology was available, this former cloth merchant and trained chemist was inspired by the French Heliographic Society's call to create "a great album of the world" using the medium of photography.[29] Working with financial partners and the French Photographic Society, Blanquart-Evrard put in place a veritable factory to produce topographical albums illustrating great monuments and landscapes from Belgium to the Holy Land (Figure 2.8).

Hiring and training an unprecedentedly large, inexpensive labor force, Blanquart-Evrard produced twenty-four albums of views, but failed to make a profit, and the

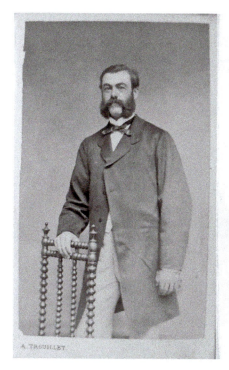

M^{ELLE} TROUILLET

1(i, Rue du Boulevard ,

(au-rez-de-chaussée)

PARIS-BATIGNOLLES.

Spécialité pour les enfants.

Figure 2.7 Front and back of commercial *carte-de-visite* by Angélina Trouillet (Paris, *c.* 1860). Although women photographers like Trouillet often advertised a specialty in young children's portraits (as her logo states), many of their clients were gentlemen, as seen here. Author's collection.

historic printworks folded in 1855. A combination of factors led to the project's demise—certainly not a lack of hard work or brilliance on the part of this inventor of the albumen print process. The ambition, scale, and risk-taking involved in it, though, offers photo historians an excellent example of photography's "masculinity."

The Taoist table of the five agents (*wuxing*) and their associations shows that *yin* and *yang* are not always, or mainly, expressed in their pure or extreme forms.[30] Many of the "ten thousand things" that make up the world are a mixture of both, and so it is in photography.[31] A blending of *yin* and *yang* impulses could produce the sublime, as in Anna Atkins' *Photographs of British Algae: Cyanotype Impressions* (1843–53).[32] Using the blue, camera-less cyanotype process, Atkins catalogued all the known species of algae in the British Isles in the first scientific work employing photographic illustrations.[33]

On the one hand, Atkins' project expressed the will to systematic mastery—what we might consider a *yang* impulse. In contrast to what nineteenth-century societies expected of leisured ladies' botanical sketching, Atkins' catalogue contained twelve parts and required a decade of professional discipline to complete. The role of the sense

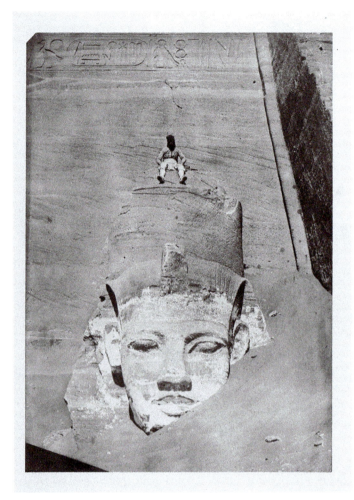

Figure 2.8 Maxime Du Camp, image of the "Westernmost Colossus of the Temple of Re, Abu Simbel" in Egypt. From the album *Egypte, Nubie, Palestine et Syrie*, published in 1852 and containing 125 photographs printed by Blanquart-Evrard, which according to the Met Museum, brought its author instant fame. From the Gilman Collection, gift of the Howard Gilman Foundation, 2005, at the Metropolitan Museum of Art, New York. Courtesy of the Metropolitan Museum of Art, New York.

of touch here, though, both in her production of the albums, and in the way she shared them, introduced a number of "feminine" elements. The delicate beauty of her blue impressions (lovely enough to frame as individual pieces of botanical artwork, yet sharp with detail appropriate for classroom examination), her hand-written text legends, and intimate gifting of each copy,[34] showed that *yin* was as strong as the *yang* in this work. Viewers might contrast Atkins' blend of methods with contemporaneous

THALLOGENS.] LICHENALES. 45

ALLIANCE III. *LICHENALES.*—THE LICHENAL ALLIANCE.

Algæ. § 3. Lichenes, *Juss. Gen.* 6. (1789).—Lichenes, *Hoffm. Enumerat. Lichenum*, (1784); *Acharius Prodr. Lichen* (1798); *Id. Methodus*, (1803); *Id. Lichenogr. Univers.* (1810); *DC. Fl. Fr.* 2. 321. (1815); *Fries in Act. Holm.* (1821); *Agardh Aph.* 89. (1821); *Eschweiler Syst. Lich.* (1824); *Wallroth Naturgesch. der Flechten.* (1824); *Grev. Flora Edin.* xix. (1824); *Meyer über die Entwickelung, &c. der Flecht.* (1825); *Fée Méth. Lich.* (1825); *Fries Syst. Orb. Veg.* 224. (1825); *Martius in Bot. Zeitung*, 193. (1826); *Fée in Dict. Class.* 9. 360. (1826); *Fries Lichenogr. Europæa.* (1831); *Eschw. in Mart. Fl. Bras.* 1. 51. (1833); *Hooker Brit. Fl.* vol. ii pt. 1. 129. (1833); *Endlich. Gen.* p. 11; *Link Ausgew. Anatom. Botan. abbild. fasc.* 3. — Graphideæ, *Chevalier Hist. des Graphidées.* (1824, &c.)

DIAGNOSIS.—*Cellular flowerless plants, nourished through their whole surface by the medium in which they vegetate; living in air; propagated by spores usually inclosed in asci, and always having green gonidia in their thallus.*

Fig. XXIX.

Perennial plants, often spreading over the surface of the earth, or rocks, or trees, in dry places, in the form of a lobed and foliaceous, or hard and crustaceous, or leprous substance, called a thallus. This thallus is formed of a cortical and medullary layer, of which the former is simply cellular, the latter both cellular and filamentous; in the crustaceous species the cortical and medullary layer differ chiefly in texture, and in the former being coloured, the latter colourless; but in the fruticulose or foliaceous species, the medulla is distinctly floccose, in the latter occupying the lower half of the thallus, in the former enclosed all round by the cortical layer. Reproductive matter of two kinds; 1, spores naked, or lying in membranous amylaceous tubes (thecæ) immersed in nuclei of the medullary substance, which burst through the cortical layer, and colour and harden by exposure to the air in the form of little discs called shields; 2, the separated cellules of the medullary layer of the thallus. These, called gonidia, or gongyli, are

Fig. XXX.

Fig. XXIX.—1. Shields of Variolaria amara; 2, a portion of the thallus of the same plant; 3. a piece of the thallus of Sticta pulmonacea, with lacunæ and soredia; 4. thallus of the same, bearing shields; 5. shield of Opegrapha scripta; 6. thallus of the same; 7. shields, young and old, of Lecanora perella; 8. shields of Bæomyces rufus; 9. part of thallus of Peltidea canina; 10. section of a shield of Sticta pulmonacea; 11. Podetia of Cenomyce coccinea; 12. section of a shield of Bæomyces rufus; 13. shields of Endocarpon miniatum; 14. thallus of the same. Chiefly from Greville's Flora Edinensis.
Fig. XXX.—Section of a shield of Parmelia parietina. *Link.*

Figure 2.9 Algae illustrations in John Lindley, *The Vegetable Kingdom: or, The structure, classification, and uses of plants, illustrated upon the natural system* (London: Bradbury and Evans, 1846), p. 45. The book's title page includes the author's many titles of authority: John Lindley, Ph.D., F.R.S, L.S., Professor of Botany in the University of London, and in the Royal Institution of Great Britain, and it contains a Latin epigraph quoting seventeenth-century naturalist John Ray. HTDC: https://babel.hathitrust.org/cgi/pt?id=coo.31924080099751&view=1up&seq=119.

works like John Lindley's *Vegetable Kingdom*, whose first section plotted the paternity of botany from Linnaeus to himself, and whose simple etched illustrations (unattributed) were inserted into dense, taxonomic text.

The scientists and businessmen who established the earliest photographic clubs and journals possessed a high level of technical knowledge, whether through their formal education in the natural sciences, their professional apprenticeships, or as leisured amateurs who had the time to conduct experiments in their own laboratories. With the exception of a lucky few, women did not have access to any of those sources of chemical knowledge, so I suspect that, just as I tended to skim past chemical formulae and diagrams when reviewing the early journals, so did the majority of their female readers.[35]

The focus on laboratory science, like the stories about wilderness and imperialist photography, then, may be deemed "masculine," because of Victorian notions of who belonged in a laboratory.[36] The freedom to pit oneself against challenging natural environments (with or without a camera), and of course the field of war, were, likewise, activities reserved for men because of period gender expectations.[37] Tendencies in early *commercial* photography and most photographic *associations* were, in other words, overwhelmingly *yang*: masculine forces of aggression, competition, rivalry, and conquest shaped a purportedly "gentlemanly," emulatory, and scientific discourse.

While *yang* values dominated the environment and the agenda of organized photography, the men entering these early societies were quite heterogenous in their interests and their talents. Gentlemen dilettantes, learned scientists, brilliant-but-temporary converts (like Roger Fenton and Peter H. Emerson), studio professionals, innovative businessmen, and serious travelers all had different relationships with the camera. Appropriately, such a heterogenous population formed different kinds of associations over the course of the 1850s, 1860s, 1870s, and 1880s. The earliest, most prestigious societies made the science of photography their main focus. Beginning in the 1860s, professionals' societies arose to look after the interests of studio photographers and equipment manufacturers. A concern with the medium's aesthetic potential preoccupied some early amateurs and journalists, and later the more serious practitioners who were devoted to art photography. The early diversity and liberality of photography's enthusiasts, though, did not translate into space for women's ideas, whether in the scientific, artistic, or commercial cadres. In that sense, photographic societies and publications merely replicated the institutions that preceded photography's invention.

Returning to our cosmological metaphor, in ancient Asia, meteorological conditions such as drought or flooding were attributed to too much *yang* or too much *yin*, respectively, in the environment. Unblocking the suppressed force, so went the theory, would return fruitfulness to the landscape. If, for example, levels of photographic surveillance in the nineteenth century, justified as they were by science and imperialism, reached oppressive proportions,[38] could this have been because the *yang* of photography ran amok as its *yin* remained hidden, suppressed, ignored, or dismissed? Few would suggest that photography in the service of geographical discovery or scientific progress was innately wicked. But, as in the politics, knowledge institutions, and professions of the era, nineteenth-century photographic discourse forgot—or refused—to honor the balancing force of "feminine" points of view. Defining the "feminine" in nineteenth-century photography will be the subject of the following chapters.

3

Theatricality

I argued in the Introduction that looking at the history of photography with a different philosophical lens could help us open up what has remained blocked. Carol Armstrong described a "little canon" of women photographers as the "minor key" in a musical metaphor for history.[1] Her metaphor evokes the black and white keys on a piano, both parts needed to achieve melody as well as harmony. Perhaps the black and white Taijitu symbol of interrelated *yin* and *yang* (Figure A in the Introduction) is even more apt, since the word "minor" connotes a sense of lesser importance.

The phenomenon of photography—a chemical reaction harnessed to produce images for unlimited uses—unleashed a flow of both *yin* and *yang* forces from its discovery onward. The next four chapters will identify some of the desires, concerns, and emphases that we might recognize as "feminine" (*yin*) during the period, forces whose dynamic balance with *yang* demands conceptual flow rather than fixity. The "feminine" values I will identify in nineteenth-century photography, then, may or may not appear in photography today, because while gender never vanishes, it continually evolves. If we hold the concept of *yin* in our minds, we can also avoid the conflation of "femininity" with *women*, since there were men all over the North Atlantic world who contributed to the following "feminine" genres and themes, just as we saw women photographers expressing *yang* in the previous chapter.

If the *yang* of photography is concentrated in the word "conquest," a single word that might encapsulate the *yin* of photography is the word "play," especially as applied to the theatrical playing of roles. This sense of play appeared mainly in the work of serious early amateurs. The "masculinity" of commercial studio photography, as discussed in Chapter 2, meant that the bulk of professional women's photography before 1890 conformed to an efficient, semi-industrial system standardized in men's professional organizations, advice literature, patent bureaucracies, and legal apparatus, none of which took women's opinions or approaches into account. Although there were exceptions in a handful of women's and men's mid-century studios,[2] mainly it was in the *play* of the amateur that *yin* infusions of theatricality, dress-up, and *tableau vivant* established the "femininity" of early photography.

The word "theatricality" has several meanings, including the formal discipline of drama, a person's flair for the dramatic, and a range of role-playing activities. Whether in its formal or informal manifestations, performing often involves costumes or what we might refer to in the postmodern world as "drag."[3] Specifically, I want to identify "dress-up" as a key entry point into the "femininity" of early photography. Art critic

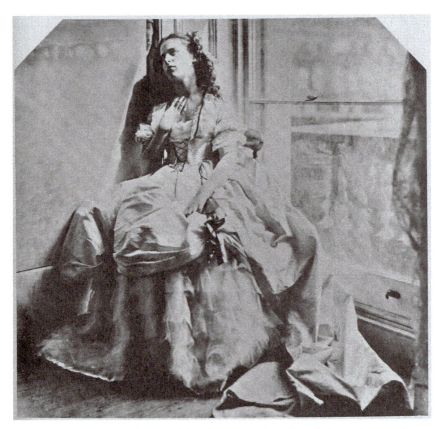

Figure 3.1 Home studio photograph by Clementina Hawarden of Clementina Maude in fancy dress (*c.* 1863–4). Wikimedia Commons: https://commons.wikimedia.org/wiki/File:Hawarden,_Clementina_-_Träumerisches_Mädchen_(Zeno_Fotografie).jpg.

Marina Warner rightly observed that the "relationship between dressing up and women's photography runs through the history of the medium from [Lady] Hawarden to Jo Spence."[4] Certainly, Clementina Hawarden's costumed portraits of her daughters from the 1860s hint at hours of intimate dress-up games, in which mother's trunks of gowns, shawls, and jewelry were brought out for sessions with the camera.

"By whisking away all of the furniture and the Victorian bric-a-brac one is accustomed to seeing in the upper-class homes of the period," Carol Mavor wrote, "Hawarden transformed the first floor of her South Kensington residence into a photographic studio: a private space for taking pictures of her daughters in theatrical poses."[5] Mother and daughters could play undisturbed as long as daylight streamed through the balcony or second-floor windows where she worked.

Despite the prominence of dress-up in photography, this relationship has been missing from standard histories of the medium, perhaps because "girls' play," whether with dolls or makeup or dress-up, has an anthropological connotation of "low status."

To date, scholarly literature on the origins and function of dress-up play for girls is sparse because it is a developmental phenomenon assumed to be unremarkable (normal) by psychologists and lay observers. In social science databases, it may be easier to find studies about boys and dress-up, wherein physicians and psychologists assure parents that "gender-bending" is perfectly healthy. In another form of the phenomenon, critics of adult "cosplay" have rhetorically shifted dress-up from its low status as girls' play to a means of creative transformation for high-status adult men.[6] In both cases, there is a "problem" with the "feminine" (i.e., incidents of males playing dress-up) that causes anxiety.

Recently addressing the controversy surrounding "princess culture" in the United States, psychologist Susan Scheftel admitted that the "cult of pink" at first struck her as "a cultural shackle that little girls needed to be shielded from."[7] But in observing her young daughter dressing up like princesses, she realized that it was helping the girl develop an identity that was "just the opposite of weak and vulnerable."[8] That, in dressing up as the heroine of her own story, her daughter was imagining herself as a powerful woman who ruled, not as a passive figure to be rescued (as mythological accounts of Andromeda or the legend of St. George would prefer it). Scheftel's insight is suggestive for the nineteenth-century women we will discuss below, who, whatever level of family wealth, beauty, or creativity, were bound by the gendered constraints of the period. From a chimney-sweeping maid (Hannah Cullwick) to an actual princess (the future Queen Alexandra) and several classes of women in between, playing dress-up, and capturing this play with the camera, gave life to desires for independence and control.

Unblocking the flow of *yin* in our accounts of photography, then, will require recognizing dressing up and related forms of play as important, essential, and "high status" forms of human self-expression, what Federica Muzzarelli called "performativity."[9] We will see examples of male and female photographers who infused their photographs with varying degrees of "feminine" theatricality. In a variety of activities performed for the camera, from formal *tableau vivant* compositions, to playing dress-up for one day, to subtler forms of play and fantasy, we will see below amateurs who, often outside the institutions of the day, delighted in the camera's ability to capture the act of role playing.

I am indebted here to Federica Muzzarelli's 2009 study of women photographers, which grappled seriously with the "femininity" of photography across the lives of twelve women's photographic legacies.[10] The theatrical element in Victorian women's staged photographs, self-portraits, and photo-collage compositions is striking, and it was expressed across a range of social classes. Was women's fondness for role playing so prevalent because the roles prescribed for them in real life, as wives, homemakers, and mothers, were psychologically confining? The vigilant protection of one's reputation and those of one's daughters operated as a virtual leash on women's movements and desires during the period. Dress-up, for young or older women, allowed for play and the opportunity to perform alternative, sometimes exotic, personas.

It is possible that making images of themselves, or other women, in romantic roles provided a therapeutic break from the life-long performance of "feminine" modesty, "humility, quiet domesticity and, above all, pious obedience to father or spouse."[11] The mandatory roles consigned to Victorian men—even with the privileges that accompanied them—may have sparked the desire for temporary escapism.

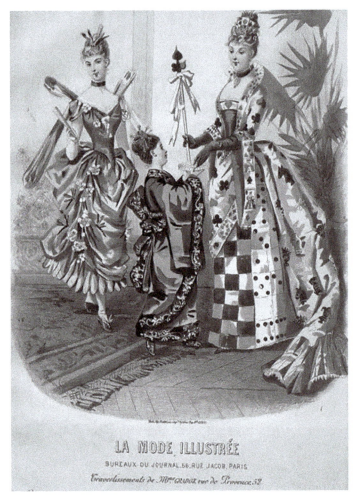

LA MODE ILLUSTRÉE

BUREAUX DU JOURNAL 56 RUE JACOB PARIS

Travestissements de Mme GRAPOR, rue de Provence, 52

Figure 3.2 Fancy dress chromolithograph in *La Mode Illustrée*, année 28, no. 1 (January 2, 1887, between pp. 30–1), featuring a dragonfly, a Japanese-themed costume, and an allegory of games. Here rendered in greyscale. Courtesy of the Metropolitan Museum of Art, New York.

Alternatively, maybe play-acting appears so often in nineteenth-century "feminine" photography because "family ritual was omnipresent" in the lives of the middle and upper classes,[12] so that everyone was "performing" all the time, in any case. Family dining tables, high-society gatherings, decorum at church, matchmaking or courting, or acting as host or hostess, to name a few examples, all required crafted, even ritualized, comportment. Performing one's part, then, was second nature to the leisured classes, male or female, so it may be unsurprising that such individuals would so successfully play parts for the camera.[13] Photography provided some amateurs with a new space for play, even escape, from the restrictive rules of everyday life.

Consider the case of Queen Alexandra, the consort of Edward VII of Great Britain, and an avid amateur photographer. Alexandra's life was a good example of how, underneath circumstances of privilege, wealth, and good looks, the individual endured a great deal of pain and humiliation. Photography for Alexandra may have served a therapeutic function, judging from the trials she faced from ill health, marriage, and motherhood. She suffered from hereditary deafness that worsened with age (otosclerosis), childbirth that destroyed her health with rheumatic fever, a lame right leg that impaired her gait, the death of her eldest son (the royal heir), and the death of an infant son in 1871.[14] Living in pain punctuated by sorrow, Alexandra also had to contend with her husband's terrible health (chronic bronchitis, skin cancer, and several heart attacks) and his flagrant infidelities. On top of those challenges were the strict protocols and constraints that governed a royal's movements all day, every day.

This photograph of Alexandra by Lafayette comes from one of the then-princess' albums (Figure 3.3), which combined her own photographs, her drawings, hand-made color decorations, and others' photographs, as here.

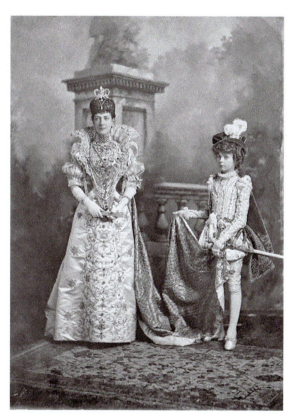

Figure 3.3 The Lafayette Studio's photograph of Princess Alexandra as Queen Marguerite de Valois at the Devonshire House Ball (1897). The attending pageboy is actually a girl, Miss Louvima Knollys, future maid of honor to the queen. Royal Collection Trust/© Her Majesty Queen Elizabeth II, 2019 (RCIN 2106295).

Here she has dressed up as the French Renaissance Queen Marguerite de Valois for a ball in 1897. Queen Marguerite (1553–1615) was a powerful and complex woman estranged then divorced from her husband, Henry IV, following mutual infidelities. Later, she commanded a failed coup against her reigning brother, and lived in exile. Unlike several of the wives of England's contemporary Henry VIII, Marguerite kept her title of queen, and lived out her life as patroness of the arts and charities in Paris during her former husband's reign. Alexandra's choice showed wit and daring. Dressing up, or dressing others up, to play heroines from literature, queens from ages past, or even more provocative figures allowed women like Alexandra to escape temporarily from the expected display of meekness or submission then prescribed for wives of whatever class station.

Another camera-friendly form of theatrical play was *tableau vivant*, defined as "a costumed group or individual in a static and carefully arranged pose, usually accompanied by elaborate sets and props," was popular throughout the nineteenth century as a theatrical genre used to illustrate mythology, famous paintings, or historical events.[15] These stagings, originating in the pre-photographic Romantic era or even earlier, predicted photography in the sense that the creator yearned to fix a fantasy in a stable image, to make it concrete, producing "a unique, irreplaceable experience" for both participants and observers.[16] Julia Margaret Cameron and others like Henry Peach Robinson, Oscar Rejlander, and Antoine Adam-Salomon understood that photography allowed them "to recreate a world that exists only in the imagination of poets, in the dreams of painters"[17] (Figure 3.4).

This notion of photography as belonging to the realm of dreams rather than to reality was the *yin* aspect of the medium, in contrast to the *yang* of photography's power to reveal "truth."

Home theatrical productions, without the camera, were an enthusiasm among all the educated classes of nineteenth-century Britain, from the postprandial recreation of schoolteachers' families to the amusement of royal children.[18] Isle of Wight neighbors Julia Margaret Cameron and Alfred Tennyson were both theatrical, and both families participated in "Mrs. Cameron's Thatched House Theatre" productions on the grounds of the photographer's house.[19] Muzzarelli likened Cameron the photographer to a kind of stage director, since "she directed visual projects [*réalisations*], verifying costumes and hairdos, setting up the decorations and organizing set design"[20] (Figure 3.5).

It was no great leap, then, when Cameron applied her camera to the theatrical productions that she had already been creating in her home. Her staged groups and individuals, exposed on wet plate negatives, included mythical allegories, literary portraits, and biblical scenes in costume, informed by her first-hand knowledge of art history gained in the galleries of France and England. Cameron's ambitious project to illustrate Tennyson's *Idylls of the King* (1874 and 1875) with thirteen different staged *tableaux* was perhaps the apotheosis of her career. This series was unusual in that Cameron necessarily undertook the project more as a professional artist than as an amateur or mere friend. The expense of the lavish photographs, though, was quite ruinous as neither Tennyson nor the publisher offered her compensation for her work.[21]

Cameron had undertaken the staging work, then, for friendship, to glorify that which she considered to be literary genius, and for personal pleasure. Throughout the

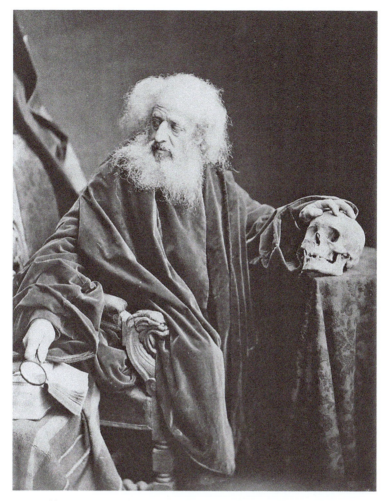

Figure 3.4 Self-portrait (*c.* 1870) by Antoine-Samuel Adam-Salomon as "A Philosopher" (a *vanitas*). More like his British contemporary William Lake Price than his fellow Parisian Nadar, Adam-Salomon staged painterly compositions using studied posing, costumes and drapery, intense chiaroscuro, and symbolic accessories. Wikimedia Commons: https:// commons.wikimedia.org/wiki/File:Philosophe_by_Antoine-Samuel_Adam-Salomon.jpg.

North Atlantic world, amateur theatricals and *tableau vivant* offered the pleasures of costuming and what was then referred to as "fancy dress," in common with the masquerade balls of the upper classes. In Edith Wharton's *House of Mirth*, for example (published in 1905 but documenting sociability that had endured several decades), Lily Bart makes a sensation posing as an aristocrat from an eighteenth-century Reynolds painting during a high-society party in New York. Another Lillie (Langtry), before turning to the stage to earn much-needed income, participated in *tableaux vivants* at

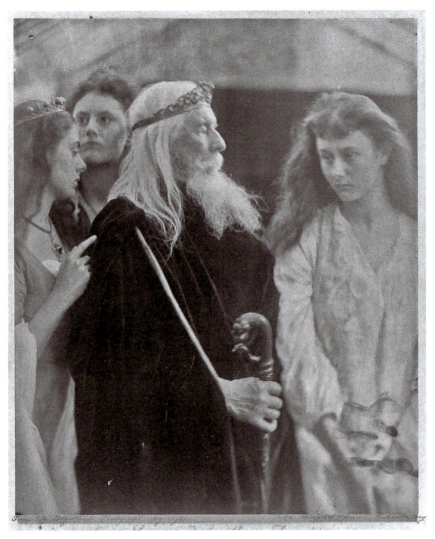

Figure 3.5 Julia Margaret Cameron, "King Lear Allotting His Kingdom to His Three Daughters" (1872). Courtesy of the Metropolitan Museum of Art, New York.

high-society parties in London, to "rapturous" applause. In 1880 at one such party (a charitable benefit), Langtry played a Walter Scott heroine in a short blue dress, on a set designed by her friend, the painter John Everett Millais.[22] Later, Langtry would use photography to help build her career and her decades-long mystique.

However amusing such diversions were, the theater nevertheless "was not an acceptable profession—actresses in Lillie's day were seen as immodest and unladylike," and often assumed to be prostitutes.[23] Across the North Atlantic world, patriarchal society had a love-hate relationship with the theater. English or French, it loved and

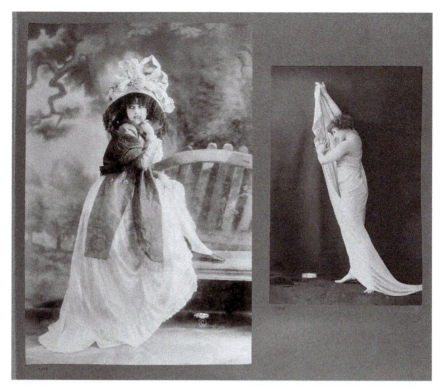

Figure 3.6 Portrait in a series of actresses and their roles by Jean Reutlinger (pre-1914). The album pages are not labeled, but Reutlinger appears to have represented his subjects in a comedic role (left) and tragic or classical role (right). Courtesy BNF/Gallica.

respected its male playwrights, but forbade its respectable daughters from becoming these geniuses' interpreters. Home-bound theatricals, then, were acceptable domestic entertainments, but embarking on a paid career in the public theater was not. Perhaps the early women amateurs that we encounter indulged in costumed *tableaux* because this activity had the exciting aroma of illicit activity.[24]

There were several male photographers during the nineteenth century who also played with theatrical compositions, such as Lewis Carroll. Commercial photographers, too, had successful careers as theatrical portraitists. What we might call publicity photographers today, talented men like Napoleon Sarony in New York, James Lafayette in Dublin, and the Reutlingers in Paris (Figure 3.6), to name just three, photographed the best and the most popular actors and actresses of their day.

Cincinnati portrait photographer James M. Landy (1838–97) created a series of "The Seven Ages of Man," portraits in costume inspired by a soliloquy in Shakespeare's *As You Like It* (Figure 3.7).[25]

Landy exhibited the "Shakespeare's Seven Ages" portfolio at the American Centennial Exhibition in 1876, the 1889 Universal Exposition in Paris, and again at the Chicago World's Fair in 1893.

Figure 3.7 James M. Landy's self-portrait in a bound version of *"Shakspere's* [sic] *Seven Ages," illustrated by J. Landy* (Cincinnati: Robert Clarke & Co., 1876). From the PhotoSeed. com archive and blog at https://photoseed.com/blog/search/?q=Landy.

The model for "The Soldier" (pictured), being the fourth "age of man," was Landy himself,[26] and it appears he relished playing the part of the knight. Opposite the tipped-in plate is Shakespeare's description: "Full of strange oaths, and bearded like the pard, Jealous in honor, sudden and quick in quarrel, / Seeking the bubble reputation / Even in the cannon's mouth."[27] The *yin* of "play" and the *yang* of "conquest" were well-blended

in Landy's photography. While using play, performance, and dress-up for his theatrical *tableaux*, Landy also mass-produced the images in large quantities as cabinet cards, aggressively marketing the series in the photographic press and at exhibitions for sales and prizes.

Theatrical careers

In this section we will look more closely at the lives of three women who provided some of the best examples of photographic theatricality. They collaborated with studio photographers, rather than use their own equipment, which up to now has disqualified them from the History-of-Photography-in-capital-letters. "The woman does not operate the camera!" we can almost hear the men of the establishment, living or dead, cry out in protest. But, if she was choosing the subject matter, designing the set, providing the costume, pose, and subsequent distribution of the images, is she not the necessary creator of the image, or active partner? Is not the male photographer, in these cases, at most a production partner in command of the light sources, or, as lesser partner, simply the printing technician? In the twentieth century, artists Claude Cahun, Cindy Sherman, and Nan Goldin also used assistants when creating self-portraits. I am arguing that this tradition may be extended further back in the history of photography.

Virginia Oldoini, Comtesse de Castiglione (1837–99), appears first on our list of "theatrical" photographers, owing to chronology, the marked femininity of her project, and perhaps her historical importance.[28] Her unique collection of self-portraits requires the contextualization provided by biography and insights from psychology. For this unusual woman born into pre-unification Italian nobility, self-presentation, carefully created using her intelligence, courage, and love of costume, seemed to be the only outlet available for her passionate personality. This future countess had political ambition in a period when women had no legitimate avenues to holding power. At the age of seventeen, with what was probably little or no say in the matter, Virginia was married to a Piedmontese count, a widower, from whom she gained the title of Contessa di Castiglione, often written in the French form of Comtesse, owing to her long residence in France during the Second Empire and Third Republic.

Cousin to the Italian nationalist Camillo Benso, Count Cavour, Castiglione's wit and beauty led to Cavour recruiting her for what we might today call "soft" diplomacy: winning Emperor Louis-Napoleon over to the Italian national cause against Austria.[29] Still a teenager, she was sent to France during the Congress of Paris following the Crimean War (1856), in order to enter court society and seduce the emperor, either politically, or sexually, or both. Through an agent in Paris, Castiglione communicated her progress back to Cavour in code. Not surprisingly, this mission alienated her husband the count, though later the countess flattered herself that she had played some role in Louis-Napoleon's decision to send troops in support of Italy against its enemy, paving the way for the establishment in 1861 of the new Kingdom of Italy.[30]

During this period of youth, the countess became famous in Europe for her unusual beauty, and was the subject of several painted portraits.[31] She had a scandalous affair with the married emperor, which ended ultimately in her disgrace when Louis-

Napoleon linked her with an assassination attempt on his life conducted by some Italian revolutionaries.[32] Thrust into such a life at a young age (she was now twenty), close to powerful men but with no official role or path for herself, it seemed clear to the young woman that her only source of success were her seductions.[33] But, like other flamboyant personalities during the nineteenth century, she endured the scorn of peers when she went too far flaunting her sexuality. Her activities at the French court led to her husband separating from her. Early in her youthful marriage, she had her only child, a son called Giorgio, from whom she was estranged after the death of his father.[34] She thus gained a reputation as both a bad wife and a bad mother. Even more painful, Giorgio died in his early twenties, having never reconciled with his mother as far as we know. Alone and exiled from court society, Castiglione became reclusive.

During her days as a court favorite, Castiglione had begun sitting for fashionable photographers Mayer & Pierson on the Boulevard des Capucines in Paris (Figure 3.8).[35]

Figure 3.8 The Comtesse de Castiglione working with the studio photographer Pierre-Louis Pierson, "The Caracal (or Ashtrakhan)" (1860s). One of about 300 self-portraits of Castiglione in the collection of the Metropolitan Museum of Art, New York. Courtesy of the Metropolitan Museum of Art, New York.

According to one biographer, "The act of posing held for her an irresistible appeal: it addressed at once her narcissism, her exhibitionist tendencies, and her love of performing."[36] The "problem" with femininity here, then, was that it was narcissistic. A generation after Castiglione's career, Sigmund Freud associated "the purest and truest" cases of adult narcissism with women, "especially if they grow up with good looks," and develop "a certain self-containment which compensates them for the social restrictions that are imposed upon them in their choice of [love] object."[37] Strictly speaking, Freud wrote, "it is only themselves that such women love with an intensity comparable to that of the man's love for them."[38] Although psychoanalysts today might object to the idea that Castiglione suffered from excessive self-love (true self-esteem might have resulted in healthier and sturdier relationships in the countess' life), it seems irrefutable that she was one of the vainest women in Second Empire France. But she foresaw, rather uncannily, that her photographic images would bring her a kind of immortality.[39]

Assessments of the countess' 450 self-portraits point to her self-absorption, a reputation strengthened by a failed marriage and troubled motherhood. But, as a young aristocrat raised from birth with the lesson that her looks were her fortune, it is not surprising that this vivacious woman would desire to record her beauty, one of the few measures of women's "success" in nineteenth-century society, before it inevitably faded. Just as important as Castiglione's narcissism, though, was her passion for dress-up, which expressed different sides of her personality, her fears, and fantasies, and provided an escape from harsh reality (Figure 3.9).

Her "roles" for the camera included a Queen of Etruria, Anne Boleyn, Lady Macbeth, peasants in regional costume, a cloistered nun, and many other characters from literature and her own imagination. Her love of theatricality was evident in her "engagement with photography as a stage on which to enact multiple versions of the self," in the guise of different characters and scenarios.[40] As a woman fond of making triumphant entrances at fancy dress balls, and a connoisseur of the full spectrum of French theater (from the bawdy boulevard to the Comédie Française to the Opera),[41] these self-portraits in costume allowed the countess to recreate, and extend, her love of theatricality. Often, her poses depict her as enveloped in full, rather elaborate gowns and headdresses, whose yards of silk, velvet, tulle, and crepe surrounded the countess like protective fortresses.

Castiglione's *œuvre*, spanning from the mid-1850s until the end of her life in the 1890s,[42] is "feminine" for another reason, separate from her passion for elaborate costumes. Although she knew Paris's great studio photographers, she showed no apparent interest in the period's "masculine" discourse on photography, which promoted the technology as a medium of truth. She used photography instead as an escape from the real. Pierre Apraxine recognized her as a "body artist" ahead of her time: "Like Castiglione, artists today are attracted to photography not because they view a photograph as an irrefutable statement of reality but because they regard the medium as a malleable tool in the service of the imagination."[43] If the *yang* of photography pointed to its realism—its evidentiary power—the *yin* of photography projected fantasy, its ability to reflect our dreams (Figure 3.10).

Figure 3.9 The Comtesse de Castiglione, working with the studio photographer Pierre-Louis Pierson, "The Queen of Etruria" (1860s). Courtesy of the Metropolitan Museum of Art, New York.

During creative and uninhibited sessions with Pierson, in painting and decorating selected portraits, and assembling albums for a few close friends, Castiglione clung to her fantasies and to her memories even in the depths of blackest loneliness.

Across the English Channel, a contemporary of Castiglione was also using photography, and photographers, to capture her innermost wishes and fantasies. Her class status and the content of her fantasies, though, could not have been more different from those of the countess. Shropshire-born Hannah Cullwick (1833–1909) was a

Figure 3.10 The Comtesse de Castiglione, working with the studio photographer Pierre-Louis Pierson, "In Flight [La Frayeur]" (1861–7). Metropolitan Museum curators explained that this version of the portrait "was summarily retouched by the countess with instructions (on the back) suggesting that the composition was intended to set off her elegant attitude and majestic gown." The countess imagined "[t]he remains of a ball where fire has broken out. A chandelier on the floor, everyone in flight. Shining white satin gown, black and red grapes with dark green and red leaves." Rendered here in greyscale. Courtesy of the Metropolitan Museum of Art, New York.

maid-of-all-work her entire life.[44] As an adult, she used photography to record her many "performances" in the context of her strange relationship with the London barrister Arthur Munby. Along with a collection of photographs, we have her diary, written (at least initially) at Munby's request, preserved with his papers at Cambridge University. In the diary, Cullwick described her relish for dirt (literally, the stuff to be cleaned off floors, grates, and shoes), which contradicted everything a Victorian woman was supposed to feel and to be. Heather Dawkins argued persuasively that Cullwick's passion for grime—she deliberately covered her face and hands in it at seemingly every opportunity—was a rebellion against hypocritical bourgeois mores that tried to keep dirt, specifically the labor of cleaning, hidden from sight.[45]

Despite her humble origins, entering domestic service at eight years old, Cullwick, like the leisured ladies already discussed, was fascinated by the theater. In 1853 at the

age of twenty, she attended a performance of Lord Byron's *Sardanapalus*, which featured a female slave character, Myrrha, whose devotion to her master touched Cullwick deeply. She would later construct her relationship with Arthur Munby on this master-slave model, going so far as to wear a locked chain around her neck whose key was in Munby's possession, and whom she referred to as "Massa." Cullwick's performance as slave—this was not an incidence of kidnapping or torture but seems to have been a relationship of mutual consent and pleasure[46]—translated into her photographs, for which she collaborated with inexpensive itinerant operators and resort-town photographers known to both Munby and herself (Figure 3.11).

The resulting collection of images shows Cullwick posed in a variety of roles, often cleaning, including one portrait of her covered in soot as a chimneysweep, but others

Figure 3.11 Portrait of Hannah Cullwick "in her dirt," as she preferred. Courtesy of the Master and Fellows of Trinity College Cambridge.

showing her dressed as a "lady" when she and Munby traveled together, and on occasions after they were legally married.

Scholars have cautioned against labeling the Munby-Cullwick relationship as a sadomasochistic affair. Cleaning and the presence of dirt signified honesty for Cullwick, and there are passages in her diary that scorn servants and bosses alike who would conceal or avoid menial labor. When a Margate photographer expressed uneasiness that she had arrived at his studio dirty, she replied, "Oh no, sir, this is only what I am every day, but I want to be done thoroughly black like I am sometimes at work."[47] Although Cullwick's pleasure in debasing herself was erotic for both partners (Munby loved the photographs), it was Cullwick, not Munby, who insisted on her bondage— unambiguously rejecting the genteel bondage of the married bourgeois lady who lived under coverture. It seems Munby failed to inspire conventional respectability,[48] and after four years of marriage during which Cullwick insisted on receiving wages as his servant, they separated.[49]

Muzzarelli wrote that, in the same way that the Comtesse de Castiglione was a "body artist" *avant la lettre*, she considered Hannah Cullwick "as a performer who put herself before the photographer's lens, resolving to satisfy simultaneously the requirements of her exhibitionism and the voyeurism of her companion."[50] Muzzarelli and Dawkins both saw Cullwick as the "principal artisan" of her photographs, frequently though not always in partnership with Munby.[51] One day, returning to the photographer's studio to collect some pictures, Cullwick expressed mild dissatisfaction with the results. Having rubbed extra lead on her arms, mouth, and nose for the session, she now saw that her appearance in the photos "wasn't ½ so black as I really was, & I was disappointed."[52] Hannah's diary shows that over the years, she absorbed the principles of portrait photography (the photographer in this case taught her that a darker result would have required the color yellow), became a discerning consumer (she knew which were the best studios in various towns), and took pride in using her own meager funds to pay for the pictures herself. She decided upon her poses (e.g., cleaning a pair of boots, blacking a grate), and developed a close, creative relationship with one Margate photographer, James Stodart.[53]

With only a brief education at a charity school in Shropshire to Munby's meticulous Cambridge education, Cullwick seems to have understood better than her husband the thoroughly performative nature of Victorian society, and its hypocrisy.[54] Without having the modern-day term, Cullwick knew instinctively that much of life was lived "in drag" (Figure 3.12).

Posing in costume, whether as drudge, lady, or even as a man, she played with her different identities but never relinquished her independence or sense of personal authenticity. "I would not be set up for a lady if I could help it," she wrote, "not for a fortune—I'd rather be low & work for my own bread."[55] The portraits became part of Munby's collection, and it is only owing to his professional status that the pictures survived in Cambridge University's archives.[56] The couple's albums have been disbound by Trinity College archivists for better conservation, destroying the intimacy of the couple's shared collection and the original order of the materials. Nevertheless, as a documentation of "feminine" role playing in the nineteenth century, the images are unique. For better understanding early photography as a theatrical medium, they are invaluable.

Figure 3.12 Portrait of Hannah Cullwick as a man (1862). Courtesy of the Master and Fellows of Trinity College Cambridge.

Where Cullwick's use of photography was strictly private, another provincial arrival to London during this period, Emilie Charlotte ("Lillie") Langtry (1853–1929), could not have been more public where her image was concerned. In contrast to Cullwick, Langtry led a relatively comfortable existence first as the only daughter in her Jersey family, then as a "professional beauty" in mid-Victorian society (Figure 3.13).

Langtry used commercial photography to promote her celebrity from the late 1870s through the early 1900s. Her career was theatrical in at least three ways: as a "professional beauty" whose appearances at high-society parties made her famous; on the stage as a professional actress; and also in the way that she used commercial photography to publicize her many roles. Beginning her career in London with a single black dress, over the years Langtry became an enthusiastic and expert wearer of costumes.

Having married Edward Langtry at the age of twenty, Lillie was fated to regret her youthful choice soon after the couple moved to London in 1876. Quickly embraced by

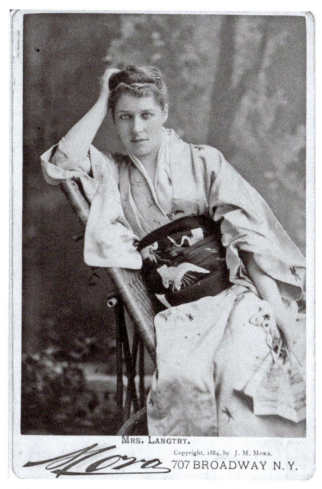

MRS. LANGTRY.

Copyright, 1884, by J. M. MORA.

707 BROADWAY N.Y.

Figure 3.13 Cabinet card of Lillie Langtry made in New York City by the Mora studio (1884). Courtesy of cabinetcardgallery.wordpress.com.

a small circle of artists who persuaded her to model for them, Langtry's energy, looks (judged irresistible by Victorian standards), and sense of fun made her a high-society darling. By 1879, Mrs. Langtry had grown estranged from her alcoholic and unsuccessful husband, and she soon realized she would have to make her own money and manage her own public image. In the process, Langtry became a self-made woman and a global celebrity.

At every stage of her career, Langtry bucked the rules of respectability and, like Castiglione, reaped the scorn of her rivals.[57] A vicious attack in the London *Town Talk* merits a full recitation:

Mrs. Langtry herself cannot assert that there is any modesty in posing to photographic artists in, to say the least, suggestive attitudes, to leer and wink and simulate smiles that can only be ranked one degree beneath lewdness. The daughter of a family who certainly cannot rank with the old and stable nobility of our country has, by some means, been raised to a fictitious popularity by means of the photographers' camera and lens, and for what purpose? To be exposed in the window of shops with her name attached to the picture … to give 'Arry and Hedward an opportunity of passing indecent remarks about her, and to disgust all respectable thinking women at the public exhibition she makes of her charms.[58]

Neither scandal, nor outrage, nor the displeasure of her husband dulled her appetite for fame. But in fairness, what Langtry wanted above all was independence: not in the way that feminists of the day were demanding (i.e., access to higher education, professional respect, and the franchise), but rather by making money on her own image (Figure 3.14).

before gone to theatres, whatever attraction may have been offered. As for Mrs. LANGTRY'S acting, compared to that of the generality of professional bred and born actresses, I think it is fairly good, and there is but little doubt that, by the time she has made one or two more fortunes, she will be able to give lessons or lectures like Mr. BOUCICAULT.

Uncle Tom's Cabin, at Her Majesty's, is a big show; but I can't help thinking that the American managers take us too much for granted, and cater for our pleasures without first troubling themselves to ascertain our tastes. In the provinces the real live bloodhounds, hymn singing, and other attractions of this curious piece, will probably prove a bigger draw than here in London, where we have already seen a goodish deal of Uncle Tom and unhappy Eliza since the days when Mrs. KEELEY was Topsy, Miss WOOLGAR bounded over the Adelphi ice, and the prompter bayed at the wing.

I am not quite certain whether Mr. HARRY JACKSON has ever received any pecuniary acknowledgment of the services he has rendered the Imperial cause by perpetuating the memory of the first NAPOLEON; but I feel no doubt that Sir JOHN will do the proper thing when he has been to see himself on the boards of Old Drury. I have frequently had the pleasure of seeing Sir JOHN himself take part in a procession, and very well he does it. Few men can take off their hats with so much grace, and show such splendid heads of hair whilst so doing.

And yet they want an Academy of Acting! What to learn? Not to make money.

Figure 3.14 A caricature accompanied gossip about Langtry in *Judy* magazine (August 23, 1882), p. 88. The writer and cartoonist congratulated her on her financial success, if not her acting talent. HTDC: https://babel.hathitrust.org/cgi/pt?id=hvd.hwxnu7&view=1up&seq=96.

Langtry's career, based as it was on her unique style and her antics, bears an uncanny resemblance to the *modus operandi* of today's celebrities. "Controlling the public's perceptions became her obsession,"[59] and she used all the media at her disposal to promote her persona, including spoken gossip, the daily press and the array of magazines of the period, as well as personal appearances, fashion, and photography. Like celebrities today, she made money by endorsing products and, owing to her tireless overseas touring and notoriety in the press, her fame became global in scope.[60] Langtry used the "social media" of her day to fashion a career for herself in ways that "reality T.V." beauties would unknowingly duplicate in the twenty-first century. The only notable difference was the "analog" formats of the era—paper-based print and photographs, live theater, and posing for painters—versus today's digital equivalents. Like "reality" stars today, Langtry had to recover from fiascos captured by the media, and also like today's celebrities, her personal relationships suffered under the spotlight of fame. When her uncharismatic husband Edward found he was unable to keep up with the constant round of invitations, she simply left him behind.

Carte-de-visite portraits of Langtry, popular actresses of the day, and members of the jewel-encrusted elite attracted British crowds in front of the shop windows that displayed them. These small images of "professional beauties" like Langtry were on sale in stationers' shops, photographers' studios, and on street corners, "bought for a penny by rich and poor alike."[61] Sitting for both photographers and painters required an ever-widening array of outfits. Langtry remembered how the social whirlwind of London awoke in her a feminine love of clothes that she had not possessed as a tomboy in Jersey:

> Constantly mingling with bejewelled and beautifully clad women, who changed their gowns as a kaleidoscope changes its patterns, created in me a growing desire to do likewise. For the first time in my life I became intoxicated with the idea of arraying myself as gorgeously as the Queen of Sheba.[62]

Having been in mourning for the death of her brother when she first arrived in London (from the original six brothers only one, Clement, reach old age), the black dress was now "thrust aside, and [she] indulged unrestrainedly in a riot of coloured garments."[63] It seems a new passion was unleashed as Langtry developed her role as professional beauty and became a royal mistress.

Even before becoming an actress, Langtry was posing for the camera. "Soon there were photographs of her on sale everywhere, in every conceivable pose, her hair down, her hair up, in riding dress, ball dress, semi-undress, writing letters," or posing in sentimental narrative or poetical *tableaux*.[64] Her photographs extended her full daily schedule of self-presentations, which included riding to see and be seen on Rotten Row in Hyde Park, attracting the interest of painters and poets at parties, and appearing in new gowns at the latest balls hosted by this or that aristocrat in town for the "season." In the beginning, Langtry depended on her husband's wealth to support her forays into London high society. When this proved inadequate, the couple lived on credit and on gifts from the Prince of Wales. When that still couldn't keep the bailiffs away, Lillie began her life as a touring actress, the lucrative success of which depended more upon

her notorious reputation than her acting talent. Like our "reality" stars today, Langtry became famous for being famous.

Also similar to today's celebrities was Langtry's eventful love life as a subject for gossip. Langtry's affair with the future King Edward VII and her other romantic relationships and second marriage are well recounted in her biographies, and so need not be repeated here. Instead, I want to situate Langtry's gallery of portraits as part of her theatrical career, similar in number and variety to Castiglione's, but different from Castiglione's case in several respects. First, Langtry was never loyal to one photographer alone, although she perhaps sat most frequently for W. & D. Downey in London and James Lafayette in Dublin. Unlike Castiglione or the Cullwick-Munby private collection, Langtry's photographs were commodities with which both the photographer and she made money, either directly from royalty payments, or indirectly when the images publicized her latest stage roles (Figure 3.15).

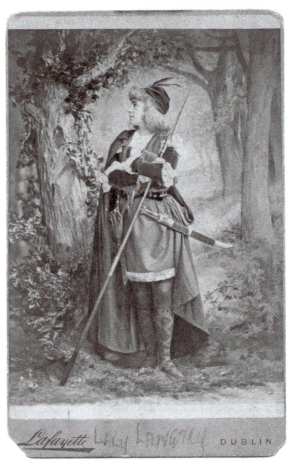

Figure 3.15 Langtry as Rosalind in Shakespeare's *As You Like It* (1890). Cabinet card made at the Lafayette studio in Dublin. Courtesy of the National Portrait Gallery, London.

 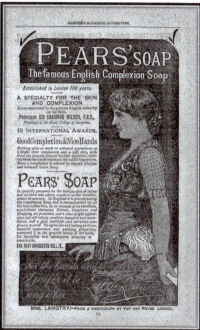

Figure 3.16 Langtry appearing in one of several Pears' Soap advertisements (1880s). Here an engraver has copied the photograph by Henry Van der Weyde. Advertisement in *Harper's Magazine*. Wikimedia Commons: https://upload.wikimedia.org/wikipedia/commons/c/c2/Lillie_Langtry_by_Van_der_Weyde.png.

The photographs, which span over thirty years from her twenties to middle age, may be divided into four main categories: beauty portraits, stage roles, product advertisements (including sheet music), and photo-mechanical reproductions of drawings and paintings of her (Figure 3.16).

Within those categories, some images were hand-colored, decorated, engraved, or cropped for multiple uses (unlike Castiglione, Langtry left this retouching to others). Having a realistic view of her acting talent—she remained outside the class of artists that included her contemporaries Sarah Bernhardt and Ellen Terry, and her reviews were always mixed—Langtry understood that it was her allure, and perhaps her scandalous love life, which brought the crowds to the theater to see her. Langtry could little control what the newspapers said about her but she could control just about every element of her photographic portraits. The photographs sustained fans' interest at the same time that they helped Langtry ensure her own immortality.

Leisured artist-photographers, a displaced aristocrat, an actress, a queen, and a servant: although wildly different in class, background, and life goals, they and the other creators mentioned in this chapter all saw the potential of photography as a medium of theatricality. Playing in front of the camera, whether inspired by *tableaux*

vivants, playing dress-up, or stage plays past or present, was an important creative theme in the history of photography that deserves more attention. Understanding better the role of performing for the camera allows the "femininity" of nineteenth-century photography to emerge more visibly, and will allow for a better integration of women's creativity into the story of photography's history.

4

Tactility

Another "feminine" preference was for the sense of touch, or tactility, in a variety of manifestations. Patrizia Di Bello has shown how the application of scissors and glue to commercial *carte-de-visite* photographs—manipulating with touch—allowed mixed-media album makers of both sexes to de-commodify the portrait for their own purposes. After the album's creation, the importance of touch continued in the intimate ways it was displayed, shared between two people, or gifted to others. The sensation of touching photographs, paper pages, heavy bindings, and each other as we sit together, though, was utterly lost when well-meaning archivists or profit-seeking auctioneers dismantled these nineteenth-century mixed-media albums in the twentieth century. This slow destruction of "feminine" creation was an important example of *yin* swallowed up by *yang*, as the sense of touch was sacrificed to the drive for mastery.

In this chapter, we will see that multiple senses of touch went into the "feminine" directions and concerns of nineteenth-century photography. Touch applied to the ways that early amateurs practiced photography or used photography, and the "retouching" jobs that women performed in commercial studios. It applied to the importance given to silky, satiny, and velvety textures foregrounded in posed photographs. Tactility was also an important component of hand-created photo-collage albums, whether in the construction of their pages as just mentioned, or in the way that sharing them invited touch and intimacy among viewers (Figure 4.1).

Linked to the previous chapter's concern for dress-up is the care with which some nineteenth-century photographers of both sexes brought out the sensuous textures, cascading sheen, or inviting folds of fabrics in their portraits and staged tableaux. The tempest of folds and the intimacy of Mary Jane Matheson's "Adelaide and Elizabeth Enveloped in a Shawl" (*c.* 1860), for example, produced a tempting tactility (Figure 4.2).[1]

Art historian Carol Mavor confessed her preoccupation with tactility when studying Clementina Hawarden's photographs of her daughters:

Although my fingertips have longed to touch the beaten hems of their skirts, the netting of their headdresses, the wires of their crinolines, the silkiness of their tights, the scented pages of the tattered and clutched books, the roundness of their pearls, and soft bits of their always new hair ... their velvet cummerbunds ... I have only touched the precious edges of their pictures.[2]

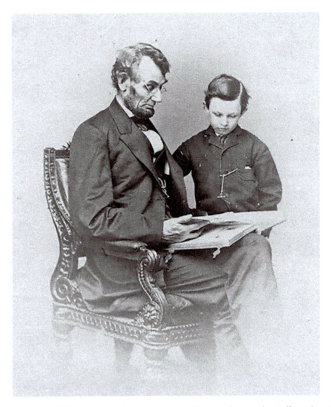

Figure 4.1 Portrait of Abraham and Tad Lincoln taken at the Brady Gallery (1864). Tad died from illness a few years later. Looking at an album together was an intimate pleasure shared between men, women, and children throughout the nineteenth and twentieth centuries. Courtesy of the U.S. Library of Congress.

Mavor described the feminine *yin* of Hawarden's subjects without naming it as such: "As objects dressed to entice and to invite play, Hawarden's pictures of her lovely daughters beckon touching, dressing, redressing, combing, brushing, hugging," she said.[3] Mavor's sensual (even at times sexual) reaction to these staged portraits may be unique, but her catalogue of items inviting us to stroke with tactile pleasure described well the quality of many of the albumen prints produced and compiled by Hawarden— prints whose rough, torn corners (damaged when a descendent dismantled the albums, as in Figure 3.1) may have increased the pictures' touchable, and touched, quality even more.

Hawarden's fellow Photographic Society member, Henry Peach Robinson, also produced texture-rich staged compositions, the best example being his photograph "Fading Away" (1858) (Figure 4.3). The emotional drama, domestic interior setting, *tableau vivant* composition, and the sensual quality of the featured fabrics and drapery in "Fading Away" is striking.

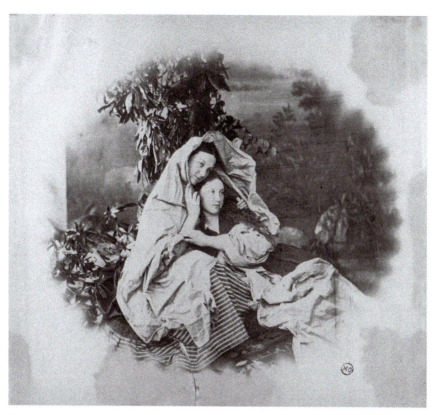

Figure 4.2 Mary Jane Matheson's "Adelaide and Elizabeth Enveloped in a Shawl" (*c.* 1860). © RMN-Grand Palais/Art Resource, NY.

The "fading" patient's flowing nightdress, the mother's elaborate bonnet, the sister's generous skirts, the curtains, the discarded silk shawl, and the velvety fringe of the stool in the picture's center all beckon to be touched, exuding a greedily "feminine" pleasure in rich textures. While the fascination with maidenly sickness and death was arguably "masculine,"[4] Robinson's concern for domestic intimacies, tactility, and theatricality gave his photograph a "feminine" gloss.

In today's environment of digital images, where all pixel-based photographs are "developed" on screen, it is easy to forget that all the early photographic techniques required the handling of multiple chemicals and fluids. The defects apparent in the photographs of Julia Margaret Cameron—stained as many of them were by visible "fingerprints, chemical streaks, even stray hairs"[5]—offer an example of "feminine" tactility perhaps even too "on the nose." For although all photographers of whatever gender had to touch and handle their ingredients (in that sense critics betrayed their misunderstanding of the medium when they describe it as mechanized), Cameron, it seems, was particularly messy. What set her apart from other photographers was her refusal to hide her touching.

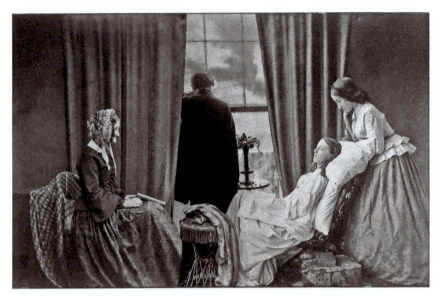

Figure 4.3 "Fading Away" by Henry P. Robinson (1858), a combination print using about five different negatives. Wikimedia Commons: https://commons.wikimedia.org/wiki/File:Fading_Away.jpg.

Whereas Bill Jay in his 1978 appraisal forgave Cameron for her prints that were "stained, spotted with dust marks, streaked with uneven coatings of collodion, even cracked,"[6] these flaws angered one or two contemporary critics who described her work as "slovenly" and "careless."[7] But Jay understood that owing to the pace of the wet-plate process—glass negatives had to be prepared with liquid chemicals, exposed, and developed all in the space of eight-to-ten recommended minutes—Cameron allowed signs of her touch to mark her creations in the pursuit of Art. Visitors to the Isle of Wight, from Lady Troubridge (a niece) to a horrified Giuseppe Garibaldi (a guest of Tennyson) recoiled at the sight of the disheveled artist (Cameron), who smelled of chemicals and whose fingers were blackened by silver nitrate.

In her willingness to allow for touch, Cameron seemed to foresee that the time allotted to pursue her art—"her true purpose in life"—would be limited.[8] But Robin Kelsey has asserted that the "viscous liquidity of wet plates and albumen prints gave her glitches a gendered meaning" beyond her frantic passion.[9] "Cameron's failure to control the sticky wetness of her collodion process," Kelsey wrote, "eroticizes and maternalizes her photography," in the process flouting the Victorian demand for household order and self-restraint. Her body overflowed onto her pictures, challenging directly the "stifling criteria of the male-dominated professional photography establishment."[10] As with Hannah Cullwick's insistence on dirt, Cameron refused to conceal the messy labor of her photography.

Most female labor in the professional studio milieu, though, was concealed as much as possible. In particular, the artistic "retouchers" who corrected and tinted commercial

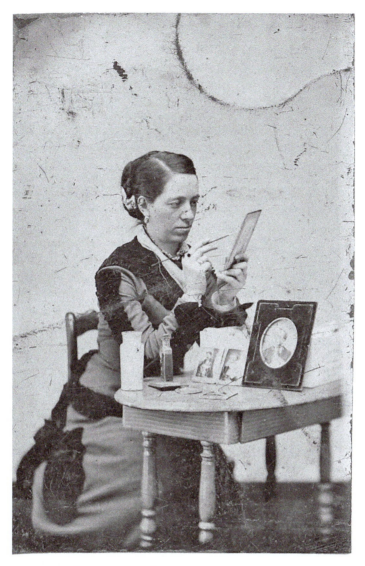

Figure 4.4 Tintype of Henrietta "Lilla" Denno Kenney (1877–1924) hand painting a photograph, probably taken in the Kenney Brothers Art Studio in Connecticut. Although this image of a woman retouching artist is relatively late (*c*.1900), the use of fine brushes and specialty oils as shown here went back to the 1840s. Furthermore, Harvard University's Schlesinger Library on the History of Women in America has collected data on "Lilla" that resembles the biographies of a number of mid-century American women studio workers. Trained as a painter, Lilla divorced her first husband following years of abuse, marrying a second husband who was a photographer. Working alongside her husband and brother-in-law in the Connecticut studio (without credit in the studio name or advertisements), Lilla was also a mother, suffragist, and traveler to Europe. Schlesinger Library, Radcliffe Institute, Harvard University.

photographs using ink and pigment might be male or female (Figure 4.4), and this job "was one branch of the business that had been open to women from the first."[11]

Studio photographers and photographic companies hired women as colorists because of the perception that nimble female fingers had a tactile sensitivity that especially suited them to such detail work. Women with artistic training used the feminine stereotype to obtain employment with photographers, either erasing tiny flaws in prints or negatives, softening or defining facial features in portraits, or supplying what neither the daguerreotype nor the glass negative possessed: colors. An array of tiny, animal-hair brushes, sponges, pigments, and gums were the tools used for these touch-up jobs.

While the masculine arbiters of photographic authenticity in the photographic societies of the day quickly condemned retouching as a practice that polluted pure photography, other observers, notably in the United States, praised women retouchers for their "feminine" skill. For example, when a Dr. Wilde and his daughter Augusta opened a studio in North Carolina in 1851, a Greensboro newspaper reported that Augusta's style of coloring was "unequaled" anywhere. The writer argued that just as women (as maternal beings) were supposedly suited for posing children successfully, so was the delicate art of tinting "exclusively within the province of a female."[12] The cliché notion of a "woman's touch" extended to the delicacy attributed to women colorists' brushwork.

Although subtlety in retouching or tinting required great skill, women workers' abilities were attributed to feminine "nature" rather than talent, a belief reflected in their low wages. An anonymous contributor to the Parisian *Revue Photographique* made a gallant prediction in 1856: "As photography gains public esteem, we will see more and more pretty fingers practicing the manipulations [of the studio]."[13] The English painter Una Howard, though, knew from experience that even natural ability had to be trained to mature as real artistry. In a letter to the British *Standard*, Howard wrote that with systematic education, women with an art background could become first-class colorists. Having become a master colorist herself, she knew that the

> art of colouring photographs, to make them lifelike, is one that has already been attempted with great success, and is calculated to afford employment to many young ladies, who, being left in straitened circumstances, have yet, while their natural protectors were living and could afford it, received lessons in painting.[14]

Appealing to the city's "lady patronesses," Howard herself offered to provide tuition to female students "to promote the cultivation of this beautiful art," which was anything but "natural" to either sex.[15]

Photo-tinting remained an overwhelmingly popular service with clients at photographic studios, despite its condemnation by photographic society leadership. But, not all coloring jobs were equal. A wide range of actual quality characterizes the tinted photographs that have come down to us in North Atlantic collections. We might divide these artifacts into roughly three categories: the garish but well-meaning color jobs;[16] minimalist jobs (usually just a bit of pink on the cheeks of the depicted

persons);[17] and expert jobs that feature seamless tones and textures.[18] Both men and women practitioners produced finished images in all three categories. Readers will find a deeper discussion of the gender of coloring in Chapter 15.

One medium where watercolors, oils, and inks were deployed freely and imaginatively was in the mid-century photo-collage album. A future chapter on the subject of hybridity will discuss in depth the extraordinary photo-collage pages created by amateurs throughout the North Atlantic world, though mainly in Britain. Here I want to reiterate the many ways that this art form depended upon and encouraged touching. In the catalogue to the 2009 exhibition *Playing with Pictures*, the curators included fourteen photo-collages depicting drawing rooms, created by ten different artists, including Lady Filmer, Lady Jocelyn, and Edward Charles Blount. To create these collages, the artists had to do one or more of the following: carefully remove glued albumen photographs from their cardboard mounts by hand (from what had been rectangular, purchased *carte-de-visite* format portraits); collect unmounted paper portraits made by friends who were camera amateurs; or, establish an understanding with the commercial photographer, whereby he or she would be persuaded to sell the paper prints unmounted. Each of those possible methods required either very careful handling (in order to avoid destroying the image), or delicacy in their interpersonal relations, when requesting images in order to cut them up. The elaborate touching did not end there, as the artist then had to utilize small scissors or sharp precision knives for the purpose of cutting and shaping the images, or often fragments of the images, into the desired size for their own composition.

The art of photo-collage was immersed in touch in other ways (Figure 4.5). Here the then-Princess Alexandra created one of the fourteen drawing room scenes featured in the *Playing with Pictures* exhibition.

All of the drawing rooms in that book depict precisely the environment where an artist might work on her photo-collage album pages. It is a scene full of touching. Although Alexandra has not depicted herself at work, we can imagine that the blue table at the right, not far from the window, was precisely the well-lit area that a leisured lady would use to work on her album with scissors, pen, and glue pot. Two ladies sit at this particular table, on which a book, perhaps an album, rests. To enjoy the contents together, the older woman and the young girl would have had to push their chairs closer together, perhaps taking care not to disturb the child lying on a large pillow at the woman's feet. Elsewhere in the room, we see a man and woman's hand touching, a baby lying at the feet of a foregrounded man, and another man in uniform leaning through the left-hand window, perhaps to flirt with the young woman leaning on the base of the window. Alexandra has manipulated a collection of photographic portraits in order to compose a busy family scene.

The princess's use of watercolor, too, enhanced the tactility of her creation. First, the watery fluid of the paint, as well as the glue used to stick the photo fragments onto the page, would have been part of the process of creation. Alexandra would have calculated the right times to apply the wet paintbrush, glue, and photo fragments to the page so that none of those elements would smear or get damaged. Her curtains, depicting tall, blazing red drapes, each one clasped by equally velvety tie-backs and valances fringed with gold, add superb texture to the scene. The princess herself stands in the center of

Figure 4.5 Collage by Alexandra, Princess of Wales, featuring photographs and hand painting (*c.*1866–9), here rendered in greyscale. Royal Collection Trust/© Her Majesty Queen Elizabeth II, 2019(RCIN 2300104).

the composition as part of a couple, though the slim young man is not her new husband, the Prince of Wales.

Pleasure in touch and texture was also manifested by Alexandra in her love of luxurious book bindings, whose soft leathers, metal decoration, and gilt papers adorned several of her photo albums and books in her personal library, too. *Luxe* albums of the Victorian era were feasts for the sense of touch:

> The cover was made of velvet or tooled leather or mother-of-pearl or even carved ivory, and the fittings were silver or cast brass, and the ensemble was designed to be a stylish ornament on the library table.[19]

Nineteenth-century albums often fell into one of two categories, depending on the decade and the owner: they either featured relatively plain binding, where the artistic creativity of the owner bloomed on the white or buff pages within (1850s, 1860s, and into the 1870s) (Figure 4.6), or albums featured deluxe covers and fixtures as just described, standardized slots for commercial-format portraits, and even pre-printed page decorations (1860s onward).[20]

Although the album manufacturing industry tried thus to cater to women's love of touch and luscious texture, arguably the pre-formatted products that arrived on the market in the 1870s short-circuited, and killed, amateurs' mixed-media creativity (of both sexes). The era of the Victorian photo-collage album was over. Alexandra, then,

Figure 4.6 A *trompe-l'œil* page from the "Madâme B" album (1870s), here in greyscale, by Marie-Blanche-Hennelle Fournier (1831–1906). On this page, Fournier created an imaginative prayer book with her own illuminations on the left, and a photograph of Hans Holbein's "Darmstadt Madonna" pasted on the right side of her painting. The Art Institute of Chicago.

was unusual as she was able to combine her own creativity with her taste for gorgeous book and album exteriors from the 1860s through the early 1900s. Perhaps the "short-circuiting" was dodged because she sent her albums for binding after she completed them.[21]

Another art historian, Verna Curtin, was struck by the magical tactile experience of the photo album (Figure 4.7):

When you hold a photo album, you sense that you are in possession of something unique, intimate and meant to be saved for a long time. As you turn the pages and look at the images, you imbibe the maker's experience, invoking your imagination and promoting personal memories.[22]

Marta Weiss agreed, observing:

The viewer of an album is not just a viewer, but a handler, who experiences a sense of possession and intimacy while holding and paging through the album. A collage album is an especially intimate object, in part because it is so individualized, but also because collage heightens the apparent tactility of the photograph.[23]

Di Bello has argued that even with the conquest of cellular phone-based digital photography and storage, the intimacy of sharing miniaturized slideshows with friends

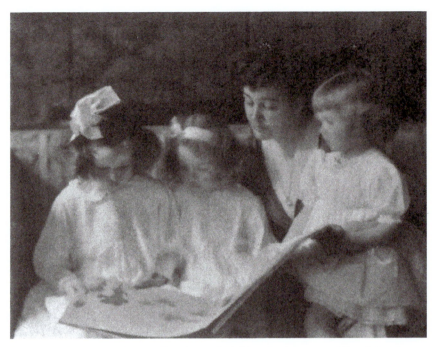

Figure 4.7 Eva Watson-Schütze, "Mother and Children Looking at an Album" (1904). Wikimedia Commons: https://commons.wikimedia.org/wiki/File:Eva_Watson-Schütze_ Mother_and_children_looking_at_an_album.jpg.

in person (in physical proximity) remains with us. True though this may be, the joy of touch that went into the method, composition, and sharing of the mixed-media album codex now can only be, and should be, evoked in our history of photography. This joy (*yin*) of touch—the pleasure taken in and inspiration from touch—manifested itself in photographers' choice of nourishing, comforting, or seductive textures. Smoothness or silkiness, finely layered furriness, or infant flesh—in short, softness—will be the subject of our next chapter.

5

Softness

Related to tactility in prominence was the "feminine" preference for softness in a number of senses of the term. The linguistic problem here is that the word "softness" in the English-speaking world is often equated with weakness, helplessness, or indecisiveness. The softness I am pinpointing in "feminine" photography, though, denotes no such thing. The attention paid to the silky abundance of textures, deliberately blurred focus, or children's luminous flesh was the result of nineteenth-century passion and conviction, never weakness. Softness, then, lay at the heart of photography's *yin* side. If the *yin* of photography captured dreams rather than exposing "hard" reality, then a world of inviting softness filled those photographic dreams. Softness of focus, expression, or narrative sentiment gave play to fantasies rather than facts.

Take for example Alice Austen's "Trude & I" (1891), which combined "feminine" theatricality, tactility, and softness in the baring of long, trailing hair, bare arms, and cotton underthings (Figure 5.1). Here the amateur arranged a home-made proscenium where she could record the play of fantasy, as she did in many of her Clear Comfort photographs.[1]

The unabashed sense of play in "Trude & I" contains a surreal softness that is the exact opposite of the thrusting rigidity of other genres, including the photographic pornography of the period, which also featured masks, stockings, or lingerie. Austen played with her femininity, with her sexuality, and with gendered taboos (against women smoking, for example). She recorded that she made the photograph with her friend at the latter's home, Dr. Eccleston's rectory, and although they were misbehaving for the day, Trude Eccleston would soon become Mrs. Charles Barton.[2] For Austen, as for many other women of the nineteenth century, there was a soft division between female friendship and girlish romance.

A few early photographers and critics recognized that a soft rather than crisp focus better allowed pictures to engage the imagination. Too many details, too many facts, led the eye astray from deeper truths. "For these reasons it is almost needless to say that we sympathise cordially with Sir William Newton," wrote Elizabeth Eastlake, "who at one time created no little scandal in the Photographic Society by propounding the heresy that pictures taken slightly out of focus, that is, with slightly uncertain and undefined forms, 'though less *chemically* would be found more *artistically* beautiful.'"[3] For photographic softness, the work of Julia Margaret Cameron is once again emblematic for its often hazy focus and atmosphere. Cameron was famous for her choice of blur over sharpness in her portraits and staged tableaux, a trait that made her rather

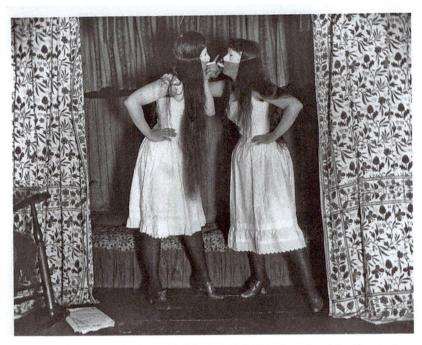

Figure 5.1 Alice Austen (1866–1952), "Trude & I" (1891). Courtesy of the Alice Austen House.

infamous among the photographic leadership of the day. German photographer and critic Wilhelm Vogel, for example, pointed out a marked divide between photographers and art critics over Cameron's merits:

> Those large unsharp heads, spotty backgrounds, and deep opaque shadows looked more like bungling pupils' work than masterpieces. And for that reason many photographers could hardly restrain their laughter … But little as these pictures moved the photographers who only looked for sharpness and technical qualities in general, all the more interested were the artists … [who] praised their artistic value, which is so outstanding that technical shortcomings hardly count.[4]

On Cameron's photographs at an exhibition of the Scottish Photographic Society, another critic wrote:

> We must give this lady credit for daring originality, but at the expense of all other photographic qualities. A true artist would employ all the resources at his disposal, in whatever branch of art he might practise. In these pictures all that is good in photography has been neglected, and the shortcomings of the art are prominently exhibited.[5]

That same year, when fellow Photographic Society member Clementina Hawarden died, photographer Oscar Rejlander's obituary honoring Hawarden implicitly contrasted the Society's affection for the late viscountess with its feelings toward Cameron:

> She worked honestly, in a good, comprehensible style. She aimed at elegant and, if possible, idealised truth. There was nothing of mysticism not Flemish pre-Raffaelistic conceit about her work. So also was her manner and conversation—fair, straightforward, nay manly, with a feminine grace.[6]

Where Rejlander silently scorned what he saw as Cameron's incomprehensible, mystical, pre-Raphaelite style, Hawarden was praised as honest and straightforward (that is, "manly").

Although contemporaneous critics, as well as historians in the twentieth century, attributed Cameron's blurriness to technical incompetence or retinal disease, recent studies have affirmed her choice as deliberate.[7] For example, when Cameron asked viewers to imagine her portrait of Hatty Campbell as the allegorical "Echo" (1868), her sharpest point of focus was placed between the model's eyes, and as we look outward from her face there is a softening of focus blurring the rest of her (Figure 5.2).

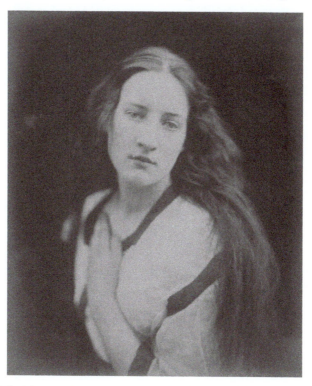

Figure 5.2 Julia Margaret Cameron, "Echo" (1868). Courtesy of the Getty Museum, Los Angeles.

Together with the dark background, Cameron produced the illusion of the figure emerging outside space and time. What better way to express the idea of the cursed nymph hidden from us, doomed to repeat our calls for eternity? Cameron's use of blurriness allowed her photograph to switch from the reality of Hatty to the fantasy of the Echo.

Years after Cameron's death, art photographers echoed her judicious use of blur in their pictorial works. These included George Davison and other members of the Linked Ring Brotherhood in Britain, members of the Paris Photo-Club such as Robert Demachy, and American professional artists such as Gertrude Käsebier, all of whom were still active after 1900. Rather than using soft focus allegorically or theatrically, these later workers, like the Impressionist painters of a previous generation, hoped their use of blurriness and retouching would enable them to better approach the truths of nature and the human spirit. The short period of High Pictorialism in the first decade of the twentieth century, with its artists' preferences for domestic subject matter, softness, and openness to women practitioners, was perhaps the most *yin* in the history of photography, some would argue too *yin*.[8]

Some of the turn-of-the-century Pictorialists took children as their painterly subjects (Figure 5.3), and it is the depiction of children that we turn to next as a subject of softness.

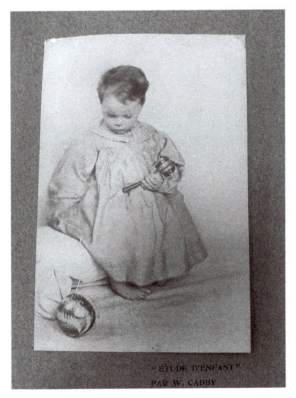

Figure 5.3 William Cadby, "Etude d'enfant," in R. Demachy and C. Puyo, *Les Procédés d'Art en Photographie* (1906). Author's photograph.

Often when photographic journalists conceded the appropriateness of photography as a profession or hobby for women, the assumption of women's "natural" affinity for babies and children was used as evidence in favor of it. Photographer Jabez Hughes' frequently reprinted "Photography as an Industrial Occupation for Women" (1873) asserted that photography was "a very proper and legitimate field for female skill," in part owing to the popular demand for portraiture of babies.[9] A generation later, critic Joseph T. Keiley argued that the true depiction of maternal love was impossible for a man, because only "a woman whose whole being vibrated with the joy of a mother's love" could capture this sentiment.[10]

In ignoring a millennium's-worth of madonnas and infants painted by men, and the many male photographers of the nineteenth century who made child portraiture a successful specialty, Keiley's assertion was rather absurd. Throughout the second half of the nineteenth century, male professionals welcomed infants and children into the studio. Photographer James Ryder, for example, took time in his autobiography to praise the family portraiture of Cleveland's Charles E. Johnson, remembering that he "was fairly dazed" by Johnson's sensitive daguerreotype depicting his daughter and her baby. "I had seen nothing before to approach it, nor dreamed a thing could be so beautiful," wrote Ryder.[11] Ryder himself admitted that little "tots" of children with golden hair were his "special delight" in the studio.[12] Regardless of men like Ryder's affinity with children, popular assumptions about women's closer relationship to children prevailed. Aspiring women photographers such as Emily Stokes of Boston and Hannah Maynard of British Columbia took advantage of the stereotype in order to build up their clientele.

All child photography, however, was not created equally. Many a photo-historian has glanced at innumerable, industrially-produced *cartes-de-visite* depicting boys and girls, portraits bound for the pre-slotted album. Only occasionally, though, do we encounter children's portraits of the era (Figure 5.4) whose gorgeous lighting, soft textures, and intimate posing force a second look.

In an 1893 interview, Philadelphia photographer Cornelia J. Needles tried to explain how her methods contrasted with conventional studio protocol. What artist, she asked,

> can improve on a child's own pose or arrangement of playthings? Compare with the graceful and much more animated positions of today the stiff, unnatural poses of our own baby portraits taken in the days when ... the "wait for the bird" expression was the height of the photographer's desire.[13]

In relegating the "wait for the bird" school of children's portraiture to a previous generation,[14] Needles was being diplomatic, since even at that late date studio-made child photography retained a mostly standardized appearance. But more importantly, she was arguing that giving children the space to be natural ("a rumpled dress and disordered curls" were a plus) was the key to artistic results.

Allowing children the time and space to act naturally could produce portraits of surprising beauty and even sensuality. An example in the early period comes from Reginald Southey's photograph of the young Hallam and Lionel Tennyson, taken on the Isle of Wight in 1857 (Figure 5.5). The tenderness of the boys' pose, nestled as they are in a confusion of fabric, hands, and feet, the pawing of a favorite book, and the

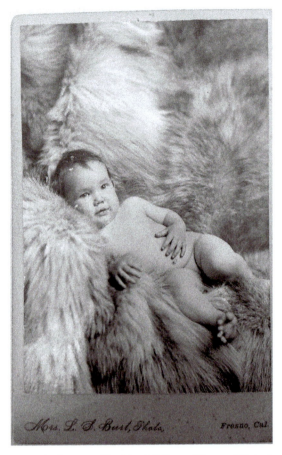

Figure 5.4 Commercial cabinet card by Mrs. L.S. Burt of Fresno, CA in the Palmquist Collection. Courtesy of the Beinecke Rare Book and Manuscript Library, Yale University.

younger boy's (Lionel's) sweet and admiring glance at his older brother, all fulfill Needles' prescription some thirty-five years before she gave it.

Traveling in the same English circles as Southey was the amateur Charles Dodgson, better known as the children's author Lewis Carroll. The sensuality of some of Dodgson's child portraits raised a few eyebrows in the twentieth century (just as the clothes-optional family portraits of Sally Mann have provoked controversy in more recent years).[15] More recent literature on Dodgson's work, though, situates his photographic scenarios in the realm of innocent love.[16] However unusual it may have been for an unmarried Oxford don to photograph friends' children as an amateur artist, what is sure is that Dodgson, like Mann, allowed his subjects to express themselves naturally through play. These images, so *yin* in their blending of play, theater, and softness, were surely the farthest thing possible from the kind of exploitative photography that accompanied the child trafficking of the Victorian period that also existed.[17]

Figure 5.5 Reginald Southey's photograph of Hallam and Lionel Tennyson (1857). Wikimedia Commons: https://commons.wikimedia.org/wiki/File:Hallam_and_Lionel_Tennyson,_by_Reginald_Southey.jpg.

The child portraits of Hannah Maynard (1834–1918) also merit special attention (Figure 5.6).[18]

Like the artists mentioned above, Maynard had the knack of bringing out the ethereal beauty not only of the infants who came before her camera, but in the relationships between young siblings. Born in Cornwall, Maynard and her husband emigrated in 1852, undertaking a difficult journey to western Canada before the availability of rail transportation there. Having established her portrait studio in the mining town where the couple settled, Maynard's reputation must have spread throughout British Columbia, because by the 1880s she was creating strange, playful, photo-collages featuring all the children who had visited the studio (Figure 5.7).[19]

Artist and biographer Claire Wilks explained how these annual "Gems" by Maynard were made up of "children she had photographed during the year. She cut out each little head and body, rephotographing and reducing some, and pasted them all onto a background, often a sheet of glass in a window frame. She then rephotographed the whole."[20] She used these compositions as studio advertisements, sent to the children's parents, at no cost, to promote the studio. Maynard did not invent this portrait-collage technique—examples in the history of photography go back to the 1850s in such genres as political portraiture and even microphotography. However, her unusual "Gems" showed a playful, creative, and experimental bent to her work that can be seen elsewhere, as in a series of surreal self-portraits that depict her as twins, triplets, and quadruplets (Figure 5.8).

"Holding down the fort" (the couple's studio) while her husband Richard traveled on distant Canadian missions as a field photographer, Maynard's child photography

Figure 5.6 Children's portrait by Hannah Maynard (*c.* 1890). Maynard's biographer Claire W. Wilks noted "the gawking naturalness of the reclining child and the alert pertness of the little girl." While "[m]ost photographers employed some kind of mechanical device to keep children upright and rigid," Maynard did not—although we can perhaps see a mother's arm in black on the right, keeping things still. Image f-05131 courtesy of the Royal BC Museum and Archives.

gave her a way to establish herself in a fairly rough frontier community. Her professional practice allowed her to weather emotionally both her husband's absences and the deaths of two daughters.[21]

Softness could also apply to color. As a final example of photographic softness that we might characterize as *yin*, I want to say a word about the autochrome and other early color image systems, whose automated filtering process made them different from any method of hand tinting. Although autochrome photographs fall outside of our timeline for this book (the patent year for the French process was 1903), they represent an interesting blend of "feminine" and "masculine" during the years before the First World War when "feminine" motifs in the graphic arts were in vogue. Although autochrome technology was patented by two brothers, Auguste and Louis Lumière of Lyon, these soft, almost impressionistic images in natural colors were made by both male and female photographers.[22] On the one hand, the dreamy pastel effect of autochrome images gave them a "feminine" softness. On the other hand, as the most

Figure 5.7 One of Hannah Maynard's "Gem" collages (n.d.). Owing to personal misfortunes, Maynard's photographs were sometimes quite gothic, whether intentionally or not. In this Gem, the base of the fountain is made out of lilies. Maynard had a daughter named Lillie who died in 1883. Image f-05085 courtesy of the Royal BC Museum and Archives.

exciting new color process available at the time, the technique was enthusiastically employed in "masculine" ways, such as in the global ethnographic project of Albert Kahn, and the wartime image collection made by Captain Jean-Baptiste Tournassoud.[23]

Women autochromists included the French Louise Deglane, whose slides are in the collection of the French Photographic Society; the American Helen Messinger Murdoch, fellow of the Royal Photographic Society; and partners Marguerite Mespoulet and Madeleine Mignon, the only female contributors to Albert Kahn's *Archives de la Planète* autochrome project (1910–31).[24] Better-known were male practitioners, including Auguste Léon in France and Alfred Stieglitz' German-American contemporary, Arnold Genthe. Prior to the Lumière brothers' patent, there were pre-autochrome color techniques like Sanger Shepherd's process, used by photographer

Figure 5.8 Detail from a combination print by Hannah Maynard, wherein Hannah pours tea for herself. (c. 1895). Wikimedia Commons: https://commons.wikimedia.org/wiki/File:Hannah_Maynard_multiple_exposure.jpg.

Sarah A. Acland at the turn of the century.[25] An acquaintance of Lewis Carroll and Julia Margaret Cameron, Acland's color photographs "were regarded as the finest that had ever been seen by her [English] contemporaries, several years before the release of the Lumière Autochrome system, which she also practiced."[26] Although the beautiful autochrome could certainly be employed in "masculine" photography—Kahn's *Archives de la Planète* reflected France's imperial identity and several officers used the autochrome process to make photographs during the First World War—I would argue nevertheless that the style of image that the process produced belonged to a pre-1914, "feminine" aesthetic whose colors were uniquely soft, floral, and intimate. We might contrast the soft autochrome image to the more forceful results attained by the tripack color film system launched in the 1940s, and mass marketed by Kodak and others until the advent of digital photography. In reinterpreting the history of photography, it is possible to differentiate between harder and softer forms of color photography, acknowledging that each technique has been used by both women and men photographers, and for a range of different purposes, mixing *yin* and *yang*.

6

Hybridity

In Chapter 4, I described the work of tinting and retouching photographs as one form of "feminine" tactility that mixed the media of photography and painting. "This retouching and painting over a photograph by incapable hands, by whom it is always done," wrote Peter H. Emerson in 1890, "is much to be deprecated."[1] One of the most passionate and talented British photographers of the period, Emerson's hatred for retouched photography, expressed with words like "falsity," "abomination," and "travesty,"[2] in a book chapter devoted to the subject, hints at a repugnance for more than mere brushwork. When Emerson and his colleagues condemned practices that threatened photography's integrity, its reputation, or its "purity," they were expressing discomfort at anything that introduced hybridity into "their" art form.

Hybridity denotes mixing, mating, or combining. In the Judeo-Christian tradition, "[h]ybrids and other confusions are abominated" within the Old Testament and, by the same token, "holiness requires that different classes of things shall not be confused."[3] In Emerson and his colleagues' abhorrence of hybrid practices, anthropologists like Mary Douglas might have detected avoidance of a residual taboo. Early photographic opinion makers felt that hybrid practices betrayed the scientific realism of photography (what they perceived to be photography's purpose and virtue), and condemned it.[4] Beginning with Emerson in the 1880s and 1890s, and continuing in the triumphal narrative march of Modernism in the twentieth century, "a rhetoric of purity," a strident insistence on "straight," untouched photography,[5] would have the effect of excluding a great deal of early "feminine" creativity from our historical accounts.

Nineteenth and twentieth-century critics perceived hybridity as "impure," a critique that anthropologists might place within a broader human attempt to separate the "pure" from the "polluted." Anthropologically, femininity has carried the taint of pollution in a variety of cultures around the globe (yet another "problem" of femininity), wherein the blood of menstruation and childbirth is fastidiously distanced from men and from holy places.[6] We will see later in Part Two that, because the purity, virility, and prestige of photography were all at stake during the period, commentators speaking for photographic institutions and the profession would make a point of keeping "feminine" hybridity hidden or denigrating it as vulgar.

Nevertheless, between mid-nineteenth-century Naturalism and twentieth-century Modernism lay a period when hybridity was temporarily embraced, in the experimental artwork of the English, French, and American Pictorialists. Combining photography with painterly conventions and materials, Pictorialists like Robert Demachy and Mary

Devens pitted themselves against photography's turn-of-the-century industrialization and cheapness by bringing a "romantic-expressive" perspective to the medium,[7] with an emphasis on high-quality printing materials (Figure 6.1).

For these art photographers, who formed mixed-sex networks across the Atlantic after 1890, hybrid techniques gave them the ability to better reach their *belle époque* ideals of beauty. Photographic history produced later during the Modernist period largely repudiated the hybrid "femininity" of Pictorialism.

Hybridity, though, was not only expressed through the hand manipulation of prints and negatives. It was also expressed through the unabashed mixing of media, as

Figure 6.1 Emma J. Farnsworth (1860–1952), "Sea Bright, Dade & Jean" (*c.* 1886), a finely-worked platinum print. Farnsworth was a medal-winning art photographer who exhibited work in North America and Europe throughout the 1890s. Courtesy of the U.S. Library of Congress.

demonstrated in skilled amateurs' photo-collage albums of the 1850s, 1860s, and 1870s. Just as importantly, hybridity became apparent in an inclination to collaborate on projects rather than to work alone or give the impression of working alone (what we might describe as *auteurism*). It was these two forms of hybridity—mixing media and working collaboratively—wherein artists used photographs for their own creative ends rather than producing prints and negatives themselves, which led to the wholesale disqualification of a number of women from the official history of early photography.

Surrealism, scissors, and glue

An otherwise respectable Englishman flying through a circus hoop in tights; friends' faces replacing those of the kings and queens in a deck of playing cards; a gentleman racing astride two children's hobby horses; giant children's heads floating on the edge of the seashore: these are just a few of the fantastical scenes created (respectively) by Georgina Berkeley, Frances Jocelyn, Edward C. Blount, and Constance Sackville-West in the late 1860s (Figure 6.2).

Figure 6.2 Page from the photo-collage album (1867–71) of Georgina L. Berkeley (1831–1919), rendered here in greyscale. Granddaughter of an earl, Berkeley herself enjoyed neither title nor inheritance. Musee d'Orsay, Paris, France, © RMN-Grand Palais/Art Resource, NY.

Other photo-collagists, such as members of the Bouverie family, Charlotte Milles, Frances E. Bree, Mary Georgiana Filmer, Kate E. Gough, the French Marie-Blanche-Hennelle Fournier and the American Anne C. Lewis, created multi-media works of art, whose pages, far from being valorized as rare illuminated manuscripts, have dispersed, often far from home, via auction sales and archival donations. Several albums have been split up among multiple owners after their original bindings were dismantled.[8]

Despite album makers' innovative use of paper photographs, their hybrid creativity ensured that scholars and curators would exclude them from the history of photography until very recently. Nor would these women and men be acknowledged as pioneers of collage, an honor extended instead to the Dadaists and Surrealists of the post-First World One period in art history, working over fifty years after these Victorians created their fantastical albums.[9] "Feminine" art forms, with all the prejudiced connotations of low prestige and uninspired domesticity that they carry, it seems, did not merit space in the heroic narrative of Western art or photography.

Readers might object that, after all, these artists were amateurs and so unworthy of critical attention. But, Victorian amateurism differed from the word's current casual meaning. The nineteenth century was a period when serious, learned, and engaged amateurs of both sexes partnered with professionals (themselves new entities) in the production of new knowledge in a variety of arts and sciences. Even at the end of the century, the line between photographic artist and amateur remained unclear—Alfred Stieglitz himself forbade Photo-Secession members from "monetizing" their work, to use the modern-day word.[10] Snipping, gluing, juxtaposing, and playing on the page, although done by non-professionals (mainly well-to-do women), produced as much novelty as it did imitation. *Surréaliste avant la lettre*, the Victorian photo-collagists subverted the industrial standardization of commercial *cartes-de-visite*, cutting up portraits in order to suggest dreams, inside jokes, and memories. The avant-garde of the 1920s and 1930s would do much the same, though some of them added an explicitly political content to their pieces (e.g., John Heartfield, George Grosz), reacting as they were to the rise of fascism in Germany.

In early photography, hybridity manifested a strongly *yin* component owing to its relationship to traditionally "feminine" media and modes, and its forays into fantasy rather than claims to fact. Starting with blank album pages, upper-class lady creators blended photographic elements with their amateur "accomplishments": drawing, painting in oils or watercolors, and a conversational knowledge of literary, scientific, and political issues of the day. "Here, authorship lies primarily in collecting, arranging and re-imagining," wrote Marta Weiss, "rather than either conceiving of the photograph or exposing it," though there were exceptions to this pattern.[11] Both Frances Jocelyn and Princess Alexandra were keen amateur photographers, and incorporated their own pictures into their album compositions. Where commercial photographers had to work with perfectly still subjects, available studio props, and a lack of color, photo-collagists surmounted all of those limitations using their artist's tools. An amateur could even create nighttime scenes—impossible using only the photography of the period—in which the moon was the only source of light on mysterious scenes of romance (Figure 6.3).

Album creating was one of several crafts usually undertaken at home, or as a country house amusement, with no expectation of public acclaim. So, while these

Figure 6.3 Moonlit scene in Lady Charlotte Milles' photo-collage album (1860–74), rendered here in greyscale. Author's photograph of the album page in the collection of the Harry Ransom Humanities Research Center, Gernsheim Collection, University of Texas, Austin.

albums caught the eyes of collectors in the twentieth century, their domestic audience, like their hybridity, ensured that nineteenth and twentieth-century photo-historians would dismiss them as unimportant. But as historians have steadily deconstructed the divide between "public" and "private" life in the nineteenth century, the stigma attached to "parlor made" pieces as the products of mere domestic hobbyism is ripe for re-evaluation.[12] As Christopher Sykes showed in *Country House Camera*, the town homes and country houses of the British gentry extended the theater of public discourse throughout the century.[13] Photo-collage albums depicted not just close family but wider circles of friends, high-society leaders, literati, politicians and royals,

and the colleagues of husbands, fathers, and brothers. These wider circles were also the audience for albums, which were perused by casual and honored guests alike, and sometimes they circulated outside the home, since photo-collage enthusiasts often knew each other.

So, while mixed-media albums never appeared at exhibitions or on gallery walls during the lifetime of their creators, they certainly had eminent audiences that understood the artists' social, aesthetic, or literary allusions. These audiences-of-an-evening would have included professional artists, critics, and photographers as well, depending on which professional personalities were invited to dine or visit. Patrizia Di Bello argued convincingly that Victorian mixed-media albums "were an important aspect of the visual culture of the time, crucial sites in the elaboration and codification of the meaning of photography, as a new, modern visual medium."[14] Scholars like Di Bello have rediscovered these sites of photographic creativity and meaning, which remained unacknowledged for a century because of the "private" mode of their production.

Album experts Elizabeth Siegel, Patrizia Di Bello, and Marta Weiss all acknowledged that some Victorian photo-collage albums were the product of more than one artist creating pages or contributing to page-compositions. Creative collaboration, then, was another aspect of hybridity and photography's "femininity." Sisters, fathers, daughters, and brothers might contribute to the completion of an album or single page, leading at times to some confusion over attribution, as for example with the English Bouverie album.[15] The Comtesse de Castiglione, who painted a number of her photographic portraits and assembled several albums for herself and select friends, provides one of the most famous examples of collaboration in this context.

Owing to the fact that the countess collaborated with a professional photographer, Pierre-Louis Pierson, she has traditionally been denied the status of photographic artist.[16] The scale of her ambition, though, whether judged as genius or madness, has compelled curators recently to acknowledge the collaboration as but part of the countess' *œuvre*, which included also her theatrical self-presentations at the court of Emperor Napoleon III. Studying her surviving portraits in American and European collections, Pierre Apraxine concluded, "it is difficult to attribute specifically to Pierson anything that is innovative or original."[17] Where the countess contributed the imaginary narratives, the costumes, hairdo, makeup, and pose, Pierson, then, contributed his technical competence, experience, and feedback. As Pierson was the countess' neighbor in the Passy area of Paris, the two were on intimate terms of friendship, and developed an exceptional creative harmony.

Over the course of four decades, from the heights of her youthful beauty to her physical and mental decay in middle age, she worked with Pierson to create some seven hundred different photographic self-portraits. Beginning with a re-creation of her infamous debut as the "Queen of Hearts" (the costume she wore to the Foreign Ministers Ball during the Congress of Paris in 1857), the partnership wound down with her depiction as a painter, touching up pictures of her mother and father, in 1895, four years before her death (Figure 6.4).

Along the way, the countess assembled multiple albums, modified some photographs by hand, painted over others, and offered a few to the Italian diplomats in her intimate

Figure 6.4 The Comtesse de Castiglione working with the studio photographer Pierre-Louis Pierson, "L'Artiste" (1895). The photograph shows the countess retouching a portrait of her father, the Marquis Oldoïni. The collaborators also recorded her working on her mother's portrait in the same session. Musee d'Orsay, Paris, France, © RMN-Grand Palais/Art Resource, NY.

circle. She gave her self-portraits titles, and had a contract drawn up with Ad. Braun et Cie, the successors to Mayer & Pierson, strictly regulating the use of the negatives, which belonged to her.[18] On occasion, Pierson exhibited a portrait of the countess under his name, but it was the countess who supplied the imaginative thrust of the compositions, and the negatives belonged exclusively to her.[19] Where Pierson supplied the *yang* (technical expertise, publicity, a professional reputation), Castiglione provided

the *yin* (theatricality, fantasy, play, hybridity). The result was a partnership unique in the early history of photography.[20]

As has been shown, *yin* expressions of photography were not restricted to the upper classes, as demonstrated by the commissioned portraits of the servant Hannah Cullwick in Chapter 3. The same was true about collaboration, and although Cullwick was skilled in many practical arts and certainly would not have objected to the staining and fumes of photographic materials, she staged her portraits with the help of studio photographers. During the same period across the Atlantic, another woman of humble origins, the American Sojourner Truth, also used photography to construct an identity on her own terms (Figure 6.5).

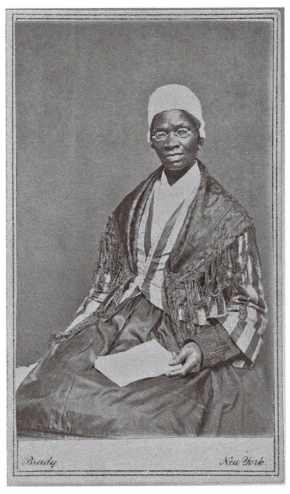

Figure 6.5 *Carte-de-visite* of Sojourner Truth from Mathew Brady's New York gallery (*c.* 1864). Courtesy of the National Portrait Gallery, Smithsonian Institution.

Truth, born as the slave Isabella Baumfree in 1797, posed not for a lover like Cullwick, or for her private self, but rather for a much larger audience of American abolitionists, women activists, statesmen, and journalists. As with the Comtesse de Castiglione and Lillie Langtry, Truth, as far as we know, had no interest in operating the camera herself. Instead, she carefully composed self-portraits that would help support her activism and allow her to control how and where she was represented.

Although born a slave in New York state, Truth was the never-passive designer of her entire life. She ran away from her owner in 1826, "after completing the spinning of one hundred pounds of wool, work she felt she owed him."[21] She proceeded to change her name, launch a speaking career, and successfully litigate in court three times: once to recover her enslaved son, again to prosecute slander against her, and to sue a streetcar conductor who tried to throw her off his car. As Sojourner Truth, she became an abolitionist lecturer and social activist, filed petitions with Congress, and with friends' assistance had letters published in the press (apparently she was illiterate). Like her portraits, her autobiography was a hybrid collaboration that contained her story as written by a friend, a scrapbook (her "Book of Life"), and autograph collection.[22]

Truth used her *carte-de-visite* portraits to support herself, selling them at her lectures and through the mail, and filing a copyright in her name for these images in 1864, "which was unprecedented for a portrait sitter."[23] Aware of the objectivized ways that African-Americans had been depicted by white photographers, and the especially cruel treatment reserved for black women,[24] Truth chose carefully the items she wore and the props she held for the camera. These items included at various times a Quaker-style bonnet and shawl, a picture of her missing grandson, and a knitting project, all items reclaiming the subjectivity that had been denied to enslaved and free African Americans.[25] Each of her accessories was deliberate and highly symbolic. In the 1860s, knitting, for example, connoted femininity as it does now, but also patriotism in the face of the raging Civil War. From the Civil War through the First World War, knitting socks and other clothing for soldiers was an ideologically acceptable, and practical way for women to participate in the conflict. Some of the *cartes-de-viste* include her knitting and show her deformed right hand, providing a demonstration of Truth's belief in overcoming personal obstacles to self-improvement.[26] Finally, the knitting also reflected Truth's deep religious beliefs, including the conviction that "idle hands are the devil's workshop."

Truth's portraits—"feminine" both in the way she depicted herself as a pious matriarch in a domestic setting and in the collaborative mode of their realization— were also designed to subvert the animal-like imagery that white Americans were used to seeing in pictures of naked, beaten, or infantilized slaves. In proving "her existence as a lady" and a Christian, Truth supported the reality of black subjectivity and used visual media to support her spoken messages in her speeches and in her autobiography: arguments for civil rights, women's rights, and human rights, including a speech against a proposed death penalty bill in the legislature of her adopted state of Michigan.[27]

Although scholars have argued that we have "no way of knowing who was responsible for Truth's cultural presentation in her photographs,"[28] it seems reasonable to infer that Truth partnered with photographers, like the Randall studio in Detroit,[29] on a product that she would sell herself to the "fans" with whom she met and corresponded on her

travels. One reporter quoted her as saying that she "used to be sold for other people's benefit, but now she sold herself for her own."[30] Truth's photographs worked in conjunction with other media to build upon the dignity she projected as a strong, enterprising woman of principle. The printed caption that accompanied her portraits was also hers: "I Sell the Shadow to Support the Substance" (Figure 6.6).

Back across the Atlantic, Lillie Langtry, too, would sell herself using photography and an assortment of other media. In the course of two London "seasons," she evolved from the obscure daughter of a Jersey dean to the "queen of fashion, beauty, and society," spending her days and nights with royalty.[31] Langtry's beauty was peculiar, like the countess' was—she perhaps would not get picked out by a fashion editor or a talent agent today owing to changed tastes. But when Queen Victoria herself took the trouble of removing Langtry's picture from the bedroom of her son Prince Leopold, she realized the woman was a phenomenon.[32] The queen's curiosity overcame her moral objections and Langtry joined the other debutants presented to the throne in 1878.

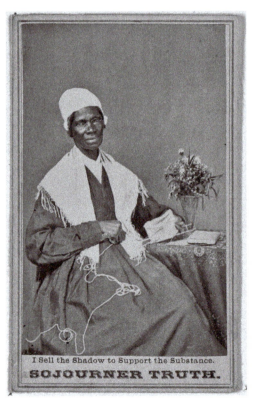

Figure 6.6 *Carte-de-viste* of Sojourner Truth (photographer unknown) with her slogan printed as a caption. The back of the card indicates her copyright: "Entered according to Act of Congress in the year 1864. [sic] by SOJOURNER TRUTH, in the Clerk's Office, of the U.S. District Court, for the Eastern District of Mich." Courtesy of the U.S. Library of Congress.

Self-presentation, in a variety of forms, played a critical role in her success. In common with Castiglione, Langtry came to the capital as an unknown provincial, using her beauty and wit to win fame and royal favor. Managing her image—both in the sense of her reputation and her pictures—Langtry's sessions with fashionable photographers like William Downey in London and Napoleon Sarony in New York were anything but passive sittings. Rather, they were marketing projects for which she "wisely negotiated a deal where she got a commission on every photograph."[33] With no formal education, Langtry used the media and her images to create a business empire.[34]

As an ambitious social climber, professional actress, and future stage company owner, Langtry partnered with her favorite photographers to produce the desired effect in her portraits. "Controlling the public's perceptions became her obsession," wrote Laura Beatty.[35] While we do not have documentation on her photographs as we do with Castiglione and, to some extent, Cullwick, all of the gowns, theatrical costumes, accessories, and dramatic poses depicted in photographs came from Langtry, not William Downey, James Lafayette, or Henry Van der Weyde (Figure 6.7).

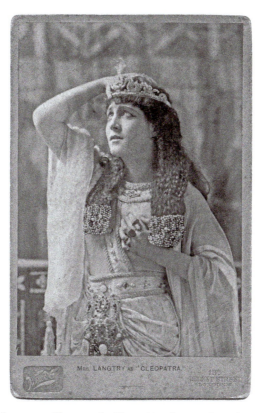

Figure 6.7 Lillie Langtry as Cleopatra by Henry Van der Weyde studio (1890). Langtry's costume for the Princess's Theatre's production of *Anthony and Cleopatra* featured an elaborate costume as seen here. National Portrait Gallery, London.

Langtry was artistic and knew how she wanted to look;[36] the photographers knew how to position the lighting, drapery, and furniture to achieve the desired result. This creative dynamic between Langtry and her photographers contrasted, in all probability, with what had been a more passive role in sitting for painters such as Watts, Millais, and Sir Edward Poynter.

Langtry's collaborations with studio photographers were business deals in which both parties benefitted. It is possible she learned how to negotiate with studios during her lengthy tours in the United States. During her first American tour in 1882, she recalled, "I had sold, for a very large sum, the monopoly of my photographs to Napoleon Sarony, then the principal publicity photographer in New York."[37] The studio was able to sell Langtry's images as long as they were popular, and attract more business by association; Langtry enjoyed either the free publicity (if she sat without paying), a percentage of royalties from sales, or a lump payment up front. Shopkeepers placed her photographs for sale next to similar images of "professional beauties," popular actors and actresses, and royal figures. In the process, Langtry built her legend, the allure of which persists to this day.

A final example of collaboration brings us back to the top of the social class ladder. One might imagine that while Lillie Langtry was conducting her affair with the Prince of Wales, his wife, the Princess Alexandra, may have resorted to the consolations of her life-long passion for photography. Beginning in the late-1880s, Alexandra formed a partnership with George Eastman's Kodak company, which was eager to gain a firmer footing in Britain during the period.[38] While Kodak supplied the princess with cameras and supplies, she lent her name to the company by participating in its amateur exhibitions and, by using its products, endorsing the brand.[39] She followed Kodak's motto, "You Push the Button, We Do the Rest," leaving others to develop and print her negatives, possibly in Windsor Castle's own darkroom. Alexandra and Kodak formed a public relations partnership that benefitted George Eastman's company at a time when he was struggling to establish a base in Britain. She used the No. 1 and No. 4 Kodak cameras offered to her by the company (her No. 4 was a purple, leather-bound "Bull's-Eye Special"), and her excellent results, when exhibited or published, boosted the brand.[40] Her six pictures in the 1897 Eastman Kodak Exhibition had a public audience first in London at the New Gallery, then in New York when the exhibition traveled in 1898.[41]

Although "it was 'not done' for ladies to boast of their achievements" during the period,[42] Alexandra's skill with the camera and her patronage of photography in Britain earned her praise in the photography community. *The Amateur Photographer & Photographic* news gushed:

> The great interest her Majesty Queen Alexandra has taken in photography, and the active part she has played in her practical use of the camera, has probably done more than most photographers realise towards popularizing the hobby, and rendering the hand camera of such universal acceptance ... The first lady photographer of the land stands in need of no assurance of the profound sympathy of the host of humbler practitioners of the art she loves.[43]

In histories of amateur photography after 1890, writers have emphasized the importance of Eastman Kodak's clever advertising campaigns aimed directly at women. Of equal importance were respected figures like Alexandra, who showed women that taking photographs was just as respectable was sitting for them. In the fifty years of photography before Kodak, however, male-dominated photographic institutions and the new professionals preferred to cast women as objects of their cameras' lenses, as paying customers, rather than as colleagues.

Part Two

A Medium of Victorian Masculinity

7

From Gender Neutral to a Masculine Medium

As late as the 1960s, the photographer and writer Berenice Abbott referred to "the photographer" as male, excluding her own world-famous self from this professional and somewhat mystical identifier.[1] Generations before Abbott, how did the photographer come to be gendered male, whether as artist, commercial professional, or, until the 1890s, the amateur?[2] Part Two will document how this process took place during the second half of the nineteenth century. Our analogy to *yin* and *yang*, while still applying, will not appear as prominent in this section of the book, so that I may focus in greater detail on the language of the nineteenth-century sources. We will focus on how spoken and written language, as reproduced in the North Atlantic sources that chronicled it, championed the "masculinity" of photography as it muted its "femininity."

In critiquing Abbott's description of the photographer, readers may object that, until recently, speakers used the masculine pronoun to stand for a sort of "universal" actor ("man's fate," "leap for mankind," etc.).[3] The second part of this book contributes to the literature that shows how this English-language phenomenon persisted in modern times. Following cultural historians, sociologists, and psychologists who have insisted on "naming men as men" in organizations that present themselves as gender neutral, Part Two will highlight "the embeddedness of masculine values and assumptions in the structure, culture, and practices" of nineteenth-century photographic societies and their publications.[4] For, as all good history students know, when men of the North Atlantic world spoke of "the rights of man" during the age of revolutions that contained the discovery of photography, they really did mean themselves (usually white men), not women. It took the broader interpretation of later generations to suppose that these rights applied to other types of people, and all these subordinate groups had to fight for them.[5]

While today's social scientists most frequently look at contemporary organizations in their gender investigations, they nevertheless provide insights that we might apply to the past. Using social science theories and my own analysis of photographic literature, we will uncover the germinating "masculinity" of early photographic institutions. Equally important, the following chapters acknowledge the undeniable fact that North Atlantic women, despite the imbalance of gendered values that overwhelmed the new art-science by the mid-1850s, continually made contributions to early photography and its prehistory. In this first chapter, I suggest that photography did not arrive pre-gendered; new scientific knowledge and technology attracted the interest of both sexes in the 1840s (Figure 7.1). The earliest community of enthusiasts excluded others by class level more than by gender.

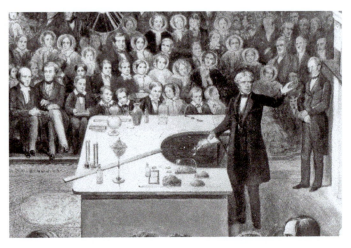

Figure 7.1 Lithograph by Alexander Blaikley of Michael Faraday's 1855 Christmas Lecture at the Royal Institution (detail). Blaikley was careful to reproduce the mixed-sex audience. Wikimedia Commons: https://commons.wikimedia.org/wiki/File:Michael_Faraday_lecturing_at_the_Royal_Institution;_Prince_A_Wellcome_V0013854.jpg.

That is, knowledge requirements and expense, rather than one's masculinity or femininity, determined one's ability to engage with the novel image-making techniques.

The notion that women were absent from or indifferent to early photographic experimentation or enthusiasm (what we might today call "early adoption") is an enduring misconception. Autodidactic women and spousal partners of early inventors, though, witnessed and assisted during the earliest experiments. Future photographer Julia Margaret Cameron remembered that during the announcement of photography's invention in 1839, she was "then residing in Calcutta, and scientific discoveries sent to that then benighted land were water to the parched lips of the starved."[6] The first mention of photography in Northumberland intellectual Pauline Trevelyan's diary was on May 1, 1839.[7] She became an avid calotypist and collector. Women of leisure, along with men, were from the very first months of photography's appearance engaged with the new science.

For forty years now, publications by researchers like Grace Seiberling, Naomi Rosenblum, Peter Palmquist, and others have tried to correct this misperception. And yet, the glorious patrilineal descent of photography remains the preferred and the persistent doctrine in the historical narrative. Accounts of the medium's earliest years are barren of female figures.[8] The reason for the absence of women and "femininity" is rooted in a long nineteenth-century campaign, built up across the North Atlantic world, to promote photography as a "masculine" profession. That is, to convince skeptical observers that photographers were manly, honorable, skilled artists and inventors. Part Two of this book will trace that campaign and its consequences from the 1850s to 1900. The rest of this chapter highlights two generations-worth of scholars' valiant efforts to reverse the invisibility of women during the invention of photography.

The women who were interested in early photography had an intellectual ancestry of amateur scientists, essayists, and translators working throughout Europe in the eighteenth and early nineteenth century.[9] An intellectual circle of British friends, for example, included Jane Marcet (1769–1858), Mary Somerville (1780–1872), Maria Edgeworth (1768–1849), and Harriet Martineau (1802–76). Marcet conducted chemical experiments with her physician husband and published a series of popular science books for ladies and laypersons. Somerville is perhaps best-known for her astronomical works of the 1830s. Maria Edgeworth and Harriet Martineau were polymaths with interests in philosophy, political economy, and education. Some of the above women may have known, or known of, the Scottish chemist Elizabeth Fulhame, whom scholars have placed at the pre-history of photography.[10] Fulhame's experiments with silver salts produced a better understanding of light sensitive chemicals, paving the way for photography a generation later.

Across the Channel in France, Louis Daguerre pursued his experiments in partnership with the Saône-et-Loire inventor, Joseph Nicéphore Niépce. Perhaps no one was more anxious for the success of Daguerre's experiments than his wife, Louise Georgina (Figure 7.2).

A French chemist of the era, Monsieur Dumas, told of his meeting with Madame Daguerre in 1825, when she attended one of his lectures at the Sorbonne. The stage-set painter's wife approached Dumas at the end of the lecture, saying that her husband had

Figure 7.2 Daguerreotype of Madame Louise Georgina Daguerre (1845), probably made by Louis Daguerre at Bry-sur-Marne, France. National Science and Media Museum, Bradford/Science and Society Picture Library.

let the idea seize him that he can fix the image of the camera. Do you think it possible? He is always at the thought; he can't sleep at night for it. I am afraid he is out of his mind. Do you think, as a man of science, it can ever be done?[11]

To which the chemist replied: "In the present state of knowledge ... it cannot be done; but I cannot say it will always remain impossible, nor set the man down as mad who seeks for it."[12] Returning home to her sleepless, preoccupied husband, Louise Georgina would have given Daguerre the chemist's hopeful albeit qualified opinion. Persistence would, as we know, pay off. Years later, it was Madame Niépce de Saint-Victor who offered to British museums specimens of her husband's experimental color photographs depicting, interestingly, "dolls dressed in coloured raiment."[13] Niépce de Saint-Victor had died in 1870 leaving his widow and family in debt, a few months before the Franco-Prussian war commenced. For reasons unknown, Madame Niépce de Saint-Victor found no buyers in Britain. Color process photography would finally emerge in the early twentieth century.

Anxious wives were not the only French-speaking women who involved themselves with the new invention. By 1856, the *Revue photographique* reported that many women were mastering the new art by taking lessons from the early "professors" of photography, and that one such student planned on opening a studio specializing in "portraits and *académies* of women."[14] One of the earliest photographic exhibitions in Europe saw a certain Madame Le Ghait, member of the new French Photographic Society, win a medal in the same category as Frederick Archer and Antoine Claudet.[15] Another woman, Madame Legay, "caused a great sensation" at the Brussels photographic exhibition of 1856 with her landscape images.[16]

Mesdames Laffon and Breton both exhibited at the early French Photographic Society salons. Madame Vaudé-Green's studio in 1850s Paris specialized in quality photo-reproductions of works of art, one of the most exciting uses of the new medium, and other women in Paris, such as Madame Bouasse-Lebel, competed with her.[17] Scholars like Françoise Condé and Dominique de Font-Réaulx have recovered the names of early workers like Amélie Saguez, who exhibited calotypes in the 1840s before the establishment of the French Photographic Society, but they have lamented the fact that many full female names, birth and death dates, and portfolios were allowed to vanish by France's early photographic institutions.[18]

Over the century and a half since photography's invention, much printer's ink has been devoted to reminding readers that Daguerre was not alone in his desire to fix the camera's image. From at least the 1820s, the desire was "in the air," across the North Atlantic and even beyond our region.[19] The second father of photography, Daguerre's contemporary William Henry Fox Talbot, developed a paper rather than metal-plate version of the photographic process. In Talbot's battle to match the French announcement, a circumstance often forgotten was that this English gentleman had three women assisting his endeavors. Talbot's wife Constance became "the first woman photographic technician" to assist her husband in the 1820s and 1830s.[20] Steve Edwards has even suggested that the idea of fixing the reflections of the *camera obscura* sprung from Talbot's dissatisfaction that his drawing skills compared to those of the talented women in his family, including his wife.[21] Constance Talbot participated in the

inventor's experiments and assisted with print production, though her role "was little noted in a culture where men were expected to take active roles and women to be quietly supportive."[22]

The second woman, Talbot's half-sister Lady Caroline Mount Edgcumbe, introduced Queen Victoria to the paper Talbotype (otherwise known as the calotype), and secured permission for Talbot to make "sun drawings" on the grounds of Windsor Castle.[23] Victoria developed such a passion for photography that another lady-in-waiting reported, "I believe the Queen could be bought and sold, for a photograph."[24] Anne Lyden and others have recently highlighted Victoria's role in British photography's flourishing, where in the past historians had credited only the Prince Consort.[25] Both the queen and the prince went on to be major patrons and collectors of photography throughout their lives. By bringing photography to the palace, Lady Edgcumbe laid the groundwork for a royal, and later national, embrace of the new technique.

The third woman, Talbot's most zealous advocate, was his mother, Lady Elisabeth Theresa Feilding (1773–1846) (Figure 7.3). Widowed with a baby son at the age of twenty-seven, Elisabeth was faced with an estate (Lacock Abbey) in ruinous condition.

Strength of character and intelligence enabled her to restore the property before Talbot attained his majority and inherited it.[26] It was perhaps this early trial that made her such a determined partner in her son's future success and place in history. Anne Lyden described her as "photography's first ardent champion," who "energetically

Figure 7.3 William Henry Fox Talbot's paper print of his mother, Lady Elisabeth Feilding (1842). Courtesy National Science and Media Museum, Bradford/Science and Society Picture Library.

promoted samples of it among the family and members of her aristocratic circle."[27] Between 1839 and 1845, Elisabeth used her pen and her upper-class social life to promote Talbot's pictures, processes, and publications all over England and abroad.

Perhaps even more frustrated than her son at the fact that Daguerre had announced his invention first, Lady Feilding undertook a full-fledged campaign to secure the laurels that she believed her son deserved. "I was quite surprized [sic] at your making the secret of Photogenic Drawing known," she wrote Talbot in early 1839, since "it precludes entirely all chance of your making your fortune by selling it as M. Daguerre intended or getting a patent."[28] Her letters betray an "irritation at her son's inability, as she saw it," to establish ownership in the way that Daguerre had in France.[29] She also guided Talbot's progress, seeing earlier than him that the products of the camera (paper negatives and resulting prints) would be more important than his original, camera-less photograms.[30] When it came to enforcing her son's patent, obtained in 1841, Lady Elisabeth was Talbot's watchdog unto her death.[31]

William Henry Fox Talbot's Welsh friend John Dillwyn Llewelyn was also an early adopter and helped found the Photographic Society of London in 1853. For this gentleman botanist, photography "was a family commitment," and he taught his brother Lewis, sister Mary and daughter Thereza (Figure 7.4).[32] His wife Emma, a cousin of Talbot, made printing her specialty in the family.

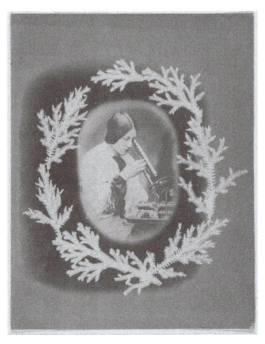

Figure 7.4 John D. Llewelyn's paper print of Thereza D. Llewelyn with her microscope (*c.* 1854) shows one father's encouragement of his daughter's scientific pursuits in the 1850s. Courtesy of the Metropolitan Museum of Art, New York.

Like her father and her contemporary Anna Atkins, daughter Thereza used the photogram technique to record seaweed specimens. Another family experiment had Thereza take stereographic photographs while her father made a single-lens negative of the same scenes. The Llewelyns may have also swapped photographs with the three English Nevill sisters, Caroline, Augusta, and Isabel, via the Photographic Exchange Club (established in 1854).[33] Also early members of the Photographic Society of London, the Nevill sisters practiced the new collodion glass-negative process, but seem to have given up photography after 1857.

Early photographic historian Robert Taft traced the paternity of American photography through Samuel Morse, who witnessed the earliest daguerreotype demonstrations in Paris in 1839, and published an account in the New York *Observer* in April.[34] Once home in New York, Morse partnered with several enthusiasts on photographic experiments, including the English expatriate John William Draper. In 1840, Dr. Draper may have produced the first daguerreotype portrait, depicting his older sister Dorothy, and her interesting life deserves a fresh look.

The story of Dorothy Catherine Draper is exemplary for showing how, in the aggressive jockeying for places in the history of photography undertaken by men, their female helpers were pushed out of the picture even as they appeared in the camera's first portraits (Figure 7.5).

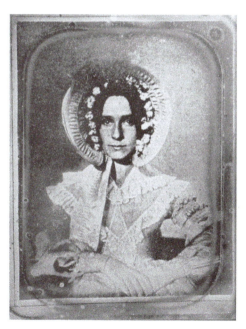

Figure 7.5 Dr. John W. Draper's daguerreotype of Dorothy C. Draper. The original was made in 1840, but it was badly damaged during attempts at restoration in the 1930s. Most reproductions are derived from copies made in 1893 for the Columbia Exposition in Chicago (as here). Wikimedia Commons: https://commons.wikimedia.org/wiki/File:Dorothy_Draper.jpg.

At first glance, we see that history has cast Dorothy as photography's object—the silent sitter for Dr. Draper's early daguerreotype, subsequently claimed (and disputed) as the first-ever photographic portrait.[35] But if we pause for a moment with the sparse biographical material (having never married, Dorothy's recorded existence was limited), several facts come to our attention. Before immigrating to America, Dorothy taught drawing and painting in London, and her savings, according to Howard McManus, "probably funded" the siblings' relocation to Virginia in 1832. Further, it appears that the girls' school Dorothy ran with her sisters in America, where she continued to teach art, generated "enough money to send John through medical school."[36]

Dorothy Draper, then, was an intelligent, unmarried woman with artistic talent, enough interested in her brother (or dutiful enough) to support his scientific career. Is it likely that such a partner (Dorothy lived with Dr. Draper's wife and children) would have been indifferent to his photographic experimentation? Logic suggests indifference would have been unlikely. Is it, moreover, feasible that Dorothy would have casually climbed onto the roof of New York University in 1840,[37] enduring full sun in her eyes for six minutes during the daguerreotype's exposure, wearing thick white metallic powder on her face, while ignorant of what was at stake, or at least what was taking place in the camera? The evidence points otherwise.[38] Indeed, one obituary for Miss Draper insisted

> her services to science involved sufficient personal inconvenience and discomfort to give her claim to be entitled the heroine of photography, and to be held in honor by the countless thousands to whom the art of photography, with all its cognate and related arts, is now a source of pleasure, of education, of culture, of livelihood, of wealth.[39]

Such posthumous appreciation was atypical. The role of passive witness—silent model—sticks tenaciously to most of the women who surrounded photography's appearance in the world.

Amateur experimenters and helpers were not the only women present at the dawn of photography. English, American, and French historians have all counted women among the earliest professional daguerreotypists as well.[40] In England, Jane Wigley, who pioneered the use of a prism to reverse the orientation of (that is, correct) the camera image, had an exclusive license to operate a daguerreotype studio in Newcastle in 1845.[41] A trade advertisement in a Montréal newspaper offered daguerreotypes by a Mrs. Fletcher in 1841.[42] The first female studio appeared in the Parisian trade directory in 1844. This was Madame Gelot-Sandoz at 2 Boulevard Poissonnière, offering portraits and photographic accessories.[43] Women daguerreotypists speckled the earliest American scene as well (Figure 7.6).

Alan Woolworth has argued, for example, that Sarah L. Eldridge (née Judd) was Minnesota's very first photographer.[44] And while it was true that western pioneering women like Eldridge may have found the field more open to them than their east coast sisters, owing to the lack of a business establishment and sparser population in frontier areas,[45] neither competition nor lack of institutional support stopped women like

> *Daguerreotypes taken by a Lady.*—Those wishing to have a good likeness are informed that they can have them taken in a very superior manner, and by a *real live lady* too, in Clay street, opposite the St. Francis Hotel, at a very moderate charge. Give her a call, gents.
>
> *Police Court—Stealing Sausages.*—A man named Chas.
> V. Guiers was arrested yesterday for stealing a quantity

Figure 7.6 Advertisement for Mrs. Julia Shannon's daguerreotype studio in the January 29, 1850 issue of *The Daily Alta California* newspaper, p. 2. None of her photographs are known to have survived.

Cordelia Gardner, Madeline Fisher, and Charlotte Prosch from establishing themselves in larger American cities like New York.[46]

It will be obvious to the reader that here I am standing on the shoulders of tireless scholars who already revealed women's presence, curiosity, and entrepreneurism during photography's first two decades. May we then put to rest, once and for all, the myth of women's absence during the infancy of photography? That will depend on how we choose to tell the story of photography in the future. In encountering the "uncovering" work of so many researchers before me, the question that emerged is, "Why, despite women's early involvement, did photography in the North Atlantic world become so 'masculine' and male-dominated after 1850?" The answer to that question demands a deeper look into the social and gender history of the period, and the language of early photography.

The rest of Part Two will look closely at the language "moves" made mainly by the men shaping photography's early institutions. Chapters 8 and 9 analyze how male photographers brought the republican ideology of the new constitutional regimes into their new associations, activities, and the photographic press. As in the political regimes, the constitutional culture of the earliest photographic societies was closely linked to evolving notions of paternity and masculinity. Chapters 10 and 11 use historical sources, gender history, and the insights of sociology and psychology to explain why so few women were members of early photographic societies, whether those societies explicitly banned them or not. Were early women photographers *silent* by inclination, or *silenced* by the institutions of photography? These chapters show how gender expectations and social institutions shaped personal "inclinations." The final chapter of Part Two, "Defending Photography," shifts focus to the rhetoric of commercial photographers attempting to form themselves into a fraternal, corporate group. Studio operators struggled to defend the "masculine" honor and reputation of their profession, in the face of critical attacks, professional disunity, and even scandals appearing in every decade of the second half of the nineteenth century.

Building a Republic of Photography

Feminist historians have shown how the new republican form of government that emerged from the North Atlantic's revolutionary era (*c.* 1775–1848) generated a literally fraternal system of power in which female input—which had supposedly characterized the pre-revolutionary regime of royals, regents, and mistresses—was eliminated from government. Although historian Mona Ozouf argued that mixed-sex sociability continued to distinguish French culture,[1] institutions in France, as in Britain and the United States, remained bastions of masculine power throughout the nineteenth century.

What can be described as intellectual republicanism—male-dominated, cross-class, and institutional—flourished even during the French Second Empire (1851–70), when that regime forced *political* republicanism underground. Like other learned associations of the era, the photographic societies that emerged in London, Paris, and the East Coast cities of North America used the model of intellectual republicanism for their production of knowledge. The new photographic societies became "the structures through which knowledge could be made into property,"[2] similar to other learned societies across the North Atlantic world. Indeed, photography was just one of the modern guilds that converted knowledge to power in the second half of the nineteenth century, akin to the period's more prestigious medical and geographical associations.[3]

In looking at the membership rolls and printed discussions in the earliest photographic journals—often organs of the clubs—what becomes apparent is that male enthusiasts were creating private republics around their passion for the new art-science. Photography historian Jennifer Tucker also observed that few developments "did more than photography to establish the public image of Victorian science as a middle-class masculine practice."[4] Scientific professionals, businessmen, aristocratic dilettantes, and military men here met on equal terms for the sake of photography's progress, but also for the sake of their identity as men. When photo clubs or editorial staff published portraits celebrating their institutions' progress (Figure 2.5), the selection was strictly masculine. Women practitioners' faces would never be shown during this fifty-year period.[5]

It may be that these enthusiasts believed the presence of women in the society's meeting rooms would have reintroduced an atmosphere of class distinctions. A handful of women appear on the early membership rolls of the Photographic Society of London (established in 1853) and the French Photographic Society (established in 1854), but there is no evidence that they attended regular meetings until the end of the century.

As we will see, the men felt (and perhaps sociologists would argue that they still feel)[6] that the presence of women would necessitate their modifying their behavior, the egalitarian atmosphere, and free discourse that they built into their club. One of the earliest photographic societies, for example, called for contributions from all "men of good will" with an interest in the sciences.[7] However, that rhetorical inclusiveness was predicated on a homosocial (male) associational space. Women, but more specifically the signs of "femininity" that most Victorian women carried with them, activated a performance of certain social conventions, whether or not they intended to do so. We will explore these gender tensions in a later chapter.

Twenty-first-century readers might be tempted to read the statutes of the earliest photographic societies as "gender neutral" or even welcoming towards women. Published in the journal at various intervals, the original rules of the London Photographic Society, for example, explicitly stated, "Ladies also shall be eligible as Members of the Society."[8] Although this provision, and the inclusion of Viscountesses Jocelyn and Hawarden in the 1860s made female membership at least thinkable, their attendance at meetings was exceedingly rare;[9] women were never society officers during this period; and, arguably, what the Photographic Society desired was the prestige of these ladies' titles on the rolls, not their discursive input. Both in Britain and France, the listing of aristocratic members gave polish to a nevertheless republican-style framework of the photographic society.

In emerging when it did, the photographic society reflected political-cultural changes as mentioned, and also, like many other learned societies of the era, fulfilled a male need to define themselves as modern, urban men. The mid-nineteenth century saw not only the expanding influence of democracy, but the disorienting impact of industrialization and advanced urbanization as well. As North Atlantic civilization changed, the definition and meaning of manhood and masculinity would evolve as well.[10] Competing in a crowded city where the values of knowledge and skill gradually eclipsed traditional masculine values of physical strength and martial valor, middle-class leaders set to work building new, secular institutions to replace ones that had become defunct, such as the traditional guild system of trades.

Photographic societies and syndicates emerged as substitutes for the guilds that had been swept away during the revolutions of the eighteenth century. Although painting and sculpture were to some extent still controlled by the national academies, established during the *ancien régime*, there was no institutional authority for the new career of photography.[11] French, British, and American leaders worked to change that, seeing that the technology held the potential as a new site of knowledge and power. In this new business world of the nineteenth century, men had lost the right to grant or refuse the title of "master" to the journeymen beneath them. These voluntary organizations therefore had to come up with other ways of defending the honor and manliness of their profession. With no traditional controls, photographers working to organize themselves had to appeal to their *confrères'* voluntary solidarity.

Mary Ann Clawson argued that one of the important ways that men replaced guilds was by continuing their traditions in fraternal associations, such as the Freemasons and the Knights of Columbus.[12] The spirit of fraternalism pervaded the first photographic societies, too, and the concept of fraternity was a favored subject among their members.

"Photographers, as a body, are a most cordial fraternity," wrote J.J. Coghill in 1859, "and in general I think there has been an expansive and generous desire among the body to keep nothing back from the brotherhood which might tend to the general good."[13] In a cut-throat environment of business competition, fraternalism encouraged emulation, solidarity, and brotherly friendship. The photographic society, especially the ones that included commercial members, attempted to mitigate the nasty effects of cyclical economic downturns, price wars, and retail oversaturation, all of which stoked photographic rivalries in the second half of the century.

The first president of the French Photographic Society, Eugène Durieu (Figure 8.1), linked his society to a national constellation of learned academies in 1855: "If, between men devoted to the same subject of study, inspired by the same tastes, if, among savants or artists, they establish a natural confraternity, why would this not also be the case for photographers!"[14]

Durieu's fellow member, Paul Périer, agreed, using one of his many Latin analogies: "Our confraternity of photographers is a republic in which the *caveant consules* [wary

Figure 8.1 Possible self-portrait of Jean-Louis-Marie-Eugène Durieu (*c*. 1855). This salted paper print is part of the Gabriel Cromer collection at the George Eastman Museum. Cromer, an early twentieth century member of the French Photographic Society, inscribed the back of the photograph with Durieu's name, followed by a question mark. Durieu himself is perhaps best known for his early photographs of female nudes. Courtesy of the George Eastman Museum.

consuls, that is, executive members] should be checked daily by the senate."[15] Périer revealed a certain amount of political sublimation, perhaps, during the reign of Napoleon III. Just as importantly, Durieu, Périer, and the other members of the photographic society were establishing a "masculine" republic where *liberté, fraternité*, and *egalité* could legally thrive.[16]

Early associations granted two other benefits: the gendering, via language, of photographic knowledge as male, and, as with all fraternal organizations, the enhancement of patriarchal power. As Clawson pointed out, the growth of the fraternal organization strengthened the bourgeois man's authority within the family, since he was acting as an emissary between his dependents and the outside world of knowledge and power.[17] His power in the family was legitimated, in a way that a woman's could not be, through his participation in knowledge-producing-and-reviewing networks. The corollary of this formula was that if women attended, contributed to, or (heaven forbid) directed learned society meetings, men's dominion over the family would collapse. Sociologist Daphne Spain put it this way: "'Gendered spaces' separate women from knowledge used by men to produce and reproduce power and privilege."[18]

In the United States, too, a fraternal spirit in photographic organizations, as in the various lodges of the day, "articulated a vision of unity and brotherhood among men of disparate social statuses."[19] This spirit became especially apparent in the earliest American organizations for commercial professionals, beginning with the founding of the National Photographic Association (NPA) in 1869 by east coast studio photographers. Formed for the pragmatic purpose of fighting the Cutting patent on the use of bromide in the collodion negative process,[20] the NPA's rhetoric, coming soon after the national trauma of the Civil War, soared toward loftier ideals. "We come from the north, the south, the east and west, all as a common brotherhood," spoke President Bogardus at the first annual conference, "by our presence and efforts to lift our art higher and higher, until it shall attain the proud eminence it deserves."[21] Unfortunately, once the goal of overturning the Cutting patent was achieved, a combination of infighting and indifference led to the folding of the NPA in 1876. A national organization for professionals was resurrected, however, in 1880.

This new American association, the Photographers' Association of America (PAA) (Figure 8.2), used the same republican, fraternal language as its predecessor, which now had two main aims.

PAA leadership hoped the rhetoric of professional brotherhood might generate solidarity during a national economic slump that had sparked studio price wars. Secondly, the PAA could promote photography as a manly and honorable profession by countering any reported incidents or innuendos that besmirched the profession's reputation in the eyes of the public.[22]

A third issue that leaders of the PAA addressed concerned customers who took unfair advantage of photographers by demanding multiple sittings and then failing to pay, leaving the proprietor with costly, orphaned proofs and prints.[23] On the subject of customers wanting something for nothing, President Ryder argued, "It should not be expected that we make re-sittings ... without extra charge; yet, where one man in a community practises this folly, it makes trouble for all the others."[24] Only fraternal solidarity would produce prosperity.

Figure 8.2 Photoengraving from the program of the 1902 PAA convention in Buffalo, NY. The portraits show the organization's officers. Hailing from Cleveland, Buffalo, Milwaukee, Boston, and Anderson, Indiana, the geographic diversity of the board demonstrated the PAA's ability to sustain a continent-wide organization in the railroad age. The PAA also used logo design, medals, and engraved symbols to establish a corporate identity, until it became the Professional Photographer's Association (PPA) in 1958. Image and metadata available at the PhotoSeed.com archive.

At the PAA's first convention in Chicago, its secretary, A.J.W. Copelin, told attendees: "In the work we have come here to perform let us be earnest, manly, mutually friendly, and brotherly; let us do all the good we can for ourselves and the craft at large."[25] Later, H. Rocher delivered a paper on "The Relation of Photographers to the Public and the Public to the Photographers," in which he exhorted his colleagues to "Guard your dignity!" To avoid being taken advantage of, "[b]e firm in what you transact with your patrons . . . I am firm, and deviate not from my rules or prices."[26] Rocher, Ryder, Wilson, and the other leaders of the PAA hoped that by disciplining the fraternity, the fraternity could then discipline its customers. Although attendees at the Chicago convention included women (speakers addressed the crowd as "Ladies and Gentlemen"), the PAA

aspired to serve "a body of intelligent men," and it neither scheduled female speakers nor solicited concerns from female members during this era.[27]

Unlike the European photographic journals that distanced themselves from photographic commerce in favor of "pure" science,[28] several of the earliest American journals were published and edited by photographic industrialists themselves. Distributed at a cheap subscription rate, publications like *Anthony's Photographic Bulletin*, *Humphrey's Journal*, and *Photographic Rays of Light* combined the goal of advertising with a purported desire to "advance the interest of the fraternity and to raise the standard of the most beautiful of the arts."[29] Promoting new products as well as professional esprit de corps, businessmen-editors advised, "There should be a brotherly feeling among photographers, for there is wisdom in a multitude of council."[30] One man who lived by this advice was the Philadelphia photographer Edward L. Wilson (Figure 8.3), who, by directing two journals, co-founding two national organizations, fighting restrictive patents, and promoting the art at the 1876 Centennial Exhibition, did all that an individual could do to increase the honor and fraternity of the photographic profession.[31]

Figure 8.3 Phototype of Edward L. Wilson by F. Gutehunst, the frontispiece in *Wilson's Photographics: A Series of Lessons, Accompanied by Notes, on all the Processes which are Needful in the Art of Photography* (Philadelphia: Edward L. Wilson, 1881). HTDC: https://babel.hathitrust.org/cgi/pt?id=gri.ark:/13960/t60625d6m&view=1up&seq=10.

The galloping masculinization of photography, as both a profession and an organized recreation, proceeded apace and reporters recorded little protest before 1890. One exception came from the American photographer Marcelia W. Barnes, who, upon learning of the New York State Daguerreian Association's formation in 1852, wrote a full-page letter to *The Photographic Art-Journal*. Barnes was "anxious to know whether female operators [were] to share its friendship and receive of its benefits."[32] Feeling that female daguerreotypists "were not cordially welcomed into the fraternity," she demanded that the new association publish a resolution on the subject. The end result, according to Peter Palmquist, was that Barnes and her colleague Agnes M. Armstrong"were duly elected as the first female members of an American photographic association."[33] Unfortunately, as we will see in a future chapter, Barnes was an exception to the rule of female silence during photographic societies' first decade. Although the *Art-Journal*'s editor showed liberality in publishing her letter, the fraternity of the photographic society, in any event its meetings, would remain a masculine domain until the 1880s. Clubs and associations were pleased to accept women's payment of dues and their donations, but relied upon their passive silence.

The physical comportment, glances, gestures, and non-verbal communication of photographic society members at their meetings are mostly lost to us, but their discussions, priorities, and occasional outbursts have been preserved in the many photographic journals that proliferated in the second half of the nineteenth century.[34] Despite the executive councils' encouragement of fraternal friendship amongst members, the societies' printed mouthpieces also recorded rivalry, combat, and factionalism that arose within the society and photography more generally. In a modern, self-surveilling society where physical fighting took on a lower or working-class connotation, how would middle-class "gentlemen" and noblemen sublimate the urge to fight?[35] In many cases, the chosen recourse bolstered the cliché that the pen, or the courts, was mightier than the sword.

In the absence of the experience of military combat for many French and British bourgeois of the era and the (admittedly long) decline of dueling, the open-ended stakes involved in the new science and business of photography necessitated a forum for manly combat ("we must all battle together," urged Wilson).[36] Members jointly fought restrictive patents, contested each other's scientific claims, confronted dishonest suppliers, and formed factional alliances when policies were subject to voting. Enemies were forged in the war of words. For instance, when the London Photographic Society tried to prohibit William Crookes from publishing the content of meetings in the unaffiliated *Photographic News*, Crookes, a scientist interested in photography for research, mounted a full-scale war as editor of the *News*. He published anonymous letters of support (which the Photographic Society accused him of writing himself), stating, "Of all men, photographers should love the light—light of all kinds, and not, with the narrow-minded sordidness of a trading clique, make, or strive to make, a market of their proceedings."[37] When that appeal failed to win his cause, Crookes published an unflattering account of a Society meeting, during which a complaint about the council being "dictatorial" provoked "cheers and hisses."[38] The chairman was asked (Crookes did not say by whom)"when the Council intended to fulfill the promise made by them in May last," to revise the rules "under which the Council exercise

irresponsible power."[39] Some disagreements became impassioned fights, and fights led to photographic society splits throughout the North Atlantic world, mainly after 1880.

The photographic society created a new space for combat, while tempering it by encouraging civilized disputation. Acknowledging the fierce competition to attain the French Prix du duc de Luynes in 1856, the *Revue photographique* predicted, "English photographers and our [French] men of science will enter the arena, and fight, with a friendly rivalry, but ardent, in order to win the palm."[40] More than friendly rivalry, disputed claims to invention produced prickly arguments, reproduced, commented upon, or hinted at in the photographic press, from 1840 onward.[41] In France, the triumph of Louis Daguerre at the expense of a rival, Hippolyte Bayard, famously led the latter to create his self-portrait as "A Drowned Man," symbolizing his bitter defeat.[42] Bridging the Channel, the rancorous argument between Louis Blanquart-Evrard and the English photographer Thomas Sutton concerned the photographic printing process Blanquart-Evrard employed at his manufactory in Loos in the 1850s. When the French businessman declined to share his chemical process, Sutton threatened to keep experimenting until he uncovered the secret, then publish a brochure describing the procedure to the whole world.[43] Eventually Blanquart-Evrard invited Sutton to France and showed him his process. Blanquart-Evrard's photograph factory in Loos folded soon after that.[44]

Yet a third early fight concerned the invention of microphotographs, disputed in England between John B. Dancer and George Shadbolt, who made his claim in the pages of the journal he edited.[45] Dancer's supporters at the Manchester Photographic Society came to his aid, and Shadbolt was pressured to renounce his claim. Drawn-out disputes, couched in gentlemanly discourse, could erupt over issues as simple as publication titles. When the *Liverpool and Manchester Photographic Journal* wished to change its name to *The Photographic Journal*, the London Photographic Society objected because the new title was too similar to its *Journal of the Photographic Society*. The same troublemaker, George Shadbolt, now the editor of the former Liverpool journal, assured the Photographic Society that photographers "as a class, are men of discernment," and so surely would not get confused by the similar titles.[46] The London Photographic Society, though, pressed its suit, and by January 1860 the confusingly-titled *Photographic Journal* had become the *British Journal of Photography*. The above examples of fighting in the photographic world do not include the cases that went to courts of law (as with the Talbot patent dispute of 1854), or incidents that led to jail time for some photographers.[47]

Indeed, from the very beginning of the organized photographic society, there were clashes and ideological breaks, starting, perhaps, with the dissolution of the Heliographic Society (established in Paris in 1851) and the rise of the more permanent French Photographic Society following a factional split.[48] Most institutional divisions, though, were decades in the future. In the early years of photography, the priority of the North Atlantic societies was to cultivate honor, glory, and yes, "masculinity" in the fraternal practice of photography.

Practitioners lived in a new age of hero worship based on scientific discovery and invention, and photography itself would play its part. The colorful career of Félix Tournachon, for example, showed how mid-century photographers might combine

traditional masculine valor with technological competence. An avid proponent of his century's exciting scientific breakthroughs, including aeronautics, Tournachon, who famously signed his work simply with the dashing "Nadar," gained fame on both sides of the Atlantic for his daring, though ultimately disastrous, hot-air balloon flights. Despite (or because of) a couple of dangerous crash landings, the photographer's flights inspired the character of Ardan (an anagram of Nadar) in Jules Verne's *From the Earth to the Moon* (1865).[49] Nadar's recent biographer noted that Ardan and Nadar "shared an equivocal motto, *Quand même*! (literally, "All the same!"), which sums up their insouciant charm, their cheerful persistence in the face of adversity."[50] Perhaps more than anyone, Nadar with his photographic, technological, and satirical exploits (he was in addition a caricature artist) represented the bright, risk-taking, "masculine" energy of nineteenth-century photography.

The early photographic press praised the new art for its ability to bring "the world face to face with its great men, its orators, its poets, its statesmen, its heroes" (Figure 8.4).[51]

The mass publication of photographs of "men of note" would strengthen the male domination of public esteem—mass-produced portraits of women tended to be of

Figure 8.4 Studio Livernois (Montréal), "Galerie des Contemporains" photomontage (1866). This mosaic of Québécois celebrities is made up of one hundred and forty-one men. Courtesy of the Montréal Municipal Archives, Canada.

actresses, beauties, and royals, not women of scientific or professional achievement, though the latter did toil during the same period.[52] Volumes arrived off the presses with photo-based illustrations, celebrating the nation's male heroes for schoolboys to emulate.[53] Photographers hoped to gain entry to this modern pantheon themselves, and such a campaign demanded a strict avoidance of "femininity." The great task of the photographic societies and journals would be to make their new, probational profession manly.

Establishing the Paternity of Photography

Common to early photographic literature and twentieth-century historiography is a persistent preoccupation with what scholars have identified as the "paternity" of photography.[1] That is, photography's patrilineal line of descending inventors and artists, from 1839 to the present. One of the very first photographic associations, the Heliographic Society in Paris (established in 1851), made photographic discoveries' attribution one of its highest priorities. In the first twelve articles of the Society's statutes, numbers four through seven all emphasized its commitment to properly crediting inventors.[2]

The rush of discoveries during the 1850s was accompanied by a rush to establish photography's genealogy, which would include no mothers, only fathers (Figure 9.1).

The constant return to photography's paternity in the sources was not simply a matter of giving credit where credit was due; it was the brick and mortar with which photography would be built as a "masculine," and male, institution. Historian Robert Nye described how

> scientific and artistic credit in an era of masculine monopoly of politics and the professions operated as a system of competition, solidarity, and gift giving between men, which not only excluded women, but made them both the muses and the objects of knowledge in men's work.[3]

Nye was discussing French doctors of the period and noted that many of them used photography in their research (e.g., Pasteur, Charcot). Across the North Atlantic world in the nineteenth century, artists, photographers, physicians, and other professionals took women as objects of study at the same time that they excluded women from the history of their disciplines.

The construction of photography's paternity at times reflected a nationalist mood, as when publication argued for the preeminence of French, British, or American actors (e.g., Daguerre, Talbot, Archer, Le Grey, Morse, or Prosch). But more often, early photographic societies and their reporters worked ardently to include the lesser-known men who developed early technologies and expressed a conciliatory cosmopolitanism (Figure 9.2). The paternity of photography would be international.

For example, William Crookes singled out Abel Niépce de Saint-Victor for acknowledgement in 1858 on the very first page of the British *Photographic News*, praising the Frenchman as "the modern Laputan sage, [who] has taught us how we may store the sunshine in our cellars," a reference to Saint-Victor's improvements on his relative's original process.[4]

LE MONITEUR

DE LA

PHOTOGRAPHIE

REVUE INTERNATIONALE ET UNIVERSELLE

DES

PROGRES DE LA PHOTOGRAPHIE

RÉDIGÉE PAR

MM. ERNEST LACAN ET PAUL LIÉSEGANG

AVEC LE CONCOURS DES SOMMITÉS SCIENTIFIQUES ET ARTISTIQUES DE TOUS LES PAYS

ILLUSTRÉE DE SPÉCIMENS DE PROCÉDÉS NOUVEAUX

TOME PREMIER.

PARIS

CHEZ LEIBER, LIBRAIRE, 13, RUE DE SEINE

LONDRES	**MADRID**	
CHEZ TRUBNER ET Cᵉ, 60, PATERNOSTER ROW	CARLOS BAILLY-BAILLIÈRE	ALPHONSE DURAND
NEW-YORK	**BERLIN**	
CHEZ WESTERMANN ET Cᵉ	CHEZ THÉOBALD GRIEBEN	
St-PÉTERSBOURG	**ELBERFELD**	
CHEZ JACQUES ISSAKOFF	CHEZ ED. LIESEGANG	

1861—62

Figure 9.1 Title page of the first volume of *Le Moniteur de la photographie* (1861–2), illustrated with heroic profiles of Niépce, Daguerre, and Talbot. The subtitling translates as, "International and Universal Review of the Progress of Photography, Edited by Messieurs Ernest Lacan and Paul Lièsegang, with the assistance of scientific and artistic luminaries from around the world. Illustrated with Specimens of New Processes."

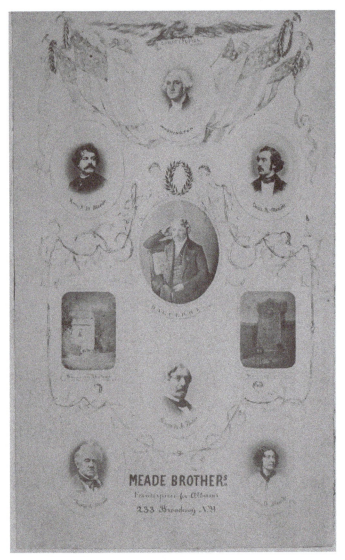

Figure 9.2 Frontispiece (faded) for albums sold by the Meade Bros. Studio (New York City, c.1862). Smithsonian curators identified the photographs below the image of George Washington (top center) as depicting the two brothers (upper left and right), Daguerre (center), a view of Daguerre's château (center-left), tomb (center-right), the Meades' father Henry (bottom left), and sister Mary Ann (right), who operated with the brothers in the studio, and became its director after their deaths. Gift of Mr. and Mrs. Dudley Emerson Lyons. Courtesy of the National Portrait Gallery, Smithsonian Institution.

A generation later, H. Baden Pritchard reconciled Anglo-French claims to the collodion process by saying, "[Gustave] Le Gray suggested collodion for photography, and [Frederick] Archer was the first to make practical use of it; but neither the one nor the other invented collodion."[5] Pritchard thereby affirmed traditional French claims to theoretical brilliance and English claims to practical genius. And although many photographers would contest each other's claims throughout the second half of the century—government pensions, lucrative patents, and national prizes were all at stake—they all saw that building a pantheon of great men of photography with generous dimensions of size and space would benefit them all.

Crookes understood that it would not be enough to mention innovators in his editorials. To instruct readers in the proper history, he inserted "A Catechism of Photography" as a regular feature in *The Photographic News* during his editorship. Using a Sunday school question-and-answer format, Crookes took students of photography through a family tree of great inventors:

Q.　Who was the original discoverer of photography?

A.　The honour of the original discovery belongs perhaps equally to natives both of France and England; but those who first reduced the art of photography to anything like completeness, were Mr. Fox Talbot, in England, and MM. Niépce and Daguerre, in France.[6]

The study of fundamentals continued in the discussion of the more recent albumen process:

Q.　Has the albumen process been long known to photographers?

A.　It has, having been used many years before the introduction of collodion.

Q.　By whom was it invented?

A.　Sir John Herschel in England and M. Niépce de St. Victor in France, who exhibited the first negatives obtained on glass by means of albumen.[7]

The "Catechism" projected a tone of even-handedness, though photography's pre-history, according to Crookes, was mainly thanks to Englishmen like "Mr. Wedgewood" and "the illustrious Sir Humphrey Davy."[8] An equally pedagogical "Dictionary of Photography" in the journal defined dozens of chemical processes, attributing them to photographic men of Germany, Italy, Britain, and France.

Crookes' mode of knowledge production, reflected in competing and subsequent photographic journals across the North Atlantic world, assured that science and technology would remain the dominant concerns discussed in the literature.[9] It naturalized the invisibility of women in two ways: conforming to a broader gendering of science as "masculine" ensured that female partners, assistants, and innovators (as mentioned in Chapter 7) would be missing from these accounts. The dominance of physics and chemistry in published articles assured, too, that "feminine" concerns and insights, as discussed throughout Part One above, would not appear in the written record. As drafted

in the early photographic literature, the genealogy of photography would consist of all fathers and no mothers. One early reporter wondered "what may not be anticipated from other as yet undiscovered processes ... in a pursuit which is engaging the attention of so many men of the highest professional and scientific attainments, and the acutest intelligence, in every part of the civilized world?"[10] The first generation of enthusiasts thus envisioned a fully-fledged, all-male family tree of photographic achievement.

Second to photography's status as a new science was the need to promote its potential as a fine art. Just as the greatest painters merited the title of "genius," so, according to the photographic press, should the best of the camera fraternity. Extolling the genius of photography was accompanied by total silence where women's contributions or points of view were concerned. For example, in Connecticut photographer H.J. Rodgers' memoir of 1872, he praised colleagues (the word genius occurred on each page of his Introduction) as the photographic equivalents of Raphael, Titian, or Correggio.[11] But in twenty-three years "under a sky-light" as a studio photographer, it seems not a single female operator, proprietor, or studio employee made an impression on Rodgers. This absence of women is somewhat surprising in a book whose author took pains to advise "women old and young" on what colors, fashions, and accessories to wear to the studio for best results. One imagines that Rodgers must have had fruitful discussions with female colleagues on how to tactfully pose uneasy sitters.[12] If this was so, he did not report them. As so often occurred in early photographic literature, women appear in Rodgers' account as paying consumers, not skilled creators (Figure 9.3).

Similarly, photographer James F. Ryder paid tribute to a number of mentors, colleagues, and competitors who populated his "fifty-two years' companionship with a camera," but he mentioned not a single female photographer, either from his adopted state of Ohio or from his frequent travels around the country.

Establishing an international, heroic, and consensual paternity of photography, then, led to the suppression of female figures in this story. Such a formula became especially apparent when the odd woman threatened to intrude into the burgeoning narrative. A strange affair in the pages of the *Journal of the Photographic Society* of London illustrates this point.[13] The story began when a certain Mr. Smith passed around some old pictures for members' inspection at a meeting of the Photographic Society in 1863.[14] The pictures had been salvaged from some waste removed from the library of Matthew Boulton, the famous industrialist who had partnered with James Watt in the mid-1700s. In their eagerness to lengthen the paternal line of photography backward in time, and at the same time strengthen its English roots, a group composed of Smith, his colleague Mr. Price (employed on the Boulton property), and members of the Photographic Society hypothesized that these salvaged pictures, some made with metal plates, others of paper, were the products of photographic experimentation going back to the 1780s.

A long discussion followed at the Society's November meeting, during which prominent members such as Dr. Diamond, Col. Wortley, and Antoine Claudet debated the likely technological origins of the pictures, many of which reproduced works of art.[15] Later, in January, Mr. Smith wrote to the Society mentioning that the paper pictures of ferns in the collection were taken by a Miss Wilkinson, Boulton's sister-in-law, and were "undoubted photographs."[16] During a visit to Boulton around 1806, a

Expression controls the shape of the face, causing it to be radiant with beauty, or dull and insipid, meaningless and ungainly. For instance, we often remark on meeting people that he or she is intelligent looking. How, I ask, can the qualities of the mind be rendered so manifestly and plainly visible, unless reflected through the material form, the face, by the moving and controlling spirit within the soul. The same is equally true in relation to the various passions, such as grief, joy, anger, hate, love, disdain, revenge, etc. Each,

Figure 9.3 Illustration in H.J. Rodgers, "To Young Ladies—How to Look Beautiful in Pictures," chapter seventeen in his *Twenty-Three Years Under a Skylight, Or Life and Experiences of a Photographer* (Hartford: H.J. Rodgers, Publisher, 1872), p. 159.

family friend recalled "Miss Wilkinson taking sun pictures on the lawn" in front of the house.[17] Smith speculated "that a camera lucida would have served Miss Wilkinson's purpose for the ferns with *such prepared* paper" (original italics).[18]

The Photographic Society, though, was accumulating letters from other sources, including the opinion of Mr. M.P.W. Boulton, the grandson of the steam engine manufacturer. Unless this statement "concerning the early date of this occurrence is confirmed by other evidence," wrote Boulton, "I should be inclined to regard it as a mistake." He continued, "I never heard till quite recently of Miss Wilkinson practising photography in any way before the time at which the process was known to the public."[19] Other family friends disagreed, notably women friends such as the sister of a

Mr. Stockdale, who gave evidence, reporting Wilkinson's use of a pre-1839 camera "in her photographic experiments."[20]

Spring of 1864 arrived and the storm would not clear. M.P.W. Boulton could not countenance the idea that his grandfather's sister-in-law was making pre-1839 photographs without Boulton's involvement, and sent the Photographic Society a two-page letter (described as a pamphlet) reiterating his view.[21] Boulton's insistence became a point of honor for Smith, who then attacked Mr. Boulton and other "snobbish" descendants, "whose only aim seems to be to erase everything by which they got their money," referring to the destruction of the old Boulton's manufactory.[22] The exchange between the two men, reproduced at length in the photographic journal, became increasingly bitter.

For the Society, the end result was group ambivalence. Members agreed that at least some of the pictures were photographic, but the dispute about Miss Wilkinson made them uneasy. The chairman quietly let the matter drop, and turned to the subject of the next annual exhibition, calling upon "brother members and others who will honour them by becoming co-exhibitors."[23] He strongly emphasized the rule forbidding any retouching on photographic entries, for the exhibition "was intended to be one of photography in the full sense of the word," rather than a hybrid of "half photography and half Art."[24] Purity and the paternity of photography thus won the day. In bringing the Wilkinson affair to light, I intend it not to serve as a corrective to the paternity of photography; rather, it shows how photographic men had to "forget" their knowledge of early women photographers in order to construct their history of photography. That a woman amateur had produced early images by light (whether from the 1780s, 1810s, or 1840s) was not identified as significant, much less celebrated, by any of the debating parties in London.[25]

Twentieth-century writers would continue to affirm, adjust, and venerate the traditional paternity of photography. Although "ladies" appear throughout Robert Taft's *Photography and the American Scene*, originally published in 1937, they were mentioned by Taft only as consumers of men's photographic services and products (Figure 9.4).

Prominent throughout Taft's text was the insertion of American men into the paternity of photography, from the prospective "Father of American Photography," Edward Anthony, to early experimentation on glass by Bostonian John A. Whipple, to Kodak's George Eastman (Figure 9.5).

Readers were treated to the names of western mountains memorializing photographer-explorers, such as Mount Watkins in the Yosemite National Park and Mount Haynes in Yellowstone National Park.[26] In a century of photographic genius, Taft argued, American men deserved their own places in the pantheon.

As shown by Geoffrey Batchen and hinted at here, the paternity of photography kept extending backwards in time, to the *camera obscura* experiments of the Renaissance, medieval optical discoveries, and even ancient Greek insights. In the celebratory atmosphere of the Columbia Exhibition of 1893, German chemist Johann Schulze was nominated the "Columbus of Photography" in the *American Annual of Photography*, for his discovery in 1727 of the light sensitivity of silver salts.[27] Forty years earlier, the president of the French Photographic Society had described fellow

A portrait awarded a gold medal for excel- Miss Jennie Lee, "a clever little actress." lence in 1871. The name of the young lady is (Photograph by I. W. Taber, San Francisco. not stated. (Photograph by W. C. North, 1875. Exposure "30 seconds, between 2 and 3 Utica, N. Y.; exposure, "30 seconds on a p. m. on dull day. The early part of the day light, clear day.") I could make the exposure in 5 seconds.")

Figure 9.4 Two of about fifteen women's portraits in Robert Taft's *Photography and the American Scene: A Social History, 1839–1889* (New York: Macmillian Company, 1938), p. 352, nine of which were of actresses and singers. None of the women's portraits in Taft's history depict photographers. Note the captions. Author's photograph from the book.

members as "the Christopher Columbuses [who] discovered a New World."[28] Or, writers gave photographic discoveries an illustrious heritage, as described by Henry Newton in 1889:

> These discoveries seem to be the offspring which nature gives us as the fruit of centuries of travail and pain. Copernicus, Galileo, Kepler, and Newton were voices in the wilderness preparing the way for the dawning light of the present time.[29]

Students of photography will notice that, up to the present day, it seems a textbook cannot begin without the author's genuflection to the trinity of Daguerre, Niépce, and Talbot in the opening chapter. Few would argue that the standardized narrative of names, dates, and places listed in the origins story suffers from factual errors. But, the scrupulousness and repetition with which each "founding father" is carefully granted his historical due by photo historians has taken on the formality of a catechism or doctrine. It is as though once the opening blessing has been uttered, these knowledgeable

Dr. R. L. Maddox, the British amateur, John Carbutt of Philadelphia, one of the whose pioneer experiments led eventually to first manufacturers of dry plates in America. the gelatin dry plate. (After a photograph (Courtesy U.S. National Museum.) reproduced in Werge, *The Evolution of* *Photography.*)

Figure 9.5 Two of about seventy-three men's portraits, mainly photographic innovators, in Robert Taft's *Photography and the American Scene: A Social History, 1839–1889* (New York: Macmillan Company, 1938), p. 365. Maddox and Carbutt's achievements are explained in Taft's captions. Author's photograph from the book.

experts of every hue are then able to move on to what they really mean to discuss. This deference to orthodoxy is the product of a century-long, masculine preoccupation that, on the one hand, helped establish the history of photography; but on the other hand, naturalized a gross imbalance of masculinity to femininity within that history, even as it forgot to mention the female participants in their story.

No Girls Allowed?

In a nineteenth-century North Atlantic civilization where gallantry toward women was expected of the modern gentleman, why did male photographers, and other experimenters assembling for the sake of "progress," prefer all-male environments in their organizations and journal staff? As we have seen, the language of fraternity and paternity allowed male photographers of the 1850s to transform their new passion into material for building a modern manliness, a manliness steeped in the new values of industrial technology, scientific innovation, and knowledge. But, this gendering process—the construction of the photographic society as a space for men—was not inevitable. As recounted earlier, photographic scholars have been reminding us for over three decades now of early women photographers' existence from the dawn of the medium onward. But in the ongoing battle to ally their identities as photographers with modern masculinity, the men organizing and structuring photography's earliest institutions had to set those women aside.

Delivering a speech to the Photographic Society of London in 1887, long-time President James Glaisher recalled that in the early days of the Society, "a number of ladies were always present, and well I recollect a Mrs. Spottiswoode, a lady of highly cultivated mind, and artistic feeling, used to give valuable criticisms upon the pictures."[1] Glaisher may have felt wistful on this occasion, a banquet during which he accepted a marble bust of himself commissioned by the Photographic Society. Over the course of Glaisher's thirty-three years in the Society, he had witnessed not only the disappearance of Mrs. Spottiswoode and the retreat of other early women amateurs, but, concurrently, the rhetorical triumph of a Victorian doctrine of "separate spheres."[2] It had taken thirty years of discursive labor—undertaken at Society meetings, sponsored exhibitions, in the pages of the affiliated journal, and other publications—to gender photography as "masculine." Although the masculinity of photographic societies would be challenged in the period after Glaisher's speech, notably by new amateur clubs and the leadership of women photographers in the United States, he nevertheless felt moved to lament what seemed a hardened preference for all-male meetings by his colleagues (we will return to President Glaisher in the next chapter).

Despite photography's unbounded novelty in the nineteenth century, it followed the pattern of other arts and sciences in the West during the period—that is, an institutionalization by male champions. Early photography's freedom from academic, professional, or state control, while allowing women to take up the new art in amateur and professional roles, did not prevent a masculine monopoly over its leadership,

precisely as was found in state-sponsored painting, geography, or science (e.g., the Royal Society). Why did such a new craft follow the old pattern? More broadly, why was it so important for these male champions of photography to have all-male assemblies?

The discipline of anthropology has often grappled with the phenomenon of the sexes' social and economic segregation, whether it be mutual, partial, or enforced with violence. The anthropological question at hand may be as follows: In order to become men, why do males banish the presence of women from their rites and rituals? Anthropologists, sociologists, and psychologists have all observed a "tendency of men to feel more at ease in other men's company," or in other words, "male homosociability" across cultures globally.[3] Men's and women's groups form spaces and rituals where the work of gender identification and norming takes place.[4] In all-male sub-groups, anthropologist Mary Douglas observed what she termed a "Delilah Complex," in which residual (primitive) fears of feminine pollution threatened male strength, virility, and superiority.[5] The distinguished men of the Victorian photographic societies likely would have scoffed at such a diagnosis, though Douglas insisted that ethnographic study of pollution and taboo around the globe can illuminate behaviors in the so-called civilized world.

Feminist historians have shown that sex-segregation has not simply been the innocent division of labor (or recreation) in complex societies. It has also allowed patriarchal societies to concentrate resources, honors, and power in the spaces allocated for men. Making learned societies into gentlemen's private clubs was a key development in that process. The gendering of certain spaces, in conjunction with the post-revolutionary "sexual contract" between husbands and wives, and the doctrine of separate spheres, would teach many (never all) women with scientific or artistic talents to keep their productivity "private" and thereby unacknowledged in the historical record.

In tandem with this gendering of space in the nineteenth century was the continued reinforcement of fine art and science as "masculine" in Europe and America. Scholars have shown the importance of such gendering work taking place in Europe since the Renaissance.[6] Photography would play a unique role in reinforcing art and science as "masculine" because the medium combined both domains. The social ascent of the man of science began early during the Industrial Revolution, according to historian Christine MacLeod. Although MacLeod framed her arguments around class and nation rather than gender, her discussion of a "new Prometheus" in industrializing Britain (that is, the figure of the inventor) signaled that this modern figure of the innovator would be male.[7] The success of inventor-businessmen like James Watt, George Stephenson, and Henry Bessemer, measured by the commemorative statues, portraits, songs, biographies, and patronage devoted to them in the nineteenth century, assured that "technical achievement and utility"[8] were now the manly aspirations of a growing class of educated or autodidactic men, not just in Britain but throughout Europe and America. The new heroes of the Victorian Age would be a different sort from the bishops and generals on horseback celebrated from early modern history, but they would, their proponents promised, still be manly men.

Combining art and science, photography also quickly became a potentially lucrative career that, North Atlantic men insisted, required protection. Historian Angela John

reminded us that there has been "a long history of struggle over male craft control, a struggle revolving round mechanization yet fundamentally concerned with the preservation of patriarchy and power."[9] In the context of photography, this craftsmen's struggle occurred twice: in the early decades, as photographers combatted critics' accusation that photography required no artistic skill (thus introducing a derogatory, low-skilled "femininity"); and later at the turn of the century, when Kodak and other streamlined systems threatened photography's professional and artistic status once again.

In the eyes of some well-meaning observers of the period, photography seemed friendly to "feminine" talent and industriousness. Early observers recommended photography to women as a supposed "minor" art, like embroidery or sketching, requiring no "manly" genius, as a wholesome activity they could perform in the home. Later, with the dry plate and roll film, amateur photography became an appropriate hobby for women and especially mothers.[10] This creeping "femininity" caused the fraternity to double down on the medium's complex, scientific, and artistic nature, the purview of men during the period.

One of the most important techniques for asserting photography's seriousness, both as a science and a professional pursuit, was the establishment of strict rules and hierarchies in the early photographic societies. As discussed in Chapter 8, male enthusiasts worked together to establish constitutional republics complete with elected government and detailed statutory rules. Within these photographic republics, the executives, or council members, alone controlled both the agendas of individual meetings and the broader, longer-term priorities of the society. This rule was enforced in the way speech was controlled at meetings, and in the content of the society's published journal. The council of the London Photographic Society for example, composed of president, three vice-presidents, secretary, treasurer, and nineteen other members, ruled "that no communication shall be read unless previously approved of by the Council."[11] In many of the early societies, there was also a hierarchy of membership, as in the French Photographic Society, which elected *membres titulaires* (full members), *membres correspondants* (often members at a distance, but in order to become a *membre titulaire* one had to first be a *membre correspondant*), and *associés amateurs*.[12] Like the London Photographic Society, the French council controlled agendas, and a second committee under the council, a *comité d'administration*, controlled the contents of the society's *Bulletin*.

Every type of membership required sponsorship by already-elected members in good standing with the society (usually two).[13] Without the concerted campaign of a husband, brother, and/or father who was already a member, then, a North Atlantic woman, without a profession, without scientific notoriety, or her own money, was unlikely to get elected to these national photographic societies, which prided themselves on the eminence of their members. One might suppose, too, that a woman who depended on a male relative for a chance of entry might have refused the chance for fear of being looked down upon by "legitimate" members. There was a secret "blackballing" system, moreover, with which members could veto the election of a member-candidate.[14] The early societies were thus perfectly designed to keep all but a tiny handful of women out. As we will see in the next chapter, a female society member, having won election, actually *appearing* at a regular meeting was exceedingly rare.

There are several reasons why the small group of women members either did not attend club meetings or attended in silence, which will be discussed in Chapter 11. In terms of placing obstacles in the way, though, I want to mention that the meetings of the photographic societies, whether English, French, or American, operated around what sociologist Joan Acker termed "the time patterns of men." For some twenty-first century students in the North Atlantic world, such a concept might appear puzzling. But not so very long ago, families that did not enjoy a staff of servants expected the woman of the family to take most of the responsibility for childcare, cooking and feeding the family, nursing, and cleaning the household. Acker discussed gender expectations within trade unions as recently as 1999:

> Meetings that occur after work when many women need to be at home cooking and caring for children, expectations that union activists will be available to go to weekend workshops far from home, and negotiation sessions that last long into the night are all problematic practices for women with families.[15]

Admittedly, the class makeup of early photographic societies was different from that of trade unions, but the difficulties alluded to were similar, so Acker's description is thought-provoking. Victorian women's domestic duties did not leave them free to commit to participating in organizations whose meetings were scheduled for men's convenience at night.

Even middle-class women who commanded the labor of servants (in terms of cooking, for example) nevertheless had child care, sick-nurse duties, and obligations toward extended family that made participation impractical. As with unions during the period, the photographic society "was constructed on the presumption that members were nonmothers."[16] But even in cases where servants freed women from evening tasks, their families would have been shocked if these women went out alone at night. As we will see later, the idea of women participating in recreational associations, especially at night, provoked the disapproval of observers and family, so that, unless the meeting was devoted to service for others (e.g., children, the poor, the Church), single and married women were supposed to feel guilty for such indulgences. Amazingly, and despite such proscriptions, North Atlantic women's growing desire for inclusion ensured that a certain number of "Miss" and "Mrs." appeared on the list of photo club membership from the 1860s to the 1890s, and especially after 1890.[17]

In both the nineteenth and twentieth century, "male-dominated social structures/ institutions were implicitly defined as if they were gender neutral."[18] Acker added that the invisibility of gender in organizations requires (and required) "ideological formulations that obscure organizational realities, including the pervasiveness of male power."[19] Unlike the proverbial treehouse, then, the sign for "No Girls Allowed" was not always explicitly nailed to the door. Occasionally, though, a photographic society member or writer would be unable to suppress the sentiment and voiced his hostility. A series of letters appearing in *The Photographic News* in 1889 does much to reveal gender anxieties just at the "tipping point" in North Atlantic women's early emancipation movement. A letter to the editor, signed "Perplexed,"[20] although seemingly friendly toward the idea of women's participation in

photographic societies, laid out many of the fears that haunted the men in these societies.

"Perplexed" wrote of an unnamed photographic society, composed of seventy male members, which had debated the subject of allowing women to become members, with no satisfactory resolution. The author or the letter reproduced the seven objections given by fellow members who had voted against the measure, as follows:

1st. All members are admitted by latchkeys.

2nd. That the rooms are open thus at all hours to members.

3rd. That the dark room is likewise open to all comers.

4th. That smoking is permitted and indulged in by members.

5th. That the privilege existing of allowing members to bring out from their lockers alcoholic refreshments proves another source of objection.

6th. That when lady members were admitted it might by the wives of certain married members be regarded as a club of objectionable character, just below a certain place of entertainment to which women members had free access by latchkeys at all hours.

7th. That jokes of varied kinds would arise and tend to lower the reputation of the Association as now existing.[21]

With the risk of the society disintegrating over the matter, "Perplexed" reported that the resolution was shelved by the council. What were the real concerns behind these seven opaque objections? The first three objections (and the sixth objection) point to a problem with the idea of women photographers freely entering and leaving the premises. A woman's freedom of movement created the possibility of sexual impropriety (an unsupervised dark room open at all hours).[22] The fear of sexual impropriety was also one of the rebuttals against women's demands for full access to a university education during the same period, which remained an all-male preserve into the twentieth century.[23] Perhaps because this provincial photographic society would not have been as elite in its membership as the soon-to-be Royal Photographic Society[24] in London (that is, "gentlemanly"), objecting members either did not trust themselves or others in the club to interact with women appropriately.

On the subject of latchkeys, the idea, in itself, of women holding door keys that allowed them to come and go as they pleased rankled their male guardians. An American poem by Harold R. Vynne complained at the end of the century:

Mothers of families would stay out late
 And walk queer circles on the parlor floor
When they came home, or noisily berate
 Their latchkeys when they wouldn't open the door.
Mine own sweet wife a fond farewell had said,
 And blithely cantered off unto her club,
Leaving poor me to put the babe to bed,
 And after that to iron, cook and scrub.[25]

Vynne's poem expressed the fear that the freedom given by the latchkey would allow women to neglect their domestic "duties," in other words the unpaid labor that wives and unmarried daughters provided in exchange for being supported by the man with whom they lived—what we might call the "sexual contract" of nineteenth-century marriage.[26]

Judging from published cartoons, jokes, and stories of the period, if there was one thing that North Atlantic men agreed on, it was their anger at the prospect of having to do such work themselves once female emancipation had arrived (Figure 10.1).

The logic of the period, across the North Atlantic, was that as women claimed the "masculine" privileges of public life, men would somehow be forced to take up the domestic slack, which would unman them. This gender anxiety was the flip side of the worshipful praise of Coventry Patmore's "Angel in the House" (written from 1854–1862), the era's ode to feminine domesticity.

Two of the objections aired by "Perplexed" dealt with a desire to smoke and drink alcohol, which during the period were explicitly "masculine" pleasures. As January Arnall noted for the Chicago camera clubs of the period, "It certainly would not have been seemly for an upper or middle-class woman to be in a space with men, booze, and smoke."[27] In fact, there were certain regions where the law forbade women from smoking, or barkeeps from serving women.[28] Just as bourgeois and titled ladies withdrew from the dining room or order to let the men smoke and drink alone (hence the aptly named "drawing room" to which women retired), enjoying single-sex

Figure 10.1 Lithograph published by Currier & Ives, New York, "The Age of Iron: Man As He Expects To Be" (1869). The man on the left is the husband, the one on the right is a servant. Usually, female servants did the laundry. Cartoons with similar scenarios also appeared in Britain and France throughout the period. Courtesy of the U.S. Library of Congress.

conversation until the men of the party came to join them, so the men's club, of whatever type, heightened its "masculinity" in a cloud of smoke and liquor-induced informality (Figure 10.2).

Behind the objectors' reference to smoking and alcohol was the fear that if women were present, propriety would prevent them from casting their inhibitions aside, which would considerably lessen their enjoyment of the evening.

The sixth and seventh objections implied that the presence of women would sully the tone and reputation of the photographic society. In a published response, Catharine Weed Barnes asked if these gentlemen "consider a photographic club a place which cannot be frequented by ladies without loss of self-respect or the respect of others?"[29] If respectable women stayed at home, so went the logic of the objection, then women

Figure 10.2 Greyscale rendering of a chromolithograph by H.A. Thomas & Wylie (1890) depicting the bar at the Hoffman House Hotel in New York. Although a public hotel, the picture included the relaxed drinking, smoking, and conversation of a nineteenth-century gentleman's club. The large painting of mythical nudes on the wall reproduces William A. Bouguereau's, "Nymphs and Satyr." Courtesy of the U.S. Library of Congress.

who went out at night (meetings were held after the breadwinner's work day was done), and in particular, women unaccompanied by a husband or a father, must be tarts. The objecting faction rather cowardly implied that it was members' wives, not necessarily themselves, who objected to meetings being open to women. Respectable wives, one is to suppose, would suspect the meeting of being nothing more than an excuse for carousing, resembling an unnamed "place of entertainment" (music hall? brothel?) in the objection.

Beyond the unflattering characterization of women in such a scenario (cast either as tarts or as sexual police), the fear of puerile snickering voiced in the final objection reported by "Perplexed" might strike us today as simply pathetic, rather than as proof of intent to suppress women photographers. But, however petty these objections were, and indeed "Perplexed" was arguing they were petty, they voiced deep-seated insecurities that were not unique to one particular English photo club. The effect of these objections was to keep women out of the photographic society, and, I would argue, photographic societies more generally, even when the letter of the law said "ladies were eligible" for membership.[30]

Following "Perplexed," another anonymous reader wrote to *The Photographic News* in disgust:

> Sir,—Being a member of the same Association as "Perplexed" . . . I think it very bad taste on his part to drag this matter into public; I am sure the members have had enough of this in their own debates. Many of the oldest and most interested members of the Association referred to strongly object to this scheme being introduced, and yet its promoter has not the good sense to let the matter drop, but continues to bring it forward, which, I fear, will lead ultimately to the injury, if not dissolution, of the Association.[31]

Perhaps the reason why the issue was so contentious in this particular photographic society was because many new amateur clubs arose in the 1880s that women were joining with greater confidence that in the past. But this "perplexing" controversy was not quite over. A third correspondent, writing under the pseudonym "Nemo,"[32] concluded: "I hold that a body of gentlemen associated for any purpose whatever have a perfect right to decline to admit ladies without being morally compelled to give any reason for such a declension at all. It is absurd to suppose the contrary."[33] With that, the matter was dropped from the pages of the *News*. If there were any women photographers who had followed the kerfuffle and wrote to the editor with their opinions, their letters were not published.

Although much conspired to discourage women from joining early photographic societies, and discouraged women members from attending meetings in person, there were certain society events that the male leadership warmly encouraged women to attend as guests. Society councils and ordinary members desired the presence of wives and daughters at annual celebrations and dinners, to which women added sparkle in their finery for the evening. Audiences at annual *soirées* were routinely addressed as "Ladies and Gentlemen," the women in the audience more often being guests of members rather than members themselves.

The presence of lady guests became so customary, that when they were missing, the leadership voiced its regret. The president of the Union Nationale de Sociétés Photographiques, Jules Janssen, spoke for the group at a branch banquet in Nancy: "We are sorry that a recent bereavement deprives us of the presence of Mme Riston; her presence encouraged the other ladies, and we will return to a tradition that, for my part, I hope will continue: the presence of our dear companions at our banquets."[34] The duty of mourning, even late in the century, was one of the many family obligations that made participation in photographic societies more difficult for women in France and elsewhere. Nevertheless, societies in Britain, France, and the United States agreed that members' wives adorned their social occasions.

Other times when women found welcome at the photographic society was as audience members during lantern lectures (Victorian slideshow technology) or during special outings. A contingent of the South London Photographic Society, for example, reported on a photographic picnic, undertaken in April of 1860. Unlike such excursions after 1890 when women amateurs joined men as members on an equal basis to photograph the picturesque outdoors, in 1860 it was understood that women friends served a strictly ornamental purpose. The reporter depicted the female excursionists as totally uninterested in photography, even exasperated by it, "and their pretty lips pouted at the idea of *photography* in connection with a *pic-nic*."[35] Like the rustics whom the party encountered on the excursion, the women's only contribution to the camera work during the trip was to spoil exposed plates by walking in front of the lens at the wrong moment.

The rhetorical impact of such a tale affirmed the gendering of photography as "masculine" (e.g., serious, technical, requiring physical stamina), and sent the message to female readers (for there were a good number)[36] that their interest in photography might be "unfeminine" in comparison to the "ladies" who supposedly disdained the camera. "Masculine" institutions "encouraged a more passive, 'feminine' role as consumers of the products of photography" for women."[37] By and large, photographic societies welcomed women in three types of scenarios: as beauty objects to be admired on social occasions (sessions of real scientific discussion were purged of women and femininity); in *statu pupillari* at open lectures or exhibitions—a role that mirrored the pupil-master dynamic of the ideal Victorian marriage; and as paying clients of the photographers' services (as studio customers, the target market for manufactured albums, jewelry, and trinkets advertised in the photographic magazines of the period). More broadly speaking, most men expected women to be the consumers rather than producers of photographic knowledge or photographs themselves.

The picture of early photographic societies that emerges, then, is one characterized by exclusion, condescension, or chauvinism if not misogyny. But if we turn our eyes from the printed narrative, the story gets more complicated than that. Margot Horwitz has explained that nearly a century before the days of women's liberation, "some husbands were understanding of their wives' need for self-expression."[38] Away from the public proceedings of the chartered societies, in the intimacy of the home studio and darkroom, many a young woman received her first lessons in photography from fathers, uncles, or husbands who loved them, and who had every confidence in their abilities.

The English Anna Atkins (1799–1871) and the American Emma Sewall (1836–1919) both had fathers who were scientists, who encouraged their daughters to learn photography with them.[39] Contemporaries Julia Margaret Cameron and Clementina Hawarden both had husbands who either encouraged their wives or blessed their activities with benign neglect. Cameron praised her husband, Charles, in her autobiography:

> My Husband from first to last has watched every picture with delight & it is my daily habit to run to him … with every glass upon which a fresh glory is … newly stamped & to listen to his enthusiastic applause. This habit of running into the dining room with my wet pictures has stained such an immense quantity of Table linen with Nitrate of Silver indelible Stains that I should have been banished from any less indulgent household.[40]

Charles Cameron patiently posed for his artist-wife on several occasions, even playing King Lear in one of Cameron's literary compositions (Figure 3.5).

Staten Island photographer Alice Austen (1866–1952) learned the art of photography from two generous uncles, who provided her with a camera, instruction, and even built her a darkroom at their shared home, Clear Comfort. For Austen, who never married, support from extended family allowed her to ignore the disapproval of others in their social circle.[41] The young men of Staten Island (frustrated suitors?) referred to Austen and her friends as "the Darned Club," but such teasing did not deter the photographer or her models.[42]

A French contemporary of Austen, Jenny de Vasson (1872–1920), had an artistic father and encouragement from a family friend, the painter Bernard Naudin.[43] A sort of provincial Lartigue,[44] de Vasson photographed family, friends, and farmers, and even soldiers departing for the front in 1914. Her biographers likened her also to the German portraitist August Sander, saying that although she was never recognized as a photographer during her short lifetime, she possessed "a talent infinitely superior to many professionals" of her day.[45] There were also occasions during the period when a wife, having taken up the profession, taught the husband the secrets of the darkroom, rather than the other way around.[46]

While at the institutional level, photographic societies ignored female potential so as to strengthen their "masculine" identity, at the personal level men and women sometimes worked together, whether in business (at the family studio) or for pleasure. Unfortunately, the sisters and wives who restricted their work, and their opinions, to the private sphere forfeited their places in the historical record. Women's compliance with the taboo against female publicity led both to their future invisibility, and to a tenacious imbalance in the historiography. Future historians of photography could help correct this imbalance by revealing in greater detail how family members learned and practiced early photography together.

Feminine Silence

Despite the eligibility of "ladies" for membership in clubs like the Photographic Society of London or the Photographic Association of America during the nineteenth century, and the sympathetic rhetoric of club leaders like London's James Glaisher, women photographers stayed away in droves until the end of the century. Before the 1880s, moreover, women declined to establish their own, single-sex photographic societies.[1] Why was this so? Students and experts in other areas of cultural history will point out that the prescribed "femininity" of the period discouraged middle-class girls from dabbling in any pursuit for which they might be labeled "bluestockings" or "strong-minded." Because there were technical and scientific aspects of photography (disciplines gendered masculine), women photographers—even amateurs—risked accruing such undesirable labels.

Middle-class girls competing in the marriage market distanced themselves from anything that might frighten away suitors.[2] This scenario played out in the fate of the fictional character Fanny Bouncer, a young woman photographer in Cuthbert Bede's comic novel, *Mr. Verdant Green* (1857). Put off equally by Fanny's camera and her rambunctiousness, the hero pursues the more retiring Patty, despite the fact that Miss Bouncer is "both good-humoured and clever."[3] The lesson would not have been lost on Bede's readers: an "overactive" intellect or imagination, whether it was absorbed by photography or some other technical hobby, was "unfeminine."

Beyond the risk of appearing "unfeminine," women living with their fathers (or husbands) would have had to gain explicit permission to join a club, and given money for club dues, from their male guardians. The reality was that most women were beholden to the rules and expectations set forth by fathers and husbands. Only a minority of progressive family men would have encouraged their women to attend evening meetings where contact with unapproved, unknown men was a certainty.[4]

As we have seen, moneyed and upper-class women with guaranteed life incomes were more prone to take up the hobby in the early period. There were many wealthy ladies in the 1860s who were members of the London Amateur Photographic Association, such as Lady Matheson, the Countess of Uxbridge, and Lady Jocelyn.[5] Middle-class women with uncertain prospects took up photography as a source of income across the North Atlantic world. But only a tiny fraction of women, amateur or professional, spoke or wrote as a photographic society member before 1880 or 1890. The self-portraiture, photo-collage, and photographic self-promotion created by women discussed in Part One, moreover, did not evoke public comment or acknowledgement during their lifetimes.

Nevertheless, a number of French and British women submitted their pictures for society exhibitions before 1880, which might at first strike us surprising. This form of participation (exhibiting pictures), though, required no public speech or appearance. And when a woman artist's work was occasionally hailed by her photographic society (e.g., Lady Hawarden's in the 1860s), this praise was never followed by invitations to join the society leadership, or even to deliver an address about her work.[6] If North Atlantic women ever tried to follow up their successes with attempts to be more active in their photographic societies, we have no record of it before 1890. In making up for their intrusion into the "masculine" spheres of fine art, science, or professional life, possibly women photographers recouped their "femininity" through their public silence. Lady Hawarden, briefly a darling of the London Photographic Society, proved exemplary in that respect by dying before she could claim her 1866 exhibition medal in person.[7]

In what was this nineteenth-century "feminine" silence grounded? This chapter will use insights from women's history, sociology, psychology, and photo history to better explain women photographers' absence, and "femininity's" invisibility, from photographic discourse during the period, even as female workers and amateurs mastered the medium in their homes and workplaces. In part, this is a story of residual prejudices in a period that saw Judeo-Christian civilizations gradually, and unevenly, secularizing. Even as secular culture gained ground during the nineteenth century, religious belief, with the weekly church attendance, Bible reading, and notions about the afterlife that it inspired, remained a guiding force for millions of North Atlantic men and women. Catholic and Protestant populations— even the non-believers within them—internalized the dictum of Church Fathers that women should be silent in public. In I Corinthians 14:34–35, Paul clearly states,

> the women should keep silent in the churches. For they are not permitted to speak, but should be in submission, as the Law also says . . . If they wish to inquire about something, they are to ask their own husbands at home; for it is dishonorable for a woman to speak in church.[8]

Similarly, I Timothy 2:11–12 says, "Let a woman learn in quietness and full submissiveness. I [Paul] do not permit a woman to teach or exercise authority over a man; she is to remain quiet."[9] These were commands that ran deep in the Judeo-Christian tradition, and which neither secular notions from the Enlightenment nor the new urban realities of industrial society would shake off easily. The emergence of the emancipated New Woman throughout the North Atlantic world in the 1890s provoked stern reprovals from the conservative press. As late as 1894, *Truth* magazine, reacting to women's greater presence in public life, resorted to religious objections:

> By the way, does the advent of the "New Woman" signify the second Fall? In disobedience to every law of experience has woman been betrayed again into tasting of the tree of knowledge, and is the whole of the painfully established system which we now enjoy to be upset in consequence?[10]

By "we" the writer presumably referred to the men who benefitted from this "established system," wherein they alone enjoyed the power that came with scientific knowledge

and professional accomplishment. The writer's reference to biblical wisdom was only one source, in addition to girls' education, plays, songs, family life, and each other's speech, which made it plain throughout the century that good girls (of whatever age) did not buck against traditional strictures.

Despite a deeply-rooted aversion to women speaking and acting in public, women all across the North Atlantic world nevertheless established a plethora of clubs and associations for themselves during the period, including political and professional organizations. Their leadership in an impressive array of privately-run social services, religious organizations, and advocacy groups for female employment, temperance, public health, and abolition has been well-documented. But although husbands and all-male governments permitted them, and they permitted themselves, to expand the domestic sphere into the public one, their clubs were expected to be philanthropic rather than professional or even recreational.[11] Commentators, clergymen, and other guardians of social norms endorsed women's church-based charities, children's welfare groups, and hospital fundraising organizations because they conformed to the "feminine" ideal of selflessness. But the idea of women (or girls) leaving the bosom of the family to enjoy themselves at a recreational or knowledge-producing association was more controversial. Family responsibilities and expectations discouraged most women from participating in recreational or learned societies until the end of the century, even if some women were nominal members of such societies.[12]

Social scientists have offered several theories why, traditionally, women and girls have been hesitant to speak up in public, mixed groups, even well into the twentieth century. Psychologist Cecelia Ridgeway, for example, pioneered the "status expectations" theory, which shows how gender stereotypes reinforce the belief that men are "diffusely more competent than women," which in turn "affects who is listened to ... who is judged to have the best ideas or the most ability, [and] who rises to leadership."[13] This theory might be relevant for a Victorian period when photographic leaders would have assumed female incompetence when it came to technology, chemistry, and mathematics—all of which early photography required.[14] Status expectations were, ironically, confirmed every time a club president like James Glaisher deplored the absence or silence of female members at meetings. His recorded comments highlighted the assumption in place, even if not shared by Glaisher himself (whose wife Cecilia was an amateur photographer), that women were technologically incompetent and would mar the serious intent of the photographic society.

During a gathering in 1887, Glaisher hypothesized, "I have noticed that when a lady is by herself at meetings she feels isolated, which feeling of isolation is removed if a second lady be present." But he assured, "a hearty welcome is always extended to ladies from the Presidential chair, and ladies should not think themselves alone when I am in the room."[15] Although well-intentioned, Glaisher's comment provoked "cheers and laughter," a response to perceived innuendo, rather than the members' approval of the sentiment, which would have been recorded with sober "here-heres" or applause. Women in the audience who heard the men's reaction (the women were guests for a celebratory evening only) would have heard the underlying message. In such interactions, Janet Chafetz observed that as women's self-confidence, prestige, and power in group interactions sinks, the level of male power and status rises. Sociologists

have shown that this gendered dynamic continued uninterrupted until a critical mass of objections coming from the women's movement intervened in the mid-to-late twentieth century.

In the 1970s, anthropologist Edwin Ardener's theory of "muted" groups explained that for such groups (women being just one), their "model of reality, their view of the world, cannot be realized or expressed using the terms of the dominant male model." As a result, women's utterances "are oblique, muffled, muted."[16] Nineteenth-century photography provides a good example of this anthropological phenomenon. As we saw earlier, women were using cameras and photographs in a variety of ways from the 1840s on, as professionals, amateurs, assistants, and consumers. But, the realities of women's lives, or the "feminine" perspective that some of them brought to their imagery, made participation in the male-dominated structures of photography—the official societies, journals, and legal frays where patents and copyright were fought over—prohibitive before 1890. Historically, the result was often silence and invisibility.

Building on Ardener, Henrietta Moore said that in a situation of male group dominance, the "free expression of the 'female perspective' is blocked at the level or ordinary, direct language. Women cannot use the male-dominated structures of language to say what they want to say, to give an account of their view of the world."[17] Silence characterized a group's voluntary self-exclusion, or the dominant male group might formally exclude the subordinate group. Karen Blair offered a historical example of the latter phenomenon in her account of the formation of Sorosis, a professional organization for American women established in 1868.[18] When the all-male New York Press Club refused entry to women journalists during a dinner given in honor of the visiting Charles Dickens, columnist Jane Cunningham Croly and her colleagues established, in response, the Sorosis club for women journalists and related professionals.

Addressing the question of whether to form an all-female or an integrated club, "Croly said women should work and work alone 'because men would overpower them if they tried to work together.'"[19] Shortly after, when the men's Press Club invited Sorosis members to a breakfast in an attempt to make amends for the Dickens affair, the men "never let their guests utter a word during all the [men's] speeches and toasts."[20] Alongside the standard sexual discrimination of the period, then, traditionally all-male organizations, however liberal their rhetoric, had little genuine interest in listening to women's voices. In the case of photography, moreover, it was assumed by all but the most progressive-minded individuals that women would not be able to make head or tail of the science debated at these meetings, where discussions combined chemistry, physics, and camera engineering.

Knowledge-seeking women during the period had to be autodidactic when it came to the arts and sciences, or else men in their family saw fit to initiate them, since the education provided by governesses or finishing schools was often shallow. The Irish intellectual Frances Power Cobb, for example, reflected on the girls' school she attended: "That a pupil in that school should ever become an artist, or authoress, would have been looked upon ... as a deplorable dereliction." She continued, "Everything was taught us in the inverse ratio of its true importance."[21] There is no space here to discuss the ethos of the period that said that truly educating girls in science and math would ruin them as future wives. What we can infer, though, was that even a brilliant

autodidact along the lines of Miss Cobb would have lacked the confidence to establish a photographic society for women.

To British, French, and American women, it would have seemed clear that men, not women, had made the discoveries and inventions for photography, and that therefore the male sex held control over the required scientific knowledge. Girls interested in photography turned to fathers, uncles, or husbands to instruct them at home. They shared their male relatives' photographic journal subscriptions, and silently absorbed the lessons of their own private experiments. When open to them, women and girls attended lectures on photographic chemistry, as at the National Photographers' Association meeting in Cleveland (1870). NPA President Bogardus noticed that during discussions of chemistry at the conference, a "large attendance was present, and in the audience were several ladies taking an attentive part in the proceedings."[22] Most likely, these women were commercial professionals seeking to build on their knowledge.

Middle and upper-class girls may have received some scientific education, but familiarity with the chemical laboratory was the rare attainment of daughters who assisted their scientific fathers or husbands (or, as in the case of Dorothy Draper, their brothers). Such lucky women did exist, and they helped populate the audiences for public scientific lectures throughout the period. Scientific women, though, made up only a portion of all the women who were interested in early photography. In the early period when chemical expertise dominated discussion at photographic society meetings and in the journals, when the force of *yang* in photography meant an emphasis on the penetration, truthfulness, and conquest of the camera, there was little space left for notions of photographic play, theatricality, or tactility. Conversant in the male idiom, a few photographers like Oscar Rejlander and William Lake Price could slip their fancifully staged, literary compositions into Photographic Society discussions. But women, raised and educated to keep their speech private, would not have perceived such institutions as a forum for "feminine" photographic interests like photo-collage, self-portraiture, or *tableau vivant*.

The "mutedness" observed in subordinate groups by anthropologists has also been discussed by social scientists who contrast men's "speech games" with those of women. In introducing a theory of speech games and "moves" in public speech, Nina Eliasoph pointed out "how the seemingly neutral bureaucracy systematically constructs barriers to women's typical speech, if the appropriate language games played . . . [are] ones men like to play."[23] Eliasoph explained that child rearing, schooling, family life, and other factors contributed to gendered speech (she was writing in the 1980s), so that women tended to be more fastidious than men about politeness, avoided posing direct questions, made requests rather than commands, refrained from interrupting, hedged, and sprinkled speech with apologies. Putting it bluntly, Eliasoph wrote that whereas the name of the man's game was "Have I won?" (i.e., have I appeared sufficiently expert), the women's game (especially apparent in women-to-women speech) was based on "collaborative building."[24]

A concrete example of men's "speech games" codified into rules may be found in the popular parliamentary procedure manual that originated in post-Civil War America, *Robert's Rules of Order*. The transactions of nineteenth-century photographic meetings, with their top-down agendas, executive hierarchy, voting procedures, and formal

speeches, evoke the same spirit as *Robert's Rules*. Full of detailed regulations for speaking, ordering meetings, and ranked types of motions, the American manual, a robustly *yang* creation, was written by and for men in the public sphere.[25] It is safe to say that General Henry M. Robert did not take into account when, why, or how women communicated, as men of the period did not expect women to speak in public, even though, as mentioned, a variety of women leaders did.[26] And yet, *Robert's Rules* remains the bible for formal meeting procedure in the United States and beyond.[27]

Reading the minutes and reports of the photographic societies of the same era as *Robert's Rules*, we see that similarly formal procedural rules—so-called masculine speech games—ordered the transactions of learned societies in Britain and North America. An early meeting of the Manchester Photographic Society, for example, showed a preference for orderly authority:

> After some preliminary business, the Honorary Secretary read a short paper entitled "Suggestions for a Photographic Exhibition," embodying the views of the Council; after which an animated discussion took place on some of the points, which ended by propositions being made and carried unanimously, that the Society should leave all arrangements in the hands of the Council.[28]

In fact, the rules and regulations guiding annual exhibitions in Britain and France became, over time, a site of some rancor. Hanging committees held the power to promote, obscure, or exclude photographic work (as in the traditional salon of the Academy), leading to occasional displeasure from members. Although "animated discussion" might protest Council policy, the rules of order at society meetings enhanced executive power and control.[29]

What happened when a woman photographer dared to speak at a photographic society meeting? There were sociological, psychological, and historical reasons why such a thing rarely occurred before 1890, despite the existence of successful amateur and professional women workers. One occurrence in 1869, however, provides an intriguing example. Whether by writing a request from her home on the Isle of Wight, or through the good offices of friends, or both, Julia Margaret Cameron managed to get on the agenda of a London Photographic Society meeting, of which she was a member, in May of 1869. Knowing beforehand of Mrs. Cameron's visit, the chairman at the meeting, James Glaisher, "remarked that he had often regretted that ladies so seldom attended the meetings of the Society. He was glad to see that two ladies were present; and one of them, Mrs. Cameron, wished to say a few words to members."[30] Cameron's presentation, soliciting advice from fellow members concerning the appearance of cracks in her glass negatives, must have had an extraordinary effect on the room. Never before, and never again until the 1890s (and then rarely) had a female member of the Society held the floor during a meeting.[31] Cameron's appearance seemed to justify the perennial epithet—"eccentric"—that writers used for her then and even now.[32]

What made Cameron eccentric was her refusal to acquiesce to the "masculine" gendering of the photographic society, or the medium writ large. During her short career as a photographic artist, Cameron regularly submitted her pictures for display at European exhibitions, brushing off fellow photographers' negative criticism by saying

that it "would have dispirited me very much had I not valued that criticism at its worth."[33] Cameron paid more attention to her reception by art critics, which was more positive. For a technical problem, however, she knew the photographic society was the perfect place to turn, and at least seven men at the springtime meeting offered Cameron diagnoses of her problem, as recorded in the Society's journal. They ascribed the cracks to her collodion mixture, her varnish, the moist climate at Freshwater (her home on the Isle of Wight), and other possible factors. Chairman Glaisher, diligently moving the agenda along, thanked Cameron, and then introduced the next speaker, Captain E.D. Lyon, who would read a paper on "Photography in India."[34] Lyon's "masculine" subject would have interested Cameron, who was born in India, and whose last photographs would be made a few years later in Ceylon.

Cameron's brief appearance that evening in the London Society's rooms on Conduit Street provokes several questions. What did the masculine gathering make of this middle-aged woman who dared to think she might contribute to the production of new knowledge, the lofty purpose of Victorian Britain's galaxy of learned societies? Who was the second woman with Cameron mentioned by Glaisher, and did Cameron's boldness give the mystery woman more confidence to speak on other occasions? Having managed to get on the meeting's agenda, and perhaps knowing that Captain Lyon's five albums of negatives from southern India would be shown, Cameron felt it worth her while to travel to London from her home, a distance of about one hundred miles, requiring transport by horse, train, and a boat. Cameron's sister, Sara Princep, lived in Kensington so she may have visited or stayed with Sara on this occasion. If Cameron attended another Society meeting, her presence was not recorded.

Judging from the years that immediately followed the 1869 incident, Mrs. Cameron's visit could not be said to have inaugurated a woman's caucus in the Society. If photography and, more explicitly, photographic societies were to be construction sites for nineteenth-century masculinity—a technological masculinity that could unify a modest range of social classes (business owners, experimental scientists, aristocratic dilettantes, military men), while providing an arena for civilized combat[35]—then "femininity" had to be silenced, and women hidden. Although novel in comparison to other arts and sciences and therefore comparatively undefined, photography's rapid appropriation by brand-new photographic societies, and the establishment of rules, cemented an association between the new medium and modern "masculinity." As we will see in the next chapter, male photographers had not only to defend their photographic societies as spaces for men, they had to defend their profession from unfriendly critics and bad actors who were giving photography a bad reputation.

12

Defending Photography

In 1857, Lady Elizabeth Eastlake wrote diplomatically that the whole question of photography's success or failure "resolves itself into an investigation of the capacities of the machine, and well may we be satisfied with the rich gifts it bestows, without straining it into a competition with art."[1] If bourgeois masculinity for the industrial age demanded professional honor, specialized knowledge, and either creativity or skill, then photographers would have to overcome Eastlake's rhetorical challenge. If, as she suggested, photography was mechanical—an automatic reaction of light on silver salts (however lovely)—then it would be difficult to ennoble it, or for its practitioners to claim status as artists or skilled professionals. But early photographers, passionate about their new science and its artistic potential, defied this early judgment,[2] working throughout the second half of the nineteenth century to earn a higher professional and social status.

As American and European industrialization advanced and capitalists increasingly relegated repetitive factory tasks to low-paid women and children, a gendered dichotomy emerged that associated "high skill" with masculinity, and "low skill" with femininity.[3] Photography's new, male establishment, headed in the official societies by businessmen and educated amateurs, had to prove that camera work was "high skill" and therefore manly. The early men had to contend not only with misinformed assumptions about photography's automation; they faced a popular suspicion that the photographer was a charlatan. The American James Ryder, for example, said that when he got started as a photographer in the 1840s the local blacksmith "disapproved of me—said I was a lazy dog, too lazy to do honest, hard work."[4] The implication was that the dubious operations of the daguerreotypist "swindled" the public out of their (legitimate) earnings (Figure 12.1). The bulk of early photographic journals' content, therefore, countered such accusations by showing the technical complexities of photographic science and artistry.

The problem of photography's mechanical components spurred its earliest enthusiasts to explain that, in fact, scrupulous preparation, deep chemical knowledge, experience with lighting, timing, and, not least, taste were all qualities required for successful photography. The verbal and written defense of camera work as more than a brainless, mechanical operation that, for example, a monkey could perform (Figure 12.2), gave photographers added opportunities to gender their medium as proudly "masculine."

During this long-running discursive campaign, photographers had not only to quarantine themselves from lowly hacks, frauds, and pornographers; fraternal solidarity

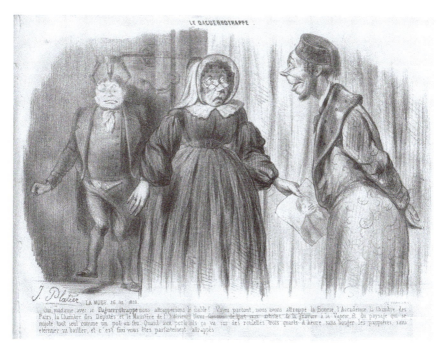

Figure 12.1 Jules Platier, "Le Daguerrotrappe," fold-out lithograph in *La Mode* (October 26, 1839). In the caption, the operator reassures the sitter's wife: "Yes, madam, with the Daguerrotrappe we'll catch the Devil! See everywhere, we've caught the Stock Exchange, the Academy, the Chamber of Peers, the Chamber of Deputies, and the Ministry of the Interior. We do art without artists, engraving with steam, and the landscape which simmers itself all alone as pot-au-feu. As for the portraits, that goes like clockwork [literally: "that goes on wheels"] Three quarters of an hour without moving the eyelids, without sneezing or yawning, and it is finished; you are perfectly caught." The woman here, though, wants to be assured that the camera will "trap" her husband—to prevent him, perhaps, from "disappearing" from the house at night to misbehave? The photographer, a figure combining bohemianism and quackery, insists "the devil will be trapped," just as his other subjects have been. Courtesy of www.daguerreotypearchive.org.

demanded also the exclusion of women who, by virtue of their sex, lowered the prestige of the profession. What Laura Prieto pointed out for the art world of the period also applied to photography, where "the very presence of women adulterated the professionalism of the enterprise."[5] When the introduction of the dry plate in the 1870s prompted a mini-boom in female participation,[6] James Ryder went on the attack: "A person without musical knowledge can turn the crank of a hand organ, and get results," he said. A novice can "press the button," he wrote, paraphrasing Kodak's new slogan, but she requires "the assistance of the technically competent man who 'does the rest.'"[7] Ryder's argument reflected how skill, gender, and pay grade were bound up in a period

Figure 12.2 Engraving of Philippe Rousseau's salon painting of 1866, "Le Singe Photographe" ("The Monkey Photographer"), published in *L'Illustration*, vol. 47, no. 1212 (May 19, 1866), p. 309. HTDC: https://babel.hathitrust.org/cgi/pt?id=mdp.39015069785262&view=1up&seq=317.

of both advancing industrialization and middle-class women's increasing willingness to step into "masculine" domains.

We will see later in Part Three that photographic commentators occasionally attacked openly the idea that women could be skilled photographers. Other male-dominated industries of the period, such as printing and typesetting, medicine, and university teaching, also generated misogynistic attacks. In all these industries, spokesmen feared that the entry of women at a level equal to men would lead to the erosion of their profession's "masculinity," with the levels of pay and prestige that masculinity assured.

Social scientists have occasionally broached the question of why, traditionally, the "feminization" of a job has lowered its prestige and, thereby, its pay.[8] One historical example of this phenomenon is the twentieth-century transition of the position of secretary from one held by men to one held by women.[9] Throughout the nineteenth

century through the First World War, the position of secretary in business, the law, or on the staff of learned institutions was manly enough to be held exclusively by men who supported their dependent families with its salary. But, by the mid-twentieth century, the position, especially in the corporate world, had been feminized, combined with that of receptionist, and made more difficult to support a family with its low salary after the Second World War. The secretary had become a dead-end job, often filled by single women or wives supplementing their husbands' income. Its level of prestige became so low, tales of tawdry sexual mischief in the office so prevalent, that by the 1990s the word itself held undignified connotations. Women's professional groups began a campaign to change the position's name from secretary to assistant, or administrative assistant. Although it remains a low-paid position filled primarily by women, the title of office secretary has been banished in the United States. Anthropologists might say that the job title was killed by the taint of femininity.

Male photographers across the North Atlantic world were determined to preserve their profession from a similar fate. Criticism of the camera forced them into a defensive position from the medium's earliest years. Lady Eastlake, the art critic, historian, and wife of the president of the Royal Academy cited above, was not the only sceptic. Some critics, ambivalent about the new art, were willing to concede that photographers could be honest and useful mechanics, but no more. Other critics were less friendly, such as the poet Charles Baudelaire, whose angry attack on the photograph in his essay on the "Modern Public and Photography" strengthened the rumor that the daguerreotypist was nothing more than a failed painter.[10] Baudelaire's compatriot Alexandre Dumas agreed, complaining that the camera produced

> a class of failed artists, composed in general of those who had not the ability to become painters; they make themselves photographers, calling themselves, some the pupils of Ingres, and others the pupils of Delaroche, as if to be a photographer they needed to be the pupil of one of these; false artists, incapable painters, who with some exceptions, if photography did not exist, could not have been photographers, and would have been trained up to some trade useful to society, instead of the disastrous occupation to which they have abandoned themselves; an occupation that has no other results than that of vulgarizing art without extending it.[11]

To answer such prejudice, H. Baden Pritchard argued in 1885 that every profession, including art and literature, has its honorable, and its two-bit practitioners:

> Among painters, we have the President of the Royal Academy, and the dauber of signboards; among actors, there is the leading tragedian, and the poor super who staggers about with a banner for a shilling a night; among litterateurs are to be found 'liners,' and historians like Macauley and Carlyle.[12]

"As in painting, acting, and writing," concluded Pritchard, "so in photography, *each man is for himself, and must win his own position.*"[13] Via the manly virtues of hard work, competition, and proving himself to his peers, the photographer, like any professional, would "in cricketing parlance, [make] 'off his own bat' what credit redounds to him."[14]

To be sure, the language of early photography's advocacy did not acknowledge the presence of women players in this game. It was only after 1890 that reporters would publish at any length accounts of women photographers' skills and successes.[15]

The reader will have noticed that the attacks and defenses cited above targeted photography's artistic, rather than scientific aspirations. Photographers' claims of scientific expertise or innovation were not as vulnerable to attack as their aspirations to artistry, to creativity, or membership in the community of fine arts.[16] As professionals, photographers could reasonably expect a reputation equal to pharmacists or other technicians. But the lack of any diploma-granting school, academic standards, or apprenticeship tradition meant that photography was an upstart technology, lower on the artistic totem pole than even lithography (a recently developed process for art printing). Not coincidentally, it was precisely this lack of gatekeeping that allowed self-taught women and girls, excluded from the national art schools of Britain, France, and the United States until the end of the century, to take up photography as a profession.

Early on, male photographers fought to earn status as legitimate artists. In the first issue of the American journal *Photographic Rays of Light* (1878), the editor asserted that the striving "for excellence in the production of photographs, possessing true harmony, and worthy of being termed artistic, should be the ambition of every progressive Artist."[17] Reporters used the names of famous painters to describe the artistic heights that photography could achieve. "We have now all the glory of grand Rembrandt's light and shade, and more than Pre-Raphaelite delicacy and exactness of detail," declared *The Philadelphia Photographer* in 1864.[18] Photographic spokesmen drew names freely from the history of painting to describe their achievements in the darkroom. They hoped the prestige of photography would rise by association.

The nineteenth-century capital of North Atlantic artistic genius was Paris, and the city's photographic leadership situated photography as a new member of the nation's fine arts family. As early as 1856, the *Revue photographique* insisted that familiarity with the necessary equipment alone did not make a great photographer. One needed, at the very least, "the creative breath that alone gives life and movement" to his compositions. Every line, continued the writer, "reveals the touch of the artist that lights the sacred fire of inspiration."[19] At the same time that art-minded photographers aspired to the status of fine artists, European intellectuals conveniently reaffirmed that "there are no women of genius."[20] Nineteenth-century women photographers would be permitted to practice the art, and even earn their living, but the grade of master or savant would be reserved for men like Nadar, Sarony, or in England Henry Peach Robinson, to name just three examples.[21]

Most studio photographers, though, realized they sold a commercial product, and they had to combine competent technique, efficiency, and customer service to succeed in a competitive market. Rather than fighting for the status of artist, they sought to protect their reputations as honest businessmen in an era that produced a large pool of dubious camera workers. In 1880, J.B. Feilner angrily described the professional landscape as follows:

> The Photographic Art, cheaply held up as an easy way of money-making, stripped of its delicate and refined beauties, hawked about as market-ware ... pompously

heralded by ignorant speculators as art, then manufactured and treated like ordinary factory work, and finally really loved by comparatively few, as a worthy and refined source of livelihood.[22]

A population of "bad apples" was giving the photographer a bad name. In one case reported in the London *Daily Telegraph*, a cheap studio photographer was brought to the police courts for having assaulted a woman who refused to pay for a poor-quality picture. "When we find photography associated with the lowest ruffianism and blackguardism, and made the medium of imposture and extortion," said the reporter, "we are apt to grow somewhat out of patience with the proprietors of … 'portraits for the million.'"[23] If the manliness of photography depended on the photographer's gentlemanliness, proved through his courtesy, skill, and taste, then the fraternity had to distance itself from an underclass of operators who preyed upon the general public and women in particular.

London, Paris, and other cities were also the sites of police raids resulting in the confiscation of enormous caches of pornographic photography. Emmanuel Hermange has argued that photography, beginning with the daguerreotype, brought an unprecedented amplitude to "the assimilation of woman as a vector object [that is, carrier or transmitter] of masculine desire," and the market for explicit images was considerable, despite the laws against selling such imagery.[24] As early as 1858, a writer for *The Photographic News* appealed directly to the producers of indecent photographs (in this case 3-D stereographs), hoping "that they will at once see, unless their sense of decency is too far vitiated, that they are bringing upon our favourite art a scandal which it is highly desirable to have removed at once." He continued, "To our mind there is something positively sacrilegious in the idea of prostituting the light of heaven to such debasing purposes."[25] After an 1861 raid in Paris, the *Moniteur de la photographie* reported on "the shameful traffic … which demeans and dishonors the art that we would like to see elevated and ennobled."[26] In 1874, the London police seized 135,248 obscene photographs from a single shop.[27] In registering their protests, photographic spokesmen distanced the legitimate fraternity from a quasi-criminal element.

In addition to fighting unreasonable patents,[28] unethical manufacturers, and hacks spoiling the profession's reputation, photographers also discovered that unscrupulous businessmen were pirating their work. For example, a dishonest photographer might carefully photograph a popular celebrity portrait in order to create a new negative, then print, mount, and sell it as his own. The campaign to obtain legal copyright for photographs, conducted in the 1860s, functioned both to combat piracy and place the photographic profession on the same level as the *honorable* authors, inventors, and artists who also enjoyed copyright protections. The campaign to gain copyright for photographs "faced fierce opposition … notably on the grounds that they were mere mechanical reproductions, not true art."[29] Nevertheless, the photographers eventually triumphed over that prejudice. In 1862, the Fine Arts Copyright was passed in Britain, the Mayer & Pierson studio won a critical lawsuit in Paris, and a congressional act in the United States added photography to already-protected maps, engravings, and musical works in 1865. In all three countries and beyond, the passage of photographer-friendly laws required testing in the courts, including the Supreme Court of the United States which upheld photographic copyright in 1884.

Finally, the defense of photography necessitated the disciplining of the consumer. The photographic press between 1853 and 1900 is littered with letters and reports from operators (always men) complaining of customers' rudeness or unreasonable demands. A big problem was that photographers were not being paid for their time, only their final product. Many studios allowed customers to sit for their portraits, paying only when they returned for the prints—*if* they returned, and *if* they were completely satisfied with the results, which they rarely were (few are those who are pleased by their own photographic image). The American photographer A.C. Sunderland reasoned in 1880, "Because photographers, as a class, are a persevering and patient body of men . . . it is still a fact that no class of men, in my humble opinion, swallow, with so serene a countenance, so many bitter pills as the photographer."[30] Organizations like the Photographers' Association of America proposed introducing prepayment as a way to tame badly behaving customers. H. Rocher scolded colleagues at a PAA meeting:

> You have lost your self-respect, and the public mean to do with you as they please, and not as you should do; for in your house and business your rules must stand, and you must abide by them, or you must bear the consequences—fall, and lose the so very necessary respect of the community.[31]

The photographer's manliness, then, required that he discipline customers to his rules. H. Baden Pritchard in England agreed, observing that there were "people especially mean in their dealings with a photographer," but when "the regulation to pay previous to sitting is adhered to, there is little chance of suffering from the meanness in question."[32] Through gentlemanly solidarity—that is, jointly agreeing to uphold best practices—photographers could strengthen their professional position.

Although photographers like H. Pritchard and Félix Nadar insisted that male clients were as vain as female ones (sometimes even more so), it was more often the high society ladies, mothers with babies, elderly women, and female tourists amusing themselves who were characterized as unreasonably demanding or foolish. James Ryder depicted a stereotypically over-curious woman who, despite his warning, dipped a towel in a basin of nitrate of silver solution and wiped her entire face with it, which would then blacken her skin.[33] The Connecticut photographer H.J. Rodgers, in praising the "many intelligent and artistically educated women who no longer demand of the photographer to do *any more* than *his part*," referred obliquely to the stupid, artistically ignorant women who demanded miracles (when it came to their looks).[34] Defending photography also meant defending its truth-telling quality, and getting the public to accept it. Although, many photographers would continue simultaneously to resort to the skills of the retoucher.

The theme that endured over the course of several defensive surges in the photographic literature of the second half of the nineteenth century was optimism in the face of scorn and scandal. As early as 1858, one reporter offered a heroic triumph against the odds:

> At first [photography] seemed likely to be confined to making black and blotchy libels on the scenery of nature, or sullen caricatures of humanity. Now not only has

it, as every one has seen, attained the power of preserving, in nearly all their strength and grace, manly intellect and feminine loveliness, but it has come to be regarded as an invaluable adjunct to the man of science, the artist, and the antiquary.[35]

In the author's assurance lay the assumption that science and intellect were "masculine," not "feminine" (which was assigned "loveliness" instead). The women photographers of the period who constantly read the gendering of photography had to possess the confidence to see through it. They had to imagine themselves as creators rather than mere consumers, and they succeeded. As photography became a republic of men, dominated by a "masculine" agenda of priorities, with a paternal genealogy devoid of mothers or "feminine" concerns, women amateurs and professionals had simply to persevere without the acknowledgement of photographic institutions. Reactions and resistance to these women creators will be the subject of Part Three.

Part Three

Women in the Studio

Just Charming

Whereas Part Two recognized the "feminine" ideas that early amateurs brought to their photography, the chapters in Part Three will turn to women working in the profession. More specifically, I will analyze attitudes surrounding women photographers' work. The producers of early photographic literature could not ignore entirely the presence of women within the hierarchy of the studio, whether as proprietors, assistant operators, retouchers, or receptionists. Having established in Parts One and Two that early societies and associations were working to make the profession "masculine," how did photographic institutions and their publications cope with the reality of women in the studio? Other than ignoring them, rhetorical strategies included treating them as marginal oddities, natural subordinates, or even nuisances. Only after 1890 did photographic societies and the press treat women as equally competent colleagues, and it was during that later period that women professionals' own publications made them visible in greater numbers, especially in the United States.

By way of introduction, the present chapter will look closely at language that men used to situate women's photography. One descriptor in particular that appeared frequently across the nineteenth-century North Atlantic photographic press with regard to women's photography was the word "charming." Male journalists and critics employed this word and its synonyms in order to demonstrate proper gallantry, or chivalry, in mentioning the women who sent photographic societies, editors, or exhibition committees (all men) examples of their work. For example, when a critic (Humbert de Molard, one of the founding members of the French Photographic Society) exposed the identity of the modest Madame Legay at the Brussels Exposition of 1856, he described her landscapes as "*charmant*," in contrast to the "artistry, intelligence of composition, [and] harmony of effects" in the work of Le Gray, Nadar, and other French representatives.[1] That word, "charming," associated also with lower-prestige genres in painting such as watercolors, flowers, domestic scenes (also called genre painting), and women's home-bound knitting projects, embroidery, and compositions in pastels, allowed its users simultaneously to acknowledge and dismiss the photographs that women dared to enter into the public sphere.[2] As for Madame Legay, it is perhaps needless to say that she was never heard from again.[3]

In public photograph exhibitions of the period, women participants might receive "honorable mentions"—occasionally even a second- or third-place award—but such compliments never led to the election of a women onto a society council, judging panel, or editorial staff before 1900. The first, and rare, time a woman was mentioned

as a photographer in *The Photographic News*, was during the annual exhibition of the London Photographic Society in 1859. The critic (perhaps editor William Crookes) wrote at the bottom of his review, "It would be ungallant not to mention the nice little instantaneous pictures" displayed by a Mrs. Down.[4] The two pictures by Mrs. Down were "well taken, and in a manner that would do credit to many of our gentlemen photographers."[5] His condescending notice of Mrs. Down's two pictures, whose titles were unnamed, in contrast to the men's titled pictures, revealed an assumption that a woman's photography would naturally be inferior to men's. Under normal circumstances, moreover, a woman's photographs would never reach the level of the London Society's most serious and valorized members, even if Down's work would "do credit" to the Society membership in this case.

When used with women, "charming" was also associated with childish innocence and naiveté. In "A Winter Amusement," an article in *The Amateur Photographer*, the writer acknowledged receiving "a bundle of very charming photographs from a lady [unnamed] who lives in the wilds of Kerry."[6] She had received the camera "as a most mysterious object which [she] did not in the least know how to put together," but fortunately a visiting "gentleman" came to the rescue to assemble the apparatus for her. She had no dark room, so processing arrangements "were necessarily of the most primitive character," but after practicing for a week she succeeded in capturing the household's costumed theatricals, which she humbly reported produced "very few absolute failures."[7] The end of the column attributed the Irish lady's eventual success (she had sent landscapes, portraits, as well as staged scenes to the editor), not to talent but to having acquired "a first-rate camera and lens."[8]

Lest readers misunderstand, "charming" was also employed throughout the century to describe men's works, but usually in order to describe their painterly beauty, technical perfection, or, often, to describe the women or girls they depicted. For example, advice in an American photographic journal in 1871 told readers: "Don't print the cartes[-de-visite] of a beautiful blonde the same as you would those of a *charming* and dazzling brunette."[9] When used in the infrequent acknowledgement of women's photographs, "charming" was a polite dismissal, a way to separate the "feminine" dilettante from serious "masculine" technical or artistic work.

Françoise Condé found similar language in the French context. Salon jury members' acknowledgements of women's photographs employed a series of "feminine" qualifiers ("pretty," "delicate," "graceful"), emphasizing, for example, the "delicate handling by a woman's hand" or "pretty fingers," resulting, according to Condé, in women workers' diminishment (*dévaloriser*).[10] Broadly speaking, she continued, "As in all artistic domains dominated by men, such as painting and sculpture, masculine appreciation tended to reduce them [women], if not pigeon-holing them, as exhibiting the famous 'woman's touch,' nevertheless denying them creativity or genius."[11] While photographers of both sexes often took as their subjects children, family scenes, "feminine" portraits, and still lives, the men photographers' work evinced technical skill or artistic "mastery" rather than mere daintiness. During an 1864 London exhibition, for example, Henry Peach Robinson's entry, "Somebody Coming," was "a study of chiaroscuro, and viewed in the twilight with half-closed eyes, it is a wonderfully perfect composition ... brilliant photography, it is most admirable."[12] Elsewhere on the wall, Clementina Hawarden

contributed "a few of her charming studies," including a large work (not titled), "a most charming picture" of a female figure striking a "graceful" pose.[13]

"Charming" also described women's earliest forays into photographic leadership. When New York photographer Catharine Weed Barnes became the first woman to present a paper at the Society of Amateur Photographers in 1889, the *New York Times* described her piece ("Photography from a Woman's Standpoint") as "a charming little paper."[14] In doing so, the newspaper missed its opportunity to herald a revolutionary change in women photographers' institutional status. With few precursors, Barnes' arrival on the scene made women speaking at club meetings, filling executive positions, judging exhibitions, and editing photographic journals a plausible proposition.[15]

As a New Woman, Barnes' assumption that her efforts equaled those of her male colleagues led her, and fellow American photographer Eva Watson (later Mrs. Watson-Schütze), to reject separate exhibition categories and clubs for women. Watson, for example, rejected the idea of separate displays for women's photography in the Woman's Building of the Chicago World's Fair in 1893.[16] Although arguably the construction of the large Woman's Building for the fair was a victory for the American female elites who campaigned to get it, Watson knew instinctively that the segregation of women's work in "ladies'" categories exiled it from serious critical attention. Barnes agreed. In a similar vein, while establishing a women's photographic society might provide independence, Barnes wrote, "it would be far wiser to become members of some society which ... will admit ladies and allow them to win their way by fair competition."[17] For Barnes and Watson, sex integration was the only path to real prestige for women in photography.[18]

As discussed throughout Part Two, reservations about femininity, feminization, and the low prestige that such qualities brought to paid work, made men's feelings about women in photography ambivalent. At heart, they feared that women's presence could lower their embattled professional status, and lower salaries. As in other nineteenth-century industries like printing and textiles, photographic syndicates, like the trade unions, employed rhetoric in an attempt to make their business a "masculine" arena, rather than champion their female colleagues as equal partners deserving respect and a good living.

There were, though, other sources of emotional ambivalence when it came to women working in a studio or darkroom, which had to do with its violating a sort of North Atlantic *purdah*, or more specifically, sexual propriety (Figure 13.1).[19]

Even the presence of photography in the home, some cartoonists pointed out, could cause unlawful promiscuity or expose it (Figure 13.2 and 13.3). In both of these French lithographs, photography is linked to the patriarchal fear of women's infidelity.

In Figure 13.2, the camera is the photographer's device with which to fool the husband. In Figure 13.3, the photographer, who resembles Louis Daguerre himself has caused domestic drama by exposing the husband's neighbor wooing his wife. The husband had only wished for a daguerreotype image of his property but got more from the truth-telling camera than he bargained for. The implication is that the husband would have preferred not to know. Whether in the parlor or in the studio, the new medium seemed to hold great potential for mischief.

When the fictional Gertrude Lorimer campaigns to establish a studio in *The Romance of a Shop* (1888), the thought of her or the other Lorimer sisters alone in a

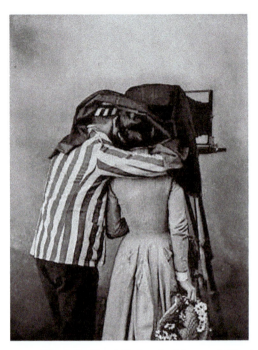

Figure 13.1 Frontispiece ("Focusing") in W.I. Lincoln Adams, ed., *The American Annual of Photography and Photographic Times* (New York: The Scovill & Adams Co., 1893). Author's collection.

shop open to the street raises eyebrows. "I say, Gerty," says sister Phyllis mischievously, "all this is delightfully unchaperoned, isn't it?" Their sister Fanny warns "[t]hat people will talk."[20] Elsewhere, Jennifer Tucker has shown that (male) photographic operators were "portrayed in the popular media as dangerously sexual men who preyed on innocent lady customers."[21] A corollary scenario, of a lady photographer attacked by a predator walking in off the street, also entered the Victorian imagination.[22] If women were vulnerable as customers, they were doubly so as paid workers unless under trusted supervision. With entry into the public sphere of work came potential for sexual mischief by both men and women.

Another dimension that made onlookers uncomfortable was the reversal of the male gaze that women photographers promised (Figure 13.4). A woman critically looking at her subject violated Victorian notions about both "femininity" and art production.

Shawn Smith has suggested that bourgeois aversion to the female gaze was linked to the North Atlantic middle class's campaign to displace aristocratic culture and values with their own doctrine of "separate spheres."[23] In this theory, a woman looking at a man, whether it be as a social superior, with erotic judgment, or general scrutiny (as through a camera), was an "aristocratic" behavior—an arrogance especially detested in upper-class women—that affronted male, bourgeois authority. The middle-class model

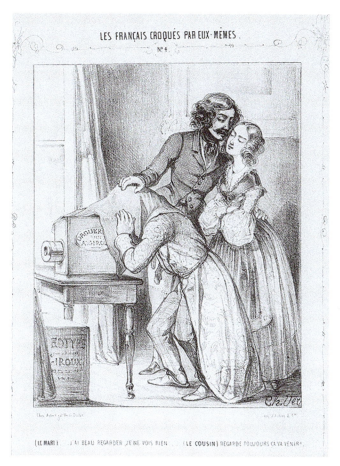

Figure 13.2 Charles Vernier, fourth chromolithograph in the series, *Les Français croqués par eux-mêmes* (1840), here rendered in greyscale. Vernier poked fun at the public's trying to understand the daguerreotype process, while at the same time creating a risqué sight gag. The caption recounted the exchange between the husband (looking through the camera) and his cousin. The Husband: . . . I'm looking closely, I don't see anything . . . The Cousin: Keep looking, it's coming soon! Author's collection.

of gender relations sought to remove this "sin of pride" from women, erecting a "private sphere" that limited her gaze and kept out the prying gazes of "illegal" men (that is, non-husbands with no rights to her body). More prosaically, the reversed studio positions, wherein the woman gazed through the camera and the male customer sat passively, turned nineteenth-century gender and aesthetic norms upside down.

On the other hand, some observers thought the interior location of studio work, especially if the studio was based in the home, would protect women's purity, unlike more compromised female workers like the paid actress, dancer, or musician, who all

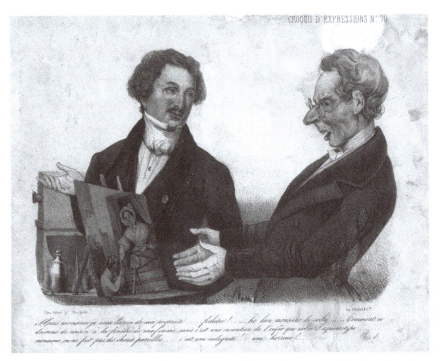

Figure 13.3 Chromolithograph (between 1840 and 1850) by Henri D. Plattel, rendered here in greyscale. The caption translates: Customer: "Sir, I desire a view of my property . . . Dammit!" Photographer: "Here it is, Sir . . ." Customer: "What, that damned neighbor at my wife's window. Your daguerreotype is an invention from Hell, Sir. One does not do such things . . . it is an indignity! A horror!" Exhibited on Luminous-Lint.com.

"shamelessly" displayed themselves in public.[24] Julia Margaret Cameron, Clementina Hawarden, Myra Wiggins, and Amélie Galup all worked in their home facilities, albeit as artists rather than as commercial portraitists. Later, elite women professionals such as Elizabeth Buehrmann and Gertrude Käsebier traveled to clients', mainly women's, homes to create portraits.[25]

Despite the uncomfortable prospect of a woman's appraising gaze, there is plenty of evidence that female commercial photographers enjoyed the patronage of male customers, who seemed not to be bothered by the temporarily reversed gaze in the woman's studio. Reviewing the *carte-de-visite* collections of women photographers in the Peter Palmquist and Martha Cooper collections, I expected women and children to dominate as their subjects. Although women professionals might embrace feminine stereotypes in order to attract mothers, children, and babies to their studios, plenty of men of all ages, too, arrived as customers in surprisingly similar numbers (Figure 13.5).

There seems to be no evidence that local customers were prejudiced against women photographers because of their sex. Nor do we find any complaints about women's studio products, or reports of unsatisfactory customer experiences in their studios.

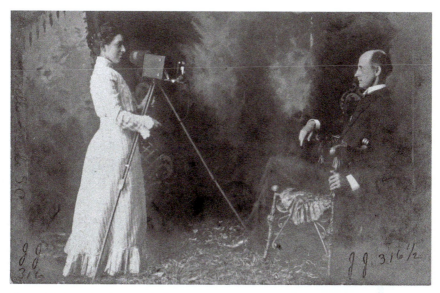

Figure 13.4 Pre-1907 postcard whose image reverses the traditional male gaze with a rather dominant female photographer and compliant male sitter. Courtesy of Martha Cooper's personal collection.

Indeed, comments in the non-photographic press were welcoming to women photographers who came to town. The Amador County newspaper in California, for example, greeted Eliza Withington's frontier studio in 1857 with the comment, "We are assured upon undoubted authority that she is an accomplished lady and most excellent artist."[26] Men (who were not photographers) may have been enticed by the relative novelty of a woman photographer: "Just think of it—Your picture taken by a lady!" the Amador reporter enthused, "We trust she may receive a liberal support."[27] Here the prospect of a woman operator was *charming* (and unthreatening), undoubtedly welcome in a frontier town where the appearance of any photographer was newsworthy.

On the other side of the globe in sophisticated Paris, the novelist Alexandre Dumas related a similarly enthusiastic story about being served by a woman photographer. His experience took place in the safely distant city of Vienna, where the novelist reported that photography was generally practiced by women rather than men.[28] This curious fact, according to Dumas, was a blessing because "at Vienna, where, as I have already said, all the women nearly are pretty, the lady photographers ought to be beautiful. They are so."[29] Whereas mounting "three, four, and even five storeys" to reach a Parisian (male) photographer's studio was an obnoxious chore, in the case of a woman "you mount [the stairs] without complaint." At the top landing, "[y]ou kiss the hand that is extended to you; that is your recompense." The smile that stubbornly withholds itself from the brusque photographers back home "comes upon the lip by itself when one looks at a pretty woman."

Dumas made no comment on the lady's work (her product seems to have been a matter of complete indifference to him), but he recommended the "charming

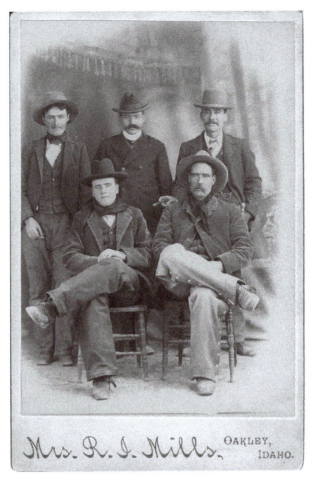

Figure 13.5 Cabinet card of six cowboy types by Mrs. R.I. Mills of Oakley, Idaho (n.d.). The collector could find no biographical information on Mills (not untypical for early women photographers west of the Eastern Seaboard). Exhibited on cabinetcardgallery. wordpress.com.

photographeress" to all his traveling friends. The tale possessed the mistaken implications that (a) women's studios were not to be found in the period's proud capital of Europe, Paris (women photographers were indeed available to the choosy Dumas), and that (b) Vienna's photographers were all female—certainly untrue, though the Austrian city may have promoted the career to women more energetically than in Paris. In terms of Dumas' and other laymen's attitudes toward women photographers, they were friendly, if perhaps condescending.[30] Hostile complaints about women photographers came not from customers, but rather, as we will see in the next chapter, from their male colleagues.

14

Work for Women?

As mentioned in the previous chapter, the second half of the nineteenth century saw the arrival of articles, occupation guides, and stories recommending photography as an appropriate livelihood for North Atlantic women. Lay observers, often quite ignorant of the knowledge and training necessary to produce consistently good photographs, also proposed the camera as an occupation for women because they thought it required little skill. An anonymous contributor to *The Scientific American*, for example, summed up the purportedly progressive point of view in 1864:

> The art of photography is so simple and easily acquired that it seems to be especially adapted as an employment for women. Its manipulations require a certain delicacy of touch, gentleness and quietude which are the natural attributes of females. No part of its attendant labor is rough; many of its operations may be done in a sitting posture.[1]

Writing with the assumption that women held a lesser intellectual and physical capacity, this author also argued that "feminine" traits (delicacy, gentleness) gave women an aptitude for the work. However, as we shall see, such proposals usually imagined women in low-prestige, subordinate studio positions rather than as business owners or operators. The acceptance of photography as paid work for women was part of a broader debate during the period over the problem of "surplus" women. Surplus women were those who, owing to demographic sex ratios and competition in the marriage market, would not be able to marry during their child-bearing years, and required a livelihood.[2] To open waged studio work to women was one thing; to welcome them as competitors at the same level as men was something different, and rarely advocated in the photographic literature.

Victorian literature and social history reminds us that the ideal for, and encouraged desire of, middle-class women remained marriage and unpaid domesticity—what I have termed the "sexual contract" of the period. But by the 1860s, intellectuals, reformers, and politicians across the region recognized that women with little prospect of marriage, who could not be supported by fathers or brothers, required employment. This revelation was not news to poor and working-class girls, who grew up expecting to perform paid work as servants, agricultural workers, spinners, and other jobs. A range of middle-class daughters who had grown up with some education, though, would not be expected, either by their families or their communities, to perform manual labor. The problem was that, because the new industrial-capitalist economic

model provided only a so-called supplementary wage to women workers, with the assumption of a male household breadwinner in the picture, women of the period in Europe, Britain, and America found it exceedingly difficult to support themselves in respectable employment.

Stuck with no prospective husbands, or family misfortunes such as a father's death, financial catastrophe, or simply the lack of a dowry, women and their champions scrambled to locate suitable occupations. Energy and imagination went into finding possibilities other than the dreaded schoolroom, which even a curate's book-loving daughter like Charlotte Brontë could not abide for its drudgery.[3] Looking back on his youth, author Edward Carpenter remembered that when his father's finances failed in the 1860s,

> there was only one conclusion— "the girls would have to go out as governesses."
> Then silence and gloom would descend on the household. It was true; that was the
> only resource. There was only one profession possible for a middle-class woman—
> to be a governess—and that was to become a pariah.[4]

Governesses became social pariahs because their position in the employer's home was one of servitude, albeit slightly above the maids-of-all-work or kitchen maids in status. Social activists and others thus took up the cause of work for women, decrying the pauperization, sometimes desperation, of single women to whom good jobs were not open. Observers understood well, too, that a link existed between the lack of dignified employment and the boom in a range of sex work during the period, both regulated and unregulated.[5]

Following broad consensus that "excess" women were a social problem, the question was what women, usually excluded from trade unions and institutions that trained students in the professions, could do. Within the period's jobs literature for girls,[6] photography emerged as a viable option to explore. In the *New Practical Guide for Young Girls in the Choice of a Profession*, for example, Madame Paquet-Mille listed the necessary skills, training, and available wages in the French photographic studio.[7] American feminist Frances Willard argued that women's adaptability and supposedly superior sense of taste suited them to the profession. Having become accomplished amateurs, Willard wrote, why should women not "continue in the art, master every detail, enter the field as professionals, and pursue the work as a business?"[8] Willard surely realized that many women had (already) worked as photographers long before her advice book was published in 1897. Yet, she believed many more hard-working women could succeed in professional photography, since, she avowed, it was "acknowledged that in woman the artistic sight is more perfectly developed than in man."[9]

Across the North Atlantic world, the idea of photography as a career choice for women appeared in a variety of publications, both photographic and non-photographic. One of the earliest advocates was Reverend Edmund S. Dixon in Charles Dickens' journal, *Household Words*. Having patronized a woman's studio in Paris, Dixon wrote,

> I could not help wishing that a few pale-faced, under-fed, thin-clad English girls
> could see how cheerfully Mademoiselle Lebour was living by the practice of

Daguerreotype. She seemed almost as happy and as independent as a first-rate governess at fifty pounds a year; if such a comparison will bear making.[10]

As mentioned in the previous chapter, Alexandre Dumas was equally impressed with his Viennese photographer, Madame Stockmann. The experience led him to ask,

> Why, then, in Paris, should not the women imitate the example that is given them in Vienna? . . . Would it not be more logical that this work was made for women? . . . If this system were employed, ten thousand young girls, who are to-day between misery and prostitution, would gain to-morrow three francs per day.[11]

Dumas perhaps did not realize that women indeed operated photographic studios in Paris and the provinces, though they were often less visible for the following reasons: Women often relied on word-of-mouth rather than advertising in trade directories (as did some men); women often partnered with fathers or husbands, who gave their masculine honorifics to the studio's name;[12] and women did not enjoy the support or publicity of French photographic societies and publications.

The Isle of Wight photographer Jabez Hughes produced one of the most famous articles advocating "photography as an industrial occupation for women."[13] Ignoring the long existence of women studio directors and assistants, Hughes suggested, rather, three levels of female labor that would benefit the industry and women themselves (speaking, he said, "as a well-wisher to the women's movement"): the "maid-of-all-work" class, the "shopwoman" class, and the "governess" class.[14] Those three classes could accomplish, between them, the printing, mounting, client reception, and accounting for the (male-directed) studio (Figure 14.1).

The studio, Hughes said, could supply wage-seeking women with "legitimate, honorable, and remunerative labor."[15] Middle-class readers would almost certainly have agreed that there was a need for such jobs, in principle if not in practice.

Occasionally, photographers recognized themselves as fathers of girls who might grow up to follow in their footsteps. The same year that Hughes prescribed three classes of female photographic labor, Edward Wilson confronted the fact that three Philadelphia colleagues, in addition to himself, had just been presented with baby daughters. This coincidence, Wilson wrote, "seems to make the apprehension arise that the photography of the future is to be in the hands of the gentler sex."[16] Wilson considered himself forward-looking, saying that he was "always willing to employ female labor wherever it [could] be made available." He noted in the same article that women of all ages were already "being taught the mysteries of photographic manipulation" at the Cooper Union in New York with the goal of graduating studio professionals.

In the minds of both men and women recommending photography as a livelihood, women's supposedly natural "artistic taste and delicate touch" made photography a suitable career for them.[17] This understanding of feminine capacity dominated the entire second half of the century. The Earl of Shaftesbury articulated this gendered assumption in 1859, explaining that the instant that work "becomes minute, individual and personal; the instant that it leaves the open field and touches the home; the instant

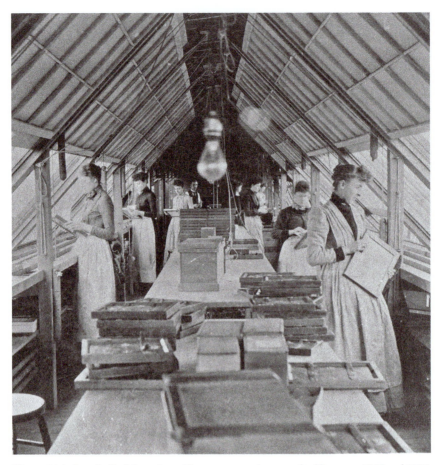

Figure 14.1 Female Kodak workers. These women, photographed between 1895 and 1905, developed all the film that arrived from customers to the Kodak processing plant. When British Kodak users trusted in the slogan "You Push the Button, We Do the Rest," they likely did not realize that "the rest" (development and printing of their pictures) was executed by women. Courtesy of the George Eastman Museum.

that it requires tact, sentiment and delicacy; from that instant it passes into the hands of women."[18] The same traits, according to some advocates, would make women good studio employees. At the end of the century, photographer Myra Sperry (b. 1862) would claim for women "more tact and quicker perceptions than men," attributing women's abilities in the studio to natural instinct rather than talent or training.[19] Savvy businesswomen were quick to echo the feminine stereotypes in hopes of drawing customers to the studio.

The same *Scientific American* article quoted above noted, "In England there are many women engaged in the art, both professionally and as amateurs."[20] A generation later, one English woman, Amy Levy, structured her novel, *The Romance of a Shop*,

around a group of sisters who establish a photography studio together in London after their father's death. A review of Levy's novel applauded the heroine Gertrude Lorimer's photographical career choice:

> And why not? It is a pursuit eminently fitted to women, involving neither the nervous strain or [sic] physical fatigue of medicine, not the noisy bustle and alert struggle of commerce. She need not hesitate, timid and self-doubtful, even though genius be omitted from the gifts offered her by niggardly Fate ... The average woman had best leave art alone; but, by force of intelligent study and thoughtful industry, she may triumph with the camera.[21]

Such comments were gendered (and insulting) not only in the association of femininity with low skill, but in the notion that delicacy, gentleness, and quietude were "simple" qualities (innate rather than painstakingly cultivated).

The end of the century was as rich with career recommendations as in earlier decades. A unique example comes from Jules Janssen, president of the National Union of French Photographic Societies, in 1895. Addressing the wives and daughters of the members of the Lyon Photo-Club, Janssen began, "I want to speak, Mesdames, about the legitimate role in the arts and sciences that you have always played, and which Photography expects of you."[22] That legitimate role, Janssen explained, was as intelligent, well-informed helpmeets who might elevate their men to genius. He gave as examples women such as Madame Villarceau and Caroline Herschel, whose "support," "counsel," and "consolatory" companionship gave confidence to their astronomer husband and brother during periods of discouragement.[23] As with astronomy (he might have added chemistry with reference to Madame Lavoisier), women, Janssen believed, had to learn the rules and difficulties of photography in order to assist in their husbands' work.

It seems highly unlikely that Janssen was unaware that French sisters and wives already were working alongside their men in amateur and professional studios, and had been for over half a century. After all, the Lyonnais ladies in his audience were at this Photo-Club gathering in solidarity with their husbands. Janssen, then, wished to glorify the intelligent but still subordinate—the "feminine"—helpmeet at a time (1895) when French feminists, and women across the North Atlantic world, were demanding equality and opportunity more loudly than ever. Like his predecessors, he spoke of "feminine" traits that lent themselves to photography:

> You have dexterous and delicate hands, you have the care [*soin*], the cleanliness, the attentiveness which are the material bases of the art, you have the feeling for the picturesque and for beauty that are its soul, you are therefore predestined for Photography.[24]

Femininity, then, in the service of masculine achievement was Janssen's wish. Rendered invisible in his account were the independent amateurs, business owners, or even women who were teaching photography to others.

Professional women taught photographic skills to amateurs and aspiring professionals of both sexes throughout the second half of the nineteenth century and

beyond. For example, Québecoise photographer Elise Livernois taught her children, and probably her husband Jules, the art of daguerreotyping in the 1850s.[25] Madame Una Howard, like many miniaturists during the early period, lent her skills to the new business of photography as it replaced miniature painting in popularity. She offered "to teach the art of colouring photographs to destitute ladies" in need of respectable employment.[26] In 1866, *Humphrey's Journal* announced "that a photographic establishment has been opened in England by Mrs Kemp, under the sanction of the Society for the Employment of Women, with the object of facilitating the entrance of ladies into the profession of photography."[27] During the same period, Monsieur and Madame Barberon of Bordeaux advertised lessons for amateurs on their studio's printed logo (Figure 14.2), and in Michigan, Lucretia Gillet, who enjoyed a long commercial career from the 1850s to 1890, tutored future landscape photographer Jay Haynes, and an apprentice, Laura A. Green.[28]

Other times, a woman, like the character of Lucy Lorimer in *The Romance of a Shop*, might learn the art from a male friend, then transfer the knowledge to her friends, relatives, or business partners.[29]

The traits that commentators insisted would make women good photographers were also the ones that often limited them to lower-paid, lower-prestige jobs in the studio. As shown in Chapter 12, the increasingly transnational fraternity of professional photographers would not allow the denigration of their manly medium. As the profession grew in the mid-nineteenth century, its male adherents sought professional respect, status, and proper remuneration for their services. Since women

Figure 14.2 Studio identification (worn away with time) on the back of a daguerreotype by M. and Mme. Barberon (active 1853–86). Courtesy BNF/Gallica.

were associated with low prestige work, men had to rhetorically link photography to male (high-status) skill and masculine honor. Frequently a compromise was reached, whereby women and girls were welcomed as relatively low-paid helpers in the studio (as retouchers, mounters, and receptionists),[30] with the understanding that the prestigious work (operating the camera and darkroom tasks) would be reserved for higher-paid men, assumed to be more capable. Unless they were wives or occasionally daughters, partners and full-time apprentices in men's studios were male.

Early examples of studio employment of inexpensive female labor included Louis Blanquart-Evrard's short-lived but productive photo printing works in northern France (1851–5), and the large Notman studio in Montréal, whose female employees' wages averaged just 25 percent of the men's wages in the 1860s and 1870s.[31] In 1863, Oliver Wendell Holmes profiled the large E. & H.T. Anthony photograph supply manufactory in New York, noting that female labor was utilized for coating plates with albumen.[32] M.J. Löwy reported in 1873 that it was "now very general indeed to find girls occupied in the different branches of work."[33] Female assistants were becoming common, said Löwy, because "they work cleanly and neatly, and because ... they are contented with more moderate wages than men," a reference to the problematic assumption that fathers or husbands were the primary earners of the home.

As mentioned above, it was women as well as men observers who encouraged women to use their "feminine" talents to succeed in the studio. An article on the "Duties of a Lady in the Reception Room," penned by an anonymous "Lady," outlined how a receptionist could further herself by becoming indispensable to her (male) employer (Figure 14.3).

A good studio receptionist, she wrote, should possess "ready tact, no small control of temper, [be] untiring in listening to the sometimes fussy desires of customers, and ever evincing a readiness to meet and carry out all their wishes."[34] The writer explained, "She should be neat in appearance, courteous and cheerful in manner—in one word, she should be *a lady*."[35] The famous Parisian portraitist Félix Nadar described the receptionist's value with a certain flair:

> Put a woman in a photography studio, as indeed in the neutral terrain of any other shop or counter, and you do not have a more sensitive and reliable instrument of precision than this touchstone to register, from the door, if the client who just entered is a gentleman or a badly raised man.[36]

As hostesses or product finishers, then, members of the fraternity might welcome North Atlantic women as inexpensive employees. Recognizing or promoting women creator-owners in the industry, though, would occur rarely until the end of the century. As late as 1887, an item in *The Photographic Times* suggested that women interested in photography should employ themselves in sewing photographic accessories, such as bags, aprons, and decorative camera plate covers. Any reader "not skilled in chemistry or optics," the writer suggested (implying women and girls), could contribute "novel fancy work" at the next church fair.[37] In the pages of the photographic press, then, the work of women often occupied a specific, and rather narrow, place.

Figure 14.3 A rare cartoon in H.J. Rodgers, *Twenty-Three Years Under a Skylight* (1872), p. 216, showing a studio receptionist dealing with "the ignorant and illiterate" class of patrons, who perhaps hoped studio prices were negotiable. The two prospective customers offer five cents for full-length ("Hull figger") portraits.

The misapprehension and condescension of lay critics contributed to the "glass ceiling" of early photography, but real hostility toward women in the field appeared almost exclusively in the specialized press. An 1867 front-page editorial in *The Photographic News* laid out both the usual concessions to "feminine" delicacy, and firm objections to women in creative or technical positions. Penned perhaps by the journal's editor at the time, G. Wharton Simpson, the author announced that "the experiment" in employing women as photographic printers "had been in the majority of instances a

decided failure."[38] The underlying problem, according to the writer, was that a female took the job "as a temporary task, from the performance of which she may obtain an income for a few years until she shall marry, the consummation to which she looks forward as a matter of course."[39] Simpson or a colleague reiterated this certainty about young women in 1870:

> A girl rarely regards any industrial occupation upon which she enters as her business for life. Marriage, as a rule, is her final aim; and any employment upon which she enters is regarded as a means of subsistence for a few years only.[40]

The consequence of this expectation was a "lack of judgement to distinguish between perfect and imperfect results, or want of the necessary care to produce them." This "feminine" lack of judgment contrasted to the lad who, "when he enters a trade or profession regards it as the business of his life, and proficiency in it as the only means of success."[41] Indeed, as mentioned above, most middle-class girls expected eventually to begin their true careers (that is, life purpose) as wives and mothers. Within nineteenth-century bourgeois norms, marriage prospects almost always trumped paid employment as a lifestyle choice for girls; and, a woman's desire to continue training or working after marriage was sternly frowned upon. Yet, the woman studio photographer was often the result of a marriage that ended through death, divorce, or separation.

Simpson's argument reflected root assumptions about femininity in Victorian society, namely that the single, female worker was waiting for a suitor to marry her, whereupon she would quit paid employment; and that women intruding on the professions did so only for fear of never obtaining a proposal of marriage. Certainly, the romances in Victorian fiction affirmed such beliefs. While female characters' adventures in the world of work took place in the novels of the Brontë sisters, Thomas Hardy, and Rebecca Harding Davis, such forays usually ended in marriage and the sexual contract. Mrs. Myra E. Sperry (b. 1862), herself a professional photographer, lamented that a "woman's instincts and nature are not conducive to happiness in business."[42] In contrast to girls, wrote Sperry, "the boy looks upon a chosen occupation as a life-long work and means of obtaining the home he hopes to have." Even a successful woman photographer, then, understood sex as bound to traditional gender roles: the male providing (and owning) the home, and the wifely mother occupying it.

Family life, education, and literature all left the middle-class female ideal of being financially supported and governed by a husband unquestioned. "Clearly the limited choices of employment and low pay for all classes of women meant that marriage was the most attractive option," affirmed historian Martha Vicinus.[43] As in many universities in the first three quarters of the twentieth century (wherein coeds were assumed to be pursuing their "M.R.S." degree), gendered assumptions and expectations led to the belief among some photographers that rigorous training, mentoring, and even encouragement was wasted on women employees.

Added to the belief in "feminine" technical incompetence and lack of seriousness was the ever-lurking fear of sexual impropriety in a mixed workplace—a fear also common to more traditional industries. *The Photographic News* reporter insisted "that the employment of men and girls, in an isolated printing establishment, finally issued in

cases of shame and sorrow."[44] Just as the photographic society's private darkroom became a site of imagined sexual chaos (discussed in Chapter 10), so too the printing rooms of the studio were judged, by this writer, as off-limits to women for decency's sake. When women wished to become professional photographers—often widows, orphans, wives of ill husbands, and single or married women in financial straits—neither the early photographic societies nor the commercial studios welcomed them as apprentices.

A photographer writing from Wales, Theodore Hicks, responded to Jabez Hughes' suggestion of photography as an occupation for women in 1873. "As to the employment of females, advocated by Mr. Hughes," wrote Hicks, "our experience teaches us that they are totally unfit for the work."[45] Aside from women's incompetence in the printing room, Hicks complained of their "pert manners and wholesale blunders."[46] Although in responding to this correspondent Simpson insisted that there was "a variety of capacity" among women studio employees, and furthermore that he had seen talented female retouchers and colorists, he nevertheless reiterated that they were "not successful in printing."[47] While Simpson admitted he had no personal experience with female employees, he somehow reached the conclusion that printing "does not seem to enlist their interest sufficiently to secure the necessary care."[48] In the contradictory rhetoric of professional photography, feminine dexterity gave women "neat-handed skill," yet their work was "careless" and prone to blunders.

For the most part, women in the field, in whatever studio position, did not bother to respond to such opinions with their own letters and articles, despite the fact that they were reading this discourse on female labor in the photographic press.[49] An exceptional piece of correspondence, however, arrived to Simpson in 1870, sent by an anonymous "Working Woman."[50] Having followed the early debate in *The Photographic News*, the working woman must have found it exasperating when the journal published a letter whose anonymous author ("Photo") naively wondered if women were employed in photography. Editor Simpson repeated his view that, most certainly, ladies were employed in the reception room, in retouching, and coloring, but that they supposedly had not "been engaged in the studio or dark room."[51] Interestingly, Photo, on the other hand, recognized that a "feminine" love of evening or fancy dress (in which customers frequently arrived at studios) should attract women to the camera. Simpson dismissed the "feminine" affinity for dress-up, stating that it was "very doubtful whether the advantage our correspondent mentions would in any degree counterbalance the disadvantages of engaging them [women] for the duties of operator."[52]

The anonymous "Working Woman's" response merits quoting at length:

> Sir,—I perceive "Photo" is not aware that women are employed in photography, and that you are doubtful whether it would be advantageous for them to operate in the studio or the dark room. "Photo" may rest assured that it is practised by women, and that not only in reception rooms and touching out.[53]

The writer explained that after assisting her husband in all branches of his studio, she had for the last several years taken over the business, including the camera, owing to her husband's failing health. She proudly proclaimed:

I have now the best studio in the neighbourhood, 21 feet by 9, with 6 feet of glass on each side, carried over the top. The sitter faces north-west. I use Mawson's collodion and developer, fix with cyanide, and use Ross's No. 2 lens.[54]

Having examined the working woman's enclosed samples, which she modestly admitted were "not so vigorous as I could wish," Simpson sportingly responded, "We are glad to report that the specimens enclosed by our correspondent are average good work."[55] Female photographers and readers of photographic journals like this "working woman" would have to wait fifteen to twenty years before such publications began reporting on women photographers, or inviting them to contribute to their pages.

As shown previously, early photographic societies, syndicates, studios, and press outlets continued to cast women as consumers of photography rather than creators, despite the contrary reality. They accepted the existence of cheap female labor filling the lowest positions in their firms, but only rarely acknowledged, before 1890, the women throughout the North Atlantic region who operated their own studios either alone or with a partner. As more women found employment in retouching and coloring, studios might either Taylorize those tasks,[56] or cheapen the labor through the putting-out system (farmed out piecework). In the next chapter we will look more closely at the conflict between the photographic elite and commercial practitioners where retouching and coloring were concerned. Despite customers' demand for colorful portraits free of facial flaws, the feminine hybridity of such techniques remained taboo for the earliest guardians of serious photography.

The Gender of Coloring

In previous chapters we saw how hybrid techniques, combining photography with drawing and painting for example, emerged as "feminine" photographic phenomena during the early history of the medium. Unlike personal albums, the practice of hand-tinting commercial photographic portraits was performed by paid workers on an industrial basis. Although popular with customers, the addition of color paint on photographic portraiture during the second half of the nineteenth century divided "purists" from the commercial photographers striving for profit. Whereas the science-minded councils of the early photographic societies rejected hand-tinting as an impurity—a technique that could only harm the virtues of the medium—portrait businesses were willing to provide the service to please their customers. In a few cases, photographers' and other studio employees' talents elevated the practice of hand-tinting to an art form in its own right (Figure 15.1).

The products of hand-coloring, whether metal images like daguerreotypes or tintypes, paper products like *cartes-de-visite*, larger cabinet cards, or even life-sized enlargements, fell into roughly three categories: a minimal or slight retouching; second, what in Chapter 4 I termed "garish but well-meaning" pigmentation, often added to images on an industrial basis; and third, expert artisanship. Edith Hemming in Québec and Madame Gouin in Paris, for example, both earned reputations for very high-quality coloration work at mid-century.[1] Practitioners of both sexes produced work belonging to all three categories throughout the second half of the nineteenth century.

Rhetorical and visual representations of "feminine" fingers and hands as delicate and nimble, or "feminine" minds as tactful and detail-oriented, meant that the job of tinting and retouching photographs was open to women from the earliest years of photography.[2] It is important to note, however, that many of the most successful early photo colorists were men. The fashionable studio of Meyer & Pierson in Paris, for example, offered overpainting (that is, using a photographic portrait as the physical base for a fully painted picture) as a specialty.[3] Antoine Claudet, the French-born London photographer, developed a hand tinting technique "considered one of the best in Europe" between the 1840s and 1860s, and several colorists apprenticed under him.[4] Miniature painters of both sexes, displaced by the new business of photography, sometimes became photographic colorists.[5]

Despite male workers' early interest in tinting work, the technique gradually acquired the taint of "femininity" (i.e., an association with second-rate skill and low wages) owing to the language used to describe it, photography's leadership's rejection of it, and the

Figure 15.1 Portrait of Madame Jules-Ernest Livernois (*c.* 1885) by Jules-Ernest Livernois (photographer) and Edith Hemming (painter). Although rendered in greyscale for publication, Hemming's fine sense of tone and detail is still visible. Hemming (1849–1931) employed watercolors, gouache and pastels to complete the work. She worked with the Livernois family for many years in Québec City. Courtesy Musée National des Beaux-Arts du Québec (inventory no. 1979.132).

partial proletarianization of the coloring profession as portraits became a mass-produced product during the 1860s, 1870s, and 1880s. This chapter will argue that, despite some actors' attempt to claim photographic coloring as a "masculine" profession requiring high skill and artistry, its rejection by photography's established leadership, and some studio directors' attempts to mass-produce the technique by hiring "casual" labor, assured the low prestige of these workers. At the same time, women workers demonstrating a full spectrum of ability embraced this new employment opportunity, recommended to them by a variety of spokesmen (Figure 15.2).

Despite the popularity of tinting and retouching, photography's institutional leaders (club councilmen, exhibition judges, journalists), waged a war of words against these techniques and their practitioners.

Figure 15.2 Advertisement for retoucher's desk in a Percy Lund & Co. supply catalogue for 1887 (Bradford, UK).

The guardians of photography judged certain manipulations to be impure and therefore damaging to photography's reputation and prestige.

At times, the pseudo-sexual terminology in the period rhetoric on "touching" is striking. Advice held that photographic prints should be "pure" and "untouched." Images were described as spoiled, tainted, or ruined when touched by the wrong hands,[6] in language that mimicked that used for young women's reputations. Behind many of the anti-retouching rules and rhetoric, moreover, was the belief that it was not just impure but dishonest. The link between photographic "manipulation" and "femininity" strained the limits of coincidence. Where "masculinity" in photography was straight, truthful, and conquering, "femininity" was deceptive and frivolous. There was something in coloring that smelled of harlotry.

Appalled by the mediocre color work routinely produced by commercial studios, often on a "putting out" basis wherein proprietors contracted home workers by the piece, the leaders of the national societies forbade tinted or retouched photographs at their annual exhibitions. A conflict soon arose between powerful proponents of photographic purity and those who believed that retouching, when done well, added a warmth that photography required. Some individuals on this latter side even argued that tinting and retouching could be, and should be, skilled, and therefore manly, occupations.

In 1858, a series of articles in the unaffiliated *Photographic News* offered "Lessons on Colouring Photographic Pictures," complete with technical details and color theory.[7] Asserting that "every photographer" would profit by studying this branch of art,[8] the author (unnamed) promised readers that the course would help them produce naturalistic results. The language of these articles combined a *yang* concern for "gear" (equipment, chemical ingredients and their reactions) with a *yin* insistence on softness of touch. The author's well-developed sense of texture and tactility, and his eye for detail emerged in the following advice:

The shadows of the neck and bosom should be cool, and the gradations as soft and delicate as possible; those of the hand and arm may be touched with carmine [a red pigment], with which the divisions of the fingers may be traced.[9]

The next lesson offered tips on tinting minute sections of lace, flowers, and jewelry. Yet for all the "feminine" concern for softness, tactility, and women's accessories, the pronouns in the articles were all masculine (the hypothetical student always "him," the equipment being "his," etc.). At this early stage, *The Photographic News* and its readers could still position this "important branch of the art" as masculine. The author concluded his course by affirming that colorists

who rise to excellence, are men of thoughtful character, who have a definite reason for every touch they give a work … In truth, it is found that a good artist, one who deserves that name, is a man of almost universal knowledge in things relative to nature and natural science, whether by intuition of genius or education.[10]

The colorists who "deserved the name" of artist, by associating that quality with masculinity, tried simultaneously to preserve their profession from low-status femininity and claim the respect they believed they deserved from the photographic establishment.

The attempt to imbue photo coloring with the virtues of manly genius, though, conflicted with studio owners' desire to provide the service at the cheapest possible rates. As mentioned in Chapter 14, Taylorization *avant la lettre* was applied to tinting work in several of the large commercial studios. In 1851, a *Photographic Art Journal* reporter described the efficient coloring process in a Parisian lithographer's workshop. The workroom was

furnished with a round table, which is surrounded by girls of singular beauty, who pass to each other the sheets upon which each lays the colors of which she holds the brush. This division of work produces neatness and freedom of tint, and that rapidity of execution, which gives colored lithography in the common mind, a superior degree of esteem.[11]

Confident "that girls of singular beauty can also be found in the New World," the reporter recommended that American daguerreotypists adopt the same system.[12] Arguably, businessmen hoped to deskill the work of hand-tinting, and in the process increase profits by hiring cheaper female labor to do it.

Early male colorists fought this capitalist logic—that is, capital's production of surplus value via proletarianization—in the same way that North Atlantic trade unionists (men) fought similar threats in a variety of industries over the course of the century.[13] The strategy was similar: Rather than encourage female employees to join with them in solidarity to protect the working conditions of colorists, male colorists blamed women for poor conditions (i.e., low pay and casual employment). Sometimes, they denigrated female skill or supposed lack of professionalism. The *Photographic News* complained that female competition "usually means working for lower rates of

remuneration."[14] With the large supply of studio workmen already seeking positions, only "better work or cheaper labour" would tempt an employer to hire a woman, and the former could "scarcely by expected."[15] Theodore Hicks asserted that women's retouching technique was faulty and "neither is the vigour of their colouring to be compared with that of males."[16] In this debate, committed, skilled artistry belonged to men, while women supplied only temporary, supposedly slip-shod work.

Male workers resented, in particular, casual female labor that took on coloring work on a part-time basis. "We should scarcely feel justified, were our opinion asked, in numbering perseverance among the virtues of lady amateurs," wrote one anonymous commentator.[17] "As far as our experience goes," he continued, "we should say that there are few [women] who give undivided attention to any particular kind of art work long enough to reach a high standard of excellence."[18] In using the fraternal "we," the writer separated a privileged in-group (serious, skilled male workers) from the inferior outsiders. Collector-historians Heinz and Bridget Henisch explained:

> In this case, attack may have been considered the best form of defense by an embattled male, because the colorist field was crowded with women practitioners, both professional and amateur. This was one branch of the business that had been open to women from the first.[19]

The acceptability of coloring as a manly profession declined in direct proportion to the visibility of its women practitioners.

Nevertheless, artistic women and girls recognized photographic tinting as a rare job opportunity that would utilize their talents. Classified notices in the photographic journals of the day advertised the availability of trained colorists of both sexes. An 1859 advertisement in the *Journal of the Photographic Society of London*, for example, read: "To Photographers.—A London Artist (a Lady), first-class colourist on paper and ivory, wishes an engagement at a seaside or inland watering place" (Figure 15.3).[20] Seaside locations promised plenty of souvenir-seeking customers in the summer months, and therefore plenty of work.

A similar classified ad addressed itself

> To Provincial Photographers. PHOTOGRAPHS (on paper) COLOURED and finished, equal to Ivory, or tinted slightly in Water Colours, by a Lady of acknowledged ability; or she would not object to an ENGAGEMENT for the season at a fashionable Watering place.[21]

Striking in these ads is their self-assured tone. Unsupported by photographic societies or professional groups, and often paid poorly,[22] women colorists of the 1850s and 1860s nevertheless announced their skills and experience with seasoned confidence.

Full-fledged female photographers, too, were shrewd enough to include tinting among the services their studios offered. Mrs. R.J. Woodward offered "Life-Size Crayons, India Ink and Water Colors" in her California studio.[23] Ruby M. Thorp Woodworth of Ohio offered customers their "[o]ld pictures copied and enlarged in ink, Water Colors, and Oil," as did Lucretia A. Gillett of Michigan.[24] A certain Miss Bond,

First-class Printer Wanted.

A YOUNG LADY preferred, who must thoroughly understand her work. Apply to W., care of Mr. T. H. GLADWELL, Publisher, 21 Gracechurch Street, E.C.

TO PHOTOGRAPHERS.—A London Artist (a Lady), first-class colourist on paper and ivory, wishes an engagement at a seaside or inland watering place. Address, E. S., DARCY's Library, 43 Cleveland Street, Fitzroy Square.

FOR SALE.—First-class ¼-plate, by VOIGTLANDER, for Portraiture, with Camera and two dark holders, French polished, price £4 10s.; may be seen at Mr. NEWMAN's, Optician, 122 Regent Street, W.

Figure 15.3 Employment want ads in the *Journal of the Photographic Society* of London, vol. 6, no. 87 (July 15, 1859). Center ad promotes the qualifications of a "first-class colourist."

though her first name is lost to history, worked as both a photographer and colorist to Queen Victoria and for the Isle of Wight photographer Jabez Hughes. Bond enjoyed the rare consideration of professional attribution on Hughes' products, which read: "Colorist: Miss Bond of Southsea . . . Patronage of H.M. the Queen and Royal Family."[25] The American colorist Lizzie A. Barber also received credit on the back of customers' portraits (Figure 15.4).

In Britain, Sophia Prideaux (a.k.a. Mrs. Clarence E. Fry) worked as a professional colorist with her husband and their business partner, Joseph J. Elliott, in the fashionable Elliott & Fry studio in London.[26] From studio owners to employees to spousal partners, then, a spectrum of women workers provided a range of products, dependent on their training, experience, and abilities.

Attempts by manual writers and male artists to explain the skill involved in fine tinting were largely unsuccessful in achieving institutional acceptance for the profession. Reporters and customers, who already misunderstood a good deal about the new medium of photography, supposed that coloring, while demanding delicacy of touch, required neither creativity nor artistic "genius." Studio owner Jabez Hughes lent credence to this misperception by saying that there was "no more obvious occupation for a woman, who is without the higher genius to lift her into the legitimate sphere of art," than hand-tinting.[27] For Hughes and other commentators, the "delicate touch" of a woman practitioner did not connote artistic talent during the period, because it was supposed to be innate to "feminine" nature and anatomy. But by denying the colorist full status as an artist (or at least a skilled artisan), Hughes unwittingly emasculated this still-predominately male professional, during a period when male colorists increasingly competed with women in the field.

Perceiving tinting as vulgar, impure, and "feminine," the councils of the premier photographic societies, and photography critics, rejected it, along with other forms of

Figure 15.4 *Carte-de-visite* of Lizzie A. Barber at her worktable in the studio of Taylor & Clarke of Springfield, Ohio (1871). Richard Rudisill Memorial *Cartes de Visite* Collection (Neg. 201356). Courtesy of the Palace of the Governors Photo Archives, Santa Fe, New Mexico.

retouching. One reviewer of photography at the 1855 Universal Exposition in Paris argued that the tinted images on display were so tacky that they could only have "dazzled the eyes of women who [were] amorous of adornment and makeup," thus simultaneously denigrating colored images and the women who (presumably) liked them.[28] During the Brussels Exposition of 1856, a critic (Humbert de Molard) openly "expressed how much he hated retouched prints,"[29] and the council of the French Photographic Society agreed with him, banning such impure products from their annual salons. The French Society warned prospective salon participants: "All coloured proofs will be excluded, as well as those which give evidence of having been 'touched' in such a way as to modify the photograph properly so called, by manual operations."[30] Other national societies followed the French society's lead.[31]

The presentation of photographic coloring as a domestic hobby that anyone could master further damaged the campaign for its "masculinity." One 1860 advertisement in *Godey's Lady's Book*, for example, promised a complete guide to such crafts as papier-mâché,

hair work, embroidery, and coloring photographs—all in the category of "fancy work."[32] An advertisement for "Newton's Prepared Colors," also in *Godey's*, promised that "any person, though not an artist," could color *cartes-de-visite* with excellent results using this product.[33] Instruction manuals with titles such as *Amusements for Wet Mornings; on Photographic Colouring* made the technique seem dilettantish, aimed as they were at ladies of leisure. Although men continued to work in the profession of tinting for the rest of the century, such associations made them unable to claim any status in the fraternity of photographic artists or workers.

Under such rules, talented female colorists had few opportunities to exhibit, much less win prizes, for their work. Nor would most customers have known who tinted their portraits, if the colorist worked in a back room or (contractually) in her home. Heinz and Bridget Henisch, whose collection and scholarship on early tinted photographs form part of the Henisch History of Photography Collection at Pennsylvania State University, concluded that the nineteenth-century photographic community considered hand-coloring "an illegitimate mixing of media, a 'cover up.'"[34] The photographer-critic P.H. Emerson wrote in 1889 that photo coloring was the product of "weak and feeble" minds, or "[s]econd and third rate practitioners" who impudently claimed to be artists.[35] But while coloring was rejected by photography's opinion leaders, the establishment did make exceptions when it came to other forms of retouching. For example, acknowledged "masters" such as H.P. Robinson, Gustave Le Gray, and Oscar Rejlander all mixed multiple negatives to produce single pictures, so-called combination prints. In those cases, the photographers showed bold originality rather than impurity, albeit not always without controversy.[36]

Despite the occasional published piece in support of high-quality coloring, by the 1870s such articles often took apologetic or defensive stances. Photographer John Hubbard, for example, wondered if his colleagues were so critical of retouching

> because they have not the ability to do good work themselves, and feel jealous of those who are in possession of sufficient artistic knowledge and power to add just that which is essential to modify those little defects which pure and simple photography sometimes gives us?[37]

As professional retouchers and colorists saw it, studio portraiture had a maddening way of bringing out customers' flaws and facial defects.[38] By correcting spots on negatives, clarifying the lights and shadows, or adding a hint of rose to the cheeks, these professionals hoped to improve what was all too often unsatisfactory. Critics countered that "the hybridity of coloured pictures" violated photography's true virtue, its realism.[39] At bottom, this fight exposed the ever-present tension between the *yin* of photography (fantasy, hybridity, play), and the *yang* (truth, realism, exposure).

In the photographic press of the 1870s, a handful of female workers' responded to the disparagement of retouching. One woman, writing anonymously as "A Photographer's Wife" in 1872, mounted a three-point defense of retouching following a disparaging article in *The Philadelphia Photographer*.[40] If we know, she asked, that freckles and blemishes, exaggerated in the collodion process, displease the client, then how do we overcome this difficulty? Better to brush out tiny flaws than to cover the

sitter's face with "chalk," as some photographers did. Her second objection concerned customers' desire for copies:

> People come to us with pictures of absent friends, or of loved ones, passed beyond their "mortal ken," and they want a *nice* copy. We look at the original, and what have we? Most probably a ferrotype, made by some perambulator in the wilds, who was not very particular about his varnish … The features may be sharp enough; but, alas! For the "gradation of light and shade," it is nowhere![41]

Seeing as portraits are "our *daily bread*," she concluded, "to decry a means which so many have found of service, as a 'trick;' and those who practice it as 'unworthy to be termed photographers'" was both unrealistic and unfair. Echoing earlier defenders of the practice, she said that the whole article in question, "in its egotistic tone, savors strongly of the grapes that Reynard could not reach!"[42] In other words, the critic was condemning her technique because he was unable to produce good results himself. Her counter-attack was as interesting for what it revealed about the involvement of a photographer's wife in the business, as it was for its defense of retouching. The letter showed that this woman, like so many photographer's wives around the world during the period, was a working partner whose lack of inclusion in the studio name, its advertisements, or in local photographic associations rendered her almost completely invisible to historians.

Just one year later, a writer named "Jennie" submitted a two-page essay on the same subject in the same journal. Similarly to the ideas of the Impressionists in France, she pointed out that the human eye does not see every detail at a glance; so where a skin blemish or stray lock of hair might not be noticed in person, the camera's lens "has a way of searching these things out," even exaggerating such flaws.[43] Nevertheless, Jennie realized that for retouching to be successful, less is more: "Shakespeare says, 'Spirits are not finely touched but to fine issues,'" she wrote (Figure 15.5).[44]

Skilled women colorists like Jennie and Una Howard were as discerning as their critics. They realized that high quality coloring work required proper training and, implicitly, proper pay.

Eunice Lockwood, one of the earliest female contributors to the photographic press in the world, affirmed Jennie's point of view in the same issue of *Philadelphia Photographer*.[45] Just as the Englishwoman Una Howard had argued in 1865, Lockwood wrote that excellence in retouching had to be taught systematically. And she conceded that sloppy work abounded. Following a tour of some thirty American studios, Lockwood reported, "the crude ideas some had of retouching were amusing in the extreme."[46] Nevertheless, Lockwood's observations, in addition to her experience as a photographer and director of her own Wisconsin studio, led to the following conclusion: "Each day's experience proves to me that by a *judicious* use of *pencil* and *thought* we can invariably please the most fastidious, and make more sales than otherwise."[47] Neither Lockwood nor any of the women who dared to comment on the issue saw a conflict between pleasing customers and achieving high-quality, artistic work. The argument of these workers, whether men in the early years or women a little later, was that retouching, whether for tinting or flaw-removal, if done by a well-trained professional with artistic talent, could enhance, rather than obscure, truthfulness.

PHOTOGRAPHIC COLOURING. —
 Madame Und Howard (Pupil of Lock), Studio
111 Strand, colours with life-like accuracy and Lock-
like delicacy the photographs with which she is
honoured; teaches pupils at one guinea the course, and
provides photographs for private study, or as specimens.
Having been favoured with orders to colour those of
the Rev. W. M. Punshon, and other distinguished
preachers, she charges for the same two guineas each,
including painting, mounting, &c.
 Photographs published by Messrs. Waddy and Good-
child, Wesleyans (of whom she is the West-end Agent),
a list of which she will furnish on application.

Figure 15.5 Una Howard's employment want ad in the *Journal of the Photographic Society* of London, vol. 6, no. 96 (April 16, 1860). The printer has misspelled Howard's first name.

One could argue that, eventually, the arguments of the colorists and retouchers won the day. In the twenty-first century, digital photography editing software like Photoshop has made color adjustment and correction seamless processes, embraced by artists, photographers, and publication designers. While ethical issues have haunted commercial photo-editing since the days of air-brushed magazine illustration in the twentieth century, the retouching profession has shed its low-prestige "femininity," present in the early period discussed here. Perhaps acceptance of the contemporary retoucher is linked to the technological aspect of computer software, in contrast to the pencils and pigments of the nineteenth century colorist's table. Performed, as ever, by both men and women, retouching's digitization has re-endowed the job with the gloss of "masculine" skill.[48]

16

The Femininity of the Studio

In 1859 when *The Liverpool Photographic Journal* altered its name simply to *The Photographic Journal*, with a broader audience in mind, editor George Shadbolt mused: "Like the ladies of the present day, we have greatly enlarged our skirts—and like them, of course, we must also regard the arrangement as an embellishment."[1] A variety of feminine metaphors frequently appeared in the pages of bulletins, journals, and magazines throughout photography's first half-century. Use of "feminine" idioms, though, was not accompanied by greater inclusion of women in the content of photography-related publications. A vocabulary of domesticity slipped into print, not owing to the voices of women reporters (who were exceedingly rare before 1880), but because businessmen believed a comfortable, decorative interior—a home-like atmosphere—was a vital ingredient to their studios' success.

Part Three has strayed a little from this book's exploration of the *yin* and *yang* of early photography. Before closing this section, though, we return to a cache of "femininity" hidden in plain sight within a photographic discourse where "masculine" (*yang*) values predominated. For, although nineteenth-century reporters all but ignored women's studios, and, as discussed, men avoided employing or promoting women to prestige positions in the studio, that did not mean that they banished all "femininity" from their shopfront. Below, we will briefly explore how some male photographers borrowed "feminine" notions when talking about the darkroom, and in designing their premises. In that way, a *yin* sense of interior decoration, coziness, and even kitchen talk slipped into the culture of photography. We will tour the interior of the deluxe nineteenth-century photographic studio to discover infusions of domestic comfort, a *yin* aesthetic that countered the *yang* of the businessman's industrial production of photographic products. Prominent photographers attempted to recreate the pleasures of the domestic salon or parlor, even as they chose not to acknowledge women business owners' (or employees') existence or points of view.

Some of the most prominent photographers of the North Atlantic world borrowed the ambience of the well-appointed home in their commercial studios, using quality furnishings, décor, polite hospitality, and other amenities. For North Atlantic business owners like Mathew Brady, Henry and Charles Meade, or Camille Silvy, there was something compelling about "feminine" domestic values that inspired the "plush and intimate"[2] design of their studios (Figure 16.1).

In Paris, Gustave Le Gray's celebrated studio of the 1850s was decorated like "a little boudoir adjoining [one's] salon," and displayed delicate, hand-tinted portraits.[3] Studio

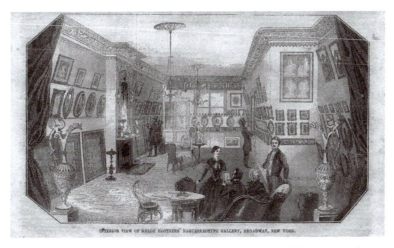

Figure 16.1 Engraving of the Meade Brothers' Daguerreotype Gallery, New York. Illustration in *Gleason's Pictorial*, vol. 4, no. 6 (February 5, 1853), p. 96.

owners "staged" not only props in front of the camera, but the art and furnishings throughout the public rooms as well. Investment in comfortable studio reception and changing rooms could, photographers realized, attract women customers. Comfortable reception and waiting rooms encouraged clients to relax both their poses and the grip on their purses.

On luxurious Victorian studios, Shirley Wajda has observed, "These parlors shared a sensibility with the domestic counterparts—to effect a calming influence on and provide a restful haven" for its regular or temporary inhabitants.[4] Photographers knew that nerves and anxiety marred sitters' facial expressions, and the result was that customers often complained or refused to pay for the portrait produced at the photographer's expense. Connecticut photographer Hart J. Rodgers devoted several chapters in his studio autobiography to advising men and women how to relax and bring out their best selves for the camera.[5] In creating a "restful haven," photographers were wise to put clients at ease.

The largest, most luxurious North Atlantic studios of the period employing elegant interior decoration were directed by men, not women (Figures 16.2 and 16.3).

Women photographers before 1900, often working alone following a husband's death or illness, a father's financial problems, or simply single and needing to earn a living, did not have the capital or the investors to create a "palace" of photography like Mathew Brady or André Disdéri (Figures 16.4).

A "masculine" tolerance for risk led the men mentioned above to borrow thousands of dollars, francs, or pounds sterling to outfit larger, more extravagant studios, which could pay dividends in the publicity they might attract (as shown in the idealized engravings above from period periodicals). Financial risk could, though, end in disaster as frequently as it ended in fortune. It is worth noting that both Brady and Disdéri eventually went bankrupt owing in part to the lavishness of their studios.[6]

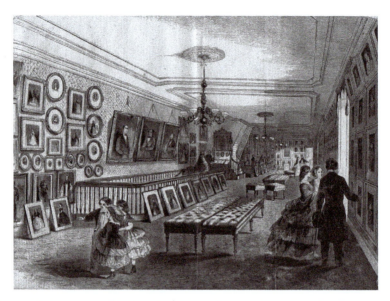

Figure 16.2 Engraving of Mathew Brady's New Photographic Gallery, New York, as illustrated in *Frank Leslie's Illustrated Newspaper* (January 5, 1861). Courtesy of the U.S. Library of Congress.

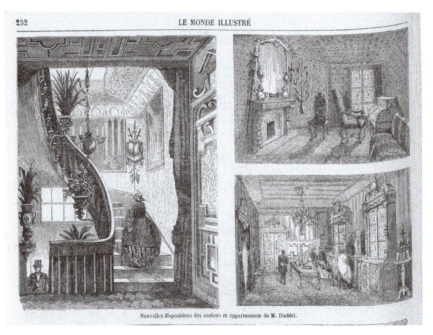

Figure 16.3 Portion of a full-page layout promoting A.A.E. Disdéri's newly inaugurated Parisian studio in *Le Monde Illustré*, année 4, no. 157 (April 14, 1860), p. 252. Specimen exhibited on Luminous-Lint.com.

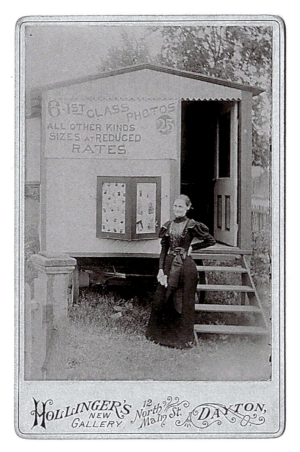

Figure 16.4 Cabinet card depicting a woman's photographic studio-gallery in Dayton, Ohio (n.d.). Exhibited on Luminous-Lint.com.

As with the new urban department stores of the era, the prosperous photographic studio and its interior gallery became public spaces open to women in their capacity as paying customers (Figure 16.5).

The Victorian dichotomy in public space, wherein men were producing and women were consuming, became a comfortable norm by mid-century, and produced large fortunes for men.[7] While the mid-century fraternity ignored female studio photographers, they wooed female customers and consumers. Several studio amenities were designed both to resemble home and attract ladies. Some studios, for example, offered separate entrances and exits for women. This arrangement allowed female customers to evade surveillance on the street. Studios of varying sizes across the North Atlantic world also employed female assistants specifically to help lady customers arrange their portrait dresses, hairstyles, and posing. Within the reception and waiting

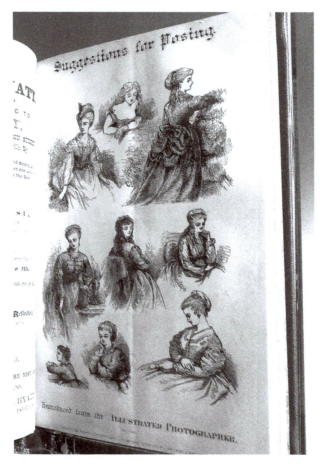

Figure 16.5 "Suggestions for Posing" in *Anthony's Photographic Bulletin*, vol. 1, no. 1 (February 1870, unpaginated). Women imagined as customers appeared often in the text and illustrations of photographic early journals. The depiction of women as photographers was rare before 1890. Author's photograph.

rooms, customers of both sexes were invited to leaf through attractive photograph albums—an activity they would normally enjoy in a private, domestic setting. Proprietors of fashionable studios, then, took great pains to make women and their companions feel at ease.

Although the appropriation of domestic order and elegance was largely in the service of attracting customers, the reporter Arbo Jay noted that elegant studios became destinations themselves, whether or not the visitor intended to have her portrait taken. In an 1883 article called "Handsome Reception Rooms," Jay described how a beautifully furnished reception room featuring "neatly-dressed ladies and gentlemen" who answered questions, framed photographs on display on the walls, tables, or in albums, and comfortable "facilities for [customers] arranging themselves" made visitors feel at

home. In that way, curious visitors ended up sitting for the camera, even though "when they first come in they have no intention of doing so."[8] Ambitious photographers embraced such advice, co-opting the comforts and charm of a bourgeois salon with the hope of boosting business.

As shown in the illustrations above, beautifully carved tables laden with pictures to peruse, upholstered chairs, plush carpeting, chandeliers, and even a piano likened some studios more to a hotel suite than a photograph manufactory. Studio businessmen concealed the industrial nature of their studios' production rooms (and arguably labor itself, as shown in Figure 16.6) with artistic decorations and homey charms in the public areas. The large Livernois studio in Québec City, for example, "adopted the airs and graces of a 'bourgeois salon' with its elegant gas chandelier, upholstered furniture . . . and walls lined with prints."[9] Prominent male photographers reproduced domestic comfort in their galleries in order to create a home-away-from-home, as well as to increase receipts. Theirs was a kind of commercial seduction, made more tempting by the fact that, during this period, a visitor to a photographic studio was usually under no obligation to open her purse until she returned to examine the resulting proofs following a sitting, and even then, she might decline to buy.[10] We can imagine, then, that some visitors would have experienced the charms of the studio as a *salon de conversation* or simply free entertainment. Visitors could freely survey the studio gallery, decorated as it was with paintings, pretty photographs of all sizes, and hand-tinted pictures (all examples of the studio's available products), then casually walk out.

Aside from providing the forum for discourse on studio décor and amenities, photographic catalogues advertised products, such as ornamental albums, that appealed to the era's domestic tastes.

Eager to attract subscribers, editors proposed that their publications, too, would themselves adorn the family parlor. For example, Edward Wilson hoped in 1864 that his new journal, *The Philadelphia Photographer*, would "be gladly welcomed as an ornament to the centre-table" of the domestic salon or parlor,[11] the same table where North Atlantic wives and mothers assembled photo-collage albums or other craft projects.

Throughout the second half of the nineteenth century, advertisers (e.g., Sears & Roebuck, Le Bon Marché, and Lewis's in Liverpool) targeted North Atlantic women as shoppers, though the owners, executives, and managers of these profitable businesses were all men.[12] Similarly, as we have seen, studio photographers desired women as paying customers rather than as partners or competitors. And likewise, photographic journals wanted women readers/subscribers, but did not seek women contributors. Nineteenth-century journal editors passionately wanted to create a community of practitioners around their publications ("You can help us, worthy reader, by sending us all the subscribers you can, or by subscribing yourself"), but active participants (as opposed to passive consumers) were imagined as men. "You, brother photographer," Wilson wrote, "can send us useful contributions, and can chide and correct us when we are in error."[13] A well-informed activist like Edward Wilson would have known that there were women professionals and amateurs in Philadelphia and around Pennsylvania.[14] He and his colleagues chose neither to publish their experiences nor to acknowledge them.

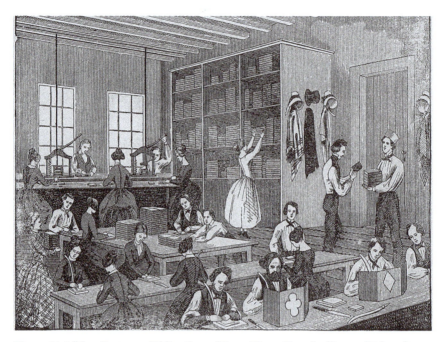

Figure 16.6 "Case Factory – Gilding Room." From Henry Hunt Snelling and Edward Anthony, *A Dictionary of the Photographic Art . . . together with a list of articles of every description employed in its practice* (New York: H. H. Snelling, 1854).

Despite the lack of invitations to women to contribute to photographic journals before 1890, surprisingly "feminine" language about recipes, cooking, and even childcare kept appearing in the pages of the photographic press. In contrast to photography magazines today, which cater to digital formats, journals in the early days of photography were full of "recipes" along the lines of a cookbook. Albumen itself (for the mid-century collodion process) was derived from egg whites, which had to be separated from the yolks for use on glass negative plates. In 1859, *The Photographic Journal* offered instructions for preparing the mixture: "Take any number of eggs, and breaking them carefully, pour the whites, free from any admixture of the yolk, into a clean bason [sic]."[15] Any housewife of the period would have been familiar with the technique.

In another example, a section entitled "Photographic Olla Podrida," *The British Journal of Photography* provided a complete recipe in "A HINT TO ALBUMENISERS":

What can you do with the yolks of your [separated] eggs? Make them into cheesecakes that will be pronounced unrivalled. Dissolve a quarter of a pound of butter in a basin placed on the hob, stir in a quarter pound of pounded lump sugar, and beat well together; then add the yolks of three eggs that have previously been well beaten; beat up all together thoroughly; throw in half of a grated nutmeg and a pinch of salt, stir, and lastly add the juice of two fine-flavored lemons and the rind

of one lemon that has been peeled very thin beat up all together, thoroughly, and pour into a dish lined with puff-paste, and bake for about twenty minutes. This is one of the pleasantest "bye-products" we are acquainted with in the economics of manufacturing photography. Try it![16]

Recipes like this photographer's cheesecake came off the press to cope with the millions of yolks produced by albumen production plants.[17]

Other processes also involved kitchen knowhow. The "Raspberry Syrup Process," for example, for aiding development of the photographic negative, was discussed four separate times in *The Photographic News*, spurring one letter writer to joke that he would "have to provide [him]self with a work on 'Domestic Cookery' to prepare for any contingency" when using the process.[18] The writer tellingly added, "On the part of the female community I would object to any such invasion of their sacred territories— there are *domestic reasons* for such objections."[19] In fact, early photography used a number of products from the kitchen, including eggs, milk, gelatin, and honey. Describing George Eastman making emulsifiers in his mother's kitchen in the 1870s, a biographer admitted, "Eastman's work over the sink now seems more closely aligned to cooking than to chemical experimentation."[20] Eastman remained very close to his mother Maria, who raised him alone as a widow, until her death in 1907.

If the mathematical formulae that at times dominated early photo journal content announced the *yang* of photography, the occasional kitchen recipe introduced a more *yin* language, and would have been more familiar to female readers of the period who had not a scientific education. Contrast Richard Walzl's "Practical Hints and Useful Recipes" in his Baltimore-based *Photographic Rays of Light*, for example, to James Chisholm's formula for fixing an "overcharged nitrate bath" in another American journal, *Anthony's Photographic Bulletin*: $AgO,CO_2 + NO_5 = AgO,NO_5 + CO_2$.[21] Enthusiast Oliver Wendell Holmes, Sr., in his pragmatic manner, declared photography to be "just like cooking. the sun is the fire, and the picture is the cake; when it is browned exactly to the right point, we take it off the fire."[22] One might wonder if Holmes ever supposed cookery author Mary Johnson Lincoln, a fellow Bostonian, would have made a good photographer.[23]

Beyond interior décor and recipes, journal editors and reporters even borrowed similes from child-rearing. Again, Philadelphians stood out for the language of parenting that they employed. Offering advice to darkroom procedure, Edward Wilson offered the following tidbit: "Chemicals are like children, the more you trifle with and disturb them the more vexatious they will become. Keep them pure, and they will reward you abundantly with good work."[24] In contrast to the language of conquest used by photographers as shown in Chapter 2, Wilson's parenting language aimed to coax his "children" into good behavior.

In another example, an anonymous contributor to *The Philadelphia Photographer* likened photography's "first steps" to those of a baby: "Look back for a moment to Daguerre. See the infant art holding up its tiny arms, grasping at the sunlight till it coaxes it to paint the image on the polished surface." Then, congratulating the fraternity on its nurturing skills, the writer declared, "Our infant has grown in strength, and can boast its manhood."[25] Similarly, when *Anthony's Photographic Bulletin* celebrated its third month

of publication, the editor bragged that the magazine's "infantile pulse beats healthily and strong, and its growth is commensurate with the expectations of its projectors."[26] From at least the 1860s to the turn of the century, photography's advocates in the press drew freely from the vocabulary of the nursery to express pride in their "child."

What, then, do we make of all this "feminine" language in the discourses surrounding the Victorian studio? Businessmen's interest in making their studios look and feel more "feminine" did not translate into professional respect for studio women themselves, some of whom, as we have seen, worked as fellow operators, colleagues, and competitors. Just as *yin* photographic practices flourished in private (as seen earlier), so *yin* language and virtues leaked into photographic print, despite policies and notions that elsewhere blocked the "feminine." Studio businessmen appropriated a "feminine" ability to create comfort and charm, learned perhaps from the supposedly natural talents of female relatives and friends. Despite lakes' worth of ink use in text making photography "masculine," even the most ruthless commercial photographers realized it would not be prudent (or possible) to suppress entirely the "femininity" of the new medium. They knew that their studio ambience ought not resemble a smelly, or even a sterile, laboratory. Staging a "feminine" interior environment was a method of cultivating customers with their display of taste.

This chapter has shown that male professionals borrowed a "feminine" concern for decorative comforts and the language of nurturance, perhaps picked up from their wives, mothers, or savvy colleagues, in order to create a seductive ambience in their places of business. "Feminine" domesticity thereby entered the language of photography, a language and vocabulary that included recipes, helpful hints, and interior decorating, even as journals and clubs largely excluded women's voices during the period in favor of a more dominant emphasis on laboratory science. If studio bosses learned from the "woman's touch" of a female colleague or employee, it was never acknowledged as her business acumen.

In the last chapter of this book, we will look more closely at some of the actual American, French, British, and Canadian women who ran their own studios from the 1840s to the 1890s. On the whole, these women did not possess the means to imitate the elegant salons in the businesses described above. Nevertheless, they generated business by offering to come to lady clients' homes, establishing studios that complemented their husband's enterprises,[27] and sometimes even arriving as the first photographer in town. By those and other means, women photographers in the early period spread throughout the North Atlantic world.

Numerous scholars and collectors mentioned throughout this book have made evidence of these women's professional lives available. While a few women photo artists and amateurs appear in historical narratives (in some cases prominently), female business owners in the pre-1890 period remain largely hidden in the historical landscape of photography. The different ways that they succeeded and failed in business is an important part of the story of early photography, as is their persistence in the face of insults, disdain, or indifference.

17

Studios of their Own

Before 1890, women studio directors in the North Atlantic world practiced their trade with little or no hope of professional acknowledgment. Female photographers before that date, such as Hannah Maynard in British Columbia (Figure 17.1) did not enjoy the professional prestige that some of their male colleagues enjoyed.

There were no female heroic counterparts to, say, Félix Nadar, Napoleon Sarony, or Antoine Claudet, whose professional reputations in Paris, New York, and London, respectively, raised them to the level of geniuses in the photographic fraternity. Women operators generally plied their trade quietly, sometimes using their husbands' or brothers' printed logos, in metropolitan capitals, provincial cities, and western boom towns.

Victorian customers patronized North Atlantic women's photographic studios throughout the second half of the nineteenth century. Although some women played into feminine stereotypes to convince prospective customers that women and children were better off in the hands of a female photographer,[1] they by no means limited their clientele to mothers and children. Attracted by the idea of a "lady photographer," adult men, too, purchased their portraits from women operators across the region and beyond. When Eliza Withington opened her California studio in 1857, one newspaper editor enthused: "She is an accomplished lady and most excellent artist . . . Just think of it—your picture taken by a Lady!"[2] Such a figure of interest must have been the talk of Ione City. Across the continent, women photographers made portraits of Civil War soldiers in uniform, prospectors hoping to cash in on the Gold Rush, college students, and bridegrooms throughout the second half of the century.

Peter Palmquist, Françoise Condé, Margaret Denny, Ron Cosens, and Sandy Barrie have studied the trade directories of the era, *carte-de-visite* logos, and amassed collections of women photographers' images. Obsessive collecting by Palmquist, Julia Driver, and William Darrah, and the discovery of forgotten tombs of glass negatives and ledgers by attic archeologists, has made the ongoing *forgetting* of these professionals irresponsible. To the deniers of women's early commercial presence we can incontrovertibly insist: *They were there*, literally and figuratively minding their business, from the 1840s onward.[3] It is important to stress that women operators worked from the earliest years of the photography studio's existence. Geneviève Élisabeth Disdéri (1817–78), for example, wife of the more famous André-Adolphe-Eugène (patentee of the popular *carte-de-visite* photo format), started a studio with her husband in Brest in the 1840s (Figure 17.2).

Figure 17.1 Husband and wife Richard and Hannah Maynard outside her studio in Victoria, British Columbia (1880s). Hannah opened the studio in 1862 and operated it until her retirement in 1912. Wikimedia Commons: https://commons.wikimedia.org/wiki/File:Hannah_and_Richard_Maynard.jpg.

She was no mere assistant to her husband because, once he left for Paris in 1854, she maintained the Brest studio alone. Later in Paris she operated a separate studio. Françoise Condé counted four women in Paris who operated studios in their own right between 1844 and 1850: Madame Gelot-Sandoz on the Blvd Poissonnière, Mlle Cecile on the Blvd des Italiens, Mlle Sthael on the rue Saint Honoré, and Madame Guillot-Saguez on the rue Vivienne.[4]

Englishwoman Jane Wigley's 1840s daguerreotype studio was mentioned earlier in Chapter 7, and across the Atlantic in Nova Scotia, a certain Mrs. Fletcher advertised herself as "prepared to execute Daguerreotype miniatures in a style unsurpassed by any American or European Artist" as early as 1841.[5] Although women operators represented a small minority of the total number of studio owners during the period, they were

Figure 17.2 Geneviève E. Disdéri, photograph of port of Brest for *Brest et ses environs* (1856), which she published. Wikimedia Commons: https://commons.wikimedia.org/wiki/File:Disdéri_brest_entrée_du_Port.jpg.

significant both for the fact that they had overcome multiple gender-based obstacles, and for the fact that in some small towns in North America, Britain, and France they operated as the first or only photographer for a period of time.[6]

A survey of the archival collections above reveals not only the clear presence of women's studios, but also the broad geography of their businesses. Women like the Chatelain sisters (Céline and Gabrielle) photographed customers in towns such as Nancy in the French Lorraine. They hung out their shingles, like Eliza Withington, in the unpaved prospecting towns of California (Figure 17.3).

They shared the tasks of a busy studio with their partners in the cathedral towns of England, like Marion Bustin. And, they also competed with men in New York, Boston, and Paris, like Angéline Trouillet (Paris) and Matilda Moore, who operated at No. 421 Canal St. in New York in the 1860s. These women were neither employees of other people's studios (e.g., colorists, retouchers, mounters, or receptionists), nor well-off amateur artists, like Lady Hawarden, working at home. They were commercial photographers who had put up capital, either alone or with partners, to establish studio businesses.

Like their male colleagues, women studio photographers were, in today's parlance, "job creators": Charlotte Prosch's daguerreotype business of 1848 became the multi-employee Excelsior Daguerreotype Gallery in Newark, NJ in 1853. Candace Reed's business grew from one studio in Quincy, Illinois in 1858 to four branches strategically located along the Mississippi River.[7] By the mid-1890s, Sallie Garrity had hired sixteen employees at her deluxe Chicago studio.[8] And yet, women's presence as successful

Ambrotypes.

MRS. E. W. WITHINGTON

HAVING completed, with a large and well arranged Sky-Light, her Ambrotype Gallery in IONE CITY, Main street, first door west of the bridge, would inform the citizens of Amador county and the public generally, that she can be found at the Gallery on Tuesdays, Wednesdays Thursdays and Saturdays, at all hours suitable for operating, where all are invited to call and examine her specimens before getting pictures elsewhere.

Mrs. W.'s motto is "Excelsior," and having recently visited not only Brady's celebrated Gallery in New York City, but many of the most noted galleries in several of the Atlantic States, she feels confident that she can give satisfaction to all who patronize her by giving them as *faithful likenesses* as they can procure elsewhere.

Instructions also given in Oriental Pearl Painting.

Come and see, and if it please you,
Secure the shadow ere the substance fade.
jy 25 40-3m

Figure 17.3 Advertisement in the Amador *Weekly Ledger* (1857) for the Ione City, California studio of Mrs. Eliza W. Withington (*c.* 1825–77). Ambrotypes were photographic images on glass which, like daguerreotypes, were not produced from negatives, and so each was unique. Courtesy of the Beinecke Rare Book and Manuscript Library, Yale University.

commercial operators—or even unsuccessful ones, since most studios, whether men's or women's, were relatively short-lived—is almost entirely missing from works devoted to photography's early history. The interesting women who defied social norms about gender, work, and public space, often as widows, divorcees, or single women, have too often disappeared from history.[9]

Despite scant acknowledgement, many professional women enjoyed success in their communities for careers lasting years, sometimes decades. For most commercial women photographers, prosperity was enough; they simply operated their businesses without access to a platform for their opinions, or membership in a society or syndicate. Rarely speaking at photographic meetings, publishing articles or books, or officiating at photographic conferences in the period before 1890, these interesting businesswomen ensured that their contributions would be ignored in the grand narratives of photography's history. In part, this invisibility was the consequence of receiving scant encouragement from the institutions that produced the published and archival records that historians would use to recreate the past.

Their absence from our popular perception of early photography was also the consequence of many women relying on word-of-mouth, rather than advertising, to attract patrons. They found contentment with a job well done and survival in a competitive market, rarely having the confidence to publish their photographs, their ideas, or experiments. As discussed in Chapter 11, this "shyness," or silence—ironical in the face of the spirited, independent personalities that allowed them to succeed in their businesses—would gradually change after 1890, when women amateurs and professionals, for a number of reasons, confidently began speaking and publishing in greater numbers. In comparison to the paucity of women's voices in the photographic journals of the 1850s, 1860s, 1870s, and 1880s, the women of the 1890s and after would produce a veritable avalanche of published commentary.[10]

Judging from the importance of women and children customers as the bread-and-butter of the commercial studio, one might suppose that a "feminine" perspective would have been a valuable quality in the studio business and the professional literature. Although a few advocates saw a close connection between photographic portraiture and "femininity" (as shown in Chapter 14), most spokesmen of the period did not value the "femininity" of photography as discussed in Part One of the present work. As in the other professions of the day, the acceptance of women in the field would have meant both more competition for men (already struggling in a cutthroat marketplace), and at the same time, fewer women devoting themselves fully to unpaid domestic labor. It was an unattractive proposition for men.

Reporters, spokesmen, and correspondents took to warning readers about the supposed pitfalls of partnering with women in the studio. They complained that women made terrible apprentices because, in their minds, women planned to quit at the earliest convenience in favor of marriage (their "true" career). As late as 1894, photographer and future physician Myra E. Sperry wrote that male operators most often refused to apprentice aspiring women. "First, he is prejudiced about her ability to learn," she wrote, "then he thinks if she does learn she will make no use of it."[11] From the studio man's perspective (that is, a non-relative), a woman apprentice posed a triple threat: her presence could lead to impropriety or whispers of it; his tutelage might be wasted if she quit to marry; or, she could succeed and become a competitor.

Until the 1890s, photography's journalists very rarely wrote about women's studios, despite their existence, as we have seen, from the 1840s, across the North Atlantic world. When businesswomen dared to assert themselves or demand acknowledgement, sometimes there were angry reactions. The case of the Bertolacci sisters provides a good example of the consequences of women photographers overstepping the boundaries of "feminine" decorum (Figure 17.4).

Caroline (1840–89) and Marie (1843–1929) Bertolacci, born of British parents in France, studied photography with their father William once the family had settled in Kensington.[12] The first part of the sisters' career was spent in photographic publishing. Specifically, they sold high-quality albums of photographed engravings of the paintings of J.M.W. Turner.[13] They exhibited these photographs competitively in the 1860s and worked in their father's studio until his death in 1883. It was only after William's death that the sisters could open their own studio, because he had forbidden them from opening a studio "on their own account."[14] Using their father's equipment, though, they

Lake of Thun.

Figure 17.4 Between 1807 and 1819, the painter J.M.W. Turner created a series of seventy prints of landscape etchings, entitled *Liber Studiorum* (Book of Studies). In 1863–4, Caroline Bertolacci and her sisters created an album of photographic reproductions of these works. This one (here in greyscale) depicts Turner's "Lake of Thun" (a Swiss landscape). Courtesy of the J. Paul Getty Museum, Los Angeles.

published four different albums devoted to Turner's various genres between 1862 and 1865.

The sisters' promotion of their acclaimed art albums got them into trouble with the Photographic Society of London. The affair began when Caroline and Marie entered some of their photographs in the Society's 1864 Exhibition.[15] Writing a letter to *Photographic Notes*, Caroline complained, first, that another publication (*The Photographic News*) had introduced their work as new, when in fact their works had been "noticed for the last three years by daily and weekly papers."[16] The *News*, she claimed, had been ignoring their work while "laud[ing] up certain foreigners, and Mr. Thurston Thompson, for having exhibited a few of the best of his '*cribs*' or scraps from some of Turner's work."[17] They were irritated at the fact that partial, possibly inferior reproductions had been praised, while their deluxe reproductions were overlooked.

Caroline's letter ventured onto dangerous ground. She criticized Thurston Thompson, a Photographic Society member, for having won an exhibition prize previously, then getting onto the Society's exhibition committee in order (she claimed) to henceforth suppress the prize in the category of photographic reproductions. This accusation led the Society to counter-attack, and it began by accusing the sisters of exaggerated self-love. In an anonymous item in the Society's journal, the writer said,

> Our attention has been called to the following passage in a letter from Miss C. Bertolacci, eulogizing the productions of herself and sister . . . and as it contains an unwarranted attack on the Committee appointed by the Council to super-intend the Exhibition of 1864, we feel bound (notwithstanding our reluctance to comment upon the statement of a lady, however ill-judged) to notice it.[18]

The writer began by closing ranks with the editor of the *News* (George W. Simpson, another Photographic Society member), saying that it was not part of "a respectable journalist's duty" to take notice of "every photograph that is published."[19] He then explained that for the 1864 exhibition, "when the Council came to consider the question of Medals, it was decided that, seeing one gentleman so far outstripped his fellows in this branch, there was practically no competition; and it was determined for this reason that no Medals should be awarded to reproductions."[20] And anyway, whereas Thompson's prints had reproduced paintings, the Bertolaccis' had reproduced engravings, "examples of what is usually regarded as the lowest walk of photography."[21] The Society was determined not just to defend its exhibition committee, but to take the sisters down a peg.

In a telling Tennyson quotation, the Society writer said that the Bertolaccis were to Thompson "'as moonlight unto sunlight, and as water unto wine,'" unwittingly categorizing the parties as *yin* (feminine) and *yang* (masculine).[22] Characteristically for the time, instead of comparing in good faith the qualities of both Turner reproduction projects, the men of the Photographic Society closed ranks in order to defend the fraternity. They even went after William Bertolacci in the following number of the journal, accusing him (tongues in cheeks) of contributing to a charitable fund within the Society in order "to advertise his daughters' photographic eminence."[23] For these young women to compare themselves to one of the Society's "masters" was, in the Society's eyes, foolish; for them to aggressively promote their work (standard procedure for any man's commercial work) was unforgiveable.

Backhanded compliments dogged women workers. As late as 1893, the American archeologist C.B. Moore qualified his praise for eleven women photographers profiled in *Cosmopolitan*, by attributing the supposed "inferiority of many women in camera work" to their sex's "lack of concentration and sustained effort," implying that the marriage market, and subsequent children, prevented women from fully applying themselves to the art.[24] Other North Atlantic intellectuals like Ernest Legouvé in France were concerned that if women were working in a laboratory or darkroom, no one would be taking care of the children.[25] Legouvé was correct in the sense that modern Western society, as reimagined by the post-revolutionary bourgeoisie, was (and perhaps still is) not built for aspiring women professionals who had children.

The nineteenth-century North Atlantic gender regime made allowances neither for middle-class women to earn a decent living, nor for women's need for independence or creative subjectivity as artists. As a portion of the orphaned, single, divorced, and widowed population, women studio photographers nevertheless carried on, despite what learned opinion said. An unusual 1883 notice in *The Photographic Times* revealed the circumstances of one woman in Wisconsin:

> The well-known photographic author and artist, Mrs. E.N. Lockwood, announces to us and her patrons of the past twenty-five years that having been, by mutual consent, divorced from her husband, Wm. M. Lockwood, she will remain in the photographic business in Ripon, Wis., and will erect a gallery in the early spring. Her studio is at present at her mother's residence.[26]

Starting over after a twenty-five-year studio partnership, Lockwood's mother allowed her to re-establish her business in her home, before Lockwood opened her own studio, which would compete with her ex-husband's. *The Photographic Times* writer awkwardly concluded, "There being no precedent to establish a code of etiquette, we are at a loss whether we ought to offer our condolence or congratulations to our brother and sister, but will venture upon the latter."[27] Having begun work in the late 1850s, Lockwood remained a photographer until her death in 1905.

Published books and articles on the commercial studios of Europe and the United States, too, maintained the illusion that women were absent from the profession. By systematically excluding women from literature about studios, spokesmen were attempting to secure the profession's prestigious, and manly, status. Photographer James Ryder, for example, wove praise for his male peers throughout his professional memoir, never once acknowledging a female colleague in his state (Ohio), in the National Photographers' Association, or in the Photographers' Association of America (both organizations he co-founded).[28]

In England, Henry Baden Pritchard's *Photographic Studios of Europe* (1882) showed results of his travels around England, Scotland, France, Germany, Austria, Hungary, and Belgium. Out of the fifteen establishments in London and nine studios further afield, Pritchard visited not a single woman's studio. Most of Pritchard's chapters featured an individual's business, but it was telling that he reserved two chapters for prison studios, one chapter for a police studio, and another chapter for the studio at Kew Observatory, thereby affirming the medium as a scientific instrument dealing in facts (photography as *yang*).

Even press articles whose titles promised the illumination of women's studios disappointed. An 1875 piece in *The British Journal of Photography*, entitled, "The Ladies of the Profession," for example, related the story of a starving, impoverished photographer's wife, rather than offering insight into women's businesses.[29] Through strategic exclusion, women photographers' lives thus fell into sometimes irretrievable oblivion. The first name, birth, and death dates of a certain "Madame Breton," for example, whose work was included in the Musée de l'Orangerie's 2015 exhibition of historical women photographers, are all unknown. Curators knew only that she was

active in Rouen around 1860 (the capital of the Normandy region and a major cathedral town in France).[30]

Disappearance and invisibility stemmed also from the lack of acknowledgement of wives' or sisters' participation in the family business.[31] Just as "one flesh" in the marital ceremony and the law meant *his* flesh, so in business it often meant that shop signs, directory entries, and company logos excluded her name. Take for example the case of Mary Ann Meade (*c.* 1824–1903), an American daguerreotypist who worked with her two brothers Charles and Henry in a large, successful New York City studio (Figure 17.5).

Smithsonian curators at the National Portrait Gallery reported that Mary was a "daguerreotypist and photographer in her own right," working for many years in her brothers' photography business. The Smithsonian's record continues:

> After Charles's death in 1858, Mary Ann began to gain greater visibility for her role in the gallery's operations. She was listed as a photographer in Trow's New York City Directory for 1861–62, and in February 1861 an article about renovations to the Meade Brothers gallery noted, 'Mr. [Henry] Meade and his sister attend personally to visitors.' In 1862, Mary Ann Meade became the gallery's director.[32]

Figure 17.5 Daguerreotype portrait of Mary Ann Meade (*c.* 1850). Courtesy of the National Portrait Gallery, Smithsonian Institution.

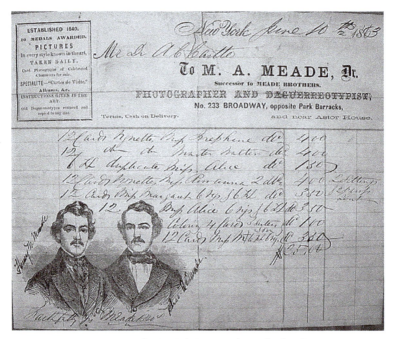

Figure 17.6 Transaction invoice for M.A. (Mary Ann) Meade, dated June 10, 1863, featuring a lithograph (*c.* 1851) of her two brothers, Henry William and Charles Richard, in happier times. Courtesy of the National Portrait Gallery, Smithsonian Institution.

Although Mary created daguerreotypes in the studio from the 1850s, her name appeared on the business' stationary only after the death of one brother and the decline of the other (Henry William died in 1865) (Figure 17.6).

Likewise, Elise Livernois, though a full creative partner and the proprietor of the family's Québec City studio, was invisible in the business' marketing devices.

In calculating the scope of women professionals' presence in nineteenth-century America, photo-historian and collector William C. Darrah posited that there would have been "no reason" for women to withhold their first names in trade directories.[33] A survey of the evidence does not support Darrah's view. In fact, there were many reasons why a woman would conceal her female identity, or why it would be concealed for her. The Palmquist Collection of commercial photographs at Yale University contains many women's logos that used only a last name, or first initial and last name (Figure 17.7).[34]

Reasons for doing so included women's attempt to side-step the assumption of feminine technical incompetence; for safety or the expectation of modesty; or affiliation with a father's established business (and logo). Another piece of evidence that some women hid their first names comes from a report on the London Photographic Society Exhibition in 1860, wherein the anonymous author remarked with some frustration that the "regulations require the *name* of the photographer." Although "ladies should be entirely at liberty to withhold their names if they please," he recommended "for the

Figure 17.7 Cabinet card of three young girls (1898), cropped, by Abigail E. Cardozo (1864–1937). She was one of several American woman photographers whose logo showed only a last name (see bottom of the card), with no honorific signaling marital status or sex. Courtesy of the Beinecke Rare Book and Manuscript Library, Yale University.

future the addition of some initials at least to the intimation as given in the present catalogue, which merely indicates—'*by a lady.*'"[35] We remember that in fictional literature during the period, too, all three Brontë sisters published under men's names, as did George Eliot, George Sand, George Egerton, and others—all of whom felt a need to hide their female identities in order to be given a chance in the marketplace. In concealing their names, women were able to demonstrate prescribed feminine modesty, and they received consideration given to a man by publishers and readers.

Wives might be invisible partners, but unlike invisible partners who were men, all ownership and profits from the studio belonged to the male spouse, even if her dowry had financed the equipping of their studio, and even if she had taught him how to use the camera (as may have been the case with Elise and Jules Livernois).[36] Ownership of the business might fall to a widow upon her husband's death, if it did not fall to a son

or male business partner. It was in such scenarios (as widows) that the names of many women photographers came to light, such as Maria Fitzgibbon in Missouri, who took over *The St. Louis Practical Photographer* after her husband's death in 1882, extending the journal's distribution east and north to Canada. In France, Françoise Condé reported that from the 1880s, Madame Deriaz, known as Veuve Deriaz (Widow Deriaz) continued the couple's photography studio in Switzerland for twelve years after her husband's death.[37] Those are just two of the widows who, from necessity, succeeded in business by virtue of their own talents.

Over the past forty years, scholars and skilled amateurs have rescued dozens of pre-1890 women studio photographers from permanent oblivion, though neither the facts nor the careers of these early professionals have made it into our perception of who early photographers were. By perpetuating women's invisibility, surveys of photography's history achieved a false consensus that women were not there in the beginning. This chapter has synthesized other scholars' discoveries, which, piece by piece, contradict that twentieth-century consensus. But beyond that, it hopefully shed some light on the stubborn history of this forgetting.

Conclusion

Judging from the diversity of scholars contributing to the subject, the history of photography continues to sit uneasily between history, art history, media studies, and other university departments. Regardless of their diverse backgrounds, most of the authorities cited in this book share a common concern with photography as a cultural force, and I join them in that concern. Our scattered community does not research photography in order to buttress the value of this or that photographer, the way a connoisseur might. We are interested, rather, in how the discourse of photography conveys power, specifically, the power to name, define, or control an agenda.

Throughout this book, I identified historical texts, even specific words, that revealed language "moves" in the never-ending game of human speech. Through verbal and written expression, in addition to images, group rules, and silences, we saw how nineteenth-century male actors' mastery of the game promoted certain conceptions of photography while ignoring others, and how it forestalled other would-be participants. Occasionally, a gender or a technique was explicitly banned, but more often they were marginalized by language moves in the speech games of the period, across multiple media.

Cuthbert Bede's cartoon (Figure B), for example, shows how textual discourse translated into popular imagery. Here, the humorist conceded that women of the period (1850s) were practicing photography. But at the same time, Bede resorted to the discursive tactic of making photography "dirty," and thereby "unfeminine" (marriageable girls be warned). Throughout the present book, we have seen similar examples of the supposedly polluting effects of photography, the message being that women wishing to preserve their purity (in a double sense) should stay away from the art/science/business. Even in North Atlantic societies today, while getting dirty is tolerated, even encouraged, in males, it is often discouraged in females.[1]

Two other prominent discursive moves in the sources were the emphasis on photography's technical properties, and the defining of photography as a "fraternity." The former—the conception of photography as a technology requiring specialized knowledge—remained a preoccupation throughout the second half of the nineteenth century, despite attempts by some scientists, inventors, photographers, and public lecturers to show the natural simplicity of the process. The dominance of technical minutiae in photographic speech and writing helped, as we saw, make photography "masculine." Training in math and chemistry, usually discouraged (or superficial) in

A PHOTOGRAPHIC POSITIVE.

LADY MOTHER (loquitur) " / SHALL FEEL OBLIGED TO YOU, MR. SQUILLS, IF YOU WOULD
REMOVE THESE STAINS FROM MY DAUGHTER'S FACE. I CANNOT PERSUADE HER TO BE
SUFFICIENTLY CAREFUL WITH HER PHOTOGRAPHIC CHEMICALS AND SHE HAS HAD A MISFOR=
.TUNE WITH HER NITRATE OF SILVER. UNLESS YOU CAN DO SOMETHING FOR HER, SHE WILL NOT
BE FIT TO BE SEEN AT LADY MAYFAIR'S TO-NIGHT. "

LONDON. PUBLISHED BY T. MC'LEAN.

Figure B Cuthbert Bede (pen name of Anglican clergyman and humorist Edward
Bradley), "A Photographic Positive," plate between pp. 50 and 51 in *Photographic Pleasures:
Popularly Portrayed with Pen and Pencil* (London: Thomas McLean, 1855).

Victorian girls, whose middle-class educations emphasized the arts of pleasing,
rendered most women quite speechless in the context of these technical debates.

As for photography as a fraternity, this characterization was partly the consequence
of the linguistic masculine being used to connote universality (the "brotherhood of
man"). But, the concept of fraternity also had a business implication. Perhaps especially
in the United States with the mid-century formation of the National Photographic
Association and then the Photographers' Association of America, the business of
photography, so went the vision, would be owned and operated by a fraternity of
honorable gentlemen, who came together in solidarity to protect and advance the
profession. Women could work in studios as subordinates, said the fraternity, and
they were welcome to contribute membership dues to those national associations.

But rarely would the mid-century fraternity solicit women workers' opinions, or even acknowledge the success with which some women operated their own studios across the country.

I began this book with a quote from John Tagg (an art historian), who, along with many of the other scholars referred to in this book and myself, took inspiration from the twentieth-century philosopher Michel Foucault. It was Foucault who influenced a number of disciplines (history, sociology, literary criticism, philosophy) by mapping out how power shifts and accumulates in different areas of society in often unstable ways. Photography, like other bodies of knowledge in North Atlantic societies, has operated as a tool to support, and sometimes to subvert, the accumulation of power by actors who master their "subjects."[2] Race, class, and gender are three of the largest human categories through which the power to discipline makes itself felt (sexuality is another).[3] For decades, scholars like Tagg, along with Elizabeth Edwards (an anthropologist), Steve Edwards (art history), and Shawn Smith (American studies) have shown how photography defined, dignified, or excluded; in short, they have shown how photography converted knowledge into power.

As useful as the Foucauldian conception of power dynamics has been in a variety of subject areas, there may be other ways of perceiving discourse in general and photography in particular. In this book, I borrowed an East Asian philosophical concept, *Taiji (yin-yang)*, in an attempt to unblock, or refresh, our thinking about photography and its history. The *yang* of photography—its ability to probe, expose, and conquer; its acolytes' proud concern for its "paternity"; the drive for expansion in the face of substantial risk; and its technologies and patents—as we well know from the literature, produced an impressive heritage from which we can learn important lessons. The ways that British, French, and American men built up the science of photography via voluntary associations, tireless publication, and an international system of rewards, was a major cultural achievement, even ignoring the canon of memorable photographs that twentieth-century curators constructed from their archives. The triumph of photography's "masculinity" and its power in these newly industrialized societies was an historical success story that Foucault would have well-recognized.

This book has also shown how the *yin* of photography brought a sense of "play" to the medium. Photography's ability to project theatricality and to reflect dreams, its tactile pleasures, its confident softness in the hands of some artists, and its hybrid creativity, all demonstrated the *yin* of photography. We saw how witty photo-collage albums and tinted artwork, dramatic self-portraits, and pictures of children that replaced impatient conventionality for brilliant intimacy, distinguished the careers of some photographers of both sexes. These values in early photography, and women's pursuit of them, also have valuable lessons to teach us.

Unfortunately, in professional photographers' anxious concern about their identities and reputations, the richness of these *yin* conceptions of photography were often ignored, dismissed, or denigrated by photography's earliest institutions. In the fraternity's determination to make photography and its new profession manly, early institutions (and certainly they were not alone) excluded women's voices from their societies and publications until the end of the century. At the same time, social, cultural, legal, and religious rules and norms persuaded most North Atlantic women to remain

silent even as some nevertheless practiced their photography as professionals, amateurs, and artists.

What if photography could retain its ability to help us understand the world, could continue to dignify both subjects—meaning here all of us with subjectivity—and objects, without the excluding or the anxious ranking that have historically accompanied photographic discourse? I think we could work toward this goal by recognizing the *yin* and *yang* of photography, past and present. As in human health (according to Chinese medicine), the waxing and waning of *yin* and *yang* is dynamic. Optimal health depends upon their balance. But, as dynamic forces, each ascends and descends depending upon climate conditions.[4] It is inevitable that at certain times, one side might be more dominant than the other. Persistent dominance, though, to the extent that we might diagnose the other force as *blocked*, merits our attention, even if just to recognize the fact.

From the late 1880s until the First World War, photography experienced a temporary ascent, or unblocking, of *yin*, owing to multiple historical factors. In the twenty years or so before the war, new photographic societies exhibited a greater openness to the "femininity" of photography, including its potential for hybridity, softness, and theatricality. A combination of social, cultural, aesthetic, and legal changes encouraged North Atlantic women to voice more confidently their views as photographers, whether in photographic clubs or in the press. The Pictorialist art photography movement across the North Atlantic world introduced serious experimentation with retouching, soft focus, and staged composition techniques, the last often depicting domestic scenes.

Beginning in the 1880s with the positive re-evaluation of the work of Julia Margaret Cameron,[5] new clubs arose that focused on artistic expression and hand craft. While the leaders of most photographic societies continued to be men, there was an unprecedented rush by French, British, and North American women to join the national flagship societies, new amateur societies, and the secessionist art-photography societies, the last often by invitation only. In Britain, the secessionist Brotherhood of the Linked Ring (founded in 1892) invited Carine Cadby, Gertrude Käsebier, and Sarah Choate Sears to be "links."[6] Similarly, the New York Photo-Secession (founded in 1902) admitted Gertrude Käsebier, Eva Watson-Schütze, Mary Devens, and Annie Brigman. The Paris Photo-Club, established in 1888, included Louise Binder-Mestro, Antoinette Bucquet, and Provençal photographer Céline Laguarde in its ranks (Figure C).[7]

Furthermore, the Photo-Club, in cooperation with exposition organizers, welcomed Frances B. Johnston's all-female exhibit of American art photography to the Universal Exposition of 1900, a watershed moment for both women photographers and the critical acceptance of photography as fine art.

During the *Belle Epoque*, the female photographer would embody the *fin-de-siècle* figure of the New Woman in Britain, France, and North America. World's Fairs, such as the Columbian Exhibition of 1893 in Chicago and the 1900 Universal Exhibition in Paris, gave a few women national leadership positions for the first time, and an international forum in which to display their photography. Another factor leading to the rise of the New Woman (or *nouvelle femme*), was the bourgeois patriarchy's realization, and partial acceptance, that some of its daughters required gainful, respectable employment. This belated realization led to new educational opportunities, legal protections, and professional certifications for women throughout the North

Figure C Céline Laguarde, "Fantaisie Louis XV," plate in R. Demachy and C. Puyo, *Les Procédés d'Art en Photographie* (Paris: Photo-Club de Paris, 1906), p. 10 (rendered here in greyscale). Laguarde's retouched image combined theatricality, hybridity, and a soft mysteriousness in the first decade of the twentieth century.

Atlantic world. Photography had long provided career possibilities for some young women, and these opportunities expanded after 1900 to include advertising work, photojournalism, and more.

The mobility of women at the end of the century, both social and physical, was also strengthened by the campaign for rational dress and enthusiasm for the bicycle. American suffragist Susan B. Anthony commented in 1896:

> Let me tell you what I think of bicycling. I think it has done more to emancipate women than anything else in the world. It gives women a feeling of freedom and self-reliance. I stand and rejoice every time I see a woman ride by on a wheel . . . the picture of free, untrammeled womanhood.[8]

Figure D E. Buckman, "Modern Goths: Amateur Photographers at Work in the Court of Lions, in the Alhambra, Granada," engraving in *The Graphic*, vol. 42, no. 1092 (November 1, 1890), p. 499.

It was no coincidence that the popularity of the bicycle, its use for photographic excursions, and greater numbers of women joining photographic societies all occurred at the same time, during the two decades on either side of the turn of the century. The restrictions posed by traditional Victorian dress, too, had made an array of physical activities difficult—even dangerous—for women,[9] and exacerbated the spectacle produced when women attempted physical tasks in public. In contrast, simplified dress designs at the end of the century, including bloomers, held emancipatory implications for women and girls daring enough to don them.[10] By 1900, women could move a bit more freely. Also, the gradual appearance of women living independently gave the rising generation the confidence to, among other things, explore the streets or head for the hills with their cameras (Figure D).

Edwin Buckman's "Modern Goths" (1890) poked fun at tourists invading the architectural monuments of Europe, but at the same time gave the two women photographers depicted a dignified, confident air. The women have total command over a large apparatus, equipment, and accessories.

The outbreak of world war in 1914 ended an aesthetic wave of *yin*, replacing it with a flood of *yang*. Ignoring the progress of European women's emancipation in the pre-war period, Curator Patrick Daum has concluded, "The dusky tones, the Pictorial twilight borrowed from Symbolism, the whole suffocating *fin-de-siècle* atmosphere—all suddenly gave way to images that unmasked reality."[11] But, the period had not been "suffocating" for the middle-class women who enjoyed new educational, professional, and creative opportunities, nor had it been for the young women who, ahead of fashion,

rejected their corsets. Moreover, the argument that photography of the 1914–18 period, war-related photography in particular, showed reality "unmasked" is debatable to say the least. Nevertheless, Daum's epitaph for Pictorialism correctly described its fall from favor amongst the photographic avant-garde. The wheel of aesthetic expression keeps turning.

As the war destroyed the physical landscapes of the Western Front, it at the same time reversed the Belle Époque's openness to "feminine" values and aesthetics. British, French, and North American militaries' war efforts reasserted strict hierarchy as the organizing principle of North Atlantic society between 1914 and 1918. At the same time, these societies' pleas for women's active contributions to the war effort precipitated a collapse of the bourgeois system of chaperoned cloistering. Women's greater visibility in the profession of photography returned after the war. The prestigious studios of English photographers Alice Hughes and Yevonde Middleton and the trans-Atlantic success of American Berenice Abbott were three examples of North Atlantic women's interwar prominence. At the same time, the global success of the Eastman Kodak Company, owing in part to its brilliant advertising campaigns aimed at an untapped female market, strengthened women's visibility as amateur, professional, and fine art photographers in the 1920s. As noted earlier, Queen Alexandra and American photographers Myra A. Wiggins and Frances B. Johnston all partnered with Kodak after 1900 to promote their photography.

On the other hand, the climate of the later twentieth century, including the anti-feminist emergence of fascism and the rise of "straight photography," which reasserted the earlier rejection of retouching and hybridity, tended again to block the *yin* of photography in favor of its "masculinity." Hypermasculine institutions like Magnum Photos[12] and the Hollywood studio system of filmmaking insisted on woman-as-object or as consumer, rather than as creator. Writers and curators from the 1930s through the end of Cold War insisted on a masculinist-as-universal approach to the history of photography. Twentieth-century photo-historians, like their predecessors, "forgot" the pre-1900 female pioneers, artists, and businesswomen in their genealogical accounts of photography's paternity, and ignored photography's "feminine" powers. Canonical photo-historians discussed earlier in this book included the early artist Julia Margaret Cameron in their accounts not as merely one expression of "feminine" values of the early period (which arguably also included Henry P. Robinson and Charles Dodgson), but as an eccentric outlier—the exception to the rule of "masculine" precision and photographic truth.

In the preceding chapters I have argued that we may retroactively diagnose a chronic suppression of *yin* in the nineteenth and twentieth-century historiography of photography. The many articles, collections, and biographies of early women photographers mentioned throughout this book have, thankfully for many years, been *treating* the malady. But, as they say in the school of functional medicine, the sickness can only be *cured* if we remove its cause. In this case, a prescription includes cultivating an awareness of the gender of photography, recognizing its spectrum of ever-evolving "masculinity" and "femininity," and embracing the different values and tendencies that human beings have brought to the medium as equally worthy of attention. As in traditional Chinese medicine, optimal health demands a dynamic balance of forces in the body. Perhaps a dynamic balance of forces is just another way of saying a dance.

Notes

Preface and Acknowledgments:

1 Dargis reported that just 4.4 percent of the top 100 box-office U.S. releases between 2002 and 2012 were directed by women. Manohla Dargis, "With 'Selma,' Ava Duvernay Seeks a Different Equality," *New York Times* online (December 3, 2014), http://www. nytimes.com/2014/12/07/movies/ava-duvernay-makes-a-mark-with-selma.html; "In Hollywood, It's a Men's, Men's, Men's World, *New York Times* online (December 24, 2014), http://www.nytimes.com/2014/12/28/movies/in-hollywood-its-a-mens-mens-mens-world.html; and "Lights, Camera, Taking Action: On Many Fronts, Women Are Fighting for Better Opportunity in Hollywood," *New York Times* online (January 21, 2015), http://www.nytimes.com/2015/01/25/movies/on-many-fronts-women-are-fighting-for-better-opportunity-in-hollywood.html?ref=arts. See also Maureen Dowd, "The Women of Hollywood Speak Out," *New York Times Magazine* online, http://www. nytimes.com/2015/11/22/magazine/the-women-of-hollywood-speak-out.html.

2 Joan Scott's ground-breaking article in the *American Historical Review* was famous by the time I entered graduate school in the 1990s. I did not apply it to my graduate research. Joan Scott, "Gender: A Useful Category of Historical Analysis," *American Historical Review*, vol. 91, no. 5 (December 1986): 1053–75.

Introduction

1 John Tagg, *The Burden of Representation: Essays on Photographies and Histories* (Minneapolis: University of Minnesota Press, 1988), 118.

2 Readers will observe that while I qualify the human spectrum of masculinity and femininity as very much constructed, performative, and shaped by time and space, I have not found it useful to deny the existence of feminine and masculine feelings, which can affect any human no matter its gender identity or sexual orientation.

3 Nicole Herz, "Photographic Culture in Two Industrial Cities: Manchester and Lille, 1839–1914," Ph.D. diss., 2 vols. (University of Virginia, 2003.)

4 A recent volume with the tantalizing title *Rethinking Photography* includes a single woman in its chapter on the nineteenth century (Julia Margaret Cameron), indicating not much "rethinking." Peter Smith and Carolyn Lefley, *Rethinking Photography: Histories, Theories and Education* (London: Routledge, 2016), ch. 2.

5 To clarify, publications that have featured the work of "lost" women photographers are nevertheless important, because they at least rescued women creators from total oblivion. Time and again, the authors of slim exhibition catalogues from across the North Atlantic world—county historical societies, photographers' descendants, or curious amateurs—wondered in their prologues how much more women's work had been destroyed by indifferent descendants or in the storms of Europe's violent twentieth century. See for example the Musée Sainte-Croix and Musée de Chauvigny,

Suzanne Tranchant: photographe et sculpteur (1861–1942) (Poitiers, France: Musée de la Ville de Poitiers, 1990), 11. Abbie Sewall wrote of her great-great-grandmother, the photographer Emma D. Sewall: "Despite the fact that she was once lauded as one of the leading female photographers of her day," having won prizes at home and abroad in the 1890s, "Emma and her work quickly slipped from view," adding that Sewall's work had never before appeared in a book on American photography. Abbie Sewall, *Message Through Time: The Photographs of Emma D. Sewall (1836–1919)* (Gardiner, ME: The Harpswell Press, 1989), 20.

6 Henrietta L. Moore, *Feminism and Anthropology* (Minneapolis: University of Minnesota Press, 1988), 3.

7 See Joan W. Scott's classic "Gender: A Useful Category of Historical Analysis," *American Historical Review*, vol. 91, no. 5 (Dec. 1986): 1053–75.

8 Continuing in what I am sure is a long tradition, I employ the following concepts not as an expert in East Asian philosophy, but as someone who, in the process of reading and teaching world history and art history, and researching my own disease (MS), found what may be a useful tool for my purposes. I thought it appropriate, too, to look outside Western thought for a solution to a problem in Western thought.

9 The *Yijing*, or *I Ching*, dates back to the first millennium B.C.E., created originally as a divination manual. Over the centuries, various schools expanded and commented upon the original sixty-four "hexagrams," and the classic became part of both Taoism and Confucianism. For the present book I have consulted William Theodore de Bary, ed., *Sources of East Asian Tradition*, Volume 1: *Premodern Asia* (New York: Columbia University Press, 2008) and Men Jiuzhang and Guo Lei, eds., *A General Introduction to Traditional Chinese Medicine* (New York: CRC Press, 2010). For an overview, see also the Golden Elixir Press, "Yin and Yang," *The Golden Elixir*, available online at http://www.goldenelixir.com/taoism/yin_and_yang.html.

10 The original sources grant *yin* and *yang* equal and intertwined status, but predictably, Confucian regimes over the centuries nevertheless reinterpreted the *yin-yang* system as a justification for the oppression of women in China. See Lijuan Shen and Paul D'Ambrosio, "Gender in Chinese Philosophy," *Internet Encyclopedia of Chinese Philosophy: A Peer-Reviewed Academic Resource*, available online here: http://www.iep.utm.edu/gender-c/.

11 As we've seen recently in the U.S. debate about transgender identities, outliers of either sex still receive opprobrium when they stray too far from sex-based gender norms. On the construction of masculine norms in the Victorian era and early twentieth century, see John Tosh, *A Man's Place: Masculinity and the Middle-Class Home in Victorian England* (New Haven: Yale University Press, 1999) and Michael Roper and John Tosh, eds., *Manful Assertions: Masculinities in Britain since 1800* (New York: Routledge, 1991). An up-to-date overview of the culture and biology of gender appeared in the entire issue of *National Geographic*, vol. 231, no. 1 (Jan. 2017).

12 Abigail Solomon-Godeau, "Sous le prisme de l'identité sexuelle: un regard sur les femmes photographes," in Guy Cogeval et al., *Qui a peur des femmes photographes? 1839–1945* (Paris: Musée d'Orsay and Musée de l'Orangerie, 2015), 15–33.

13 The following works did not make my top five "key texts" but were indispensable to the present book's foundation: Federica Muzzarelli, *Femmes photographes: émancipation et performance (1850–1940)*, trans. from Italian to French by Chantal Moiroud (Malakoff, France: Editions Hazan, 2009); Melissa Miles was the first photo historian to "untangle" the gendering of photography in Elizabeth Eastlake's famous essay, in "Sun-Pictures and Shadow-Play: Untangling the Web of Gendered Metaphors in Lady

Elizabeth Eastlake's 'Photography,'" *Word & Image*, vol. 24, no. 1 (Jan.-March 2008): 42–50. See also John P. Jacob, ed., *Kodak Girl: From the Martha Cooper Collection* (Göttingen, Germany: Steidl, 2011). I cannot leave out Martin W. Sandler, *Against the Odds: Women Pioneers in the First Hundred Years of Photography* (New York: Rizzoli International Publications, Inc., 2002), or William C. Darrah, "Nineteenth-Century Women Photographers," in Kathleen Collins, ed., *Shadow and Substance: Essays on the History of Photography* (Bloomfield Hills, MI: Amorphous Institute, 1990), 89–103.

14 Naomi Rosenblum, *A History of Women Photographers* (New York: Abbeville Press, 1994), whose third edition was published in 2010. Unfortunately, and significantly, Rosenblum did not incorporate very much material from *Women Photographers* into later editions of her general survey, *A World History of Photography* (New York: Abbeville Press, 1984), which is actually, by and large, a North Atlantic survey. Spanning over 700 pages in her fourth edition (2007 paperback), it would be impractical to alter the survey by *adding on* to the content. What might be required is a new way of surveying the history of photography itself, using different categories of analysis.

15 Margaret H. Denny, "From Commerce to Art: American Women Photographers 1850–1900," Ph.D. diss. (University of Illinois at Chicago, 2010).

16 Especially useful to me have been Palmquist's two-volume *Camera Fiends & Kodak Girls*, which contain primary sources on women in photography from 1840 to 1965 (New York: Midmarch Arts Press, 1989 and 1995), and Peter Palmquist and Gia Musso, *Women Photographers: A Selection of Images from the Women in Photography International Archive* (Arcata, CA: Peter E. Palmquist, 1997). But the real revelation is the over 30,000 women whose work or biographical information are represented in the Peter Palmquist Collection of Women in Photography at the Beinecke Library, of which about 700 practiced their art before 1900 across the United States, England, and Scandinavia.

17 A *carte-de-visite* was a popular portrait format in the second half of the nineteenth century, measuring 9 cm by 6 cm and employing rectangular albumen prints. In the last quarter of the century, the larger cabinet card format became more popular in Britain and America, employing albumen print photographs mounted on larger cards measuring 10.75 cm × 16.5 cm. On both formats see John Hannavy, ed., *Encyclopedia of Nineteenth-Century Photography*, vol. 1, (London: Routledge, 2008), 233 and 276.

18 Bronwyn A.E. Griffith et al., *Ambassadors of Progress: American Women Photographers in Paris, 1900–1901* (Giverny, France: Musée d'Art Américain Giverny, 2001).

19 Musée d'Orsay and Musée de l'Orangerie, *Qui a peur des femmes photographes? 1839–1945* (Paris: Editions Hazan, 2015) and the small accompanying album by Thomas Galifot and Marie Robert, *Qui a peur des femmes photographes? 1839–1945* (Editions Hazan, 2015). The exhibition remained on display until Jan. 24, 2016.

20 Anna Tellgren, "Les Femmes Photographes: Aspects of French Photo History from the Perspective of Women Photographers," in Lena Johannesson and Gunilla Knape, eds., *Women Photographers: European Experience* (Gothenburg: Acta Universitatis Gothoburgensis, 2004), 297–300. The myth was established in books like Helmut Gernsheim's *Creative Photography: Aesthetic Trends 1839–1960* (New York: Dover Publications, Inc., 1962). In that historical work, nine of the 142 plates illustrating pre-1900 images are by women (though there are two others, photomontages, that are unattributed). Seven of those nine are by Julia Margaret Cameron.

21 Guy Cogeval, "Qui a *encore* peur des femmes photographes?" in *Qui a peur des femmes photographes? 1839–1945* (Paris: Editions Hazan 2015), 12.

22 The absence of vital facts for nineteenth-century women extends to the nobility. The talented amateur photographer Lady Alice Mary Kerr, for example, daughter of the seventh Marquess of Lothian, has come down to us with only a death date (1892). Another intriguing example: In contrast to the men who served as royal photographers during Queen Victoria's reign, the one woman photographer in this elite group, Frances Sally Day, has an inexact birth date (*c.* 1816). All the serving men—William Bambridge, J.J.E. Mayall, Camille Silvy, and others—have clear life dates and Wikipedia articles devoted to them. For that reason, throughout this book I will include women's birth and death dates (exclusively) when I have learned them, except in cases where a woman's dates are well-established.

23 The legal concept of coverture (sometimes spelled couverture) was originally an Anglo-Norman legal doctrine whereby, upon marriage, a woman's legal rights and obligations were subsumed by those of her husband, in accordance with the wife's legal status of *feme covert*. Although an unmarried woman (a *feme sole*), had the right to own property and make contracts in her own name, often we have even fewer reference dates for nineteenth-century single women because there was no marriage date. Coverture, which had medieval origins and stubborn modern incarnations, arose from the religious belief that a husband and wife were "one flesh," that is, his. See Genesis 2:24 in the Old Testament, and Mark 10:8 in the New Testament.

24 Abbie Sewall, *Message Through Time: The Photographs of Emma D. Sewall (1836–1919)* (Gardiner, ME: The Harpswell Press, 1989), xv.

25 Diane W. Block, "Books and Company: Mid-Victorian Albums and the Feminine Imagination," master's thesis (University of Mexico, 1995); Marta R. Weiss, "Dressed Up and Pasted Down: Staged Photography in the Victorian Album," Ph.D. diss. (Princeton University, 2008); Margaret H. Denny, "From Commerce to Art: American Women Photographers 1850–1900," Ph.D. diss. (University of Illinois at Chicago, 2010); Françoise Condé, "*Les Femmes photographes en France: 1839–1914*," maîtrise d'histoire (Université Paris VII-Jussieu,1992); Andrea Kunard, "Assembling Images: Interpreting the Nineteenth Century Photographic Album with a Case Study of the Sir Daniel Wilson Album," master's thesis (Carleton University, 1997); and January P. Arnall, "'Adventures Into Camera-Land': Women, Image-Making, and the Social Environment of Chicago Camera Clubs at the Turn of the Century," Ph.D. diss. (Claremont University, 2009).

26 The history program at my institution (which I have helped to update with my colleagues) gives undergraduate students a two-semester World History survey instead of Western Civilization, long gone from the course catalogue. The program's history of Europe is broken down into five chronological courses, from "Ancient Civilizations" to "Europe Since 1945," which are choices, among others, for majors to take in our required "Wider World" category.

27 The same is true for the Scandinavian region, which was precocious when it came to the entry of women into the business of nineteenth-century studio photography. See Lena Johannesson and Gunilla Knape, eds., *Women Photographers: European Experience* (Gothenburg: Acta Universitatis Gothoburgensis, 2004).

28 Jeanne Moutoussamy-Ashe published a work dedicated to the history of African-American women photographers: *Viewfinders: Black Women Photographers* (New York: Writers & Readers Publishing, Inc., 1993). Using post-Civil War censuses, trade directories, and black newspapers, Moutoussamy-Ashe identified eight African-American women photographers working before 1900, including two by name: Mary

Warren of Houston and Hattie Baker of Cleveland. If white women endured historical concealment, black women's existence, whether as creators or as citizens, was completely denied until the end of the nineteenth century. The author confessed: "Historical research on black women is a difficult task. But more specifically, historical research on the black woman photographer seemed impossible, since there was so little material available" (xviii–xix). Moutoussamy-Ashe began the process of reversing invisibility in 1986 (year of the book's first edition), and scholars have been able to build upon her scholarship.

29 Christopher Pinney, ed., *Photography's Other Histories* (Durham, NC: Duke University Press, 2003) and Pinney, *Photography and Anthropology* (London: Reaktion Books, 2011). Shawn M. Smith, *American Archives: Gender, Race, and Class in Visual Culture* (Princeton: Princeton University Press, 1999) and *Photography on the Color Line: W.E.B. Du Bois, Race, and Visual Culture* (Durham, NC: Duke University Press, 2004). Tanya Sheehan (most recently), *Study in Black and White: Photography, Race, Humor* (University Park, PA: Pennsylvania State University Press, 2018). See also Simone Brown, *Dark Matters: On the Surveillance of Blackness* (Durham, NC: Duke University Press, 2015), Elizabeth Edwards, ed., *Anthropology and Photography, 1860–1920* (New Haven: Yale University Press, 1994), Ali Behdad and Luke Gartlan, eds., *Photography's Orientalism: New Essays on Colonial Representation* (Los Angeles: Getty Research Institute, 2013), and Eleanor M. Hight and Gary D. Sampson, eds., *Colonialist Photography: Imag(in)ing Race and Place* (New York: Routledge, 2004).

30 Patricia Marks, *Bicycles, Bangs, and Bloomers: The New Woman in the Popular Press* (Lexington: University of Kentucky Press, 1990), ix.

31 Enid Yandell et al., *Three Girls in a Flat* (Chicago: Laura Hayes, 1892), 96. Several of the illustrations in Yandell's autobiographical novella are photograph-based, perhaps photogravures. However, the text does not credit the photographers. Rather, a list of illustrators is given at the beginning of the book.

32 I take this concept from sociology, wherein power negotiations are a series of "moves" in a "game" of interactions, from Erving Goffman and Nina Eliasoph.

33 Grace Seiberling matter-of-factly included the names of the British women involved in the earliest amateur photo exchange clubs of the 1840s, without discussing gender, in *Amateurs, Photography, and the Mid-Victorian Imagination* (Chicago: University of Chicago Press, 1986).

34 Feminist anthropologists put it this way: "Anthropology itself orders the world in a male idiom. The fact that linguistic concepts and categories in Western culture equate 'man' with society as a whole—as in 'mankind', and as in the use of the male pronoun to mean both he and she—has led many anthropologists to imagine that the 'male view' is also 'society's view.'" Moore, 4. The feminist historical insight that the Enlightenment and subsequent intellectual and revolutionary movements gendered the individual, or citizen, male, thereby assuring women's dependent status on a father or husband, has a large historiography. Refer to the bibliography for works by Joan Scott, Lynn Hunt, Sherry Ortner, Carole Pateman, Mary Louise Roberts, Charles Sowerwine, and others.

35 This new field of work, wrote Louis Daguerre in 1838 (before the formal announcement of the invention of the daguerreotype), "will please many ladies." Quoted in Thomas Galifot, "'La femme photographe n'existe pas encore positivement en France': femmes, féminité et photographie dans le discours français au XIXe siècle et début au XXe siècle," in *Qui a peur*, 35.

Chapter 1: What was the Problem with Femininity?

1 Ian Jeffrey, *Revisions: An Alternative History of Photography* (Bradford: National
 Museum of Photography, Film & Television, 1999). Forward by the Head of the
 Museum, Amanda Nevill, perhaps one of the first British women to direct a national
 museum in Britain. The museum's name changed to the National Media Museum in
 2006.
2 Ibid., 8.
3 The calotype was an early paper-based photographic process, invented and named by
 William Henry Fox Talbot, who introduced it to the public in 1841. Unlike the unique,
 metal-based daguerreotype, the calotype produced a negative from which multiple
 positive images could be printed by contact.
4 To take the example of sociology, Janet Chafetz offered an overview of "classical"
 sociology in the multi-authored *Handbook of the Sociology of Gender* (New York:
 Kluwer Academic/Plenum Publishers, 1999). The so-called Woman Question was
 addressed by such founding fathers of the discipline as Auguste Comte, Herbert
 Spencer, and Emile Durkheim, all of whom looked at women and femininity as
 constituting a "problem" in the North Atlantic societies that emerged from their
 seventeenth- and eighteenth-century constitutional revolutions. Other scholars
 concluded that the "'problem of women' was a question taken up by science generally
 in the second half of the nineteenth century . . . This was not simply part of the
 widening scope of scientific inquiry. It was clearly also a response to the enormous
 changes that had overtaken women's lives with the growth of industrial capitalism."
 Tim Carrigan, Bob Connell, and John Lee, "Toward a Sociology of Masculinity," *Theory
 and Society*, vol. 14 (1985), 553. Hundreds of historians, too, have chronicled discourse
 surrounding the post-revolutionary Woman Question, including Christine Bard,
 Rachel Fuchs, Karen Offen, Patricia Marks, Mona Ozouf, Andrea Mansker, Mary
 Louise Roberts, Catherine Hall, Gisela Bock, Lee Holcombe, and Christina Crosby.
5 Bourgeois and aristocratic society created rules for breaking these rules, as Michèle Plott
 described in "The Rules of the Game: Respectability, Sexuality, and the *Femme Mondaine*
 in Late-Nineteenth-Century Paris," *French Historical Studies*, vol. 25, no. 3 (Summer 2002):
 531–55. At the top of British society, Albert Edward, the Prince of Wales conducted sexual
 affairs with several married women, while married to Princess Alexandra.
6 Naomi Rosenblum, *A History of Women Photographers* (New York: Abbeville Press,
 1994), 109.
7 Amy Levy, *The Romance of a Shop* (Ontario: Broadview Press, 2006), 72.
8 Amy Levy (1861–89) had been a student at Newnham College in Cambridge and a
 member of the newly-opened University Club for Ladies in London. At the age of
 twenty-seven, she committed suicide by inhaling carbon monoxide. The inner side of
 the front cover of the Internet Archive's copy of Levy's *A London Plan-Tree and Other
 Verse* has a period obituary pasted onto it from *The Jewish Chronicle*, which touched
 upon Levy's role as a Jewish writer in Victorian England. To view it, click backward to
 the cover here: https://archive.org/details/londonplanetree089levy.
9 On the Forissier Affair, see Peter Baldwin, *Contagion and the State in Europe, 1830–
 1930* (Cambridge: Cambridge University Press, 1999), 377.
10 Scholars have debated the impact of the First World War (1914–18) on women's
 emancipation. But, most agree that the social circumstances produced by the Allies'
 war effort gave women greater freedom of movement, which is why I used the date of
 1914 as a cut-off date for the traditional community surveillance that watched

women's movements before the war, which then became impractical during the total
war effort. Neither French wartime photo agencies nor the military hired women
photographers during the war, though there were women who operated their
husbands' photo studios throughout France. See my discussion of photographers
during the First World War in *Hold Still, Madame: Wartime Gender and the
Photography of Women in France during the Great War*, St. Andrews Studies in French
History and Culture, no. 7 (Fife: St. Andrews University Centre for French History and
Culture, 2014), available online here: http://hdl.handle.net/10023/5016.

11 On Michigan photographer Marcelia W. Barnes, scroll to 234/2850 in David V. Tinder,
Directory of Early Michigan Photographers (Ann Arbor: William L. Clements Library,
University of Michigan, 2013), available online here: http://clements.umich.edu/
eadadd/tinder_directory.pdf. Barnes also contributed to the photographic press, such
as her letter to the editor in *The Photographic Art-Journal*, vol. 4, no. 4 (Oct. 1852): 257.
Material on Eunice Lockwood is sadly scarce, but see her own contributions to the
photographic press as listed in my bibliography. Lockwood's studio career is traced
through two married names in the Wisconsin Historical Society's *Wisconsin
Photographers Index 1840–1976*, a PDF available on the Society's Website: http://www.
wisconsinhistory.org/Content.aspx?dsNav=Ny:True,Ro:0,N:4294963828-
4294963805&dsNavOnly=Ntk:All%7cphotographers%7c3%7c,Ny:True,Ro:0&dsRecor
dDetails=R:CS3528&dsDimensionSearch=D:photographers,Dxm:All,Dxp:3&dsComp
oundDimensionSearch=D:photographers,Dxm:All,Dxp:3. See also Margaret Denny,
"From Commerce to Art: American Women Photographers 1850–1900," (Ph.D. diss.
University of Illinois at Chicago, 2010), 82–8. On Catharine Weed Barnes Ward, see
Peter E. Palmquist, *Catharine Weed Barnes Ward: Pioneer Advocate for Women in
Photography* (Arcata, CA: Peter E. Palmquist, 1992), and Margaret Denny, "Catharine
Weed Barnes Ward: Advocate for Women Photographers," *HOP*, vol. 36, no. 2 (May
2012): 156–71. Palmquist and Denny included bibliographies of Ward's many
photographic articles, and Ward was herself an editor of the monthly *American
Amateur Photographer* between 1890 and 1895.

12 The Pictorialist movement in art photography arose throughout the North Atlantic
world from the late 1880s to the early 1920s. The soft lines and "feminine" subject
matter of some Pictorialist photography bore some similarity to Impressionism in
painting. The movement's adherents insisted on high quality production materials, and
intervened by hand in the darkroom, and during or after the printing process. They
wished to strengthen photography's claims to fine art status by distancing their
practice from cheap, industrial production, a move akin to the Arts & Crafts
movement in Britain and the United States. See John Taylor, *Pictorial Photography in
Britain 1900–1920* (London: Arts Council of Great Britain, 1978) and Peter C. Bunnell,
ed., *A Photographic Vision: Pictorial Photography, 1889–1923* (Salt Lake City, UT:
Peregrine Smith, 1980). And more recently, Thomas Padon, ed., *Truth Beauty,
Pictorialism and the Photograph as Art, 1845–1945* (Vancouver, BC: Vancouver Art
Gallery, 2008). When discussing the artistic movement, Pictorialism and Pictorialist
are capitalized.

13 Early twentieth-century critics also felt Pictorialist photography was old-fashioned.
John Taylor discussed the ways that Pictorialism failed to be "modern," remarking that
it has been "consigned [by critics] to the margins because of its attachment to the
drawing-room values" of the Victorian and Edwardian era. John Taylor, "Pictorialism"
in John Hannavy, ed., *Encyclopedia of Nineteenth-Century Photography*, vol. 2 (London:
Routledge, 2008), 1130. In the late 1930s, Beaumont Newhall, as librarian-curator at

the Museum of Modern Art in New York, rejected Pictorialist works in favor of "straight" photography devoid of handwork or retouching. See Beth Ann Guynn's entry on Beaumont and Nancy Newhall in Hannavy, vol. 2, 997.

14 Chafetz, 4.

15 Carol Armstrong, *Camera Women* (Princeton: Princeton University Art Museum, 2001), 9.

16 The "either/or" mentality, in which a person, place, or thing must fit into one category or its opposite, has been recognized by gender theorists as a vocabulary of oppression. See Julia Epstein, "Either/Or—Neither/Both: Sexual Ambiguity and the Ideology of Gender," *Genders*, no. 7 (Spring 1990): 99–142, and Katrina Roen, "'Either/Or' and 'Both/Neither': Discursive Tensions in Transgender Politics," *Signs*, vol. 27, no. 2 (Winter 2002): 501–22.

Chapter 2: "Masculine" Photography in the Nineteenth Century

1 The canon of college course textbooks includes the following, in chronological order of publication, and with dates of most recent editions: Beaumont Newhall, *The History of Photography: From 1839 to the Present* (New York: Museum of Modern Art, 1949, 1982); Helmut and Alison Gernsheim, *The History of Photography From the Earliest Use of the Camera Obscura in the Eleventh Century up to 1914* (London: Oxford University Press, 1955), *The History of Photography, 1685–1914: From the Camera Obscura to the Beginning of the Modern Era* (New York: McGraw-Hill, 1969), and the abbreviated *Concise History of Photography* (New York: Dover Publications, 1965, 1986); Naomi Rosenblum, *A World History of Photography* (New York: Abbeville Press, 1984, 2007); Heinz K. Henisch and Bridget Ann Henisch, *The Photographic Experience, 1839–1914: Images and Attitudes* (State College, PA: Penn State University Press, 1994); Michel Frizot, ed., *Nouvelle histoire de la photographie* (Paris: Adam Biro/ Bordas, 2001 [1994]), published in English as *A New History of Photography* (Köln: Könemannnew, 1998). The Newhall volume followed his catalogue for the 1937 MOMA exhibition in New York, "Photography 1839–1937," which "eschew[ed] the then popular 'pictorial' school of photography in favor of exhibiting only 'pure' or 'straight' [straightforward] photography," the explanatory "straightforward" original to Beth Ann Guynn's entry on Beaumont and Nancy Newhall in John Hannavy, ed., *Encyclopedia of Nineteenth-Century Photography*, vol. 2 (London: Routledge, 2008), 997.

2 Michael Roper and John Tosh, eds., *Manful Assertions: Masculinities in Britain since 1800* (New York: Routledge, 1991) and Heather Ellis and Jessica Meyer, eds., *Masculinity and the Other: Historical Perspectives* (Newcastle upon Tyne, UK: Cambridge Scholars Publishing, 2009).

3 On the links between knowledge and empire see the classic works, Edward Said, *Orientalism* (New York: Vintage, 1979) and Daniel R. Headrick, *The Tools of Empire: Technology and European Imperialism in the Nineteenth Century* (Oxford: Oxford University Press, 1981). For the American context, see Martha A. Sandweiss, *Print the Legend: Photography and the American West* (New Haven: Yale University Press, 2002).

4 Quoted in Douglas Collins, *The Story of Kodak* (New York: Henry N. Abrams, Inc., 1990), 81. On George Eastman and his company, see also Elizabeth Brayer, *George Eastman: A Biography* (Rochester, NY: University of Rochester Press, 2015).

5 H. Baden Pritchard, *About Photography and Photographers* (New York: Arno Press, 1973 [1883]), 87.

6 On male sexuality and its visuality, see Michael S. Kimmel, ed., *The Gender of Desire: Essays on Male Sexuality* (Albany: State University of New York Press, 2005).

7 "Introductory Address" [unsigned], "The Future of Photography," *PN*, vol. 1, no. 1 (Sept. 10, 1858): 1. The First Lady of photographic criticism, Elizabeth Eastlake, also used gendered language in her writing, notably casting the sun as masculine (as would a Taoist), and photography as feminine. Here the femininity of photography came from the camera as "passive, dark, empty and waiting to be penetrated," equally Taoist terms (for *yin*). Melissa Miles, "Sun-Pictures and Shadow-Play: Untangling the Web of Gendered Metaphors in Lady Elizabeth Eastlake's 'Photography,'" *Word & Image*, vol. 24, no. 1 (2008): 44.

8 A. Belloc, "The Future of Photography," *PN*, vol. 1, no. 2 (Sept. 17, 1858), 13. Belloc's original French (translated for the English journal) would have made the gender of "nature" more obvious. Belloc's sentiment was repeated in America in 1880. A.C. Sunderland of New York addressed the Photographers' Association of America, saying, "it may be said of photographers that they have captured light, and made it so subservient to their will that it enables them to capture and hold fast the shadow of the subject which it reveals to us." In *The Philadelphia Photographer*, vol. 17, no. 202 (Oct. 1880): 300.

9 Quoted in Larry J. Schaaf, *Records of the Dawn of Photography: Talbot's Notebooks P & Q* (Cambridge: Cambridge University Press, 1996), xxvi.

10 Anon., "Atelier de M. Gustave Le Gray," *La Revue Photographique*, no. 7 (May 5, 1856): 99.

11 John L. Gihon, "Do Large Galleries Pay?" *Photographic Rays of Light*, vol. 1, no. 3 (July 1878): 72.

12 For example, the value of photography was "as a handmaid or assistant of the fine arts." In Frank Howard, "Photography as Connected with the Fine Arts," *JLPS*, vol. 1, no. 13 (Jan. 21, 1854): 154.

13 Scott C. Lesko, "Aesthetics of Soft Focus: Art Photography, Masculinity and the Re-Imagining of Modernity in Late Victorian Britain, 1885–1914," Ph.D. diss. (Stony Brook, NY: Stony Brook University, 2012), 32.

14 Anon., "The Photographic Exhibition at the Crystal Palace: First Notice," *PN*, vol. 1, no. 3 (Sept. 24, 1858): 29. A propos, the cover illustration for the George Eastman Museum's history for French readers reproduced Harold Edgerton's 1964 stop-action photograph of a bullet going through an apple, an event whose speed makes it impossible to see with the naked eye. George Eastman House Collection, *Histoire de la photographie: de 1839 à nos jours* (Taschen, 2005).

15 M.A. Root, "A Plea for Heliography," *The Philadelphia Photographer*, vol. 1, no. 2 (Feb. 1864): 21.

16 "Photography in Algeria," a series of columns by "C.A.," appears throughout volume one of *The Photographic News*, beginning with no. 1 (Sept. 10, 1858): 5.

17 See for example an account of Yosemite in *Anthony's Photographic Bulletin*, vol. 1, no. 11 (Dec. 1870): 221. And see "Photographing the Frontier," ch. 14 in Robert Taft, *Photography and the American Scene: A Social History, 1839–1889* (New York: Dover Publications, Inc., 1938).

18 R.W., "Photography in India," *PN*, vol. 1, no. 11 (Nov. 19, 1858): 128.

19 Ibid.

20 James F. Ryder, *Voigtländer and I in Pursuit of Shadow Catching: A Story of Fifty-two Years Companionship with a Camera* (No city: Rare Books Club, 2013 [1902]), 26.

Likewise, a period biography of Québec photographer Jules Isaï de Livernois is dominated by the story of Livernois' "adventurous voyage to the Pacific Coast via Cape Horne." Michel Lessard, *The Livernois Photographers* (Québec City, Canada: Musée du Québec, 1987), 71.

21 Geoffrey Batchen, *Burning with Desire: The Conception of Photography* (Cambridge, MA: MIT Press, 1997), 35; Steve Edwards, *The Making of English Photography: Allegories* (State College: Penn State University Press), 41. Peter Smith and Carolyn Lefley, *Rethinking Photography: Histories, Theories and Education* (New York: Routledge, 2016), 9.

22 André Rouille published documents related to the most prominent early photographic fights and rivalries in *La Photographie en France, textes et controverses: une anthologie 1816–1871* (Paris: Macula, 1989).

23 *The Amateur Photographer* reported in 1884: "It is not generally known that Lady Brassey, the talented and successful author of 'A Voyage in the Sunbeam,' is a first-rate photographer. She seldom, if ever, goes on a tour without a camera, lens, and stock of dry plates." Notice in *The Amateur Photographer*, vol. 1, no. 1 (Oct. 10, 1884): 5.

24 Carla Séréna, *Mon Voyage: souvenirs personnels de la Baltique à la mer caspienne* (Paris: Maurice Dreyfous, Editeur, 1881).

25 A complete html edition of *A Woman's War Record, 1861–1865* (New York: G.P. Putnam's Sons, 1889) with illustrations is available at the University of North Carolina's *Documenting the South* Website here: http://docsouth.unc.edu/fpn/collis/collis.html.

26 Mrs. Isabella L. Bishop, "The Chinese Far-West," *JPSL*, vol. 22, no. 10, new series (June 1898): 322–34.

27 *Cartes-de-visite* were the popular small-format portraits, originating in France, whose relative cheapness arguably democratized the acquisition of family portraiture beginning in the 1850s. For much of the second half of the century, *carte-de-visite* production was the bread and butter of the professional photographer's studio. Its popularity led to popular collecting, trading, and pre-slotted photo albums for the cards' storage and display in the home.

28 Hannah Maynard's combining of "masculine" and "feminine" traits in her business was especially intriguing. While the first part of her studio career saw her specializing in baby and child portraiture while she raised her own children, her later period saw her employed as Victoria's first police photographer. She produced early mug shots for the province's police, and invented a way to produce the frontal and profile views of the accused criminals with just one camera exposure, using mirrors. Carol Williams, "Economic Necessity, Political Incentive, and International Entrepreneurialism: The 'Frontier' Photography of Hannah Maynard," in Carol Payne and Andrew Kunard, eds., *The Cultural Work of Photography in Canada* (Montréal: McGill-Queen's University Press, 2011), 34–5.

29 The Société héliographique (1851–3) preceded the Société française de photographie in Paris, which was established in 1854. On Blanquart-Evrard's *imprimerie photographique*, see my account in Nicole Herz, "Photographic Culture in Two Industrial Cities: Manchester and Lille, 1839–1914," Ph.D. diss., vol. 1 (University of Virginia, 2003), 57–63, and see Pierre-Lin Renié's entry on Blanquart-Evrard in Hannavy, vol. 1, 167–8.

30 A version of the table, correlating the five elements (wood, fire, soil, metal, and water) with its associations (including direction, seasons, colors, and emotions) is available on the *Golden Elixir* Website, here: http://www.goldenelixir.com/taoism/table_wuxing.html.

31 The "ten thousand things" (*wanwu*) is a convenient metaphor for everything that has been generated by the Tao (the Way), in other words all things in the universe. The *Tao Te Ching* explains the generative process of the Tao, "which happens spontaneously and has neither cause nor purpose." The Tao "generates the One, the One generates the Two, the Two generate the Three, the Three generate the ten thousand things." Quoted in "An Introduction to Taoism," *The Golden Elixir*, available online here: http://www.goldenelixir.com/taoism/taoism_intro_2.html.

32 Recently Luc Sante described Atkins' images as "explode[ing] with one unexpected shape after another; the ghostly, nearly transparent *Nitophyllum gmelini*; the svelte, shiny *Enteromorpha intestinalis*; the infinitesimally delicate *Conferva fontinatis* ..." In Sante, "Early Developments," *The New York Review of Books*, vol. 66, no. 8 (May 9, 2019): 42. Atkins' blue photograms should be viewed with their color. There are seventeen extant copies of her multi-volume book, including the British Library's copy, digitized here: http://www.bl.uk/catalogues/photographyinbooks/record.asp?RecordID=3048.

33 Naomi Rosenblum, *A History of Women Photographers* (New York: Abbeville Press, 1994), 41. On Atkins see also Larry J. Schaaf, *Sun Gardens: Victorian Photograms by Anna Atkins* (New York: Aperture, 1985). Lindsay Smith offered an original analysis of Atkins' use of the blue cyanotype in ch. 3 of *The Politics of Focus: Women, Children and Nineteenth-Century Photography* (Manchester: Manchester University Press, 1998), "'Lady Sings the Blues': The Woman Amateur and the Album," 52–7.

34 Lot essay (with assistance from Larry Schaaf) for Sale 6900, Lot 48 (May 19, 2004) of Robert Hunt's copy of Anna Atkins' *Photographs of British Algæ: Cyanotype Impressions* (bound privately in London), which incidentally sold at the time for £229,250. Available online here: http://www.christies.com/LotFinder/lot_details.aspx?intObjectID=4278518#top.

35 An admission from the editor of *The Liverpool Photographic Journal* in 1854 was revealing. After receiving complaints about the abstruse nature of the new journal's articles, he proposed "a series of papers, purposely intended for beginners ... These, by being freed as much as possible from all technicalities, would be better suited to ladies, who are now frequently honouring us with, not merely their attention, but with their experiments." Report from the Liverpool Photographic Society in *The Liverpool Photographic Journal*, vol. 1, no. 2 (Feb. 11, 1854): 16.

36 Historian Robert Nye recently described how "[t]he laboratory and clinic were the working spaces of modernity and its modern heroes," in reference to the period's camera-using physicians. From his review of Mary Hunter, *The Fate of Medicine: Visualizing Masculinities in Late Nineteenth-Century Paris* (Manchester: Manchester University Press, 2016), on the H-France website at http://www.h-france.net/vol17no218nye.pdf.

37 From at least 1848 to the end of the century, individuals were proving that gender expectations rather than sex-based ability excluded women from fighting in battle. Sometimes they proved this fact by disguising themselves as men in order to participate, or simply mounting the barricades in skirts. See for example Bonnie Tsui, *She Went to the Field: Women Soldiers of the Civil War* (Lanham, MD: TwoDot, 2006) and Gay Gullickson, *Unruly Women of Paris: Images of the Commune* (Ithaca: Cornell University Press, 1996).

38 John Tagg linked photographic technology to state and class power apparatuses in several works, including *The Burden of Representation: Essays on Photographies and Histories* (Minneapolis: University of Minnesota Press, 1988).

Chapter 3: Theatricality

1 Carol Armstrong, *Camera Women* (Princeton: Princeton University Art Museum, 2001), 10.

2 A notable exception was in the combination-print self-portraits of Hannah Maynard in British Columbia. Maynard was a professional studio photographer from the 1860s to the 1890s in Canada. Her self-portraits, wherein Maynard tripled, quadrupled, and quintupled her image in playful domestic scenes, were neither for sale nor for public exhibition during her lifetime. See Monique L. Johnson, "Montage and Multiples in Hannah Maynard's Self-Portraits," *HOP*, vol. 41, no. 2 (May 2017): 159–70.

3 The *Oxford English Dictionary* limits its definition of "drag" to feminine attire worn by a man, while the *New Oxford American Dictionary* expanded the term to mean the wearing of clothing by the opposite sex. Gender studies scholars such as Judith Butler, though, have broadened the concept further to make the point that all gender is expressed through performance so that, in the words of the entertainer RuPaul Andre Charles, "You're born naked and the rest is drag." In RuPaul, *Lettin It All Hang Out* (New York: Hyperion, 1995), xiii.

4 Marina Warner, "Parlour Made," in David Brittain, ed., *Creative Camera: Thirty Years of Writing* (Manchester: Manchester University Press, 1999), 223.

5 Carol Mavor, *Becoming: The Photographs of Clementina, Viscountess Hawarden* (Durham, NC: Duke University Press, 1999), xv.

6 Janine Fron, Tracy Fullerton, Jacquelyn Ford, and Celia Pearce, "Playing Dress-Up: Costumes, Roleplay and Imagination," unpublished paper delivered at the Philosophy of Computer Games conference in Reggio Emila, Italy (Jan. 24–7, 2007), available online as PDF here: http://ludica.org.uk/LudicaWIG07.pdf.

7 Susan Scheftel, "Princess Culture: What Is It All About?", post in her "Evolving Minds" blog, *Psychology Today* (Aug. 24, 2015), online at https://www.psychologytoday.com/blog/evolving-minds/201508/princess-culture-what-is-it-all-about.

8 Ibid.

9 Federica Muzzarelli, *Femmes photographes: émancipation et performance (1850–1940)* (Malakoff, France: Editions Hazan, 2009), 9.

10 Muzzarelli's twelve photographers were (from the pre-1900 era): Virginia Oldoini (Comtesse de Castiglione), Hannah Culwick, Julia Margaret Cameron, Clementina Hawarden, and Alice Austen. From the post-1900 era: Hannah Höch, Gertrude Arndt, Anne Brigman, Claude Cahun, Tina Modotti, Leni Riefenstahl and Madame Yevonde.

11 Precisely the qualities that the "shameless" actress Lillie Langtry was scorned for not possessing during the period. See Laura Beatty, *Lille Langtry: Manners, Masks and Morals* (London: Chatto & Windus, 1999), 277.

12 Anon., "Le Portrait de famille: Suzanne Tranchant, ses neveux, la vie de loisirs à la Chantellerie," in Musée Sainte-Croix and Musée de Chauvigny, *Suzanne Tranchant: photographe et sculpteur (1861–1942)* (Poitiers, France: Musée de la Ville de Poitiers, 1990), 55.

13 Christopher Sykes argued that the ritualistic lifestyle of the English upper classes, combined with the wealth that gave them access to photographic equipment, home studios, darkrooms, instructional literature, and plenty of time to pursue the hobby, created the perfect environment (i.e., country houses) for photographic experimentation. Christopher S. Sykes, *Country House Camera* (London: Pavilion Books Ltd., 1987). The title of Sykes' book does not do justice to the way in which the

author reversed the invisibility of early female amateurism by establishing the class context that made it possible in the nineteenth century.

14 Frances Dimond, former curator of the Royal Photograph Collection, provided fascinating biographical detail in *Developing the Picture: Queen Alexandra and the Art of Photography* (London: Royal Collection Enterprises, Ltd., 2004). See also Kate Strasdin, "Fashioning Alexandra: A Sartorial Biography of Queen Alexandra 1844–1925," Ph.D. diss. (Southampton: University of Southampton, 2014). Strasdin observed: "She used clothes throughout her life to both display and disguise herself" (from diss. abstract).

15 New Orleans Society for Tableau Vivant, "History of Tableaux," available online at http://www.notableauvivant.com/about/.

16 Muzzarelli, 45.

17 Ibid., 45. Charles Baudelaire disagreed. For him, the "strange abominations produced when clownish people are grouped together" for a theatrical photograph simply degraded the theater. See Elissa Marder's discussion of Baudelaire's "Le Public moderne et la photographie" (1859), *Nineteenth-Century French Studies,* vol. 46, no. 1 and 2 (Fall-Winter 2017–18): 1–24, esp. 7–8.

18 Alan Thomas, *Time in a Frame: Photography and the Nineteenth Century Mind* (New York: Schocken Books, 1977), 86.

19 Colin Ford, *Julia Margaret Cameron: 19th Century Photographer of Genius* (London: National Portrait Gallery, 2003), 70.

20 Muzzarelli, 42.

21 "I do it for friendship not that I would not gladly have consented to profit if profit had been offered," Cameron wrote to Edward Ryan in 1874. Helmut Gernsheim, though, characterized her campaign to promote a second edition of the book (with full-sized photographic illustrations rather than the engraved woodcuts of the first edition) as a "long screed." Her ambition defeated, Cameron acquiesced to her elderly husband's urgent desire to retire in Ceylon (site of the family's business interests), packed up her equipment, and left England. Although a portion of the family would return with her for a visit in 1878, Cameron would die in Ceylon in 1879, age sixty-three. Helmut Gernsheim, *Julia Margaret Cameron: Her Life and Photographic Work* (New York: Aperture, 1975), 45–6.

22 Beatty, 166. And see Pierre Sichel, *The Jersey Lily: The Story of the Fabulous Mrs. Langtry* (Englewood Cliffs, NJ: Prentice-Hall, Inc., 1958), 37.

23 Beatty, 216.

24 Martha Vicinus noted that acting "was the highest paid profession a woman could enter—if she was successful—and it gave her more freedom than any other occupation," perhaps making the actress as much a figure of fantasy for middle-class women as for the men who pursued her sexually. "Whereas in virtually every other occupation they held ancillary roles to men," Vicinus continued, "women were at the center of the theater." In Vicinus, ed., *A Widening Sphere: Changing Roles of Victorian Women* (Bloomington: Indiana University Press, 1977), xviii–xix.

25 See David Spencer's digital collection and blog, *PhotoSeed,* with high-quality illustrations of Landy's series, available here (scroll down): http://photoseed.com/blog/archives/2016/.

26 A framed set of *Shakespeare's Seven Ages of Man,* sold at auction in 2008, included a letter from a relative of Landy's, naming each of the models in the series. Information from Cowan's Auctions available online here: https://www.cowanauctions.com/lot/j-landy-s-shakespeare-s-seven-ages-of-man-in-photography-55085.

27 Shakespeare, *As You Like It* (c. 1600), Act II, Scene VII. Another interesting group of *tableau vivant*-style albums were created by the Englishman Richard Cockle Lucas

(1800–1883), discussed by Marta R. Weiss in "Dressed Up and Pasted Down: Staged Photography in the Victorian Album," Ph.D. diss. (Princeton: Princeton University, 2008).

28 One of the earliest biographies of the countess came from the French poet who purchased her portraits after her death: Robert de Montesquiou, *La Divine comtesse: étude d'après Mme de Castiglione* (Paris: Goupil & Cie., 1913). More recent treatments come from Marta Weiss et al., *La Comtesse de Castiglione* (Paris: SNELA La Différence, 2009) and Pierre Apraxine and Xavier Demange, *"La Divine Comtesse": Photographs of the Countess de Castiglione* (New Haven: Yale University Press, 2000), which publicized the collections belonging to, respectively, the Musée d'Orsay and the Metropolitan Museum of Art. Earlier, Abigail Solomon-Godeau saw Castiglione as nothing but a stooge of the patriarchy in "The Legs of the Countess," *October*, vol. 39 (Winter 1986): 65–108. Some 372 of Castiglione's self-portraits may be viewed on the New York Metropolitan Museum of Art Website, though the museum sites only Louis Pierson, not Castiglione, as their creator: http://metmuseum.org/art/collection/search#!/search?artist=Pierson,%20Pierre-Louis$Pierre-Louis%20Pierson.

29 Her command over several languages, including unaccented English, heightened her qualifications. Apraxine, 15.

30 "Convinced of her historical importance, she was to feel that her role had never been properly acknowledged." Ibid., 15.

31 Castiglione's painted portraits included one by George Frederick Watts, whose career linked several women in this chapter: Castiglione (a portrait), Lillie Langtry (another portrait), and Julia Margaret Cameron, who was his friend and whose portrait he also painted in 1852.

32 Both Weiss' and Apraxine's exhibition catalogues stated that the attempted murder (April 6, 1857) was conducted by *Carboneri*, but neither source provides documentation for that claim. Felice Orsini's famous attempt on the emperor's life occurred later, on January 14, 1858, in a more easterly neighborhood.

33 Castiglione's other lovers included the French diplomat Prince Henri de La Tour d'Auvergne-Lauraguais and the banker Ignace Bauer. Apraxine, 18–19.

34 Xavier Demange, "A Nineteenth-Century Photo-Novel," in ibid., 69.

35 There were two Mayers in the business, brothers Léopold and Louis, who both retired by 1862 to leave Pierre-Louis Pierson in charge of the studio. Ibid., 24, 26.

36 Ibid., 27.

37 Sigmund Freud, "On Narcissism: An Introduction," in Ivan Smith, ed., *Freud – Complete Works*, open-access PDF (No city, 2010), 2943. A link to Smith's English-language compilation is available on the Online Resources page of the Website *Sigmund Freud – Life and Work*: http://www.freudfile.org/resources.html.

38 Ibid.

39 The countess' fame continues to flow in waves. In addition to twenty-first century exhibitions at the Musée d'Orsay and the Metropolitan Museum of Art in New York, the countess inspired several biographies, paintings, and two Italian films, in addition to gracing the cover of the monumental *Nouvelle histoire de la photographie*, edited by Michel Frizot (Paris: Adam Biro/Bordas, 1994), a work that discussed her only as the object of Pierson's camera. Nor were the countess' self-portraits discussed in a recent issue of the French cultural magazine, *Télérama*, which placed her, once again, on the cover, and on the inside of the back cover. She was only mentioned in passing as Napoleon III's mistress in an article within titled, "Cocottes à palper" (in approximate English: "Tarts to Feel Up") *Télérama* (hors-série) with the theme, "Regards sur le

Second Empire," no. 203 (Sept. 2016), 20. She appeared once more on the cover of the third edition of Robert Hirsch's textbook, *Seizing the Light: A Social & Aesthetic History of Photography* (New York: Routledge, 2017).

40 Weiss et al., 186.

41 Apraxine, 33.

42 Curator Pierre Apraxine broke down the collaboration between the countess and Pierson into three main periods: initiation from 1856–8, a longer period following her return from Italy between 1861 and 1867, and towards the end of her life from 1893–5 (though she had also visited him one or two times in the 1870s). Apraxine noted that their collaboration "lasted close to forty years—certainly the longest collaboration of its kind in the history of portraiture." Apraxine, 27–8.

43 Ibid., 12.

44 Biographies of Cullwick and her husband Arthur Munby include Liz Stanley, ed., *The Diaries of Hannah Cullwick: Victorian Maidservant* (London: Virago, 1984) and Diane Atkinson, *Love and Dirt: The Marriage of Arthur Munby and Hannah Cullwick* (London: Pan Books, 2003).

45 Heather Dawkins, "The Diaries and Photographs of Hannah Cullwick," *Art History*, vol. 10, no. 2 (June 1987), 167 and 172.

46 Readers unfamiliar with Hannah Cullwick's story might object that the class power difference between Munby and herself would have made a relationship of free equals impossible. True that may be, though biographical evidence indicates that Cullwick entered the relationship, and married Munby, on her own terms. Munby had always been attracted to women in dirty jobs, and collected photographs of them. But when he attempted to domesticate Cullwick—to make her into a "lady"—she refused.

47 Hannah Cullwick, *The Diaries of Hannah Cullwick*, ed. by Liz Stanley (New Brunswick, NJ: Rutgers University Press, 1984), 75–6.

48 Munby's diaries, though, reveal ambivalence about what he wanted from her. During their early relationship, Munby had encouraged Cullwick's self-abasement as an expression of Christian godliness (something he thought necessary for her, not himself, as Liz Stanley pointed out). He had an active social life in London and elsewhere, though, and Cullwick's insistence on her servility (with the clothing, comportment, and behavior that accompanied it) became impractical within Munby's lifestyle.

49 Nevertheless, they stayed in touch, and Munby dedicated his tribute to England's humble helpers, *Faithful Servants* (London: Reeves and Turner, 1891), to she "who hath no reward/Nor honour from above,/Save that she now is wed,/And doth for one alone/What maids like her are bred/To do for every one."

50 Muzzarelli, 96–7.

51 Muzzarelli, 98. The one instance where the photographer proposed a composition was during a session with James Stodart around 1864 in Margate, during which Stodart posed Cullwick stripped to the waist as a repentant "Magdalene." See Dawkins, 179–180. Instinctively, Cullwick understood that this was an art project and that the photographer meant her no harm: "Mr S. was a serious sort o' man & we neither of us laugh'd or smil'd over it," she wrote in her diary. Her only complaint about the resulting pictures was that her hands looked "too big & coarse." Cullwick, 76.

52 Cullwick, 76.

53 Hannah hinted that Stodart was interested in her, though it is not clear exactly what his feelings were. He had a Munby-esque attraction to her, smiling as he told her, "Well, you *are* dirty." Later, offering her a job, he said, "You're a fine strong girl & you've such

big arms ... I wonder if we [the Stodart family] could bargain with her to come & live here." Finally, upon Hannah's departure to London, he presented her with a hand-tinted portrait of himself. Cullwick's reporting in the diary was part of a game since all of this would have been read by Munby. Did she want him to know that other men were interested in her? Such passages (there were several) may have been a sly response to the fact that Munby saw other women, both ladies and non-ladies. Another interesting fact that appears in the diary is that Stodart's sisters and daughters worked with him in the studio at 55 Fort Road, Margate.

54 Dawkins described Hannah's attitude toward bourgeois marriage and "lady" status as "cynical." Dawkins, 164.

55 Cullwick, 16.

56 Per Arthur Munby's request, the Munby papers at Trinity College, Cambridge remained sealed until 1950. Although Cullwick mentioned having her own photograph album in her diaries, it either became part the Munby collection of papers (which includes 11 albums), or it disappeared after her death.

57 Disapproval stemmed from equal parts moral outrage and jealousy. George Bernard Shaw, who never wrote a part for Langtry, complained, "She has no right to be intelligent, daring and independent as well as lovely." Quoted in Linda Cookson, "Jersey Girl," *The Independent* (October 10, 2003), available online at http://www.independent.co.uk/travel/uk/jersey-girl-91135.html.

58 Anonymous *Town Talk* reporter (1879) quoted in Laura Beatty, *Lillie Langtry: Manners, Masks and Morals* (London: Chatto & Windus, 1999), 156.

59 Beatty, 6. On celebrity from Lillie Langtry to reality stardom, see Su Holmes and Diane Negra, eds., *In the Limelight and Under the Microscope: Forms and Functions of Female Celebrity* (New York: Continuum, 2011).

60 "Langtry merchandise spanned the fashion, health, and cosmetics industries and included dresses, accessories, and beauty products that she created, inspired, or endorsed." Catherine Hindson, "'Mrs. gtt Seems to Be on the Way to a Fortune': The Jersey Lily and Models of Late Nineteenth-Century Fame," in Holmes and Negra, 30.

61 Beatty, 55.

62 Lillie Langtry (Lady de Bathe), *The Days I Knew* (New York: George H. Doran Co., 1925), 131.

63 Ibid., 131. The extravagant pleasure taken in fabrics was not exclusively for show. Langtry reported that she also allowed dressmakers to line the inside of her clothes with the softest ermine and fox furs—a hidden, tactile pleasure.

64 Beatty, 78.

Chapter 4: Tactility

1 Mary Jane (née Perceval), Lady Matheson(1810–96) is the subject of a Camille Silvy portrait at the National Portrait Gallery in London, available online here: https://www.npg.org.uk/collections/search/portrait/mw191595/Mary-Jane-ne-Perceval-Lady-Matheson.

2 Carol Mavor, *Becoming: The Photographs of Clementina, Viscountess Hawarden* (Durham, NC: Duke University Press, 1999), 25.

3 Mavor, *Becoming*, 44.

4 Barbara Welter identified a kind of worship of moribund virgins in nineteenth-century literature in *Dimity Convictions* (Athens: Ohio University Press, 1976), 11.

5 Patrizia Di Bello, "Femmes et photographies en Grande-Bretagne (1839–1870): de la marge à l'avant-garde," in *Qui a peur*, 73.
6 Bill Jay, "Julia Margaret Cameron: An Appraisal," chapter written for an anthology that was not published (1978), n.p. PDF available online here: http://www.billjayonphotography.com/J.M.Cameron-an%20appraisal.pdf.
7 Photographer-critics' complaints about what they perceived as Cameron's sloppiness were, however, often softened by praise for her originality. See for example Anon., "Exhibition. Photographic Society of Scotland [First Notice]," *BJP*, vol. 12, no. 245 (Jan. 13, 1865): 20. One of the photographers who described Cameron's work as slovenly was Dr. Hugh Diamond, one of the founders of the London Photographic Society, perhaps best known for his photographs of female patients at the Surrey County Lunatic Asylum in the early 1850s.
8 Helmut Gernsheim, *Julia Margaret Cameron: Her Life and Photographic Work* (New York: Aperture, 1975) 27. Cameron's career as a photographer lasted about fifteen years, interrupted off and on by financial constraints and long voyages to and from Ceylon, where she died in 1879.
9 Robin Kelsey, *Photography and the Art of Chance* (Cambridge, MA: The Belknap Press, 2015), 77.
10 Ibid., 79.
11 Heinz K. Henisch and Bridget A. Henisch, *The Painted Photograph, 1839–1914* (University Park, PA: Pennsylvania State University Press, 1996),168. In Ontario, for example, "women performed the bulk of the operations involved in the retouching of negatives, and the finishing, colouring, and mounting of photographs; [and] they covered and gilded daguerreotype cases." In Diana Pedersen and Martha Phemister, "Women and Photography in Ontario, 1839–1929: A Case Study of the Interaction of Gender and Technology," in Marianne G. Ainley, ed., *Despite the Odds: Essays on Canadian Women and Science* (Montréal: Véhicule Press, 1990), 108.
12 Quoted in Peter Palmquist and Gia Musso, *Women Photographers: A Selection of Images from the Women in Photography International Archive* (Arcata, CA: Peter E. Palmquist, 1997), n.p.
13 Anon., "Des Dames photographes," *La Revue Photographique*, no. 15 (Nov. 5, 1856): 196.
14 Howard's letter was reprinted as "Female Employment in Colouring Photographs," *PN*, vol. 9, no. 339 (March 3, 1865): 108.
15 Ibid. Howard had been the superintendent of the Gentlewoman's Self-Help Institute, a job training school funded by noblewomen, for genteel women who required employment. A description of the Institute was included in Azamat Batuk, *A Little Book About Great Britain* (London: Bradbury, Evans & Co., 1870), 225–6.
16 See for example a brightly painted *carte-de-visite* by the Smeatons Photographic Gallery in Quebec, on the nineteenth Century Photographic Images photostream on Flickr here: https://tinyurl.com/y7538ql5.
17 An example of a minimally tinted daguerreotype in the George Eastman Museum collection online: https://www.flickr.com/photos/george_eastman_house/4420679946/.
18 A New Hampshire dealer's tinted daguerreotype (which has some surface damage), for sale, showing a sisterly embrace: http://www.finedags.com/index.cfm?fuseaction=galleries.itemdetail&fgid=archive&fitmtypeid=daguerreotypes&pgnum=1&itmid=D15-49.
19 Margery Mann, "Introduction," in John Humphrey, *Women of Photography: An Historical Survey* (San Francisco: San Francisco Museum of Art, 1975), n.p.

20 An early description of pre-fabricated, pre-slotted albums on the market appears in "Drawing-Room Photographic Albums," *BJP*, vol. 9, no. 167 (June 2, 1862): 204. On the history of manufactured photograph albums, see Elizabeth Siegel, *Galleries of Friendship and Fame: A History of Nineteenth-Century American Photograph Albums* (New Haven: Yale University Press, 2010).

21 The art of bookbinding was a separate interest of Alexandra's, which she shared with her daughter Princess Victoria. She also patronized the British Guild of Women Book Binders. Dimond, 94 and 96.

22 Curtin quoted in Peter Smith and Carolyn Lefley, *Rethinking Photography: Histories, Theories and Education* (New York: Routledge, 2016), 138.

23 Marta Weiss, "Dressed Up and Pasted Down: Staged Photography in the Victorian Album," Ph.D. diss. (Princeton: Princeton University, 2008), 87.

Chapter 5: Softness

1 Clear Comfort was the family home lived in by the never-married Austen (1866–1952) for most of her life. For Austen's life and work, explore the Alice Austen House Website here: http://aliceausten.org/. For an analysis of Austen's photography, see Federica Muzzarelli, *Femmes photographes: émancipation et performance (1850–1940)* (Malakoff, France: Editions Hazan, 2009), 159–73.

2 Documentation of the Alice Austen House collection, available here: http://aliceausten.org/trude-i.

3 Elizabeth Eastlake, "Photography," *The London Quarterly Review*, no. 101 (April 1857): 442–68.

4 Quoted in Malcolm Daniel, "Julia Margaret Cameron (1815–1879)," *Heilbrunn Timeline of Art History* on the Metropolitan Museum of Art Website, available here: http://www.metmuseum.org/toah/hd/camr/hd_camr.htm.

5 Anon., "Exhibition of the Photographic Society of Scotland and its Medals." *JPSL*, vol. 9, no. 154 (Feb. 15, 1865): 196.

6 Oscar G. Rejlander, "In Memorium [Obituary]," *BJP*, vol. 12, no. 236 (Jan. 27, 1865): 38.

7 Mirjam Brusius, "Impreciseness in Julia Margaret Cameron's Portrait Photographs," *HOP*, vol. 34, no. 4 (Nov. 2010); 347; Di Bello, "Femmes et photographies" in *Qui a peur*, 73; Muzzarelli, 31; and Violet Hamilton commented on Cameron's own testimony recording her preference for blur in *Annals of My Glass House: Photographs by Julia Margaret Cameron* (Seattle: University of Washington Press, 1996), 12, 27, and 28. See also Kelsey's discussion of Cameron's "sketchiness," 80–1. Colin Ford faulted Cameron's equipment and "a congenital sight problem" in *Julia Margaret Cameron: A Critical Biography* (Los Angeles: The J. Paul Getty Museum, 2003), 42.

8 Partisans of the North Atlantic "straight" style that emerged by the First World War gave the soft-focused Pictorialist style the disparaging moniker of the "Fuzzy Wuzzy School." See for example in J.E. King, "A Photographic Protest," *American Photography*, vol. 8, no. 6 (June 1914): 340; and Anon., "Exhibitions: Nottingham Camera Club," *BJP*, vol. 50, no. 2233 (Feb. 20, 1903): 153.

9 Jabez Hughes, "Photography as an Industrial Occupation for Women," originally published in the *London Photo News* and *Anthony's Photographic Bulletin* in 1873, transcribed at Clio: Visualizing History, https://www.cliohistory.org/exhibits/palmquist/occupation/.

10 Quoted in Naomi Rosenblum, *A History of Women Photographers* (New York: Abbeville Press, 1994), 82.

11 James F. Ryder, *Voigtländer and I in Pursuit of Shadow Catching: A Story of Fifty-two Years Companionship with a Camera* (No city: Rare Books Club, 2013 [1902]), 5. I used both the reprint (here) and a digitized version of the original book during research. Only the digital (although unsearchable) version contains the book's original illustrations.

12 Ibid., 25.

13 Clarence B. Moore, "Women Experts in Photography," *Cosmopolitan*, vol. 14 (March 1893): 586, 588.

14 The "wait for the bird" or "watch the birdie" phrase comes from studio photographers' attempts to catch and hold the attention of infants by waving toys or dolls above the camera.

15 Sally Mann (b. 1951) is an American photographer who courted some controversy over the publication of images of her small children, who sometimes appeared nude. Readers can evaluate the tone and content of Mann's images on her own website, https://www.sallymann.com/. In particular, see the selections from her *Family Pictures* and *At Twelve* projects.

16 Roger Taylor and Edward Wakeling, *Lewis Carroll, Photographer: The Princeton University Library Albums* (Princeton: Princeton University Press, 2002), 53–6.

17 Ronald Pearsall, *The Worm in the Bud: The World of Victorian Sexuality* (Harmondsworth, UK: Penguin Books, 1983), 360. Perhaps our contemporary terms "hard" and "soft" to describe different grades of pornography are different ways of saying *yang* and *yin*, respectively.

18 On Hannah Maynard see Claire W. Wilks, *The Magic Box: The Eccentric Genius of Hannah Maynard* (Toronto: Exile Editions, Ltd., 1980). See also Carol Williams, "Economic Necessity, Political Incentive, and International Entrepreneurialism: The 'Frontier' Photography of Hannah Maynard," in Carol Payne and Andrew Kunard, eds., *The Cultural Work of Photography in Canada* (Montréal: McGill-Queen's Univeristy Press, 2011), 23–42. And Peter Palmquist and Gia Musso, *Women Photographers: A Selection of Images from the Women in Photography International Archive* (Arcata, CA: Peter E. Palmquist, 1997), n.p. (alphabetized biographies follow the book's portfolio, which ends with no. 84).

19 On Hannah Maynard see Wilks, *The Magic Box*. See also Williams, "Economic Necessity," 23–42. And Palmquist and Musso, *Women Photographers*, n.p. (alphabetized biographies follow the book's portfolio, which ends with no. 84).

20 Wilks, 9.

21 Carol Williams realigned Mrs. Maynard's work with that of her husband Richard by arguing that both of them used photography in the interest of the European conquest of western Canada. While his landscape and ethnographic images assisted the Department of Indian Affairs and other agencies, her all-white "Gems" affirmed women's role "as *civilizers* of the frontier and *reproducers* of the Euro-American race" (Williams' italics). Williams, "Economic Necessity," 30.

22 Reproduction costs make providing color figures in this book prohibitive, but in the last few years several good treatments online have made examples of autochrome plates accessible for study. Autochromes are not prints, but slides that must be viewed as projections on a surface. The following is a selection of exquisite autochromes at the American Smithsonian: https://www.si.edu/sisearch?edan_q=autochrome.

Sample the autochromatic "Archives de la Planète" at the Albert Kahn Museum here: http://albert-kahn.hauts-de-seine.fr/archives-de-la-planete/presentation/presentation-detaillee/. The French Médiathèque de l'Architecture et du Patrimoine has made many First World War-era autochromes available here: http://www.mediatheque-patrimoine.culture.gouv.fr/fr/archives_photo/visites_guidees/autochromes.html.

23 See the last two web addresses in note 20.

24 Whereas Deglane's birth and death dates are unknown, and Mespoulet's place of birth and death are unknown (1865–1980), a detailed biography of Murdoch (1862–1956) may be found on the Luminous-Lint website for photographic history. Collector Mark Jacobs rescued Murdoch and other women autochromists from unwarranted oblivion in his essay, available online here: http://www.luminous-lint.com/app/vexhibit/_THEME_Autochromes_Women_01/2/0/0/.

25 Giles Hudson offered a full book-length treatment of Acland in *Sarah Angelina Acland: First Lady of Colour Photography, 1849–1930* (Oxford: Bodleian Library, 2012).

26 Anonymous review of Giles Hudson, *Sarah Angelina Acland: First Lady of Color Photography* (Chicago: University of Chicago Press, 2012) in *The Photo Review*, vol. 31, no. 1 (2015): 38.

Chapter 6: Hybridity

1 Peter H. Emerson, *Naturalistic Photography for Students of the Art* (New York: E.&F. Spon, 1890), 184.

2 Ibid., 184–5.

3 Mary Douglas, *Purity and Danger: An Analysis of the Concepts of Pollution and Taboo* (New York: Routledge, 1995 [1966]), 54. Prohibited hybrids in Leviticus and elsewhere include mixed-bred cattle, sowing fields with more than one type of seed, and cloth made from more than one material.

4 The great collector Helmut Gernsheim (1913–95) said that photography was "a medium whose sole contribution to art lies in its inimitable realism." Quoted in Marta Weiss, "Dressed Up and Pasted Down: Staged Photography in the Victorian Album," Ph.D. diss. (Princeton: Princeton University, 2008), 10–11.

5 Jordan Bear, *Disillusioned: Victorian Photography and the Discerning Subject* (University Park, PA: Pennsylvania State University Press, 2015), 154. On the persistent celebration of "Straight Photography's" triumph in Modernist narratives, see Cecilia Strandroth, "The 'New' History? Notes on the Historiography of Photography," *Konsthistorisk Tidskrift*, vol. 78, no. 3 (2009): 142–53.

6 "Purity and Impurity" section in Rosemary R. Ruether, "Women in World Religions: Discrimination, Liberation, and Backlash," in Arvind Sharma, ed., *The World's Religions: A Contemporary Reader* (Minneapolis: Fortress Press, 2011), 146–7.

7 John Taylor's entry on "Pictorialism" in John Hannavy, ed., vol. 2 *Encyclopedia of Nineteenth-Century Photography*, vol. 2 (London: Routledge, 2008), 1126.

8 The exhibition album for *Playing With Pictures* clearly stated each featured album's geographic origin, physical state, and archival location (a total of fifteen). At the time of the catalogue's publication in 2009, the Berkeley album, now unbound, had come to the Musée d'Orsay via a private collector who purchased it at a Christie's auction in London in 1987. The English Blount album resides in the Gernsheim Collection at the University of Texas. The English Bouverie album belongs to the George Eastman House. The English Cator album belongs (or belonged) to Hans P. Kraus, Jr., a New

York dealer. The English Frances Bree, or F.B. album belongs to a private collector in London. The English Filmer album was unbound and split over time between a private collector, the Wilson Centre for Photography (London), the Musée d'Orsay, and the University of New Mexico Art Museum. The English Gough album came to the Victoria & Albert Museum via a private collector. The English Jocelyn album belongs to the National Gallery of Australia (Canberra). The English Johnstone album belongs (or belonged) to Hans P. Kraus, Jr. The French Madame B album belongs to the Art Institute of Chicago. The English Milles album, now unbound, belongs to the Gernsheim Collection at UT. The English Paget album belongs to the V&A. The Princess Alexandra album belongs to the Royal Collection (Windsor). The English Sackville-West album belongs to the George Eastman House. The English Westmorland album belongs to the J. Paul Getty Museum (Los Angeles). Based on the scope of locations alone, the exhibition was a miraculous curatorial triumph.

9 As far as I know, Victorian photo-collagists have not appeared in any of the standard works on art history, or textbooks on women artists like Nancy G. Heller's *Women Artists: An Illustrated History* (New York: Abbeville Press, 1987). Despite the abundant scholarship on Victorian women's photo-collage albums, Peter Smith and Carolyn Lefley's 2016 chapter on "The Constructed Photograph" drew a paternal line of invention from Daguerre to Rejlander to Robinson to early twentieth century surrealist postcards without a single mention of the earlier hybrid photo albums. See *Rethinking Photography: Histories, Theories and Education* (New York: Routledge, 2016), 112–18. Surveys of the history of collage, such as Eddie Wolfram's *History of Collage: An Anthology of Collage, Assemblage and Event Structure* (New York: Macmillan, 1975), begin in the early twentieth century (in this case, with Cubism). See also Françoise Monnin, *Le Collage: Art du vingtième siècle* (Paris: Editions Fleurus, 1993), which contains two late-nineteenth century novelty postcards (18–19). Jordan Bear reminded us that photo-collage emerged in the work of Paris Commune-era photographers like Eugène Appert, whose composite compositions chronicled the violence of the Commune, the Napoleonic family in exile, and the regime of President Thiers at Versailles. Bear, "Pieces of the Past: Early Photomontage and the Voice of History," *HOP*, vol. 41, no. 2 (May 2017): 126–40.

10 For example, Gertrude Käsebier's commercial career caused her falling out with Stieglitz in 1906.

11 Weiss, "Dressed Up," 70–1.

12 Marina Warner, "Parlour Made," in David Brittain, ed. *Creative Camera: Thirty Years of Writing* (Manchester: Manchester University Press, 1999), 220–5.

13 Christopher S. Sykes, *Country House Camera* (London: Pavilion Books Ltd., 1987), 19–20.

14 Patrizia Di Bello, *Women's Albums and Photography in Victorian England: Ladies, Mothers, and Flirts* (New York: Ashgate, 2007), 2.

15 Miranda Hofelt used the initials inscribed on pages of the Bouverie album to hypothesize contributions from Elizabeth Pleydell-Bouverie (née Balfour) and her daughters Jane Pleydell-Bouverie, Ellen Pleydell-Bouverie, Janet Pleydell-Bouverie, and possibly her son Henry Pleydell-Bouverie. The family were well-to-do gentry, splitting their time between an estate in Wiltshire and a London home in fashionable Belgravia. Elizabeth Siegel et al., *Playing with Pictures* (Chicago: The Art Institute of Chicago, 2009), 178–80.

16 Castiglione (1837–1899) does not appear in Naomi Rosenblum's comprehensive *History of Women Photographers* (New York: Abbeville Press, 1994, 2000, and 2010) probably for the reason that she did not operate the camera.

17 Pierre Apraxine and Xavier Demange, *"La Divine Comtesse": Photographs of the Countess de Castiglione* (New Haven: Yale University Press, 2000), 11.

18 Among the contract's provisions, "M.M. Ad. Braun et Cie commit themselves ... not to allow any printing or release, not to have any print made of the portraits of Madame de Castiglione or those of her son, which are part of the collection, without receiving from her a verbal request or a written note signed in her hand." Printed in ibid., 162.

19 Pierson exhibited the portrait of the countess as the Queen of Hearts at the Exposition Universelle in 1867. The two friends also discussed a more extensive display of her portraits for the Exposition of 1900, but she died in 1899.

20 The materials discussed in this chapter present an incipient contrast between *yin* forms of collaboration (interior, intimate, with less-defined attributions) and *yang* forms of collaboration (public, profit-motivated, clearly defined divisions of tasks). In such a configuration, the case of Pierson and the countess seemed to blend *yin* and *yang*.

21 Darcy G. Grigsby, *Sojourner Truth, Photography, and the Fight Against Slavery*, brochure for the exhibition at UC Berkeley Art Museum (July 27-October 23, 2016), unpaginated, available online at: http://bamlive.s3.amazonaws.com/SojournerTruth-brochure.pdf.

22 Olive Gilbert and Sojourner Truth, *Narrative of Sojourner Truth, a Northern Slave, Emancipated from Bodily Servitude by the State of New York, in 1828* (New York: Published for the Author, 1850). The book went into four editions during Truth's lifetime.

23 Ibid. The ability to copyright photographs had been much-debated in the British, French, and American courts at mid-century. When photographers won the right (their images finally having been judged their unique works of art), it was the photographers, and not their sitters, who held it. Here there is a link between Truth and Castiglione's photographer, Louis Pierson, who was the plaintiff in the French case that led to photographers' power to copyright their images. See Tim Padfield, "Copyright," in Hannavy, vol. 1, 338.

24 Sojourner Truth had been beaten by owners on several occasions, suffered a disfiguring field accident that crippled her right hand, was abused by a religious cult leader, and possibly bore one child by an owner. Darcy Grimaldo Grigsby, *Enduring Truths: Sojourner's Shadows and Substance* (Chicago: University of Chicago Press, 2015), 7, 8. See also Margaret Washington, *Sojourner Truth's America* (Champaign: University of Illinois Press, 2009), 51–2.

25 Mandy Reid, "Selling Shadows and Substance: Photographing Race in the United States, 1850–1870s," *Early Popular Visual Culture*, vol. 4, no. 3 (Nov. 2006): 288.

26 Sojourner Truth's lectures to the residents of the postwar Freedmen's Village in Virginia frequently emphasized the importance of former slaves taking advantage of education opportunities, job training, and work that would allow them to become independent. Grigsby, 81.

27 Reid, 296. On Truth's photographs, see also Kathleen Collins, "Shadow and Substance: Sojourner Truth," *HOP*, vol. 7, no. 3 (July-Sept. 1983): 183–205. Throughout the period covered by this book, several African-American studios worked similarly to reverse objectification and assert black subjectivity in their portraits of ambitious, successful, and unstereotypical families. On African-American photography, see the National Museum of African American History and Culture, *Through the African American Lens: Double Exposure* (London: Giles, 2015) and Deborah Willis, *Reflections in Black: A History of Black Photographers 1840 to the Present* (New York: W.W. Norton & Co., 2000).

28 Teresa Zackodnik quoting Carla Peterson in "The 'Green-Backs of Civilization':
 Sojourner Truth and Portrait Photography," *American Studies*, vol. 46, no. 2 (Summer
 2005): 132. It is possible that Truth's Quaker or abolitionist friends and colleagues
 (often white women) assisted Truth with her self-representations. On one occasion, for
 a photograph of Truth wearing a red, white, and blue shawl (colors not evident in the
 carte-de-visite), we have evidence that they did. Moreover, authors like Harriet Beecher
 Stowe and male journalists, although distorting Truth's speech and history, helped to
 spread the orator's fame and reputation. See Grigsby, 28–9.

29 Many of Truth's *cartes-de-visite* and cabinet cards bear no photographer's stamp, but
 several have the Randall logo. One portrait in the Willard Library in Battle Creek,
 Michigan features a Randall portrait of Truth on a Frank Perry mount (Perry operated
 in Battle Creek). There is also a portrait by the Mathew Brady studio (New York).

30 Quoted in Eve M. Kahn, "New Books Analyze the Photographs of Frederick Douglass
 and Sojourner Truth," in the Art & Design section of *The New York Times* (Sept. 24,
 2015), available online here: https://www.nytimes.com/2015/09/25/arts/design/
 new-books-analyze-the-photographs-of-frederick-douglass-and-sojourner-truth.html.
 As a slave, Truth had four different owners before her flight to freedom at the age of
 thirty.

31 Pierre Sichel, *The Jersey Lily: The Story of the Fabulous Mrs. Langtry* (Englewood Cliffs,
 NJ: Prentice-Hall, Inc., 1958), 74.

32 Anecdote about Queen Victoria reported in Helen Cathcart, "Secret Papers Tell True
 Story of Prince's Romance with Lily Langtry," *Chicago Tribune*, vol. 109, no. 195
 (August 16, 1950), part 2, page 1. Probably the offending portrait was a sketch by
 Frank Miles, which Langtry said was sold to Leopold in an interview in the Napier,
 New Zealand *Daily Telegraph*, no. 3507 (October 3, 1882): 4.

33 Melissa B. Harmon, "Lusting After Lillie," *Biography*, vol. 1, no. 9 (Sept. 1997): 69.

34 Langtry rode a life-long, undulating wave of fortunes and debts. Regardless, she was
 able to leave £10,000 and her villa in Monaco to her last companion, Mathilde Peat.
 Langtry's will quoted in Laura Beatty, *Lillie Langtry: Manners, Masks and Morals*
 (London: Chatto & Windus, 1999), 313. Purchases in real estate, a personal railway car,
 and capital investments were described in Helen R. Goss, "Lillie Langtry and Her
 California Ranch," *Historical Society of Southern California Quarterly*, vol. 37, no. 2
 (1955): 161–76. See also Linda Cookson, "Lillie Langtry was born in Jersey 150 years
 ago . . .," the *Independent* online, Indy/Life section (October 11, 2003), available at
 https://www.independent.co.uk/travel/uk/jersey-girl-91135.html.

35 Beatty, 6.

36 Finding herself in need of income by 1880 (she was 27), Langtry's friend James
 Whistler told her "it was not too late for [her] to become an artist," having seen
 promise in the caricatures she had drawn of him and others while he was painting her
 portrait. Lillie Langtry (Lady de Bathe), *The Days I Knew* (New York: George H. Doran
 Co., 1925), 136.

37 Ibid., 118.

38 On Eastman and his partners in Britain, see Elizabeth Brayer, *George Eastman: A
 Biography* (Rochester, NY: University of Rochester Press, 2006), 73–93.

39 Alexandra participated in at least five Kodak-sponsored exhibitions in London
 between 1897 and 1905. Her pictures were also reproduced in the *Graphic* magazine
 (1905), *The Book of the Union Jack Club* (1908), and her *Christmas Gift Book*, sold for
 charity in 1908.

40 Douglas Collins, *The Story of Kodak* (New York: Harry N. Abrams, Inc., 1990), 101.

41 Frances Dimond, *Developing the Picture: Queen Alexandra and the Art of Photography* (London: Royal Collection Enterprises, Ltd., 2004), 167.

42 Ibid., 9.

43 Anon. [perhaps Editor F. J. Mortimer], "A Royal Photographer," *Amateur Photographer & Photographic News*, vol. 51, no. 1337 (May 17, 1910): 483.

Chapter 7: From Gender Neutral to a Masculine Medium

1 Quoted in Abbie Sewall, *Message Through Time: The Photographs of Emma D. Sewall (1836–1919)* (Gardiner, ME: Harpswell Press, 1989), xi. Sewall further quoted Abbott: "Every step in the process of making a photograph is preceded by a conscious decision which depends on the man in back of the camera and the qualities that go to make up that man, his taste, to say nothing of his philosophy." Sewall, xiv.

2 Becky Simmons, an archivist at the Rochester Institute of Technology, penned a relatively lengthy entry on "Amateur Photographers, Camera Clubs and Societies" for John Hannavy's *Encyclopedia of Nineteenth-Century Photography*. Her article did not mention women's early interest, and the only female amateur she named for the pre-1890 period was Julia Margaret Cameron. See John Hannavy, ed., *Encyclopedia of Nineteenth Century Photography*, vol. 1 (London and New York: Routledge, 2008), 31–4.

3 In French, the "universal" pronoun is the ungendered *on* (one, as in "one could say that"), rather than the masculine *il* or *ils*, though this never mitigated the assumption of a male subject in nineteenth and twentieth-century French social scientific literature. Gisèle Freund, pioneering the cultural history of photography in the 1930s—herself a photographer—failed to include a single female actor in her *Photographie en France au XIXe siècle: essai de sociologie et d'esthétique* (Paris: La Maison des amis des livres/A. Monnier, 1936).

4 David Collinson and Jess Hearn, "Naming Men as Men: Implications for Work, Organization and Management," *Gender, Work and Organization*, vol. 1, no. 1 (Jan. 1994), 6. And see Gisela Bock, "Women's History and Gender History: Aspects of an International Debate," in Robert Shoemaker and Mary Vincent, eds., *Gender and History in Western Europe* (London: Arnold, 1998), 25–42. Elsewhere in English, the importance of words like "seminal" or "dissemination," both related to semen, are similarly common when reading history or the social sciences. Although interestingly, semen comes from the more ancient French word *la semence* (derived from the more ancient Latin), which takes the feminine gender and refers to grain or seed.

5 To be sure, as historians have well shown, North Atlantic women like Mary Wollstonecraft (English, 1759–97), Olympe de Gouges (French, 1748–93), and Judith Sargent Murray (American, 1751–1820) had, from the first, contested the implicit and explicit exclusion of women in the new national constitutions of the revolutionary era. Every decade of modern patriarchy produced its sources of resistance.

6 Julia Margaret Cameron and Violet Hamilton, *Annals of My Glass House. Photographs by Julia Margaret Cameron* (Seattle: University of Washington Press, 1996), 15. As the daughter and wife of Indian colonizers, Cameron's racial attitudes have been surprisingly little-studied, although her late work in Ceylon appears in exhibition catalogues and biographies such as Colin Ford's chapter on "Ceylon" in *Julia Margaret Cameron: A Critical Biography* (Los Angeles: The J. Paul Getty Museum, 2003), 76–89.

7 Larry J. Schaaf, "'Splendid Calotypes' and 'Hideous Men': Photography in the Diaries of
 Lady Pauline Trevelyan," *HOP*, vol. 34, no. 4 (Nov. 2010): 329.

8 In a recent example, the catalogue for the J. Paul Getty Museum exhibit edited by
 Karen Hellman, *Real/Ideal: Photography in Mid-Nineteenth-Century France* (Los
 Angeles: The J. Paul Getty Museum, 2016), contains not a single plate by a French
 woman photographer, and left Françoise Condé's 1992 thesis surveying French women
 photographers from 1839–1914 unacknowledged. Nor did the authors acknowledge
 the museological gender gap, despite the fact that the Parisian exhibit, *Qui a peur des
 femmes photographes?*, had begun to address this problem in 2015. The Getty exhibit
 conformed to what a late-nineteenth century chronicler would have defined as the
 French national paternity of photography. Complete invisibility of early women
 photographers in the Getty book was prevented by the brief mention of amateurs
 Amélie Guillot-Saguez (p. 13) and Mathilde Odier (p. 17).

9 The literature concerning the gendering of modern (professional) science has become
 quite large. The women named in this chapter maintained their scientific pursuits despite
 exclusion from new, professional credentials and institutions in nineteenth-century
 Britain. Works that analyze the gendering of modern science include Londa Schiebinger,
 The Mind Has No Sex? Women in the Origins of Modern Science (Cambridge: Harvard
 University Press, 1989), and Mary R.S. Creese, *Ladies in the Laboratory? American and
 British Women in Science, 1800–1900* (Lanham, MD: Scarecrow Press, 1998).

10 Fulhame's birth and death dates are unknown. We know the original publication date
 of her *Essay on Combustion with a View to a New Art of Dying and Painting, wherein
 the Phlogistic and Antiphlogistic Hypotheses are Proved Erroneous* (London: J. Cooper,
 1794), and that she was made an honorary member of the Philadelphia Chemical
 Society. Jessica C. Linker, "The Pride of Science: Women and the Politics of Inclusion
 in 19th-Century Philadelphia," *Legacies* [magazine of the Historical Society of
 Pennsylvania], vol. 15, no. 1: 6–11.

11 The anecdote was repeated years later in many journals, especially in the United States.
 This quotation from Anon., "History of Photography in America," *Phrenological Journal*,
 vol. 54, no. 4 (April 1872): 251. Peter Palmquist also found the anecdote in the *Boston
 Daily Evening Transcript* and the *New York Illustrated News*. See Women in Photography
 International Archive, *Bibliography of Articles By and About Women in Photography*
 (unpublished bound volume in the Palmquist Collection at the Beinecke Library, 1997), 1.

12 Ibid.

13 H. Baden Pritchard, *About Photography and Photographers* (New York: Arno Press,
 1973 [1883]), 61. Pritchard described the plates as having been produced by violent
 sub-chloride of silver after prolonged exposure. Elsewhere, he wrote that the widow
 lent the photographs to the London Photographic Society for exhibition. Pritchard,
 "The History of Photography," *Nature*, vol. 5 (Feb. 8, 1872): 285.

14 Anon., "Des Dames photographes," *Revue photographique*, no. 13 (Nov. 5, 1856), 196.
 Académies were compositions with nude and draped figures in the classical style.

15 Anon., "Rapport du Jury chargé de juger la section de photographie à l'exposition
 universelle des arts industrielle de Bruxelles," *BSFP*, t. 2 (Dec. 1856): 347.

16 Anon., "L'Ennemi juré des retouches," *Revue photographique*, no. 13 (Nov. 5, 1856): 196.

17 Anon., "Des Dames photographes:" 196.

18 See Françoise Condé "Les Femmes photographes en France: 1839–1914," maîtrise
 d'histoire (Université Paris VII – Jussieu, 1992) and see Dominique de Font-Réaulx, "Où
 sont les femmes photographes? Femmes photographes françaises au milieu du XIXe
 siècle," in *Qui a peur des femmes photographes?*, 53.

19 In tracing the complexities of photography's long, multi-national emergence, Geoffrey Batchen rightly wondered what we mean by the phrase "in the air," in *Burning With Desire: The Conception of Photography* (Cambridge, MA: MIT Press, 1997), 53.

20 Margery Mann, "Introduction," in John Humphrey, *Women of Photography: An Historical Survey* (San Francisco: San Francisco Museum of Art, 1975), n.p.

21 Steve Edwards, "The Dialectics of Skill in Talbot's Dream World," *HOP*, vol. 26, no. 2 (Summer 2002): 114. Historians have revealed themselves to be somewhat uncomfortable with Constance Talbot's role in her husband's experiments, and his mother Elisabeth's more aggressive stance when it came to defending his business interests. This discomfort is owing partly to the limited sources available, typical for early Victorian women. Students of photography may find Constance and Elisabeth's letters to and from William Fox Talbot in the digitized correspondence project led by Larry J. Schaaf, available at: http://foxtalbot.dmu.ac.uk/.

22 Naomi Rosenblum, *A History of Women Photographers* (New York: Abbeville Press, 1994), 40.

23 Caroline was a lady-in-waiting at the castle. J. Paul Getty Museum, *William Henry Fox Talbot: In Focus* (Los Angeles: J. Paul Getty Museum, 2002), 70.

24 This other lady-in-waiting was the Honorable Eleanor Stanley. Bill Jay, "Queen Victoria's Second Passion: Royal Patronage of Photography in the 19th Century," unpublished article by Bill Jay, available as a PDF online here: http://www.billjayonphotography.com/QnVictoria2ndPassion.pdf.

25 Anne M. Lyden, *A Royal Passion: Queen Victoria and Photography* (Los Angeles: J. Paul Getty Museum, 2014).

26 Larry J. Schaaf and project staff, "WHF Talbot: Biography," in *The Correspondence of William Henry Fox Talbot*, available here online: http://foxtalbot.dmu.ac.uk/talbot/biography.html.

27 Lyden, 9.

28 Elisabeth Theresa Feilding, née Fox Strangways to William Henry Fox Talbot, doc. no. 3819 (Feb. 27, 1839), in *The Correspondence of William Henry Fox Talbot*, available online here: http://foxtalbot.dmu.ac.uk/letters/transcriptFreetext.php?keystring=&keystring2=patent&keystring3=&year1=1839&year2=1846&pageNumber=3&pageTotal=203&referringPage=0.

29 Lyden, 9.

30 Elisabeth Theresa Feilding, née Fox Strangways to William Henry Fox Talbot, doc. no. 3874 (May 4, 1839), in *The Correspondence of William Henry Fox Talbot*, available online here: http://foxtalbot.dmu.ac.uk/letters/transcriptFreetext.php?keystring=Elisabeth&keystring2=Feilding&keystring3=&year1=1839&year2=1877&pageNumber=23&pageTotal=246&referringPage=1.

31 For example, in 1839 Feilding wrote to Talbot, "I enclose you a bit from the Leipsic [sic] Gazette which shews [sic] they are pirating you in Bavaria without any acknowledgement." Elisabeth Theresa Feilding, née Fox Strangways to William Henry Fox Talbot, doc. no. 3856 (April 7, 1839), in *The Correspondence of William Henry Fox Talbot*, available online here: http://foxtalbot.dmu.ac.uk/letters/transcriptName.php?bcode=Feil-ET&pageNumber=774&pageTotal=997&referringPage=38. Lyden noted that Lady Elisabeth "policed the classifieds, bemoaning the various ways in which photographic operators were attempting to bypass or circumvent the patenting restrictions." Lyden, 15. In 1854, following a failed trial, Talbot elected not to extend his patent. In the 1850s both the Talbotype (or calotype) and the daguerreotype were gradually supplanted by the glass-negative collodion process, which was not patented.

32 Entry on John Dillwyn Llewelyn by Richard Morris in Hannavy, vol. 2, 867. On Mary
 Dillwyn, see the National Library of Wales, "Mary Dillwyn's Llysdinam Album,"
 available online here: https://www.llgc.org.uk/en/discover/digital-gallery/
 photographs/mary-dillwyns-llysdinam-album/.

33 The active Nevill sisters displayed photographs in two early Society exhibitions in
 addition to participating in the Exchange Club. *The Liverpool Photographic Journal*
 reported on the London Society's 1854 exhibition: "Mr. Hennah's portraits are the best
 in the exhibition, excepting a frame of exquisite productions—portraits and groups—
 from collodion negatives, by the Ladies Neville [sic]." Anon., "The Exhibition of
 Photographs and Daguerreotypes, by the London Photographic Society," *The Liverpool
 Photographic Journal*, vol. 1, no. 2 (Feb. 11, 1854): 19. On the three Nevill sisters see
 also John Hannavy's entry on them in Hannavy, vol. 2: 992.

34 Robert Taft, *Photography and the American Scene: A Social History* (New York: Dover
 Publications, Inc., 1964 [1938]), 8.

35 Although a New York University exhibit at the 1893 Chicago World's Fair claimed
 Dorothy's portrait to be the "Oldest Sun Picture of the Human Face," that claim was
 disputed both at the time and more recently. Julie K. Brown, *Contesting Images:
 Photography at the World's Columbian Exposition* (Tucson: University of Arizona Press,
 1994), 38–9. See also Howard R. McManus, "The Most Famous Daguerreian Portrait:
 Exploring the History of the Dorothy Catherine Draper Daguerreotype," *The
 Daguerreian Annual* (1995): 148–71.

36 McManus, 150. Donald Fleming characterized the relationship as follows: "This
 tireless woman, with straight black hair combed over her cheeks, had begun to set the
 pattern of Draper's family life: all of his people, weak and strong, fell to revolving
 about himself. With Dorothy there is the sense of strong will and quick spirits
 deliberately handed over for her brother to use as he liked." Although John Draper
 married, he insisted that his sister devote her life to him as well, making her
 give up her American suitor in 1839. That suitor, Andrew H. Green (a mere clerk
 at the time) went on to become a wealthy New York civic leader, overseeing the
 planning of Central Park among many other projects, and never marrying. Donald
 Fleming, *John William Draper and the Religion of Science* (New York: Octagon Books,
 1972), 22.

37 Brown, *Contesting Images*, 39.

38 Dorothy's nephew admitted, "You the sister—the lifelong aid to dear uncle John . . .
 have a just and great share in all the glory of your brother's life." Dorothy also provided
 drawings to illustrate her brother's books. The Draper nephew (Tom Gardner) was
 quoted in McManus, 150.

39 Excerpt from the *Rochester Democrat and Chronicle* in the *Chicago Inter-Ocean* (Dec.
 22, 1901), available online at "Find a Grave," here: https://www.findagrave.com/cgi-bin/
 fg.cgi?page=pv&GRid=79159833.

40 The British Royal Photographic Society published a series of regional lists culled from
 city directories, censuses, and other sources. Its resources are listed online here: http://
 www.rps.org/blogs/2013/september/researching-historical-photographers. David
 Webb's *photoLondon* website lists nine thousand city photographers with biographical
 information, available here: http://www.photolondon.org.uk/default.asp. In the United
 States, multiple state historical societies have generated lists of nineteenth-century
 photographers, such as Wisconsin, available online as a PDF here: http://www.
 wisconsinhistory.org/pdfs/WHI-Wisconsin-Photographers-Index-1840–1976.pdf. A
 revised version of Gary Saretzky's *New Jersey History* article on early New Jersey

photographers is available online as a PDF here: http://gary.saretzky.com/
photohistory/resources/photo_in_nj_July_2010.pdf.

And Peter Palmquist spent his career scouring multiple sources to generate lists of
early women professionals across the country and especially in the western states. In
France the most useful starting point may still be Françoise Condé's thesis, "*Les
Femmes photographes en France: 1839–1914*," which includes directory-derived lists of
early women professionals in Paris and elsewhere in France. Students should beware
that directories never included the names of all the service providers in any given year,
since a business owner had to pay to be listed.

41 Roger Watson and Helen Rappaport, *Capturing the Light: The Birth of Photography, a
True Story of Genius and Rivalry* (New York: St. Martin's Press, 2013), 247.

42 Ibid., 247.

43 Condé, 54.

44 Alan R. Woolworth, *Sarah L. (Judd) Eldridge* [1802–1886], *Minnesota's First
Photographer and Ariel Eldridge, Builder, Merchant and Civil Official*, bound volume in
the Palmquist Collection, Beinecke Library (compiled from 1988–1995).

45 Out of all the state representatives in the newly established Photographers' Association
of America (thirty-four vice-presidents in 1880), just one was female: Mrs. M.A.
Eckert of Montana. The accomplished Eunice N. Lockwood, of Wisconsin, served on
the Life Insurance Committee.

46 Charlotte Prosch began on Broadway in New York City, but fierce competition,
including Mathew Brady's palatial studio on the same street, drove her to bustling
Newark, New Jersey in 1847. Gary Saretzky, "Charlotte Prosch: New Jersey's First
Female Daguerreotypist," *Garden State Legacy*, no. 31 (March 2016), republished as a
PDF here: http://gary.saretzky.com/photohistory/Charlotte_Prosch_New_Jerseys_
First_Female_Daguerreotypist_Saretzky_GSL31.pdf.

Chapter 8: Building a Republic of Photography

1 Mona Ozouf's rejection of "Anglo-Saxon" feminism became infamous after the
publication of "Essay on French Singularity," the final chapter in her *Women's Words*,
trans. by Jane Marie Todd (Chicago: University of Chicago Press, 1997), 229–283. See
the first responses to her essay by friendly, as well as hostile, scholars in "Femmes: une
singularité française?" *Le Débat*, no. 87 (Nov.-Dec. 1995): 118–46.

2 Jordan Bear, *Disillusioned: Victorian Photography and the Discerning Subject*
(University Park, PA: Pennsylvania State University Press, 2015), 121.

3 France, Britain, Canada, and the United States all had very active, all-male colonial-
geographical associations during the period. See Dominique Lejeune, *Les Sociétés
de géographie en France et l'expansion coloniale au XIXe siècle* (Paris: Albin Michel,
1993). And on the confluence of medicine, masculinity, and visual art in nineteenth
century France, see Mary Hunter, *The Face of Medicine: Visualizing Masculinities
in Late Nineteenth-Century Paris* (Manchester: Manchester University Press,
2016).

4 Jennifer Tucker, "Gender and Genre in Victorian Scientific Photography," in Ann B.
Shteir and Bernard Lightman, eds., *Figuring It Out: Science, Gender, and Visual Culture*
(Hanover, NH: Dartmouth College Press, 2006), 142.

5 In the *British Journal of Photography*'s "Jubilee Number" in 1904, the editor celebrated
the journal's fifty years with thirty-six portraits of photographers and contributors, not

a single one depicting a woman, *BJP*, vol. 51, no. 2301 (June 10, 1904), illustrations throughout the number.

6 For example, Sharon R. Bird, "Welcome to the Men's Club: Homosociality and the Maintenance of Hegemonic Masculinity," *Gender & Society*, vol. 10, no. 2 (1996): 120–32.

7 This was the Société Héliographique, a forerunner of the French Society of Photography. F.-A. Renard, "But du Journal La Lumière," *La Lumière*, première année (1851), no. 1, 1.

8 See the original twenty-one rules of the Photographic Society of London in *JPSL*, vol. 1, no. 1 (March 3, 1853): 4–5. The rule about ladies is no. 9. The original sixty articles of the French Photographic Society's constitution made no provision for women.

9 Early female members' absence from society meetings contrasted with their presence, and the presence of their work, at the societies' annual exhibitions, where they were occasionally mentioned in published accounts.

10 John Tosh led the way for scholarship on nineteenth-century masculinity with works like *Manful Assertions: Masculinities in Britain since 1800*, co-edited with Michael Roper (London: Routledge, 1991) and *Manliness and Masculinities in Nineteenth-Century Britain: Essays on Gender, Family and Empire* (New York: Pearson Longman, 2005). The modernization of manliness had many other sites besides learned societies, such as dress and even trends in facial hair. See Philippe Perrot, *Fashioning the Bourgeoisie: A History of Clothing in the Nineteenth Century*, trans. by Richard Bienvenu (Princeton: Princeton University Press, 1994), and Christopher Oldstone-Moore, *Of Beards and Men: The Revealing History of Facial Hair* (Chicago: University of Chicago Press, 2015).

11 Léon Vidal, a prominent member of the French Society of Photography and the Chambre Syndicale de la Photographie, proposed that the men of the syndicate "create a school under its patronage, designating who would be its professors, and surveilling the functioning and procedure for the annual distribution of diplomas following serious exams, to students who earned the title of *opérateur diplômé*." Similar calls were made in the professional associations of Britain and the United States beginning in the 1870s. The Chambre Syndicale was never able to establish a permanent school. *Journal de l'industrie photographique. Organe de la Chambre Syndicale de la Photographie*, 1er année, no. 12 (Dec. 1880): 183.

12 Mary Ann Clawson, *Constructing Brotherhood: Class, Gender, and Fraternalism* (Princeton: Princeton University Press, 1989).

13 J.J. Coghill, "Photography, as Adapted for Tourists. Exemplified by a Recent Visit to the Spanish Coast," *JSPL*, vol. 5, no. 82 (April 9, 1859): 250.

14 M.E. Durieu's address to the Provisional Administrative Committee, *BSFP*, t. 1 (Jan. 23, 1855): 23.

15 Paul Périer, "Exposition Universelle – 5e article," *BSFP*, t. 1 (Sept. 1855): 260.

16 Historians have shown that the fact that these fraternal republics sometimes operated within state monarchies (Victorian Britain, France under Napoleon III) did not affect their flourishing. The crown in both cases tolerated republican-styled governing of men's voluntary associations so long as they did not threaten the imperial regimes, which they did not. For the French case, see Carol E. Harrison, *The Bourgeois Citizen in Nineteenth-Century France: Gender, Sociability, and the Uses of Emulation* (New York: Oxford University Press, 1999).

17 Clawson, 50.

18 Daphne Spain, *Gendered Spaces* (Chapel Hill: University of North Carolina Press, 1992), 3.

19 Clawson, 6.

20 Robert Taft *Photography and the American Scene: A Social History, 1839–1889* (New York: Dover Publications, Inc., 1938), 331–4, 498. On the American photographers' legal campaign for the revocation of James A. Cutting's patent covering the use of collodion and potassium bromide in photographic emulsions, see Lynn Berger, "Peer Production in the Age of Collodion: The Bromide Patent and the Photographic Press, 1854–1868," in Nicoletta Leonardi and Simone Natale, eds., *Photography and Other Media in the Nineteenth Century* (University Park, PA: The Pennsylvania State University Press, 2018), 91–102.

21 Coverage of the NPA conference in Cleveland in *Anthony's Photographic Bulletin*, vol. 1, no. 6 (July 1870): 102.

22 In France, the Chambre Syndicale de la Photographie would "follow the example of our American brothers" in establishing annual congresses for professional photographers. The purpose of the syndicate was to encourage "the excellent spirit of fraternal solidarity" that animated its members. Piracy and asserting copyright for photography were prominent concerns in this organization. *Bulletin de la Chambre Syndicale de la Photographie et ses application. Supplement au 'Moniteur de la Photographie,'* no. 1 (April 1, 189): 5 and 7.

23 See for example Jabez Hughes' remedy for the problem in "Receive Payment at the Time of Sitting," *Photographic Rays of Light*, vol. 1, no. 3 (July 1878): 74–6.

24 President [James F.] Ryder, "Photographic Jealousies," *The Philadelphia Photographer*, vol. 17, no. 201 (Sept. 1880): 268.

25 Notes from the "First Day, Tuesday, August 24th, 1880," *The Philadelphia Photographer*, vol. 17, no. 201 (Sept. 1880): 263. The editor of *The Philadelphia Photographer*, Edward L. Wilson, was deeply involved in both the previous National Photographic Association and the new Photographer's Association of America. Speakers used fraternal language despite a mixed-sex audience. Edward Wilson suggested that the bouquets decorating the tables at the conference hotel be "transferred to the bosoms of the ladies—for there were plenty there." Ibid., 262.

26 H. Rocher, "The Relation of Photographers to the Public and of the Public to the Photographers," *The Philadelphia Photographer*, vol. 17, no. 201 (Sept. 1880): 270.

27 One exception: Among the thirty-four vice-presidents elected to the PAA from throughout the United States and its territories, there was one woman, Mrs. M.A. Eckert of Montana. Eunice N. Lockwood, who had been a member of the NPA, was also a member of the PAA. Social changes and women's activism at the end of the century made it possible, though still infrequent, for women to speak at photographic meetings. Miss Mary Carnell and Miss Lena McCauley addressed the PAA on the subject of "Women in Photography" in 1910. Her address was reprinted in *Wilson's Photographic Magazine*, vol. 47 (1910): 364–6.

28 The *Bulletin* of the French Society of Photography, for example, declared, "it would find a moral responsibility in the association of men that brings closer, without any aim of private speculation, the pure love of art and of the science of photography." *BSFP*, t. 1 (1855): 2.

29 From opening remarks in the first issue of *Photographic Rays of Light*, vol. 1, no. 1 (Jan. 1878): 1, a journal published by Richard Walzl's Photographic Emporium in Baltimore. Walzl declared in the same opening that he would "present the 'Photographic Rays of Light' to the fraternity *for One Dollar a Year*" (italics in original), 2. *Anthony's Photographic Bulletin* was published by E. & H.T. Anthony & Co., a large photographic supply manufacturer, in New York City. The photographer Samuel D. Humphrey first established the *Daguerrean Journal* in 1850, which became *Humphrey's Journal of the*

Daguerreotype and Photographic Arts in 1852 until John Towler changed it to *Humphrey's Journal of Photography* in 1864. See William and Estelle Marder, "Nineteenth-Century American Photographic Journals: A Chronological List," *HOP*, vol. 17, no. 1 (Spring 1993): 95–100.

30 "Editor's Portfolio" [Richard Walzl], *Photographic Rays of Light*, vol. 2, no. 2 (April 1879): 62.

31 Anon., "Edward Livingston Wilson," *The Photographic Times and American Photographer*, vol. 18, no. 355 (July 6, 1888): 313–15. In bolstering the manliness of photography, Wilson trumped the Fourth Estate's slogan in his own variation: "The camera is mightier than the pen or the pencil." This statement is on the title page of *Wilson's Photographics: A Series of Lessons, Accompanied by Notes, on all the Processes which are Needful in the Art of Photography* (Philadelphia: Edward L. Wilson, 1881).

32 Marcelia W. Barnes, "To the Editor of the Pho. Art-Journal" [italics in the original], *The Photographic Art-Journal*, vol. 4, no. 4 (Oct. 1852): 257.

33 Peter Palmquist, "Is Anatomy Destiny: Notes from the Historical Record," *Women in Photography International Archive*, Archive 8 (Oct.-Dec. 2001) available online here: http://www.womeninphotography.org/archive08-Oct01/gallery3/index.htm.

34 In France, Britain, and the United States, photographic journals came and went almost with the fly-by-night frequency of new studio businesses. Especially challenging for the researcher is the fact that many journals and magazines were abruptly absorbed by other publications, which themselves changed names over time. Publication information in the Gale online database *Nineteenth Century Collections* (see "Photography: The World Through the Lens" within), available on site at the U.S. Library if Congress, is helpful in untangling different publications, as is Robert S. Sennett's useful volume, *The Nineteenth-Century Photographic Press: A Study Guide* (New York: Garland Publishing, Inc., 1987).

35 In the psychological theory of "precarious manhood," clinicians asserted the following: "Although physical aggression is often an effective demonstration of manhood, it may be an option that is largely unacceptable to men in many cultural milieus, particularly professional, educated subcultures that proscribe fighting." In Joseph A. Vandello and Jennifer K. Bosson, "Hard Won and Easily Lost: A Review and Synthesis of Theory and Research on Precarious Manhood," *Psychology of Men and Masculinity*, vol. 14, no. 2 (2013): 105.

36 "First Day, Tuesday, August 24th, 1880," *The Philadelphia Photographer*, vol. 17, no. 201 (Sept. 1880): 263.

37 Correspondence section in *PN*, vol. 1, no. 13 (Dec. 3, 1858): 152.

38 Cover story in *PN*, vol. 1, no. 14 (Dec. 10, 1858):157. The Photographic Society's complaint against the *News'* publishing its proceedings appeared in the *JPSL*, vol. 5, no. 73 (Nov. 22, 1858): 71.

39 *PN*, vol. 1, no. 14 (Dec. 10, 1858) : 157.

40 Anon., "Prix du duc de Luynes," *Revue photographique*, vol. no. 12 (Oct. 5, 1856): 177. The Duc de Luynes established the prize competition that year to encourage innovation in better printing technology.

41 For France, see André Rouillé's anthology, *La Photographie en France, textes & controverses: une anthologie* (Paris: Editions Macula, 1989). Also in France was the sibling rivalry between Félix and Adrien Tournachon, who fought each other over rights to the lucrative pseudonym "Nadar" in court in the 1850s. See Adam Begley's recent account of the fight in *The Great Nadar: The Man Behind the Camera* (New York: Tim Duggan Books, 2017), 94–6.

42 Hippolyte Bayard's protesting self-portrait, "Le Noyé" or "The Drowned Man," has been reproduced in photography's historical literature many times. See for example Naomi Rosenblum, *A World History of Photography* (New York: Abbeville Press, 1994), 33. A good grayscale copy of the self-portrait also appears on a Paris University class Web page here: https://hippolytebayard1840.files.wordpress.com/2011/04/hippo1.jpg.

Aside from Bayard, Daguerre found himself in dispute with Niépce's son, Isadore. H. Baden Pritchard wrote that Daguerre had improved Niépce's original process so that now it was "quite distinct, and unconnected in every way with that discovered by his [Isadore's] father; and Daguerre therefore refuses [sic] to publish the same except under his own name. Isadore protests for some time, but, like Esau, ultimately sells his birthright for a consideration." H. Baden Pritchard, *About Photography and Photographers* (New York: Arno Press, 1973 [1883]): 9.

43 Nicole Herz, "Photographic Culture in Two Industrial Cities: Manchester and Lille, 1839–1914", Ph.D. diss. (Charlottesville: University of Virginia, 2003), vol. 1, 62.

44 For an account of Louis Blanquart-Evrard's photographic *imprimerie* in the Nord and its failure, see Herz, vol. 1: 57–62.

45 On the Dancer/Shadbolt dispute, see Herz, vol. 1, 42.

46 Editorial in *The Photographic Journal* (formerly called the *Liverpool Photographic Journal*), vol. 6, no. 85 (Jan. 1, 1859): 2.

47 Fighting a number of patents in 1870, Edward L. Wilson was arrested in New York when a claim was made against him for $30,000 worth of damages. Wilson lost the case in court and had to pay a fine of $3,200, "but another result, and the complete overthrow of the patent followed," earning Wilson, who was then president of the NPA, adoration from the society's ranks. Anon., "Edward Livingstone Wilson," *The Photographic Times and American Photographer*, vol. 18, no. 355 (July 6, 1888): 314. Later in the century, a disputed patent for nitrocellulose film led to years of litigation between Eastman Kodak and the Reverend Hannibal Goodwin of Newark, New Jersey. By the time the courts decided in favor of Goodwin, making Eastman pay five million dollars in restitution, Goodwin was dead (his film patent now belonged to the Ansco photo supply company). The full story was reported by Barbara Moran in "The Preacher Who Beat Eastman Kodak," *Invention & Technology Magazine*, vol. 17, no. 2 (Oct. 2001): 44–51.

48 André Gunthert, "L'Institution photographique: le roman de la Société Héliographique," *Etudes photographiques*, no. 12 (Nov. 2002): 37–63.

49 Begley, 151.

50 Ibid., 151.

51 H.J. Morton, "Photography as a Moral Agent," *The Philadelphia Photographer*, vol. 1, no. 8 (Aug. 1864): 118. Twenty years later, H. Baden Pritchard argued for the establishment in Britain of a National Photographic Portrait Gallery (the National Portrait Gallery had already been established in 1856). Such a gallery would contain "true portraits of our great men" (he did not mention women). "All that is wanted [to establish such a gallery] is a small committee of capable men, who would take care that the photographs are likenesses, and that they are permanent." Pritchard, 49–50.

52 Linda L. Clark, *Women and Achievement in Nineteenth-Century Europe* (Cambridge: Cambridge University Press, 2008). Ruth Watts, *Women in Science: A Social and Cultural History* (New York: Routledge, 2007).

53 The genre was typified in Lovell Reeve, ed., *Portraits of Men of Eminence in Literature, Science, and Art, with Biographical Memoirs. The Photographs from Life, by Ernest Edwards, B.A.* (London: Lovell Reeve & Co., 1863), whose new volumes appeared

throughout the 1860s. Satirical magazine *Fun* poked fun at the learned editors when it discovered one portrait of a woman in the 1866 edition, a Miss Bessie Parkes. "It is not very polite of these academical stars to tell Miss P., by implication, that she's a jolly good fellow." *Fun*, vol. 3, new series (June 9, 1866): 124.

Chapter 9: Establishing the Paternity of Photography

1 Geoffrey Batchen, *Burning with Desire: The Conception of Photography* (Cambridge, MA: MIT Press, 1997), 35. Peter Smith and Carolyn Lefley, *Rethinking Photography: Histories, Theories and Education* (New York: Routledge, 2016): 9. See also Jordan Bear, *Disillusioned: Victorian Photography and the Discerning Subject* (University Park, PA: Pennsylvania State University Press, 2015), 119.

2 For example, Article 4: "When a member decides to make known an improvement, a discovery, or even a project, his communication will be made to the Society and for the Society, it will be written in a book devoted to registering such actions, [and] the date will be recognized and certified in this register." "Statuts de la Société Héliographique," *La Lumière*, vol. 1, no. 1 (Feb. 9, 1851): 1.

3 Robert Nye on Hunter, at http://www.h-france.net/vol17no218nye.pdf.

4 Editor's introductory address in *PN*, vol. 1, no. 1 (Sept. 10, 1858): 1. Saint-Victor, a second cousin of the inventor of the heliograph, contributed several improvements to early photographic processes, so it is not entirely clear which one Crookes was referring to here. The reference to Laputa comes from Swift's *Gulliver's Travels* (published in 1726).

5 H. Baden Pritchard, *About Photography and Photographers* (New York: Arno Press, 1973 [1883]), 162. Pritchard credited a Mr. Maynard, of Boston, with inventing collodion (nitrocellulose).

6 Anon.[probably Editor Crookes], "A Catechism of Photography," *The Photographic News*, vol. 1, no. 1 (Sept. 10, 1858): 9.

7 Anon., "A Catechism of Photography," *The Photographic News*, vol. 1, no. 26 (March 4, 1859): 303.

8 Anon., "A Catechism of Photography," *The Photographic News*, vol. 1, no. 1 (Sept. 10, 1858): 9.

9 Early publications in France accomplished the same thing, such as Auguste Belloc's *Les Quatre branches de la photographie: traité complet théorique et pratique des procédés de Daguerre, Talbot, Niepce de Saint-Victor et Archer* (Paris: W. Remquet et Cie, 1855). Anniversaries, such as the fiftieth year since the public announcement of the daguerreotype, were also occasions to "present a diorama of men more or less connected with this history," as in L.H. Laudy's speech to the Society of Amateur Photographers of New York, "The Discovery of the Daguerreotype Process," printed in *Wilson's Photographic Magazine*, vol. 26, no. 342 (March 16, 1889): 185.

10 Article copied from the London *Literary Gazette* in *PN*, vol. 1, no. 10 (Nov. 12, 1858): 11.

11 H.J. Rodgers, *Twenty-Three Years under a Sky-Light, or Life and Experiences of a Photographer* (Hartford, CN: H.J. Rodgers, 1872), 13–16.

12 One fellow Connecticut photographer, for example, was Mrs. Roana Royce (born *c.* 1843) of Willimantic, CN.

13 As far as I could trace it, the story commenced in *JPSL*, vol. 8, no. 139 (Nov. 16, 1863): 384 (cover page). An unnamed reporter summarized events later in the same number of the journal: 403–6.

14 The guest speaker was Francis Pettit Smith, curator of the then brand-new Patent Office Museum in South Kensington. Smith would be knighted in 1871. Christine MacLeod, *Heroes of Invention: Technology, Liberalism and British Identity, 1750–1914* (Cambridge: Cambridge University Press, 2007), 240.

15 Ironically, many of the pictures reproduced works by Royal Academy co-founder Angelica Kauffman (1741–1807), whose death would end female membership to the Academy until 1922 (the year Annie Swynnerton was elected).

16 Letter from F.P. Smith reproduced in *JPSL*, vol. 8, no. 141 (Jan. 15, 1864): 429.

17 Ibid., 433. Occasionally, women (and men) in the eighteenth century approached photographic ideas like eerie premonitions. Compare the silhouetting technique of Mary Granville Delany (1700–88), for example, to the velvet-backed ambrotype: "Mrs. Delany drew an image on white paper, then probably used a knife to cut the paper away from inside the image. In other words, she ingeniously worked with a kind of negative image. The middle of the white paper contains a detailed but empty space that doesn't really materialize until it's mounted on a black background." Molly Peacock, *The Paper Garden: An Artist Begins Her Life's Work at 72* (New York: Bloomsbury, 2010), 27–8.

18 Letter from F.P. Smith in *JPSL*: 429. Smith may have been hinting that Wilkinson was using a contact process, akin to Talbot's photogenic drawing. The Photographic Society therefore doubted that it was in fact a *camera lucida* that Wilkinson used, since that was simply a tool for accurate drawing.

19 Ibid., 433. Mr. Boulton reiterated his view about Wilkinson in another letter sent shortly after the first, saying "that Miss Wilkinson did not practise photography before the time at which the process was made public, and the statements assigning an earlier date to her practise of it are mistakes" (433–4).

20 Ibid., 434.

21 *JPSL*, vol. 9, no. 143 (March 15, 1864): 3–4.

22 Ibid., 12.

23 Ibid., 2. Ironically (or symbolically?), the Photographic Society would use space in the Gallery of Female Artists for their exhibition that year.

24 Ibid., 4.

25 The affair, reported in the *Illustrated London News* and *The Athenaeum*, reached U.S. shores, and was summarized by Edward L. Wilson in Philadelphia. "The conclusion at which we arrive," according to *The Athenaeum*, was "that the received history of photographic discovery is not in the slightest degree disturbed by the 'mechanical pictures,' or the photographs, found at Soho, Birmingham." See Anon., "The Last Century Photographs," *The Philadelphia Photographer*, vol. 1, no. 8 (Aug. 1864): 127. For another account, which did not include Miss Wilkinson, see Bear, 121–5.

26 Named after William H. Jackson and Frank J. Haynes, respectively. Robert Taft *Photography and the American Scene: A Social History, 1839–1889* (New York Dover Publications, Inc., 1938), 294.

27 Julie K. Brown, *Contesting Images: Photography at the World's Columbian Exposition* (Tucson: University of Arizona Press, 1994), xvi and 125. The French Photographic Society had earlier referred to Christopher Columbus*es* in the plural. E. Durieu addressed his fellow members, ". . . photographers march ahead to illuminate this little-known country of photography . . . but the Christopher Columbuses discovered more than a new world where savants, one day, will find the seeds of an abundant and rich culture." *BSFP*, t. 1 (Jan. 23, 1855): 24.

28 E. Durieu, address from the president of the Provisional Administrative Committee, *BSPF*, t. 1(Jan. 23, 1855): 24.

29 Henry J. Newton, "Early Days of Amateur Photography," *Wilson's Photographic Magazine*, vol. 26, no. 342 (March 16, 1889): 188.

Chapter 10: No Girls Allowed?

1 Anon., "Testimonial Banquet to the President," *JPSL*, vol. 11, no. 5, new series (Feb. 25, 1887): 79. Mrs. Spottiswoode was an amateur photographer based in India, where her husband was an army captain. She was also a member of the Amateur Photographic Association, and the couple knew Julia Margaret Cameron, who made their photographic portrait. See R.D. Wood, *Julia Margaret Cameron's Copyrighted Photographs*, self-published PDF (May 1996), nos. 70–2 in Wood's compilation, available at http://www.midley.co.uk/cameron/cameron.pdf. Early reporters knew that women were reading the photographic journals. See for example a detailed explanation of the wet collodion, dry collodion, and waxed paper processes in "Photography for Ladies" in *The Liverpool Photographic Journal*, vol. 2, no. 17 (May 12, 1855): 63–8.

2 Three analyses of the doctrine of separate spheres and its limits in the nineteenth century include Leonore Davidoff, "Adam Spoke First and Named the Orders of the World: Masculine and Feminine Domains in History and Sociology," Catherine Hall, "The Early Formation of Victorian Domestic Ideology," and Amanda Vickery, "Golden Age to Separate Spheres? A Review of the Categories and Chronology of English Women's History," all chapters in Robert Shoemaker and Mary Vincent, eds., *Gender and History in Western Europe* (London: Arnold, 1998).

3 David Collinson and Jess Hearn "Naming Men as Men: Implications for Work, Organization and Management," *Gender, Work and Organization*, vol. 1, no. 1 (Jan. 1994): 15.

4 Cynthia F. Epstein, "Similarity and Difference: The Sociology of Gender Distinctions," in Janet S. Chafetz, ed., *Handbook of the Sociology of Gender* (New York: Kluwer Academic/Plenum Publishers, 1999), 45–61. Joseph A. Vandello and Jennifer K. Bosson, "Hard Won and Easily Lost: A Review and Synthesis of Theory and Research on Precarious Manhood," *Psychology of Men and Masculinity*, vol. 14, no. 2 (2012): 101–13.

5 Mary Douglas, *Purity and Danger: An Analysis of the Concepts of Pollution and Taboo* (New York: Routledge, 1995 [1966]), 155.

6 Christine Battersby, *Gender and Genius: Towards a Feminist Aesthetics* (Bloomington, IN: Indiana University Press, 1990). Londa Schiebinger, *The Mind Has No Sex?: Women in the Origins of Modern Science* (Cambridge, MA: Harvard University Press, 1991). For the case of medicine, see Ornella Moscucci, *The Science of Woman: Gynaecology and Gender in England, 1800–1929* (Cambridge: Cambridge University Press, 1993). Feminist art historians have studied how female artists worked around the institutional and gender-based obstacles in their way. See Gabriel P. Weisberg and Jane R. Becker, eds., *Overcoming All Obstacles: The Women of the Académie Julian* (New York: Dahesh Museum, 1999); Tamar Garb, *The Body in Time: Figures of Femininity in Late Nineteenth-Century France* (Seattle: University of Washington Press, 2008); and Charlotte F. Zarmanian, *Créatrices en 1900: Femmes artistes en France dans les milieu Symbolistes* (Paris: Editions Mare & Martin, 2015). For Britain see Deborah Cherry, *Beyond the Frame: Feminism and Visual Culture, Britain 1850–1900* (London: Routledge, 2000). For the United States see Laura R. Prieto, *At Home in the Studio: The*

Professionalization of Women Artists in America (Cambridge, MA: Harvard University Press, 2001).

7 Christine MacLeod, *Heroes of Invention: Technology, Liberalism and British Identity, 1750–1914* (New York: Cambridge University Press, 2010), ch. 2, "The New Prometheus," 27.

8 Ibid., 211.

9 Angela V. John, ed., *Unequal Opportunities: Women's Employment in England, 1800–1918* (New York: Basil Blackwell, Ltd., 1986), 8.

10 The marketing link between amateur photography and mothers recording their children's milestones is discussed in Nancy M. West, *Kodak and the Lens of Nostalgia* (Charlottesville: University of Virginia Press, 2000).

11 Rule 17 in the "Rules of the Photographic Society," printed in *JPSL*, vol. 1, no. 1 (March 3, 1853): 4–5.

12 Article 7 in the "Statuts de la Société Française de Photographie" (French Photographic Society), *BSFP*, t. 1 (1855): 6.

13 See the "Laws of the Society," *JPSL*, vol. 15, no. 233 (May 16, 1872): 151–2. The French Photographic Society created similar rules. See articles 7–13 of the French Society's statutes (there were a total of sixty separate articles in the statutes, covering over ten pages of rules): *BSFP*, t. 1 (1855): 5–17.

14 The blackballing system originated with the Photographic Society of London in 1853, wherein rule no. 12 stated, "Members shall be balloted for, and that one black ball in five shall exclude." See *JPSL*, vol. 1, no. 1 (1853): 4. Many early societies adopted the measure, such as the Manchester Photographic Society, which prescribed blackballing in its original rule no. 9 (1855).

15 Joan Acker, "Gender and Organizations," in Chafetz, 181.

16 Sonya O. Rose, *Limited Livelihoods: Gender and Class in Nineteenth-Century England* (Berkeley: University of California Press, 1992), 16.

17 In particular, see the Miss/Mrs.-peppered membership lists of the London Amateur Photographic Association, which appeared in *JPSL* during the period. A trickle of French women amateurs entered the country's regional societies in the 1890s, such as in Lyon, Caen, Le Havre, and the national society in Paris. The list of French Photographic Society members in 1898 included a Mlle L. de Lambertye, Mlle Pellechet, Mme Raffard, and Mme Vauzanges. See the list in the *BSFP*, t. 14, new series (Jan. 1898): 7–23.

18 Chafetz, 4.

19 Acker, "Gender and Organizations," in Chafetz, 178.

20 Bernard and Pauline Heathcote deduced the identity of "Perplexed" as Henry Blandy, president of the Nottinghamshire Amateur Photographic Association (NAPA). They reported that shortly after this correspondence, Blandy resigned from the presidency and helped found the Nottinghamshire Camera Club, in which four women were elected to serve as executive committee members, probably a first in the United Kingdom. Eventually, NAPA reversed its policy, and the two societies amalgamated in 1891, including women members. Bernard V. and Pauline F. Heathcote, "The Feminine Influence: Aspects of the Role of Women in the Evolution of Photography in the British Isles," *HOP*, vol. 12, no. 3 (July–Sept. 1988): 269–70.

21 Anon., "Women at Photographic Meetings," *PN*, vol. 33, no. 1618 (Sept. 6, 1889): 590.

22 The Toronto Camera Club, established in 1888, denied women members the use of its rooms during the evenings, except on the first and third Mondays of each month (presumably when chaperones would be employed to supervise members). Diana

Pedersen and Martha Phemister, "Women and Photography in Ontario, 1839–1929: A Case Study of the Interaction of Gender and Technology," in Marianne G. Ainley, ed., *Despite the Odds: Essays on Canadian Women and Science* (Montréal: Véhicule Press, 1990), 107.

23 Patricia Marks, *Bicycles, Bangs, and Bloomers: The New Woman in the Popular Press* (Lexington: University of Kentucky Press, 1990), 109. Rita McWilliams-Tullberg traced the long defeat of nineteenth-century women's campaign for full university membership in "Women and Degrees at Cambridge University, 1862–1897," in Martha Vicinus, ed., *A Widening Sphere: Changing Roles of Victorian Women* (Bloomington: Indiana University Press, 1977), 117–45.

24 The Photographic Society of London changed its name to the Photographic Society of Great Britain in 1874, and in 1894 it became the Royal Photographic Society of Great Britain. The society, though, had enjoyed royal patronage and support from its beginnings.

25 Poem printed in Marks, 117.

26 I borrow the term "sexual contract" from Carole Pateman, but whereas she created the phrase to discuss the history of contract theory, I am using it to describe the implicit agreement inherent to nineteenth-century North Atlantic marriage as I summarized it here.

27 January P. Arnall, "'Adventures Into Camera-Land': Women, Image-Making, and the Social Environment of Chicago Camera Clubs at the Turn of the Century," Ph.D. diss. (Claremont University, 2009), 55.

28 Ethel Powers objected to the ban on women smoking in New York in *The Evening World* (Jan. 24, 1908), a page in the digital collection, *Click Americana*, available at: http://clickamericana.com/eras/1900s/public-smoking-by-women-banned-1908.

29 Catharine Weed Barnes, "Why Ladies Should Be Admitted to Membership in Photographic Societies" (1889), in Peter E. Palmquist, ed., *Camera Fiends & Kodak Girls*, vol. 2: *60 Selections by and about Women in Photography, 1855–1965* (New York: Midmarch Arts Press, 1995), 41.

30 Laura R. Prieto saw a similar phenomenon in nineteenth-century American artists' associations. Organizations like the Rhode Island Art Association, for example, "did not formally forbid women, but it had no women members and its constitution used masculine pronouns to describe associates." Prieto, *At Home in the Studio: The Professionalization of Women Artists in America* (Cambridge, MA: Harvard University Press, 2001), 42.

31 Anon., in "Correspondence," *PN*, vol. 33, no. 1619 (Sept. 13, 1889): 607.

32 "Nemo" is Latin for "nobody," and the name of the hero (Captain Nemo) in Jules Verne's *Twenty Thousand Leagues Under the Sea* (1870), first translated into English in 1873.

33 "Nemo" in "Correspondence," *PN*, vol. 33, no. 1620 (Sept. 20, 1889): 623.

34 Speech delivered by Janssen at the banquet following the meeting of the UNSP at Nancy, *BSFP*, t. 14, 2e série (May 27–30, 1898): 485.

35 A.H.W., "Our Photographic Pic-Nic, and How We Fared," *BJP*, vol. 7, no. 116 (April 16, 1860): 113–14.

36 Photographic journals were key sources of instruction for women and girls during the early decades of photography, when joining a photographic society was difficult, and attending society meetings even more so. Another way we know that part of the audience for the photographic press was female was because some of the correspondents who wrote to the editors were women. See for example "A Lady

Amateur" and "Emily" in *BJP*, vol. 7, no. 109 (Jan. 1, 1860): 15, and no. 110 (Jan. 15, 1860): 14; "Sarah C.M." in *PN*, vol. 1, no. 4 (Oct. 1, 1858): 44; and "Lydia" in *JPSL*, vol. 2, no. 32 (July 21, 1855): 206. Many correspondents hoping for answers to their questions signed with only their initials or with pseudonyms, such as "An Inquirer," "An Amateur," or "A Subscriber," some of whom may have been women.

37 Pedersen and Phemister, "Women and Photography in Ontario," 88.

38 Margot F. Horwitz, *A Female Focus: Great Women Photographers* (New York: Franklin Watts, 1996), 26.

39 Sewall's biographer concluded that her husband "supported and encouraged her in her artistic and intellectual endeavors. Whether he understood her or not, he apparently accepted the fact that her needs transcended those of being a wife and mother and that she would always hold part of herself in reserve." Abbie Sewell, *Message Through Time: The Photographs of Emma D. Sewall (1836–1919)* (Gardiner, ME: The Harpswell Press, 1989), 6.

40 Quoted in Colin Ford, *Julia Margaret Cameron: A Critical Biography* (Los Angeles: The J. Paul Getty Museum, 2003), 42.

41 Alice (Born Elizabeth Alice Munn) and her mother were abandoned by her father, but the two women apparently lived happily in the maternal grandparents' stately home with several other relatives. She photographed social life on Staten Island, as well as the rougher streets of New York's Lower East Side, living contentedly on income from her inheritance. In 1929, however, the Wall Street Crash destroyed the family's wealth, and Alice ended up destitute. Luckily, she was able to transmit her photograph collection to a staff member of the Staten Island Historical Society, which today holds seven thousand original items from her collection. Alice Austen House, "Her Life," available online here: http://aliceausten.org/her-life/.

42 A description of an Austen photograph ("The Darned Club," 1891) depicting Alice and three friends, explains the title of the picture. In the collection of the Alice Austen House, available online here: http://aliceausten.org/darned-club.

43 Christian Cujolle, Yvon Le Marlec, Gilles Wolkowitsch, and Jean-Marc Zaorski. *Jenny de Vasson: une femme photographe au début du siècle* (Paris: Editions Herscher, 1982), 11.

44 Jacques Henri Lartigue (1894–1986) was a talented French amateur photographer born a generation after Jenny de Vasson. Both artists came from well-to-do families, and used their cameras to document their family, friends, surroundings, and travels. Whereas Lartigue came to the attention of John Szarkowski, curator at the Museum of Modern Art in New York, who then organized a major exhibition of Lartigue's early photographs in 1963, Jenny de Vasson died in obscurity, though preserved from total oblivion when the discovery of her surviving *œuvre* in 1980 led to several exhibitions in the French provinces.

45 Cujolle et al., 6.

46 For example, Dolly B. Andruss (1825–1904), a daguerreotypist in New York and Illinois in the 1850s and 1860s, taught her husband, William. See Margaret Denny, "From Commerce to Art: American Women Photographers 1850–1900," Ph.D. diss. (University of Illinois at Chicago, 2010), 58–65.

Chapter 11: Feminine Silence

1 Chicago, Illinois led the way in welcoming a new generation of women photographers into its societies. The city offered three clubs in the 1880s whose memberships and

official positions included women: the Chicago Amateur Photographers' Club (est. 1881), the Photographic Society of Chicago (est. 1886), and the Chicago Camera Club (est. 1889). See Margaret Denny, "From Commerce to Art: American Women Photographers 1850–1900," Ph.D. diss. (University of Illinois at Chicago, 2010), 194–7.

2 Lee Holcombe wrote, "'Strong-minded' was one of the most abusive terms that could be applied to a [Victorian] woman, and even the most dedicated feminists strove to avoid being so labelled." *Victorian Ladies at Work: Middle-Class Women in England and Wales, 1850–1914* (Hamden, CN: Archon, 1973), 4.

3 Cuthbert Bede [Rev. Edward Bradley], *The Further Adventures of Mr. Verdant Green*, sequel to *The Adventures of Mr. Verdant Green*, published together in *Mr. Verdant Green: Adventures of an Oxford Freshman* (Stroud, UK: Nonsuch Publishing, Ltd., n.d. [1857]), 219.

4 By the 1890s, male guardianship in the North Atlantic world was gradually collapsing under the demands of the New Woman. George Gissing's novel *The Odd Women*, for example, reflected the movement for emancipation by presenting a heroine who retains her personal and financial independence by refusing her suitor's proposal. George Gissing, *The Odd Women* (London: Lawrence & Bullen, 1893).

5 *JPSL* reported regularly on the activities of the London Amateur Photographic Association (est. 1861), which admitted female members throughout the 1860s, though not as club officers. See for example *JPSL*, vol. 8, no. 123 (July 15, 1862): 93.

6 See also praise for Lady Mary Jane Matheson's (1820–96) work at exhibitions of the Scottish Photographic Society. The society paid "special attention [to] the admirable interiors contributed by Lady Matheson: for graceful pose and delicate execution . . . 'Portraits of Two Ladies' is not surpassed by any professional work in the room." Reported in *JPSL*, vol. 5, no. 78 (Feb. 5, 1859): 181. Although Lady Matheson was a member of the Scottish Society until it disbanded in 1871 (members felt "everything that can be discovered about photography is already known"), she was never, as far as I could tell, welcomed as a speaker or into a leadership position. For historical information on the Photographic Society of Scotland, including its office holders, visit the Edinburgh Photographic Society's useful Website here: http://www.edinphoto.org. uk/3/3__pss.htm. The Musée d'Orsay holds a family album created by Lady Matheson, who was born in Québec.

7 Reporting on President Frederick Pollock's awarding of prizes for the London Photographic Society's 1866 exhibition, the Society's secretary wrote, "The next Medals were awarded to the late Lady Hawarden; and the Secretary read a letter from Lord Hawarden expressive of regret that he was not able to attend and receive it" following her death. Report in the *JPSL*, vol. 11, no. 176 (Dec. 15, 1866): 159. Although Lady Hawarden refused to intrude on what she understood as the gentlemen's proceedings at Society meetings, she found other ways to use her skills for the public good before her death. Reporting on "Photography at the Horticultural Gardens" in 1864, the *JPSL* noted: "At the late fête given at these Gardens in aid of the Female Schools of Art, the Viscountess Hawarden kindly undertook to take portraits of all who desired, on payment for the same. So successful were her labours, that upwards of £50 were received for the funds from this act of kindness of her ladyship." In *JPSL*, vol. 9, no. 147 (July 15, 1864): 84.

8 English Standard Version of the Bible (New Testament).

9 Ibid.

10 Quoted in Patricia Marks, *Bicycles, Bangs, and Bloomers: The New Woman in the Popular Press* (Lexington: University of Kentucky Press, 1990), 11. The specter of Eve's

disobedience still cast its shadow on debates about women's rights at the turn of the twentieth century. See also Kimberly A. Hamlin, *From Eve to Evolution: Darwin, Science, and Women's Rights in Gilded Age America* (Chicago: Chicago University Press, 2014).

11 Karen Blair labeled this strategy within the women's movement "Domestic Feminism," wherein women used their reputations for nurturing and superior morality to claim a legitimate place in the public sphere, via their own, often philanthropic organizations. See Annette Baxter's "Preface" in Karen J. Blair, *The Clubwoman as Feminist: True Womanhood Redefined, 1868–1914* (New York: Holmes & Meier Publishers, Inc., 1980), xii–xiv.

12 Françoise Condé counted a dozen female members in the national French Photographic Society between 1856 and 1914, showing that French women were active as amateurs "despite the huge mass of men [in the Society] that had the effect of hiding them." Condé, "*Les Femmes photographes en France: 1839–1914*," maîtrise d'histoire (Paris: Université Paris VII – Jussieu, 1992), 20–1.

13 Cecelia L. Ridgeway and her colleagues in sociology at Stanford University, across the country, and abroad have been observing and writing about gender and status for over two decades. See C.L. Ridgeway, "The Social Construction of Status Value: Gender and other Nominal Characteristics," *Social Forces*, vol. 70 (1991): 376–86. Cecelia L. Ridgeway and Chris Bourg, "Gender as Status: An Expectations States Theory Approach," in A.H. Eagley et al., eds., *The Psychology of Gender*, 2nd ed. (New York: Guilford, 2004), 217–18. See also Linda Brannon on "benevolent sexism," where people who hold this attitude tend to see women as weaker, more in need of protection, and less competent than men." Brannon, *Gender: Psychological Perspectives*, 6th ed. (New York: Allyn & Bacon, 2011), 65.

14 Diana Pedersen and Martha Phemister, "Women and Photography in Ontario, 1839–1929: A Case Study of the Interaction of Gender and Technology," in Marianne G. Ainley, ed., *Despite the Odds: Essays on Canadian Women and Science* (Montréal: Véhicule Press, 1990), 89.

15 "Testimonial Banquet to the President," *JPSL*, vol. 11, no. 5, new series (Feb. 25, 1887): 79.

16 Henrietta L. Moore, *Feminism and Anthropology* (Minneapolis: University of Minnesota Press, 1988), 3.

17 Ibid.

18 See Jane C. Croly's account of Sorosis' founding in *The History of the Woman's Club Movement in America* (New York: Henry G. Allen & Co., 1898), 15–34. The word sorosis, which combines Greek (soros) and Latin (osis), refers to "a fleshy multiple fruit" such as a pineapple or mulberry, not to be confused with cirrhosis, a disease of the liver. Definition from Oxford University Press' *English Living Dictionary*, available online at https://en.oxforddictionaries.com/definition/sorosis.

19 Quoted in Blair, 21. Significantly, the photographer Catharine Weed Barnes was an early member of Sorosis. Barnes would later break gender norms by publishing photographic articles, speaking at photo club meetings, and becoming one of the first women to be a photo exhibition judge.

20 Blair, 21.

21 Quoted in Marks, 97.

22 Proceedings of the National Photographers' Association in *Anthony's Photographic Bulletin*, vol. 1, no. 6 (July 1870): 108.

23 Nina Eliasoph, "Politeness, Power, and Women's Language: Rethinking Study in Language and Gender," *Berkeley Journal of Sociology*, vol. 32 (1987): 81.

24 Ibid., 87. See also Linda Brannon's discussion of "women's language" in the works of Robin Lakoff and Deborah Tannen in Brannon, *Gender: Psychological Perspectives*, 6th ed. (New York: Allyn & Bacon, 2011), 320–2.

25 The original author was Brigadier General Henry M. Robert, who published the first edition as a *Pocket Manual of Rules of Order for Deliberative Assemblies* (Chicago: S.C. Griggs & Co., 1876). It should be mentioned that Robert's descendants, who took charge of ongoing editing, have included several women, such as Sarah Corbin Robert, the general's daughter-in-law.

26 Only in the 2000 edition of *Robert's Rules* did the guidebook acknowledge "chair" or "chairwoman" as valid alternatives to "chairman" in parliamentary procedure. Rachel Donadio, "Point of Order," *New York Times Book Review* (May 20, 2007): 27. One critic quoted in Donadio's piece concluded that the guide "institutionalizes a win-lose mentality [during debates], when often there are close decisions in which both sides need representation." By Eliasoph's definition, this was a good example of a masculine language game.

27 The Robert's Rules Association produced an eleventh edition of the book in 2011.

28 Anon., "Manchester Photographic Society," *Photographic Notes*, vol. 1, no. 6 (May 25, 1856): 51.

29 For another example of a typically formalized meeting agenda, see the reported minutes of the Photographic Society of Philadelphia in *The Philadelphia Photographer*, vol. 1, no. 12 (Dec. 1864): 188–9.

30 Transactions of the Photographic Society of London's ordinary meeting held on May 11, 1869, *JPSL*, vol. 14, no. 205 (May 15, 1869): 34. Cameron's presentation was summarized in one paragraph, while the other members' discussion of her specimens (their opinions) was more fully reported.

31 A claim made based on the published reports of meetings in the Society's journal. It is certainly possible that, for whatever reason, the Society secretary neglected to record, or the journal editor neglected to publish, other episodes involving female members. I find this possibility to be unlikely under Glaisher's liberal tenure, though certainly omittance could have occurred before his presidency. A piece of evidence to make us wonder about this possibility can be found in *The Photographic News* under the editorship of William Crookes. During a dispute he had with the Photographic Society council over whether he ought to be permitted to report on Society meetings in the *News* (discussed here in Chapter 8), Crookes published a bitter account of a Society meeting in 1858, during which a vocal complaint against the "dictatorial" council provoked "cheers and hisses." If Crookes' report was based in reality, what other Society dramas were missing from the record of the *Photographic Journal*? See *PN*, vol. 1, no. 14 (10 Dec. 1858): 157. A few years before Cameron's visit, a new Society member, Madame Brunner of Sunderland, exhibited specimens of her colored photographs on ivory at a Society meeting, but it is unclear from the short report whether a) she was present, or b) if she participated in discussion about them. Transactions of the Ordinary General Meeting of the Photographic Society of London, *JPSL*, vol. no. 143 (March 15, 1864): 3.

32 Kristen A. Hoving, "'Flashing thro' the Gloom': Julia Margaret Cameron's 'Eccentricity,'" *HOP*, vol. 27, no. 1 (2003): 45–59. Bill Jay described Cameron as eccentric four separate times in "Julia Margaret Cameron: An Appraisal," http://www.billjayonphotography.com/J.M.Cameron-an%20appraisal.pdf.

33 Julia Margaret Cameron, "Annals of My Glass House," in Beaumont Newhall, ed., *Photography, Essays and Images: Illustrated Readings in the History of Photography* (New York: Museum of Modern Art, 1980), 136.

34 *JPSL*, vol. 14, no. 205 (May 15, 1869): 34.
35 See Chapter 8, "Building a Republic of Photography."

Chapter 12: Defending Photography

1 Lady Elizabeth Eastlake, "Photography," reprinted from the *London Quarterly Review* in Alan Trachtenberg, ed., *Classic Essays on Photography* (New Haven, CN: Leete's Island Books, 1980), 64.

2 Photography must have been a lively topic of discussion in the Eastlake household, since Elizabeth's husband, Sir Charles, was the first president of the Photographic Society of London.

3 For an overview of the gendering of work in nineteenth-century Europe and the United States, see Joan W. Scott, "The Woman Worker," in Geneviève Fraisse and Michelle Perrot, eds., *A History of Women in the West*, vol. 4: *Emerging Feminism from Revolution to World War* (Cambridge, MA: Belknap Press, 1995), 399–426.

4 James F. Ryder, *Voigtländer and I in Pursuit of Shadow Catching: A Story of Fifty-two Years Companionship with a Camera* (No city: Rare Books Club, 2013 [1902]), 32. This confrontation had an interesting ending. Once Ryder moved his business to the next town, he had a visit from the same blacksmith, who was weeping uncontrollably. He begged Ryder to come back to the village with him in order to photograph his dead son, who had drowned in a log flume ride, which Ryder did. After that, the man was Ryder's "devoted friend."

5 Laura R. Prieto, *At Home in the Studio: The Professionalization of Women Artists in America* (Cambridge, MA: Harvard University Press, 2001), 97.

6 The dry plate was a glass plate for making negatives that, unlike the wet, collodion plate, allowed photographers to store and transport plates without having to develop them immediately after exposure. They could also purchase them rather than having to prepare them themselves. As a variety of North Atlantic companies improved the dry plate, women without a laboratory education could more easily take up photography. However, Bill Jay argued that the dry plate caused more new *men* to enter the profession than new women. Bill Jay, "Women in Photography: 1840–1900," unpublished article by Bill Jay, available as a PDF online here: http://www.billjayonphotography.com/Women%20In%20Photography.pdf.

7 Ryder, 131.

8 See Pierre Bourdieu, *Masculine Domination* (Stanford: Stanford University Press, 2001), 91–6. See also John C. Touhey, "Effects of Additional Women Professionals on Ratings of Occupational Prestige and Desirability," *Journal of Personality and Social Psychology*, vol. 29, no. 1 (1974): 86–9, and Peter Glick, "Trait-Based and Sex-Based Discrimination in Occupational Prestige, Occupational Salary, and Hiring," *Sex Roles*, vol. 25, no. 5/6 (1991): 351–78. In the sphere of higher education, Rita McWilliams-Tullberg explained that throughout the second half of the nineteenth century, there was "fertile ground in which to propagate the claim that Cambridge as a mixed university would no longer be considered a serious academic institution and would quickly slide into irrevocable decline." McWilliams-Tullberg "Women and Degrees at Cambridge University," in Martha Vicinus, ed., *A Widening Sphere: Changing Roles of Victorian Women* (Bloomington: Indiana University Press, 1977), 139.

9 See William B. Bradshaw's account in recognition of "Administrative Professional Day" in "Secretary, Administrative Assistant or Administrative Professional?" *The Blog* in

The Huffington Post (April 26, 2014) available online here: http://www.huffingtonpost. com/william-b-bradshaw/secretary-administrative_b_5218728.html. For historical treatments of male resistance to women entering "their" profession, see Cynthia Cockburn on the British printing industry, *Brothers: Male Dominance and Technological Change* (London: Pluto Press, 1983) and on the French printing industry, see Charles Sowerwine, "Workers and Women in France before 1914: The Debate over the Couriau Affair," *Journal of Modern History*, vol. 55, no. 3 (Sept. 1983): 411–41.

10 Charles Baudelaire, "Salon de 1859, II, Le Public Moderne et la Photographie," *Revue française*, 5e année, t. 17 (June-July 1859): 262–6. Félix Nadar, who photographed the poet in 1855 and 1856, agreed at least in part with Baudelaire and Dumas, writing in his autobiography that a lack "of technical training and talent was no problem" when he was starting out in the 1850s. Félix Nadar, *When I Was a Photographer*, trans. by Eduardo Cadava and Liana Theodoratou (Cambridge, MA: MIT Press, 2015 [1900]), 174, 176. See also his characterization of A.A.E. Disdéri as taking advantage of "the door that photography had just opened to all those without a profession." Nadar, 153.

11 Anon., "Alexander Dumas on Photography," *PN*, vol. 10, no. 414 (Aug. 10, 1866): 379.

12 H. Baden Pritchard, *About Photography and Photographers* (New York: Arno Press, 1973 [1883]), 17. American photographer H.J. Rodgers agreed, admitting that "innumerable charlatans [reflected] shadows of reproach and disrespect" upon their beautiful art. In Rodgers, *Twenty-Three Years under a Sky-Light, or Life and Experiences of a Photographer* (Hartford, CN: H.J. Rodgers, 1872), 219.

13 Ibid., italics my own.

14 Ibid.

15 For example, Clarence B. Moore, "Women Experts in Photography," *Cosmopolitan*, vol. 14, no. 5 (March 1893): 581–90.

16 It should be noted that the profession of "art photographer," as something distinct from the commercial studio photographer or scientific photographer was being slowly worked out throughout the second half of the nineteenth century and early twentieth. Several men and women during the period who considered themselves "amateurs" could, from our perspective, be identified as serious artists. For example, Peter H. Emerson (who was a physician), Julia Margaret Cameron, Robert Demachy, and the Oregonian Myra Wiggins.

17 Anon., "Prefatory," *Photographic Rays of Light*, vol. 1, no. 1 (Jan. 1878): 2.

18 Anon., "Photography in the Fields," *The Philadelphia Photographer*, vol. 1, no. 5 (May 1864): 67.

19 Anon., "Bibliographie," *Revue photographique*: 47. The writer was reviewing A.A.E. Disdéri's *Renseignements photographiques indispensables à tous* (Paris: l'auteur [the author], 1855).

20 Christine Battersby quoting Cesare Lombroso's *The Man of Genius* (1863) in *Gender and Genius*, 4. Battersby also quotes from Rousseau, Ruskin, and Renoir, who all denied genius could come from a woman. Drawing on Simone de Beauvoir's *The Second Sex* (*Le Deuxième Sexe*, 1949), anthropologist Sherry B. Ortner wrote the classic account of gendered creativity in "Is Female to Male as Nature Is to Culture?," in Michelle Zimbalist Rosaldo and Louise Lamphere, eds., *Women, Culture, and Society* (Stanford: Stanford University Press, 1974), 67–87. See also Adrianna M. Paliyenko, *Genius Envy: Women Shaping French Poetic History, 1801–1900* (University Park, PA: Pennsylvania State University Press, 2016), esp. the intro. and ch. 1.

21 During the long campaign to gain women's admittance to the French School of Fine Arts (Ecole des Beaux-Arts), Madame Bertaux, the president of the Union des Femmes

Peintres et Sculpteurs, observed, "It's almost as if the Fine Arts administration is saying: We very much want women artists, but we want to incarcerate them in the most humble mediocrity; they will be permitted to make industrial art, fans, screens, small pots of flowers, and portraits of cats, but we bar them the route to honors and glory. That we reserve for ourselves alone." Quoted in Tamar Garb, "'Men of Genius, Women of Taste': The Gendering of Art Education in Late Nineteenth-Century Paris," in Gabriel P. Weisberg and Jane R. Becker, eds., *Overcoming All Obstacles: The Women of the Académie Julian* (New York: Dahesh Museum, 1999), 124. In another creative profession, anthropologists similarly observed "that when a culture (e.g. France or China) develops a tradition of *haute cuisine*—'real' cooking, as opposed to trivial ordinary domestic cooking—the high chefs are almost always men." In Ortner, 80 (though arguably this rule of thumb has softened since the 1970s when Ortner was writing).

22 Quoted in Heinz K. Henisch and Bridget A. Henisch, *The Painted Photograph, 1839–1914* (University Park, PA: Pennsylvania State University Press, 1996), 45.
23 Transcript of a *Daily Telegraph* article in *JPSL*, vol. 7, no. 113 (Sept. 16, 1861): 260–1.
24 Emmanuel Hermange, "Des Femmes photographes et photographiées," in Alain Corbin et al., eds., *Femmes dans la cité, 1815–1871* (Paris: Creaphis, 1997), 104.
25 Anon., "Questionable Subjects for Photography," *PN*, vol. 1, no. 12 (Nov. 26, 1858): 136.
26 News from the Tribunal Correctionnel de la Seine in *Le Moniteur de la photographie*, no. 15 (Oct. 15, 1861) : 119. An interesting detail provided in this case was that fourteen young girls were cited as accomplices, and had been prosecuted the previous year as well. The tribunal, though, found that the 1861 images had come from sessions that took place before their previous conviction, and the girls were only fined.
27 Hermange, 105.
28 See the examples of patent disputes in Chapter 8.
29 Tim Padfield, "Copyright," in John Hannavy, ed., *Encyclopedia of Nineteenth Century Photography*, vol. 1 (London and New York: Routledge, 2008), 337.
30 Transactions of the Photographers' Association of America in *The Philadelphia Photographer*, vol. 17, no. 201 (Sept. 1880): 300.
31 H. Rocher, "The Relation of Photographers to the Public and the Public to the Photographers," *The Philadelphia Photographer*, vol. 17, no. 201 (Sept. 1880): 270.
32 Pritchard, 156.
33 Ryder, 109.
34 Rodgers, 51–2 (Rodger's italics). Rodgers treated the reader to anecdotes about frustrating and ignorant customers (men and women both) in his chapter entitled "Perplexities of a Photographer's Life," 176–86.
35 Article copied from the London *Literary Gazette* in *PN*, vol. 1, no. 10 (Nov. 12, 1858): 11.

Chapter 13: Just Charming

1 Anon., "L'Ennemi juré des retouches," *La Revue Photographique*, no. 13 (Nov. 5, 1856): 195, and Humbert de Molard, "Exposition universelle de photographie à Bruxelles," *BSFP*, t. 2 (Oct. 1856): 289.
2 On the gendered hierarchy of art versus craft, see Rozsika Parker and Griselda Pollock, *Old Mistresses: Women, Art and Ideology*, 3rd ed. (London: I.B. Tauris, 2013).
3 See also Ernest Lacan's mention of "Mme L." as reported in London's *Photographic Notes*: "Of this lady and her works M. Lacan speaks with the enthusiastic gallantry of his nation." The ladies, said Lacan, "know what a delicious charm mystery lends to

every thing [sic], and so we know nothing of Mme. L. but that her views rival the finest
in an exhibition containing the works of Aguado, Baldus, Alinari, Vigier, Clifford,
Caranza, &c., &c." Opening essay in *PN*, vol. 1 (Oct. 15, 1856): 200.

4 Anon., "The Exhibition of the Photographic Society," *PN*, vol. 1, no. 22 (Feb. 4, 1859):
 255.

5 Ibid.

6 Anon., "A Winter Amusement," *The Amateur Photographer*, vol. 1, no. 12 (Dec. 26,
 1884): 186.

7 Ibid.

8 Ibid.

9 Anon., "How To Make Things Go," *The Photographic Times*, vol. 1, no. 12 (Dec. 1871):
 181 (my italics).

10 Françoise Condé, "*Les Femmes photographes en France: 1839–1914*," maîtrise d'histoire
 (Paris: Université Paris VII – Jussieu, 1992), 41. The early French photographer
 Madame Laffon entered silk photographs, her specialty, at the London Society's
 Exhibition of 1864, where they were described as "charming specimens." Report of the
 jurors in *JPSL*, vol. 9, no. 146 (June 15, 1864): 67. It must be said, however, that
 Viscountess Jocelyn, mentioned in a list with notables Sir A.K. MacDonald and the
 Earl of Caithness, proved "that in the amateur pursuit of an elegant accomplishment
 results may be obtained which rival in all excellence the works of the most able of
 those who practise the art as a profession." *JPSL*, vol. 9, no. 146 (June 15, 1864): 65.

11 Condé, 41.

12 Anon., "The Photographic Exhibition: Studies and Genre Subjects," *PN*, vol. no. (June
 24, 1864): 302.

13 Ibid., 303. This was Hawarden's second exhibition—she won silver (first place) medals
 both times (1863 and 1864). Robinson seems to have submitted pictures both to the
 Edinburgh and London exhibitions of 1864, receiving an award only at the former. See
 report of the Photographic Society of Scotland in *JPSL*, vol. 9, no. (May 16, 1864): 44.
 Hawarden died of pneumonia at the age of forty-two the following year. Robinson
 would return to win the medal in London in 1865, famously beating Julia Margaret
 Cameron's "poetical but badly manipulated portraits." See Anon., "The Dublin
 Exhibition—Photographic Department," *JPSL*, vol. 9, no. 158 (June 15, 1865): 94.

14 Anon., "With the Picture Takers: Amateurs Using the Short Days for Experiments and
 Exhibitions," *The New York Times*, vol. 39, no. 11,950 (Dec. 16, 1889): 9.

15 On Barnes (later Barnes Ward), see Peter Palmquist, *Catharine Weed Barnes Ward:
 Pioneer Advocate for Women in Photography* (Arcata, CA: Peter E. Palmquist, 1992),
 and Margaret Denny, "Catharine Weed Barnes Ward: Advocate for Women
 Photographers," *HOP*, vol. 36, no. 2 (May 2012): 156–71.

16 On Watson-Schütze (1867–1935), see Tom Wolf, *Eva Watson-Schütze, Photographer*
 (New Paltz, NY: Samuel Dorsky Museum of Art, 2009). Watson would open her own
 studio in 1897 and served on the Philadelphia Salon jury in 1899 and 1900.

17 Catharine Weed Barnes, "Why Ladies Should Be Admitted to Membership in
 Photographic Societies," in Peter E. Palmquist, ed., *Camera Fiends & Kodak Girls*, vol. 2
 (New York: Midmarch Arts Press, 1995), 42. Barnes' home-town photo club in Albany
 refused to admit women during the period, forcing her to join a society in New York City.

18 Not all their turn-of-the-century contemporaries agreed. Fellow American Frances
 Benjamin Johnston, not short of professional prestige herself, organized an American,
 all-women photo exhibit at the Paris Exposition in 1900, provoking French critics to
 respond with the untrue declaration, "Women photographers do not really exist yet in

France." Louis Gastine, "La Femme photographe," *Bulletin du Photo-Club de Paris*, 12e année (Aug. 1902): 268–71.

19 *Purdah* is a South Asian term (from the Persian) encompassing the behavioral regulations between women and certain kinds of men in Hindu and Muslim societies. The system aims to seclude women from men using segregated spaces, veils, and a prohibition on touching. It includes social standards of feminine modesty and decorum, and the avoidance of public appearances for women. It can be argued that a nineteenth-century bourgeois version of *purdah* in the North Atlantic world found expression in the cult of domesticity, chaperonage, and even light veiling of women in public. In the context of gendered spaces, Daphne Spain wrote, "The system of purdah was developed to keep women secluded in the home in a space safe from unregulated sexual contact, yet it also served to restrict women's educational and economic opportunities." Daphne Spain, *Gendered Spaces* (Chapel Hill: University of North Carolina Press, 1992), 12.

20 Amy Levy, *The Romance of a Shop* (Peterborough, Canada: Broadview Editions, 2006 [1888]), 96–7.

21 Jennifer Tucker, "Gender and Genre in Victorian Scientific Photography," in Ann B. Shteir and Bernard Lightman, eds., *Figuring It Out: Science, Gender, and Visual Culture* (Hanover, NH: Dartmouth College Press, 2006), 145.

22 Amy Levy's heroines are "aware of the dangers inseparable from the freedom which they enjoyed" as studio photographers. They realize that in order to succeed they must overcome their fears and trust their own judgement when it comes to male clients. Levy, 136.

23 Smith analyzed this gender dynamic in sources of American literature, notably Hawthorne's *House of the Seven Gables* (1851) and a fantasy short story, "The Magnetic Daguerreotypes" (1852), which appeared in the *Photographic Art-Journal*. See Shawn M. Smith, *American Archives: Gender, Race, and Class in Visual Culture* (Princeton: Princeton University Press, 1999), 15–23.

24 Tamar Garb, "'Men of Genius, Women of Taste': The Gendering of Art Education in Late Nineteenth-Century Paris," in Gabriel P. Weisberg and Jane R. Becker, eds., *Overcoming All Obstacles: The Women of the Académie Julian* (New York: Dahesh Museum, 1999), 117–18.

25 A substantial literature exists for Käsebier (1852–1934), including an exhibition catalogue from Stephen Peterson and Janis A. Tomlinson, eds., *Gertrude Käsebier, the Complexity of Light and Shade: Photographs and Papers of Gertrude Käsebier in the University of Delaware Collections* (Newark, DE: University of Delaware Museum, 2013). Chicago high-society photographer Elizabeth Buehrmann (1886–?), on the other hand, despite many contributions to exhibitions during her career, and membership in the New York Photo-Secession and the Paris Photo-Club, has a death date that differs from source to source. A useful capsule biography and short bibliography for Buehrmann is in Naomi Rosenblum, *A History of Women Photographers*, (New York: Abbeville Press, 1994), 330 and 396 (which gives her death date as 1962).

26 Quoted in Jeanne H. Watson, *To the Land of Gold and Wickedness: The 1848–59 Diary of Lorena L. Hays* (St. Louis, MO: The Patrice Press, 1988), 226. Information on Elizabeth W. Withington's (1825–77) successful career may be found in Peter Palmquist and Gia Musso, *Women Photographers: A Selection of Images from the Women in Photography International Archive* (Arcata, CA: Peter E. Palmquist, 1997) (biographical appendix) and Margaret Denny, "From Commerce to Art: American Women Photographers 1850–1900," Ph.D. diss. (University of Illinois at Chicago, 2010), 334–5 and 396.

27 Jeanne H. Watson, 226.
28 Although Dumas' assertion about Viennese studios could not have been true, he stated it twice in his report. Translation of Alexandre Dumas' article from *Les Nouvelles* in Anon., "Alexandre Dumas on Photography," *PN*, vol. 10, no. 414 (Aug. 10, 1866): 379 and 380.
29 Ibid. (and quotations throughout this paragraph).
30 Lest we stereotype Dumas' predilection for pretty photographers as a French disposition, a similar story also appeared in the English *Amateur Photographer*, wherein a woman photographer generated business by innocently flirting with and flattering customers. "She does not grip the subject by the shoulders and rudely distort him into a pose," said the reporter, "but the gentle touch of her soft hands electrifies him, and he would stand on his head at the slightest intimation that such an attitude would be good." Anon., "A Woman's Success as a Photographer," *The Amateur Photographer*, vol. 1, no. 9 (Dec. 5, 1884): 142.

Chapter 14: Work for Women?

1 Anon., "Photographic Items," *The Scientific American*, vol. 10, no. 11 (March 12, 1864): 167.
2 On the concept of surplus women in the British context, see Susie L. Steinbach's entry on "Great Britain" in Bonnie G. Smith, ed., *The Oxford Encyclopedia of Women in World History*, vol. 1 (Oxford: Oxford University Press, 2008), 397.
3 On Charlotte Brontë's teaching years, see Elizabeth Gaskell's classic biography, *The Life of Charlotte Brontë*, 2 vols. (London: Smith, Elder & Co., 1857), and three of Brontë's novels utilize her experiences from school teaching: *Jane Eyre* (1847), *Villette* (1853), and *The Professor* (published posthumously in 1857).
4 Edward Carpenter quoted in McWilliams-Tullberg, "Women and Degrees at Cambridge University," in Martha Vicinus, ed., *A Widening Sphere: Changing Roles of Victorian Women* (Bloomington: Indiana University Press, 1977), 122.
5 On the prevalence of prostitution in nineteenth-century Europe, see Judith R. Walkowitz, *Prostitution and Victorian Society: Women, Class, and the State* (Cambridge: Cambridge University Press, 1982) and Alain Corbin, *Les Filles de noce: misère sexuelle et prostitution au XIXe siècle* (Paris: Flammarion, 1978).
6 The scope of the present book does not allow for a full review of North Atlantic jobs literature for girls, but here are a few helpful sources: A pre-1900 sample includes, from the United States, A Working-Woman [Miss H.M. Cammon], "Woman's Work and Wages," *Harper's New Monthly Magazine*, vol. 38, no. 227 (April 1869): 665–70; in Dio Lewis' *Our Girls* (New York: Clarke Bros., 1883), the progressive author suggested a variety of careers from amanuensis to dentist to librarian, and included prestige professions like medicine and law; and Frances E. Willard, *Occupations for Women: A Book of Practical Suggestions for the Material Advancement, the Mental and Physical Development, and the Moral and Spiritual Uplift of Women* (Cooper Union, NY: The Success Company, 1897). French women writers showed their social scientific chops in studies like Julie-Victoire Daubié's *La Femme pauvre au XIXe siècle* (Paris: Librairie de Guillaumin et Cie, 1866), Maxime Breuil's *Deux discours sur le travail des femmes* [originally a lecture given at the Salle du Vauxhall](Paris: Armand le Chevalier, 1868), and Lilla Pichard, *Le Choix d'un état: arts et métiers propres aux femmes. Livre de lectures courantes, scientifiques et morales, accompagnées de conseils et d'exemples*

pratiques (Paris: G. Tequi, 1879). In Britain, period works include J.B., "On the Obstacles to the Employment of Women," *The English Woman's Journal*, vol. 4, no. 24 (Feb. 1, 1860): 361–75, and Emily Pfeiffer, *Women and Work* (London: Trübner & Co., 1888). The debate about work for women in France from the Second Empire through the early Third Republic was particularly heated, because conservatives were unable to reconcile the desire to increase the nation's birthrate with the need for unmarried or widowed women to have respectable employment. There was also anxiety over any change that would soften gender differentiation, an anxiety also expressed in Britain and the United States, but perhaps not at as high a pitch. See for example, Le Solitaire [pseud.], *La Femme ne doit pas travailler* [*Woman Should Not Work*](Paris: Auguste Ghio, éditeur, 1886).

7 Mme Paquet-Mille, *Nouveau guide pratique des jeunes filles dans le choix d'une profession* (Paris: Lecène, Oudin et Cie, 1891), 294–5.

8 Willard, 242.

9 Ibid., 243.

10 Judging from the misery surrounding the figure of the governess, Lebour and her lady partner were probably much happier than most governesses, as they were their own bosses and, as Dixon said, enjoyed independence. Edmund S. Dixon, "More Work for the Ladies," *Household Words*, vol. 6, no. 130 (Sept. 18, 1852): 18–22.

11 Anon., "Alexandre Dumas on Photography," 381.

12 If we may extend our evidence to the *far* North Atlantic, Henrik Ibsen's 1884 play, *The Wild Duck*, contains a photographer's wife and daughter as two of the three main family characters. Over the course of the play, it is revealed that the photographer's wife, Gina, is the one "who really carries on the business," so that her husband can "take refuge in the parlor" in order to put his mind "to more important things" (a "great invention" that is never specified). Henrik Ibsen, *The Wild Duck*, translated by Christopher Hampton (New York: Samuel French, Inc., 2014).

13 Jabez Hughes, "Photography as an Industrial Occupation for Women," in Peter E. Palmquist, ed., *Camera Fiends & Kodak Girls*, vol. 1 (New York: Midmarch Arts Press, 1989), 29–36. The article was originally published in *Victoria Magazine* and reproduced in the *BJP*, vol. 20 (May 9, 1873): 222–3. Across the Atlantic it also appeared in *Anthony's Photographic Bulletin* and is available unabridged on Clio online here: https://www.cliohistory.org/exhibits/palmquist/occupation/.

14 Hughes in Palmquist, ed., *Camera Fiends & Kodak Girls*, vol. 1, 33 and 36.

15 Ibid., 30.

16 Anon. [Editor Edward L. Wilson], "The Future of Photography to be in the Hands of the Gentler Sex," *The Philadelphia Photographer*, vol. 10, no. 113 (May 1873): 129 (cover page).

17 Willard, 242. See also Catharine Weed Barnes, "Women as Professional Photographers," in Julia Ward Howe, ed., *Papers Read Before the Association for the Advancement of Women* (Syracuse, NY: C.W. Bardeen, Publisher and Printer, 1892), 43–9. Barnes used all the period clichés of femininity to argue that photography was a great career for women.

18 Quoted in Angela V. John, ed., *Unequal Opportunities: Women's Employment in England, 1800–1918* (New York: Basil Blackwell Ltd., 1986), 15.

19 M.E. Sperry, "Women and Photography," *Pacific Coast Photographer*, vol. 3, no. 8 (Sept. 1894): 153.

20 Anon., "Photographic Items," 167. Apparently unbeknownst to the writer, there were many American women professionals and amateurs as well.

21 Piece in the *Pall Mall Gazette* (1895) quoted in Hilary Fraser, *Women Writing Art History in the Nineteenth Century: Looking Like a Woman* (New York: Cambridge University Press, 2014), 144.

22 Transactions of the annual meeting of the Union Nationale des Sociétés Photographiques de France, hosted by the Photo-Club of Lyon, in *BSFP*, t. 11, no. 16, new series (June 1895): 399.

23 Janssen probably referred to Villarceau's first wife, whose full name and dates of birth and death may be unrecorded, but who was lauded by her husband for her mathematical calculations in J. Bertrand, "Eloge historique de M. Yvon Villarceau," in *Mémoires de l'Académie des Sciences de l'Institut de France*, t. 45, new series (1899): xvii–xviii. Caroline L. Herschel (1750–1848) assisted her brother William, but was an astronomer in her own right, discovering several comets and nebulae, and becoming the first woman to be paid by the crown for her astronomical work.

24 Transactions of the annual meeting of the Union Nationale des Sociétés Photographiques de France, hosted by the Photo-Club of Lyon, in *BSFP*, t. 11, no. 16, new series (June 1895): 399.

25 Elise L'Heureux Livernois (1837–96) was business partners both with her celebrated husband, Jules Isaï Benoît, and her son Ernest, who later took over the family studios. "It is also possible that [Jules] Livernois' wife, Elise, introduced him to the medium," wrote the family's biographer, Michel Lessard. "Aside from raising the children," wrote Lessard, "Elise, a sturdy woman, worked to help make ends meet. It is quite likely that she played a paramount role in one or more of the three studios throughout Jules Isaï's career as a photographer." Elise L'Heureux identified herself as an artist-photographer in Québec City's business directories. Michel Lessard, *The Livernois Photographers* (Québec City, Canada: Musée du Québec, 1987), 27 and 79–81.

26 Anon., "Female Employment in Colouring Photographs," *PN*, vol. 9, no. 339 (March 3, 1865): 108.

27 Anon., "Female Photographers," *Humphrey's Journal*, vol. 18, no. 12 (Oct. 15, 1866): 192.

28 A directory-derived list of women photographers recorded that Lucretia A. Gillett advertised in a trade directory between 1860 and 1890, having moved from her home in New York State to Michigan. She was a member of the National Photographic Association and helped establish a Photographic Hall for the 1876 Centennial Exhibition in Philadelphia. Aside from Haynes, Gillett trained Laura A. Green as an employee in her Saline, MI studio, enabling Green to establish her own studio in 1888. From unpublished biographical notes on nineteenth-century women photographers in Michigan, in the Palmquist Collection, Beinecke Library.

29 In the novel, Lucy Lorimer, age twenty, departs for a three-month training period with a photographer, Mr. Russel, who is a family friend in northern England. She then returns to London, where she and her three sisters establish a studio on Upper Baker Street.

30 In 1883, H. Baden Pritchard reported that a printing girl in a photographic studio (UK) might earn fifteen to eighteen shillings per week, which was less than one pound and would have meant poverty without another source of income. Girls occupied with spotting (flaw removal) or mounting, he said, usually earned eight to ten shillings a week. Pritchard, *About Photography and Photographers* (New York: Arno Press, 1973 [1883]), 39. These rates had not risen since Jabez Hughes reported in 1873 that female employees earned "from ten to fifteen shillings per week." Hughes wrote, "[t]heir recommendation [advantage] is, not that they do their work better, but that they can be got cheaper than men." Hughes in Palmquist, *Camera Fiends & Kodak Girls* ed.,

vol. 1, 33. In Montréal, Canada, the handful of women employees in the large Notman studio earned between $5–$12, biweekly, between 1866 and 1882. See Colleen M. Skidmore, "Women in Photography at the Notman Studio, Montréal, 1856–1881," Ph.D. diss. (Edmonton, Canada: University of Alberta), 157. In going over photography as a job for French women, Madame Paquet-Mille characterized retouching photographs as piecework, wherein *carte-de-visite*-sized negatives might fetch from 20–25 centimes per piece, and larger negatives might fetch from 75 centimes to 1 franc 50 centimes. A nine to ten-hour day, she concluded, might bring the worker 4–5 francs. She did not include higher-prestige studio positions in her description of the field for her female readers. Paquet-Mille, 294.

31 Skidmore, 165.
32 Oliver Wendell Holmes, "Doings on the Sunbeam," *The Atlantic Monthly*, vol. 12, no. 69 (July 1863): 1–15.
33 Anon., "Female Assistants in the Studio," *PN*, vol. 17, no. 764 (April 25, 1873): 199.
34 A Lady, "Duties of a Lady in the Reception Room," *PN*, vol. 24, no. 1137 (June 18, 1880): 296.
35 Ibid.
36 Félix Nadar, *When I Was a Photographer*, trans. by Eduardo Cadava and Liana Theodoratou (Cambridge, MA: MIT Press, 2015 [1900]), 103.
37 Anon., "Woman's Work in Photography," *The Photographic Times and American Photographer*, vol. 17, no. 287 (March 18, 1887): 127–8.
38 Anon., "Employment of Women in Photography," *PN*, vol. 11, no. 438 (Jan. 25, 1867): 37.
39 Ibid.
40 Anon., "Echoes of the Month, By an Old Photographer," *PN*, vol. 14, no. 604 (April 1, 1870): 147.
41 Ibid.
42 Sperry, 153.
43 Vicinus, ix.
44 Anon., "Employment of Women in Photography," 37.
45 Theodore Hicks, "Printing, Toning, Female Assistants, Etc.," *PN*, vol. 18, no. 769 (May 30, 1873): 263.
46 Ibid.
47 Ibid. (editor's response immediately following Hicks' letter).
48 Ibid. W.H. Warner expressed the opposite opinion about women photo printers in 1868: "Women, in my opinion, are specially fitted for printers. They possess great tact and judgement, manipulate with great delicacy and labour patiently, and may be left to themselves oftener and for a longer period than men can be." Warner, "Some Practical Jottings: Printing," *The Illustrated Photographer*, vol. 1 (May 20, 1868): 81. Here women's "feminine" traits counted for rather than against them.
49 The possibility exists that women's articles and letters were suppressed by the editor, but in the case of *The Photographic News* I think it would have been more likely for Simpson to publish any such correspondence, whose controversial nature could have enhanced his readership. On the other hand, publishers may have wished to avoid stoking a feared war between the sexes.
50 A Working Woman [pseud.], "Female Labour in the Studio," *PN*, vol. 14, no. 605 (April 8, 1870): 164.
51 Editor's response below Photo. [pseud.], "Female Photographers," *PN*, vol. 14, no. 603 (March 25, 1870): 142.

52 Ibid.

53 A Working Woman, "Female Labour in the Studio," 164.

54 Ibid., 165.

55 Ibid.

56 The term Taylorism is named after a pioneer of "scientific management," the American mechanical engineer Frederick Winslow Taylor, and refers to the de-skilling of job tasks by dividing it up, making the workers into interchangeable parts of a manufacturing process. Taylorism in large photography studios arrived *avant la lettre*, since Taylor only began publishing his ideas in about 1911, though he was studying labor in Philadelphia before that. See Daniel Nelson, *Frederick W. Taylor and the Rise of Scientific Management* (Madison: University of Wisconsin Press, 1980).

Chapter 15: The Gender of Coloring

1 Heather A. Shannon, "#5WomenArtists: The Women Who Hand-Tinted and Colored Photographic Work in the 19th Century," *Guest Post's Blog* on the Eastman Museum website, available here: https://www.eastman.org/5womenartists-women-who-hand-tinted-and-colored-photographic-work-19th-century. On Laure Gouin, see Thomas Galifot, "Parent-Elles, Partner, Daughter, Sister of . . .: Women Artists and the Ties of Kinship," *AWARE*, symposium papers published (June 15, 2017) at https://awarewomenartists.com/en/publications/parentele-risque-de-photographie-amateures-professionnelles-xixe-siecle-debut-xxe-siecle-france-grande-bretagne-etats-unis/.

2 In this chapter, I will include retouching more generally as a studio technique linked to hand-coloring. John Plunkett included color tinting in his essay on "Retouching" in John Hannavy, ed., *Encyclopedia of Nineteenth-Century Photography*, vol. 2, (London: Routledge, 2008), 1189–91.

3 Pierre Apraxine, and Xavier Demange, *"La Divine Comtesse": Photographs of the Countess de Castiglione* (New Haven: Yale University Press, 2000), 25. Apraxine also discussed the Comtesse de Castiglione's penchant for tinting and retouching in the same work, 41–45.

4 Laura Claudet, "Colouring by Hand," in Hannavy, vol. 1, 322.

5 John Plunkett, "Retouching" in Hannavy, vol. 2, 1189.

6 *The Photographic Art Journal* (New York) described tinted daguerreotypes as "outrageously ruined" in 1851. Quoted in Heinz K. Henisch, and Bridget A. Henisch, *The Painted Photograph, 1839–1914* (University Park, PA: Pennsylvania State University Press, 1996), 32.

7 The series commenced in *PN*, vol. 1, no. 12 (Nov. 26, 1858): 138, and continued with weekly installments through June 10, 1859. See also Alfred H. Wall, "Practical Instructions on Coloring Photographs," *BJP*, vol. 7, no. 112 (Feb. 15, 1860): 56–7. Wall offered to critique students' work by mail, which included at least two women (a "Miss D." of Kingsland and an "Ann Page").

8 Anon., Review of *The Principles and Practice of Harmonious Colouring, Especially as Applied to Photographs*, *PN*, vol. 1, no. 26 (March 4, 1859): 302.

9 Anon., "Lessons on Colouring Photographs," *PN*, vol. 1, no. 15 (Dec. 17, 1858): 174–5.

10 Anon., "Lessons on Colouring Photographs," *PN*, vol. 2, no. 40 (June 10, 1859): 160.

11 J. Zeigler, "Extracts from *La Lumière*: 2—Coloring Daguerreotypes," *The Photographic Art Journal*, vol. 2 (Aug. 1851): 109.

12 Ibid.

13 Annelise Maugue pointed out that the one issue that the Catholic Church and the French Confederation of Unions (Confédération Générale du Travail) agreed upon was the desirability of getting women out of the paid workforce. In Maugue, *L'Identité masculine en crise au tournant du siècle, 1871–1914* (Paris: Edition Rivages, 1987), 12–13.

14 Anon., "The Employment of Women in Photography," *PN*, vol. 18, no. 766 (May 6, 1873): 223.

15 Ibid.

16 Theodore Hicks, "Printing, Toning, Female Assistants, Etc.," *PN*, vol. 18, no. 766 (May 30, 1873): 263.

17 Anon. [excerpt from *The American Queen*], "The Painting of Photographs," *The Photographic Times and American Photographer*, vol. 13, no. 154 (Oct. 1883): 547.

18 Ibid.

19 Henisch and Henisch, 168.

20 Advertisement in classifieds section of *JPSL*, vol. 6, no. 87 (July 15, 1859): n.p.

21 Advertisement in classified section of *JPSL*, vol. 6, no. 96 (April 16, 1860): n.p.

22 See note no. 30 in chapter fourteen for references on studio workers' wages.

23 Cabinet cards by Mrs. R.J. Woodward in the Palmquist Collection, Beinecke Library.

24 *Cartes-de-visite* and cabinet cards in the Palmquist Collection, Beinecke Library.

25 Quoted in Henisch and Henisch, 155.

26 An intriguing manuscript, dated 1861, formerly belonging to Sophia (b. 1838), appeared for sale on the M. Benjamin Katz Fine Books Website. Hand-written by Mrs. Fry, the book recorded her "Remedies, Recipes, Salves, Cures and Chemical Formulae." See Katz' description of the artefact online here: http://www. mbenjaminkatzfinebooksraremanuscripts.com/?page=shop/flypage&product_id=317 8&keyword=PORTRAIT&searchby=keyword&offset=20&fs=1.

27 Jabez Hughes, "Photography as an Industrial Occupation for Women" (1873), available on Clio at http://www.cliohistory.org/exhibits/palmquist/occupation/. Compare Hughes to the Viennese photographer M.J. Löwy, who thought experienced female colorists were "of great use and value," and could command good pay in Vienna. In "Female Assistants in the Studio," *PN*, vol. 17. No. 764 (April 25, 1873): 199.

28 Anon., "Exposition Universelle," *BSFP*, tome premier (May 18, 1855): 147.

29 Anon., "L'Ennemi juré des retouches," *Revue Photographique*, no. 13 (Nov. 5, 1856): 195. Interestingly, de Molard made a point of praising a certain Madame Legay in the same report, an amateur who exhibited her photographs in Brussels, and whose pictures were all "taken from nature without any retouching." Perhaps retouching was already in 1856 becoming associated with "impure," second-rate femininity; so that de Molard felt he had to separate good female work (rarely noticed in the French photographic press) from the practice he so detested.

30 Anon., "Exhibition of the French Photographic Society," *PN*, vol. 1, no. 21 (28 Jan. 1859): 245.

31 The Photographic Society of Scotland, for example, posed the rule that all exhibition pictures "must be untouched and from single Negatives," though it made an exception for "Views, which may have the Sky Printed from another Negative" (capital letters in the original), Anon., "The Exhibition of the Photographic Society of Scotland," *JPSL*, vol. 10, no. 166 (Feb. 16, 1866): 260. The London Photographic Society (as well as Birmingham) compromised with the rule that colored photographs would be admitted "only when accompanied by untouched copies of the same picture." In *JPSL*,

vol. 4, no. 62 (Jan. 21, 1858): 132; though, in 1864 the London Society barred any colored or retouched pictures from its annual exhibition. Photographer Edward Dunmore wrote in *The Photographic Times* (1890): "At one time, if hand work could be detected on a photograph, even if it required the aid of a magnifier, it was disqualified as unfit to compete with its untouched brotherhood." Quoted in Henisch and Henisch, 56.

32 "A VALUABLE BOOK FOR LADIES—ART RECREATIONS," advertisement in *Godey's Lady's Book*, (Jan. 1860), from the *Godey's Lady's Book* Collection on Accessible Archives, available by subscription at http://www.accessible-archives.com/.

33 Advertisement, "To COLOR PHOTOGRAPHS—A New Preparation Called Newton's Prepared Colors," *Godey's Lady's Book* (May 1863), transcribed on Accessible Archives, available by subscription at http://www.accessible-archives.com/.

34 Henisch and Henisch, 32.

35 Peter H. Emerson, *Naturalist Photography for Students of the Art* (New York: E.F. Spon, 1890): 6–7.

36 Acceptance of elite male photographers' manipulated pictures was also the case in France. Agreeing in general with de Molard's condemnation of the retouching, writers at the *Revue Photographique* nevertheless praised the hybrid products of M. Nadar *fils* and MM. Mayer et Pierson, which "could and should take rank, even among the competition, in the category of photographic applications." From "L'Ennemi juré des retouches," 195. For an overview on combination prints and their reception, see Robert Hirsch, "Multiple Printing, Combination Printing, and Multiple Exposure," in Hannavy, vol. 2, 960–2. And see Jordan Bear, *Disillusioned: Victorian Photography and the Discerning Subject* (University Park, PA: Pennsylvania State University Press, 2015), 32. See also Alfred H. Wall's criticism of the technique, discussed in David Coleman, "Henry Peach Robinson," in Hannavy, vol. 2, 1203.

37 John Hubbard, "On Photographic Pictures," *JPSL*, vol. 15, no. 233 (May 16, 1872): 144.

38 The flaws that retouchers erased could be either facial flaws (blemishes, scars, freckles, or moles) or technical flaws (spots) that occurred in the developing and printing process.

39 Plunkett in Hannavy, vol. 2, 1189.

40 A Photographer's Wife [pseud.], "Retouching the Negative," *The Philadelphia Photographer*, vol. 9, no. 100 (April 1872): 101. The writer was responding to H.H. Snelling, "Retouching Negatives," *The Philadelphia Photographer*, vol. 9, no. 99 (March 1872): 71–2.

41 Ibid., 101.

42 Ibid.

43 [Jennie], "What a Retoucher Can See On This Touchy Subject," *The Philadelphia Photographer*, vol. 10, no. 113 (May 1873): 140.

44 Ibid., 141.

45 Eunice N. Lockwood, "The National Photographic Association as a Means of Instruction," *The Philadelphia Photographer*, vol. 10, no. 113 (May 1873): 134.

46 Ibid.

47 Ibid. Lockwood's italics.

48 See for example the PBS short documentary, *Is Photoshop Remixing the World?* (2014) in which a male digital artist, male glamor photo editor (featuring his retouched images of female models), and male meme creator extol the creative possibilities available with the software. Available online at http://www.pbs.org/video/-book-photoshop-remixing-world/.

Chapter 16: The Femininity of the Studio

1 Opener in *The Photographic Journal*, vol. 6, no. 85 (Jan. 1, 1859): 2. The journal's name would change again in 1860 to the *British Journal of Photography*, and it retains that name up to the present day.
2 Description of Félix Nadar's studio in Adam Begley, *The Great Nadar: The Man Behind the Camera* (New York: Tim Duggan Books, 2017), 80.
3 Excerpt from *L'Illustration* in *La Revue Photographique*, no. 7 (May 5, 1856): 98–9.
4 Shirley T. Wajda, "The Commercial Photographic Parlor, 1839–1889," *Perspectives in Vernacular Architecture*, vol. 6: *Shaping Communities* (No city: Vernacular Architecture Forum, 1997), 220.
5 H.J. Rodgers, *Twenty-Three Years Under a Sky-Light, or Life and Experiences of a Photographer* (Hartford: H.J. Rodgers, Publisher, 1872).
6 Carol Johnson covered Mathew Brady's career-long financial difficulties in her entry on the photographer in John Hannavy, ed., *Encyclopedia of Nineteenth-Century Photography*, vol. 1, (London: Routledge, 2008), 197–9. The classic account of Disdéri's rise and fall is Elizabeth A. McCauley's *A.A.E. Disdéri and the Carte de visite Portrait Photograph* (New Haven: Yale University Press, 1985). See also his entry by Carolyn Peter in Hannavy, vol. 1, 417–19.
7 See, for example, the case of luxury department stores in Michael B. Miller, *The Bon Marché: Bourgeois Culture and the Department Store, 1869–1920* (Princeton: Princeton University Press, 1981).
8 Arbo Jay, "Handsome Reception Rooms," *St. Louis Photographer*, vol. 1, no. 3 (March 1883): 26.
9 Michel Lessard, *The Livernois Photographers* (Québec City, Canada: Musée du Québec, 1987), 120.
10 This business norm was a source of frustration for many photographers at mid-century. In 1889, the *Burlington Free Press* only half-jokingly reported: "An Indiana court has decided that unless a woman is pleased with her photographs she need not pay for them. Since this decision was rendered forty-five photographers have spilled their chemicals out of the window and left the state." In *Wilson's Photographic Magazine*, vol. 26, no. 341 (March 2, 1889): 156.
11 Anon. [editor], "A Word To Our Patrons," *The Philadelphia Photographer*, vol. 1, no. 1 (Jan. 1864): 13.
12 A classic, fictionalized account of the Bon Marché was depicted by Emile Zola in *Au Bonheur des Dames* (originally serialized in 1883), in which the heroine, Denise, gains business influence by marrying the store's director, not through her performance as an employee. On the Sears catalogue during the period, see Boris Emmet and John E. Jeuck, *Catalogs and Counters: A History of Sears, Roebuck and Company* (Chicago: University of Chicago Press, 1965). And on Lewis's department store, see Asa Briggs, *The Friends of the People: The Centenary History of Lewis's* (London: B.T. Batsford, 1956).
13 Anon. [editor], "How You Can Help Us," *The Philadelphia Photographer*, vol. 1, no. 1 (Jan. 1864): 14.
14 The Pennsylvania Historical and Museum Commission found the following professional women photographers in PA trade directories before 1870: Sarah A. Boehm, Catharine A. Burrows, Catharine Clowney, Mrs. William Currie, Mlle England, Mlle Gunn, Eliza Henry, Sally G. Hewes, Charlotte M. Hutton, Camille LaChapelle, Elizabeth D. Maan, Elizabeth D. Mahan, Kate McFarland, Ann McGinn, Hyla H.

Peacock, Summer A. Smith, Herline Thurston & Co., and Julia A. Willard. Note that many photographers, too, practiced without paying for a directory listing, and that list does not include amateurs. From Linda A. Ries and Jay W. Ruby, eds., *Directory of Pennsylvania Photographers, 1839–1900* (Commonwealth of Pennsylvania: Pennsylvania Historical and Museum Commission, 1999).

15 Anon., "Letters to a Young Photographer: No. 1," *The Photographic Journal* (soon to become the *British Journal of Photography*), vol. 6, no. 85 (Jan. 1, 1859): 10.

16 Anon., "A Hint to Albuminisers," *BJP*, vol. 8, no. 149 (Sept. 2, 1861); 313. Olla Podrida is a kind of spicy Spanish stew, used here to indicate "miscellaneous items" in the journal.

17 Douglas Collins reported that six million egg whites were used each year in English albumen paper plants alone. Much of the yolk was sold by the albumen manufactures to bakeries, and tanners who made kid gloves. Douglas Collins, *The Story of Kodak* (New York: Harry N. Abrams, Inc., 1990), 32. See also Beaumont Newhall, "60,000 eggs a day," *Image: Journal of Photography of the George Eastman House*, vol. 4, no. 4 (April 1955): 25–6. Newhall's title comes from the productivity of the Dresden Albumenizing Company, where "Girls did nothing all day long but break eggs and separate the whites from the yolks."

18 Anon., "The Raspberry Syrup Process," *PN*, vol. 1, no. 12 (26 Nov. 1858): 141.

19 Ibid. (italics in original).

20 Collins, 40.

21 Anon., "Practical Hints and Useful Recipes," *Photographic Rays of Light*, vol. 1, no. 1 (Jan. 1878): 23. James Chisholm, "A Simple Method of Taking the Iodine Out of an Overcharged Nitrate Bath," *Anthony's Photographic Bulletin*, vol. 4, no. 5 (March 1873): 79.

22 Oliver Wendell Holmes, "Doings of the Sunbeam," Part I, *The Atlantic Monthly*, vol. 12, no. 69 (July 1863): 1–15, available in *The Photography Criticism CyberArchive*, online at http://nearbycafe.com/photocriticism/members/archivetexts/photohistory/holmes/holmessunbeam1.html.

23 Mary Johnson Bailey Lincoln (1844–1921) was, however, much younger than Holmes, Sr. (1809–94). Among her publications were *Mrs. Lincoln's Boston Cook Book: What to Do and What Not to Do in Cooking* (Boston: Roberts Brothers, 1884) and *The Boston School Kitchen Textbook: Lessons in Cooking for the Use of Classes in Public and Industrial Schools* (Boston: Roberts Brothers, 1887).

24 Stand-alone tidbit in *The Philadelphia Photographer*, vol. 1, no. 3 (March 1864): 46.

25 Anon., "Photography: A Progressive Art," *The Philadelphia Photographer*, vol. 1, no. 9 (Sept. 1864): 131.

26 Anon. (editor), leader in *Anthony's Photographic Bulletin*, vol. 1, no. 3 (April 1870): 33.

27 For example, some American women ran photography studios while their husbands were away prospecting for gold or other metals; other women managed a portrait studio while their spouses photographed wilderness areas or sought their fortunes; and some women's studios operated within or beside a husband's general store or other business.

Chapter 17: Studios of their Own

1 Eunice N. Lockwood's advertising slogan, "Instantaneous Portraits of Children A Successful Specialty," was printed on her products. A Lockwood specimen illustrates

Anon., "A Woman Behind the Camera," *Shades of the Departed Magazine*, March 2010 issue: 38.

2 Peter Palmquist quoting an Ione City, CA newspaper in "Elizabeth [Eliza] W. Withington," on *Clio: Visualizing History*, available online at https://www.cliohistory.org/exhibits/palmquist/withington/.

3 The Palmquist Collection of women photographers at Yale University includes over 600 individual women either directing their own studios or in partnership with family members *before 1900*, the bulk of which are American in this collection. That number excludes women employees in photographic firms, unidentified women using only their last names (without feminine first names or honorifics), and of course most of the European businesswomen of the period. In 1893, Martha L. Rayne estimated nearly 1,200 women photographers were working in the United States. See Martha L. Rayne, *What Can a Woman Do?* (1893; repr., New York: Arno Press, 1974), 126. Jessie Boucherett reported that between the 1861 and 1871 English census, the number of women photographers in England and Wales jumped from 168 to 694. See Boucherett in Theodore Stanton, ed., *The Woman Question in Europe: A Series of Original Essays* (New York: G.P. Putnam's Sons, 1884), 104. Good sources of biographical information on women photographers before 1900 include (for the United States) Margaret Denny, "From Commerce to Art: American Women Photographers 1850–1900," Ph.D. diss (University of Illinois at Chicago, 2010), Peter E. Palmquist and Gia Musso, *Women Photographers: A Selection of Images from the Women in Photography International Archive, 1852–1997* (Arcata, CA: Peter E. Palmquist, 1997), and for France, Françoise Condé, "*Les Femmes photographes en France: 1839–1914*," maîtrise d'histoire (Paris: Université Paris VII-Jussieu, 1992). The nineteenth-century commercial directory work of scholars and collectors like Gary D. Saretsky (New Jersey), the Wisconsin Historical Society, and the 1980s Royal Photographic Society Historical Group in Britain made welcome inroads uncovering male and female studio workers' names and dates. See also the rescue of three female daguerreotypists of the 1840s and 1850s in Bernard V. and Pauline F. Heathcote, "The Feminine Influence: Aspects of the Role of Women in the Evolution of Photography in the British Isles," *HP*, vol. 12, no. 3 (July-Sept. 1988): 259–73. One of whom (Ann Cooke) purchased the exclusive right to practice in Lincolnshire from license-holder Richard Beard in 1843.

4 Condé, 68. See also dictionary entries for the amateurs Amélie Esther Guillot-Saguez (1810–64), Félicie Dosne (1823–1906), the Comtesse d'Essertein (dates unknown), Caroline Félicité Octavie Marie de Montbreton, Vicomtesse de Marquet (1804–89), and Adèle Elisabeth Hubert de Fonteny (1810–62), the first photographic printer in Paris, in Sylvie Aubenas and Paul-Louis Roubert, eds., *Primitifs de la photographie: le calotype en France, 1843–1860* (Paris: Gallimard, 2010).

5 Quoted in Roger Watson and Helen Rappaport, *Capturing the Light: The Birth of Photography, a True Story of Genius and Rivalry* (New York: St. Martin's Press, 2013), 247.

6 For example, the teacher Sarah L. Eldridge (née Judd) was perhaps the first photographer (daguerreotypist) in the Minnesota Territory. She arrived in Minnesota from Illinois in 1843. See G. Hubert Smith, "First Photographers of Minnesota," unpublished typescript in the Peter Palmquist Collection, Beinecke Library. Smith opened his account by saying, "The first photographs taken in Minnesota were probably made by a woman schoolteacher." Julia Ann Rudolph may have been the only photographer in the gold-mining town of Nevada City, CA during her career there in the 1840s and 1850s. See the entry on Julia Ann Rudolph in the alphabetized "Biographies" section of Palmquist and Musso (unpaginated).

7 Denny, "From Commerce to Art," 53–5.

8 Ibid., 92.

9 Margaret Denny attributed their disappearance in part to a society that sought only
 evidence of "true womanhood" (feminine piety, modesty, and domesticity) as the
 legacy of their lives. Because of this preference, several nineteenth-century women
 photographers' obituaries neglected to mention their pioneering careers, in favor of
 listing their children's names, church membership, and charity work. See Denny, "From
 Commerce to Art," 57, 64. Likewise, Martin Sandler reported on the American
 Margaret W. Morley (1858–1923): ". . . the few biographical details do little to account
 for her relatively prolific photographic career," and that the "little that exists about
 Morley in print mentions not a word about her ever having taken a single photograph."
 Martin W. Sandler, *Against the Odds: Women Pioneers in the First Hundred Years of
 Photography* (New York: Rizzoli International Publications, Inc., 2002), 25.

10 The Women in Photography International Archive's *Bibliography of Articles by and
 about Women in Photography, 1840–1990*, third edition (unpublished bound volume
 held in the Peter Palmquist Collection at the Beinecke Library, 1997) allows us to
 visualize the contrast between the earlier and later period. Beginning in 1843 with
 Elizabeth S. Carey's poem, "Lines written on Seeing a Daguerreotype Portrait of a
 Lady" in the *Illustrated London News*, this bibliography contains sixteen pages' worth
 of listed articles by or about women from 1843 to 1890 (five decades' worth). Entries
 dated from 1890 through 1900 (ten years only), on the other hand, fill twenty-two
 pages. Leafing further to count pages for 1901–14 entries, we can add thirty-eight
 more pages of article entries.
 Collector Ron Cosens summed up the situation of early women photographers in
 his short biography of English photographer Emma Exley (1824–89): "This spirited
 woman has left no memorial other than her name in census information and trade
 directories and a few of the photographs that she took." The same could be said for
 well over a thousand women in the North Atlantic world practicing during Emma's
 lifetime. Cosens used trade directories as well as newspaper articles, census data, local
 histories, and Exley's *cartes-de-visite* to reconstruct her life. See Cosens' biography of
 Exley online at Photographers of Great Britain & Ireland 1840–1940, available here:
 http://www.cartedevisite.co.uk/photographers-category/biographies/c-to-f/emma-
 exley/.

11 M.E. Sperry, "Women and Photography," *Pacific Coast Photographer*, vol. 3, no. 8
 (Sept. 1894): 153.

12 The *photoLondon* database contains some biographical and business information on
 the sisters online at http://www.photolondon.org.uk/ (all London workers are listed
 alphabetically on the site). A third Bertolacci sister, Ida (1845–1933), worked with
 Caroline and Marie, but her name did not appear with theirs in the sisters' publications.

13 C.C. and M.E. Bertolacci's *"England and Wales," by J.M.W. Turner, R.A. A Series of
 Photographic Reproductions* (London: Colnaghi, 1864) ironically garnered praise in
 JPSL, vol. 10, no. 155 (March 16, 1865): 20 (Colnaghi in London also published Julia
 Cameron's works); and praise in Anon., "The Misses Bertolacci's Photographs After
 Turner's Works," *Fine Arts Quarterly Review*, vol. 2, new series (Jan. 1867): 202–4.

14 http://www.photolondon.org.uk/. Once their commercial studio was established, the
 sisters made "a specialty of fancy dress balls and similar occasions," capturing the
 occasions for dress-up for ladies in the area.

15 Having submitted "a series of beautiful photographic engravings from Turner's pictures
 of England and Wales" to the Photographic Society for exhibition, a short review

followed in the March 1865 issue of *JPSL* that praised the work as "a superb volume." The reviewer drew attention to "the exceeding excellence of the photographic qualities of these reproductions ... The negatives are very perfect, and the care taken with the printing is beyond all praise." In *JPSL*, vol. 10, no. 155 (March 16, 1865): 9 and 20.

16 *JPSL*, vol. 10, no. 157 (May 15, 1865): 54.

17 Ibid.

18 Ibid.

19 Ibid.

20 Ibid., 54–5.

21 Ibid., 54.

22 The quotation comes from Alfred Tennyson's "Locksley Hall" (first published in 1842).

23 *JPSL*, vol. 10, no. 158 (June 15, 1865): 100.

24 Clarence B. Moore, "Women Experts in Photography," *Cosmopolitan*, vol. 14, no. 5 (March 1893): 581.

25 Ernest Legouvé, *La Question des femmes* (Paris: J. Hetzel et Cie, 1881), 14. Legouvé believed that girls should receive a "vigorous" scientific education, not in order to one day make their own contributions or interpretations, but in order to "share their husbands' ideas and their children's studies" (15).

26 Excerpt transcribed in Anon., "A Woman Behind the Camera," *Shades of the Departed Magazine*, March 2010 issue: 38.

27 Ibid. The cheerful notice was also very unusual for the time owing to the social stigma attached to divorce. Eunice Lockwood later remarried, to the Reverend Joseph B. Davison, a widower, in 1889. Information about Davison in *Wisconsin Congregational Church Life*, vol. 26, no. 3 (Jan. 1920): 17.

28 Some of Ryder's Ohio colleagues and competitors included Mrs. Mary Waldack, Mrs. Ruby M. Thorp Woodworth, Miss Anna Guthrie, and Mrs. Elizabeth Rich. He also would have known NPA member Eunice Lockwood (born c. 1841).

29 Anon., "'The Ladies of the Profession.'—Sketches," *BJP*, vol. 22, no. 816 (Dec. 24, 1875): 621.

30 Unknown life dates is fairly common for American photographers as well, even remarkably successful ones like Julia Ann Rudolph (née Swift), who crossed the continent from New York to California in 1855–6, and eventually operated two studios for several decades, one in Nevada City, CA and the other in Sacramento. On Rudolph see the alphabetical "Biographies" section in Palmquist and Musso (unpaginated).

31 In the European context, Gunilla Knape said it was difficult "to get an exact picture of the number of active women photographers at various times, since they have not always been visible, but, for example, have been concealed behind a male studio name." In Lena Johannesson and Gunilla Knape, eds., *Women Photographers: European Experience* (Gothenburg: Acta Universitatis Gothoburgensis, 2004), 9. By the same token, in nineteenth-century Michigan, Edwin A. Chapman received credit for many photographs that his wife had taken in the studio. Mrs. Jennie A. Chapman (born 1839 or 1840) was a photographer in her own right. From Dr. Bruce Marsh's research on his Cabinet Card Gallery, online at https://cabinetcardgallery.com/category/female-photographers/.

32 Curatorial information about the daguerreotype portrait of Mary Ann Meade on the Smithsonian National Portrait Gallery website, available here: https://tinyurl.com/ybpqxq8j.

33 William C. Darrah, "Nineteenth-Century Women Photographers," in *Shadow and Substance: Essays on the History of Photography in Honor of Heinz K Henisch*, ed. Kathleen Collins (Bloomfield Hills, MI: The Amorphous Institute Press, 1990), 90.

34 For example, Miss Inez G. Fitzgerald, Mrs. Laura T. Allen, and Mrs. Julia Ann Rudolph, all working in California in different decades, each declined to put their first names or honorifics on their *carte-de-visite* logos.

35 Anon., "Exhibition. London Photographic Society's Exhibition," *BJP*, vol. 7, no. 111 (Feb. 1, 1860): 41. The same reporter noted there were two pictures of Conway Castle (Wales) at the exhibition "by S.H.G. (a Liverpool lady, as we are credibly informed)" (42).

36 Michel Lessard, *The Livernois Photographers* (Québec City, Canada: Musée du Québec, 1987), 79.

37 Condé, 69.

Conclusion

1 Social scientists and school teachers have linked the gendered "dirt" taboo to some adolescent girls' disinclination to pursue sports or scientific activities. See Maihan B. Vu et al., "Listening to Girls and Boys Talk About Girls' Physical Activity Behaviors," *Health Education & Behavior*, vol. 33, no. 1(2006): 81–96. Claudia Cockburn and Gill Clarke, "'Everybody's looking at you!': Girls Negotiating the 'Femininity Deficit' they incur in Physical Education," *Women's Studies International Forum*, vol. 25, no. 6 (Dec. 2002): 651–65. And, Amanda Marcotte, "Great Ad Reveals All the Ways We Hold Girls Back," Slate.com (June 26, 2014) at http://www.slate.com/blogs/xx_factor/2014/06/26/_inspire_her_mind_verizon_and_makers_collaborate_on_an_ad_about_girls_and.html.

2 See Michel Foucault, "The Subject and Power," in *Beyond Structuralism and Hermeneutics*, edited by H. Dreyfus and P. Rabinow (Chicago: University of Chicago Press, 1983), 208–26.

3 Michel Foucault, *Histoire de la sexualité*, 4 vols. (Paris: Éditions Gallimard, 1976, 1984, and 2018).

4 I mean climate in a broad sense to include social, political, and other forces and trends, though by no means should we exclude meteorological climate from this complex context of human action.

5 See for example Peter Henry Emerson's retrospective assessment in "Mrs. Julia Margaret Cameron," *Sun Artists*, no. 5 (Oct. 1890), 33–46; V.C. Scott, "Mrs. Cameron, Her Friends, and Her Photographs," *The Century Magazine*, vol. 55, no. 1 (Nov. 1897): 3–10; and Marie A. Belloc, "The Art of Photography: Interview with Mr. H. Hay Herschel Cameron," *The Woman At Home*, vol. 8 (April 1897): 581–90.

6 Carine Cadby seems to have been the only *British* woman member of the Linked Ring.

7 Rosenblum, *A History of Women Photographers* (New York: Abbeville Press, 1994), 98.

8 Quoted in Nellie Bly, "Champion of Her Sex," *New York Sunday World* (Feb. 2, 1896): 10.

9 Recall that two of the earliest woman photographers, English sisters Charlotte and Lucy Bridgeman, died when their hoop skirts caught fire in their home in 1858. David Brittain, *Creative Camera: Thirty Years of Writing* (Manchester: Manchester University Press, 1999), 225. On the inflammatory and disease-spreading qualities of Victorian women's skirts, see Alison M. David, *Fashion Victims: The Dangers of Dress Past and Present* (London: Bloomsbury Academic, 2015), esp. ch. 6, "Inflammatory Fabrics: Flaming Tutus and Combustible Crinolines."

10 Named after activist Amelia Bloomer in the 1850s, bloomers began as pantaloons and overskirt, evolving later into unskirted "athletic" (shorter) knickerbockers worn with stockings. The Latvian-American Annie "Londonderry" Kopchovsky completed a trip around the world on her bicycle wearing bloomers in 1895. Her ordeal was chronicled in Peter Zheutlin, *Around the World On Two Wheels: Annie Londonderry's Extraordinary Ride* (New York: Citadel Press Books, 2007).

11 Patrick Daum, "Unity and Diversity in European Pictorialism," in Saint Louis Art Museum, *Impressionist Camera: Pictorial Photography in Europe, 1888–1918* (London: Merrell, 2006), 19. Daum's chapter in this volume omitted mention of any European women Pictorialists.

12 Two women, Maria Eisner and Rita Vandivert, co-founded Magnum after the Second World War, but the agency insists (on its website) that these individuals served as support staff for the photographers, not as one of the "dynamic visionaries" who pursued stories around the globe. Magnum Photos, "History," available at https://www.magnumphotos.com/about-magnum/history/.

References

Primary sources

Notable North Atlantic journals consulted:
American Amateur Photographer
Anthony's Photographic Bulletin
The British Journal of Photography
Bulletin de la Société Française de Photographie
Bulletin du Photo-Club de Paris
Frank Leslie's Weekly
Godey's Lady's Book
Journal of the Photographic Society of London
La Lumière
The Philadelphia Photographer
The Photographic Art-Journal
The Photographic News
Photographic Notes
Photographic Times
La Revue Photographique
The St. Louis Practical Photographer (then *The St. Louis and Canadian Photographer*)
Wilson's Photographic Magazine

"Alexandre Dumas on Photography." *The Photographic News.* Volume 10. Number 414 (August 10, 1866): 379–81.

Barnes, Catharine Weed. "Women as Photographers." *American Amateur Photographer.* Volume 3. Number 9 (September 1891): 338–41.

Barnes, Catharine Weed. "Women as Professional Photographers." In *Papers Read Before the Association for the Advancement of Women*, 43–9. Syracuse, NY: C.W. Bardeen, 1892.

Barnes, Marcelia W. "To the Editor of the *Pho.-Art Journal.*" *The Photographic Art-Journal.* Volume 4. Number 4 (October 1852): 257.

Barnes, Marcelia W. "Communications." *The Photographic Art-Journal.* Volume 5. Number 5 (May 1853): 300–1.

Beach, F.C. "Modern Amateur Photography." *Harper's New Monthly Magazine.* Volume 78. Number 464 (January 1889): 288–97.

Belloc, Marie A. "The Art of Photography. Interview with Mr. H. Hay Herschel Cameron." *The Woman at Home.* Volume 8 (April 1897): 581–9.

Bisland, Margaret. "Women and Their Cameras." *Outing.* Volume 17. Number 1 (October 17, 1890): 36–43.

"The British Journal of Photography, 1854–1914." *The British Journal of Photography.* Volume 61. Number 2824 (June 19, 1914): 477–80.

Caffin, Charles H. "Mrs. Gertrude Kasebier and the Artistic-Commercial Portrait." In *Photography as a Fine Art: The Achievements and Possibilities of Photographic Art in America*, 51–81. New York: Doubleday, Page & Co., 1901.

"Des Dames Photographes." *Revue Photographique*. Number 13 (November 5, 1856): 196.

Daubié, J.-V. *La Femme pauvre au xixe siècle*. Paris: Librairie de Guillaumin et Cie, 1866.

Davie, Helen L. "Women in Photography." *Camera Craft*. Volume 5. Number 4 (August 1902): 130–8.

Dilke, Emilia. "Benefit Societies and Trade Unions for Women." *The Fortnightly Review*. Volume 51. Number 270 (June 1889): 852–6.

Dixon, Edmund S. "More Work for the Ladies." *Household Words*. Volume 6. Number 130 (1852): 18–22.

"Duties of a Lady in the Reception Room: By a Lady." *The Photographic News*. Volume 24. Number 1137 (June 18, 1880): 296–7.

"Echoes of the Month by an Old Photographer" [includes "Female Labour in Photography"]. *The Photographic News*. Volume 14. Number 604 (April 1, 1870): 146–8.

Emerson, Peter H. "Mrs. Julia Margaret Cameron." Reprint of *Sun Artists*, Number 5 (1890) 33–40. New York: Arno Press, 1973.

"Employment of Women in Photography." *The Photographic News*. Volume 11. Number 438 (January 25, 1867): 37–8.

"The Employment of Women in Photography." *The Photographic News*. Volume 18. Number 766 (May 6, 1873): 222–3.

"Female Assistants in the Studio." *The Photographic News*. Volume 27. Number 764 (April 25, 1873): 199.

"Female Labour in the Studio." *The Photographic News*. Volume 14. Number 605 (April 8, 1870): 164–5.

"Fourth Session [of the Photographers' Association of America]. Thursday, August 26th, 1880." *The Philadelphia Photographer*. Volume 17. Number 202 (October 1880): 294–303.

"The Future of Photography to be in the Hands of the Gentler Sex." *The Philadelphia Photographer*. Volume 10. Number 113 (May 1873): 129.

From the Editorial Table, begins "Mrs. E.N. Lockwood, of Ripon, Wisconsin . . ."]. *The Beacon*. Volume 1. Number 6 (June 1889): 141.

Gastine, M.L. "La Femme Photographe." *Bulletin du Photo-Club De Paris*. Année 12 (1902): 267–71.

Gusawist. "A Story of the World's Fair." *St. Louis and Canadian Photographer*. Volume 18. Number 9 (September 1894): 426–8.

Hicks, Theodore. "Printing, Toning, Female Assistants, Etc." *The Photographic News*. Volume 18. Number 769 (May 30, 1873): 262–3.

Hughes, Alice. "Photographic Portraiture as a Profession." In *Some Arts and Crafts. The Woman's Library*, Volume 4, edited by Ethel M. M. McKenna, 295–320. London: Chapman and Hall, 1903.

Hughes, Jabez. "Photography as an Industrial Occupation for Women." In *Camera Fields & Kodak Girls: 50 Selections by and about Women in Photography, 1840–1930*, 29–36. New York: Midmarch Arts Press, 1989.

Ignota. "A Lady Photographer Who Never Photographs Men. A Talk with Miss Alice Hughes. Illustrated with Some Specimens of her Art." *The Harmsworth Magazine*. Volume 11 (1899): 195–200.

[Jennie]. "What a Retoucher Can See on This Touchy Subject." *The Philadelphia Photographer*. Volume 10. Number 13 (May 1873): 139–41.

"A Lady Amateur." *The Photographic Times*. Volume 22. Number 546 (March 4, 1892): 117–18.

"The Ladies of the Profession: Sketch No. 2." *The British Journal of Photography*. Volume 22. Number 816 (December 24, 1875): 621.

Langtry, Lillie (Lady de Bathe). *The Days I Knew*. New York: George H. Doran Co., 1925.

Levy, Amy. *The Romance of a Shop*. Peterborough, Canada: Broadview Press, 2006 [1888].

Lockwood, Eunice N. "Does It Pay to Attend the N.P.A. Meetings? What a Lady Photographer Thinks." *The Philadelphia Photographer*. Volume 9. Number 106 (October 1872): 337–8.

Lockwood, Eunice N. "Do Your Best." In *Photographic Mosaics: An Annual Record of Photographic Progress*, edited by Edward L. Wilson, 104–5. Philadelphia: Edward L. Wilson and the Keystone Press of William J. Dornan, 1883.

Lockwood, Eunice N. "Yesterday and To-Day; Or, Justice for All." *Anthony's Photographic Bulletin*. Volume 17. Number 19 (October 9, 1886): 592–3.

Lockwood, Eunice N. "The Egyptian Photograph, or 'Magic Vignette.'" *Wilson's Photographic Magazine*. Volume 26. Number 343 (April 6, 1889): 219–20.

Lockwood, Eunice N. "[To the Editor of *The Beacon*]." *The Beacon*. Volume 2. Number 16 (April 1890): 94–5.

Manson, George J. "Photography." In *Work for Women*, 37–46. New York: G.P. Putnam's Sons, 1883.

[Membres et statuts de la Chambre Syndicale et du Syndicat de la Photographe]. *Bulletin de la Chambre Syndicale de la Photographie et ses Applications. Supplement au "Moniteur de la Photographie."* Number 1 (April 1, 1899): 1–7.

"The Misses Bertolacci's Photographs After Turner's Works." *Fine Arts Quarterly*. Volume 2, new series (January 1867): 202–4.

Moore, Clarence B. "Women Experts in Photography." *Cosmopolitan*. Volume 14 (March 1893): 580–90.

Morrill, Frederick K. "The Ladies of the Chicago Camera Club." *The American Amateur Photographer*. Volume 3. Number 11 (November 1891): 1–6.

Musée des Arts Décoratif. *Exposition des arts de la femme: guide-livret illustré*. Paris: Imprimerie de A. Warmont, 1895.

O'Connor, V. C. Scott. "Mrs. Cameron, Her Friends, and Her Photographs. Tennyson, Watts, Taylor, Herschel." *The Century Magazine*. Volume 55. Number 1 (November 1897): 3–10.

Paquet-Mille, A. *Nouveau guide pratique des jeunes filles dans le choix d'une profession*. Paris: Lecène, Oudin, et Cie, Editeurs, 1891.

Pascaline. "La Femme Photographe." *La Photographie*. Tome 15 (1903): 28–30.

[Perplexed]. "Women at Photographic Meetings." *Photographic News*, September 6, 1889.

Pichard, Lilla. *Le Choix d'un état: arts et métiers propres aux femmes. Livre de lectures courantes, scientifiques et morales, accompagnées de conseils et d'exemples pratiques.* Paris: G. Tequi, 1879.

[A Photographer's Wife]. "'Retouching the Negative.'" *The Philadelphia Photographer*. Volume 9. Number 100 (April 1872): 101.

"Photographers' Association of America." *The Philadelphia Photographer*. Volume 17. Number 201 (September 1880): 261–70 and 275–7.

"Photography for Ladies." *The Liverpool Photographic Journal*. Volume 2. Number 17 (May 12, 1855): 63–4.

Pritchard, H. Baden. *About Photography and Photographers*. New York: Arno Press, 1973 [1883].

Rayne, Martha L. "Women as Photographers." In *What Can a Woman Do?*, 126–9. New York: Arno Press, 1974 [1893].

Rodgers, H.J. *Twenty-Three Years Under a Skylight: Or Life and Experiences of a Photographer*. Hartford, CN: H.J. Rodgers, 1872.

"Rules of the Photographic Society." *Journal of the Photographic Society*. Volume 1. Number 1 (March 3, 1853): 4–5.

Ryder, James F. *Voigtländer and I in Pursuit of Shadow Catching: A Story of Fifty-Two Years' Companionship with a Camera*. Cleveland, OH: The Cleveland Printing & Publishing Co., 1902.

Saturday Review. Modern Woman and What Is Said of Them. Introduction by Mrs. Lucia G. Calhoun. New York: J.S. Redfield, Publisher, 1868.

Sperry, M.E. "Women and Photography." *Pacific Coast Photographer*. Volume 3. Number 8 (September 1894): 153–4.

"The Spirit Photographs" [Mrs. Stuart's spirit photographs]. *The Journal of Photography*. Volume 5. Number 14 (January 15, 1863): 329–30.

Stanton, Theodore, editor. *The Woman Question in Europe: A Series of Original Essays*. New York: G.P. Putnam's Sons, 1884.

"Statuts de la Société Héliographique." *La Lumière*. Number 1 (February 9, 1851): 1–2.

Vidal, Léon. "L'Exposition des artistes américains au Photo-Club de Paris." *Le Moniteur de la Photographie*. Number 4 (1901): 49–51.

Wade, Elizabeth F. "Amateur Photography Through Women's Eyes." *The Photo-American*. Volume 15 (March 1894): 235.

Wade, Elizabeth F. "The Camera as a Source of Income Outside the Studio." *Photographic Times*. Volume 24 (June 8, 1894): 358–61.

Wells, Kate Gannett. "The Transitional American Woman." *The Atlantic Monthly*. Volume 46. Number 278 (December 1880): 817–23.

Willard, Frances E. "Women as Photographers." In Frances E. Willard, *Occupations for Women: a book of practical suggestions for the material advancement, the mental and physical development, and the moral and spiritual uplift of women*, 242–8. Cooper Union, NY: The Success Company, 1897.

Withington, Mrs. E.W. "How a Woman Makes Landscape Photographs," *The Philadelphia Photographer*. Volume 13. Number 156 (December 1876): 357–60.

"Woman's Work in Photography." *The Photographic Times and American Photographer*. Volume 17. Number 287 (March 18, 1887): 127–8.

A Working-Woman. "Women's Work and Wages." *Harper's New Monthly Magazine*. Volume 38. Number 227 (April 1869): 665–70.

Yandell, Enid, Jean Loughborough, and Laura Hayes. *Three Girls in a Flat*. Chicago: Laura Hayes, 1892.

Further historical documentation is included in the captions of illustrations.

Secondary sources

Abraham, Hélène. *Une Figure de Femme: Jenny de Vasson, 1872–1920*. Paris: Imprimerie Chantenay for Chariot d'Or, 1965.

Abrams, Lynn. *The Making of Modern Woman: Europe 1789–1918*. New York: Longman, 2002.

Accampo, Elinor A., Rachel G. Fuchs, and Mary Lynn Stewart. *Gender and the Politics of Social Reform in France, 1870–1914*. Baltimore: The Johns Hopkins University Press, 1995.

Albert, Nicole G. *La Castiglione: Vies et Métamorphoses*. Paris: Perrin, 2011.

Anonymous. "A Woman Behind the Camera." *Shades of the Departed Magazine*, March 2010.

Apraxine, Pierre, and Xavier Demange, *"La Divine Comtesse": Photographs of the Countess de Castiglione*. New Haven: Yale University Press, 2000.

Armstrong, Carol. *Camera Women*. Princeton: Princeton University Art Museum, 2001.

Armstrong, Carol. "From Clementina to Käsebier: The Photographic Attainment of the 'Lady Amateur.'" *October*. Volume 91 (Winter 2000): 101–39.

Arnall, January P. "'Adventures into Camera-Land': Women, Image-Making, and the Social Environment of Chicago Camera Clubs at the Turn-of-the-Century." Dissertation, Claremont University, 2009.

Aubenas, Sylvie, and Paul-Louis Roubert, editors. *Primitifs de la photographie: le calotype en France, 1843–1860*. Paris: Gallimard, 2010.

Bard, Christine, editor. *Un Siècle d'antiféminisme*. Paris: Librairie Arthème Fayard, 1999.

Battersby, Christine. *Gender and Genius: Towards a Feminist Aesthetics*. Bloomington: Indiana University Press, 1990.

Birkett, Jeremy and John Richardson. *Lillie Langtry: Her Life in Words and Pictures*. Poole, UK: Blandford Press, Ltd., 1979.

Bear, Jordan. *Disillusioned: Victorian Photography and the Discerning Subject*. University Park, PA: Pennsylvania State University Press, 2015.

Bear, Jordan. "Pieces of the Past: Early Photomontage and the Voice of History." *History of Photography*. Volume 41. Number 2 (May 2017): 126–40.

Beatty, Laura. *Lillie Langtry: Manners, Masks and Morals*. London: Chatto & Windus, 1999.

Bergstein, Mary. "'The Artist in His Studio': Photography, Art, and the Masculine Mystique." *Oxford Art Journal*. Volume 18. Number 2 (1995): 45–58.

Blair, Karen J. *The Clubwoman as Feminist: True Womanhood Redefined, 1868–1914*. New York: Holmes & Meier Publishers, Inc., 1980.

Block, Diane W. "Books and Company: Mid-Victorian Photocollage Albums and the Feminine Imagination." Master's thesis, University of New Mexico, 1995.

Bourdieu, Pierre. *Masculine Domination*. Translated by Richard Nice. Stanford: Stanford University Press, 2001.

Brannon, Linda. *Gender: Psychological Perspectives*. Sixth edition. New York: Allyn & Bacon, 2011.

Brayer, Elizabeth. *George Eastman: A Biography*. Rochester, NY: University of Rochester Press, 2006.

Brough, James. *The Prince & the Lily*. New York: Coward, McCann & Geoghegan, Inc., 1975.

Brown, Julie K. *Contesting Images: Photography at the World's Columbian Exposition*. Tucson: University of Arizona Press, 1994.

Brusius, Mirjam. "Impreciseness in Julia Margaret Cameron's Portrait Photographs." *History of Photography*. Volume 34. Number 4 (November 2010): 342–55.

Cameron, Julia Margaret, and Violet Hamilton. *Annals of My Glass House: Photographs by Julia Margaret Cameron*. Seattle: University of Washington Press, 1996.

Carrigan, Tim, Bob Connell, and John Lee. "Toward a New Sociology of Masculinity." *Theory and Society*. Volume 14 (1985): 551–604.

Cazaumayou, Henri. *Hommage de Julia Margaret Cameron à Victor Hugo*. Paris: Maison de Victor Hugo, 1980.

Charlesworth, Michael. "The Group Portraits of Charlotte Milles." *History of Photography*. Volume 23. Number 3 (Autumn 1999): 254–9.

Chafetz, Janet S., editor. *Handbook of the Sociology of Gender*. New York: Kluwer Academic/Plenum Publishers, 1999.

Chenut, Helen. "Anti-Feminist Caricature in France: Politics, Satire and Public Opinion, 1890–1914." *Modern & Contemporary France*. Volume 20. Number 4 (2012): 437–52.

Cherry, Deborah. *Beyond the Frame: Feminism and Visual Culture, Britain 1850–1900*. New York: Routledge, 2000.

Clawson, *Constructing Brotherhood: Class, Gender, and Fraternalism*. Princeton: Princeton University Press, 1989.

Cockburn, Cynthia. *Brothers: Male Dominance and Technological Change*. London: Pluto Press, 1991.

Collins, Kathleen. "Shadow and Substance: Sojourner Truth." *History of Photography*. Volume 7. Number 3 (September 1983): 183–205.

Collinson, David, and Jeff Hearn. "Naming Men as Men: Implications for Work, Organization and Management." *Gender, Work and Organization*. Volume 1. Number 1 (January 1994): 2–22.

Condé, Françoise. "*Les Femmes photographes en France: 1839–1914*." Maîtrise d'histoire, Université Paris VII-Jussieu, 1992.

Crombie, Isobel. "The Work and Life of Viscountess Frances Jocelyn: Private Lives." *History of Photography*. Volume 22. Number 1 (Spring 1998): 40–51.

Cujolle, Christian, Yvon Le Marlec, Gilles Wolkowitsch, and Jean-Marc Zaorski. *Jenny de Vasson: une femme photographe au début du siècle*. Paris: Éditions Herscher, 1982.

Cunningham, Gail. *The New Woman and the Victorian Novel*. New York: Macmillan Press, Ltd., 1978.

Daniel, Malcolm. "Inventing a New Art: Early Photographs from the Rubel Collection in the Metropolitan Museum of Art." *Metropolitan Museum of Art Bulletin*. Volume 56. Number 4 (Spring 1999): 1–56.

Davidov, Judith F. *Women's Camera Work: Self/Body/Other in American Visual Culture*. Durham, NC: Duke University Press, 1998.

Dawkins, Heather. "The Diaries and Photographs of Hannah Cullwick." *Art History*. Volume 10. Number 2 (June 1987): 154–87.

de Bary, William T., editor. *Sources of East Asian Tradition*. Volume 1: *Premodern Asia*. New York: Columbia University Press, 2008.

Denny, Margaret. "Catharine Weed Barnes Ward: Advocate for Women Photographers." *History of Photography*. Volume 36. Number 2 (May 2012): 156–71.

Denny, Margaret. "Royals, Royalties and Remuneration: American and British Women Photographers in the Victorian Era." *Women's History Review*. Volume 18. Number 5 (November 2009): 801–18.

Denny, Margaret. "Framing the Victorians: Photography, Fashion, and Identity." In *The Places and Spaces of Fashion, 1800–2007*, edited by John Potvin, 34–50. New York: Routledge, 2009.

Denny, Margaret. "From Commerce to Art: American Women Photographers 1850–1900." Dissertation, University of Illinois, 2010.

Di Bello, Patrizia. *Women's Albums and Photography in Victorian England: Ladies, Mothers, and Flirts*. New York: Ashgate, 2007.

Di Bello, Patrizia. "Seductions and Flirtations: Photographs, Histories, Theories." *Photographies*. Volume 1. Number 2 (September 2008): 143–55.

Dimond, *Developing the Picture: Queen Alexandra and the Art of Photography*. London: Royal Collection Enterprises, Ltd., 2004.

Dodier, Virginia. *Lady Hawarden: Studies from Life, 1857–1864*. New York: Aperture, 1999.

Doherty, Amy S. "Women in Focus: Early American Women Photographers." *Picturescope*. Volume 31. Number 2 (1983): 50–6.

Douglas, Mary. *Purity and Danger: An Analysis of the Concepts of Pollution and Taboo*. New York: Routledge, 1995.

Dowling, Ben. *Queen Bee of Tuscany: The Redoubtable Janet Ross*. New York: Farrar, Straus and Giroux, 2013.

Doy, Gen. *Seeing & Consciousness: Women, Class and Representation*. Washington, D.C.: Berg, 1995.

Doy, Gen. "Women, Class and Photography: The Paris Commune of 1871." In *Seeing & Consciousness: Women, Class and Representation*, 82–106. Washington, D.C.: Berg, 1995.

Dubois, Ellen C., and Lynn Dumenil. "Women in the Cartoons of Puck Magazine." In *Through Women's Eyes: An American History with Documents*. Volume 2. Second edition, 393–9. New York: Bedford St. Martin's, 2008.

Duché, Jean. *Deux siècles d'histoire de France par la caricature: 1 consultat, 2 empires, 3 monarchies, 4 révolutions, 5 républiques*. Paris: Editions du Pont Royal, 1961.

Dykstra, Natalie. *Clover Adams: A Gilded and Heartbreaking Life*. Boston: Houghton Mifflin Harcourt, 2012.

Edwards, Steve. *The Making of English Photography: Allegories*. University Park, PA: Pennsylvania State University Press, 2006.

Edwards, Steve. "The Dialectics of Skill in Talbot's Dream World." *History of Photography*. Volume 26. Number 2 (Summer 2002): 113–18.

Eliasoph, Nina. "Politeness, Power, and Women's Language: Rethinking Study in Language and Gender." *Berkeley Journal of Sociology*. Volume 32 (1987): 79–103.

Epstein, Anne R. "Gender, Intellectual Sociability, and Political Culture in the French Third Republic, 1890–1914." Dissertation, Indiana University, 2004.

Everton, Elizabeth. "Scenes of Perception and Revelation: Gender and Truth in Antidreyfusard Caricature." *French Historical Studies*. Volume 35. Number 2 (Spring 2012): 382–417.

Fleming, Donald. *John William Draper and the Religion of Science*. New York: Octagon Books, 1972.

Ford, Colin. *Julia Margaret Cameron: 19th Century Photographer of Genius*. London: National Portrait Gallery Publications, 2003.

Ford, Colin. *Julia Margaret Cameron: A Critical Biography*. Los Angeles: The J. Paul Getty Museum, 2003.

Frady, Kelsey T. "Frances Benjamin Johnston: Imaging the New Woman Through Photography." Master's thesis, University of Alabama, 2012.

Fraisse, Geneviève, and Michelle Perrot, ed. *A History of Women in the West. IV: Emerging Feminism from Revolution to World War*. Cambridge, MA: The Belknap Press of the Harvard University Press, 1993.

Franzen, Monika, and Nancy Ethiel. *Make Way! 200 Years of American Women in Cartoons*. Chicago: Chicago Review Press, 1988.

Fraser, Hilary, Stephanie Green, and Judith Johnston. *Gender and the Victorian Periodical*. New York: Cambridge University Press, 2003.

Freeman, Larry. *Victorian Posters*. Watkins Glen, NY: American Life Foundation, 1969.

Freund, Gisèle. *La Photographie en France au XIXe siècle: essai de sociologie et d'esthétique*. Paris: Christian Bourgeois Editeur, 2011.

Friedewald, Boris. *Women Photographers: From Julia Margaret Cameron to Cindy Sherman*. New York: Prestel, 2014.

Fuchs, Rachel G., and Victoria E. Thompson. *Women in Nineteenth-Century Europe:* New York: Palgrave Macmillan, 2005.

Garb, Tamar. *The Body in Time: Figures of Femininity in Late Nineteenth-Century France.* Seattle: University of Washington Press, 2008.

Garvey, Ellen G. *Writing with Scissors: American Scrapbooks from the Civil War to the Harlem Renaissance.* New York: Oxford University Press, 2012.

Glauber, Carole. *Witch of Kodakery: The Photography of Myra Albert Wiggins, 1869–1956.* Pullman: Washington State University Press, 1997.

Glick, Peter. "Trait-Based and Sex-Based Discrimination in Occupational Prestige, Occupational Salary, and Hiring." *Sex Roles.* Volume 25. Numbers 5–6 (1991): 351–78.

Green, Valerie. "Hannah Hatherley Maynard: A Woman Ahead of Her Time: Pioneer Photographer Cut an Eccentric Swath Through Victoria." *Times Colonist.* Number 356, Special Edition. December 7, 2008: C3.

Greenhalgh, Paul. *Ephemeral Vistas: The Expositions Universelles, Great Exhibitions and World's Fairs, 1851–1939.* Manchester: Manchester University Press, 1988.

Griffith, Bronwyn, editor. *Ambassadors of Progress: American Women Photographers in Paris, 1900–1901.* Chicago: Terra Foundation for the Arts, 2001.

Grigsby, Darcy G. *Enduring Truths: Sojourner's Shadows and Substance.* Chicago: University of Chicago Press, 2015.

Gronberg, Theresa A. "Femmes de Brasserie." *Art History.* Volume 7. Number 3 (September 1984): 329–44.

Guest, Raechel E. "Victorian Scrapbooks and the American Middle Class." Master's thesis, University of Delaware, 1996.

Gunthert, André. "L'Autorité du photographique. Naissance de la Société Française de Photographie." In *L'Utopie Photographique.* Paris: Le Point du Jour, 2004: 14–24.

Gurshtein, Ksenya A. "The Mountain and the Mole-hill: Julia Margaret Cameron's Allegories." *Bulletin of the University of Michigan Museums of Art and Archeology.* Volume 17 (2007): 5–25.

Hall, Trevor H. *The Medium and the Scientist: The Story of Florence Cook and William Crookes.* Buffalo, NY: Prometheus Books, 1984.

Hamilton, Violet, and Julia M. Cameron. *Annals of My Glass House: Photographs by Julia Margaret Cameron.* Seattle: University of Washington Press, 1996.

Hannavy, John, editor. *Encyclopedia of Nineteenth Century Photography.* Volumes 1 and 2. London and New York: Routledge, 2008.

Hannum, Gillian G. "Frances Benjamin Johnston: Promoting Women Photographers in *The Ladies' Home Journal.*" *Nineteenth Century.* Volume 24. Number 2 (Fall 2004): 22–9.

Hannum, Gillian G. "Dream Children: The Photographically Illustrated Books of Elizabeth B. Brownell." *Nineteenth Century.* Volume 30. Number 1 (Spring 2010): 11–15.

Harding, Colin. "The Smudger's Art: The Popular Perception and Representation of Itinerant Photographers in the 19th Century." In *Visual Delights: Essays on the Popular and Projected Image in the Nineteenth Century,* edited by Simon Popple and Vanessa Toulmin, 143–53. Trowbridge, UK: Flicks Books, 2000.

Harker, Margaret. *The Linked Ring: The Secession Movement in Photography in Britain, 1892–1910.* London: Heinemann, Ltd., 1979.

Harmelle, Claude. *Amélie Galup: Une femme photographe à la fin du siècle. Albi/Saint-Antonin: 1895–1901.* Paris: Association Orelie, 1984.

Harmon, Melissa B. "Lusting After Lillie." *Biography.* Volume 1. Number 9 (September 1997): 66–70 and 90.

Harrison, Carol E. *The Bourgeois Citizen in Nineteenth-Century France: Gender, Sociability, and the Uses of Emulation.* New York: Oxford University Press, 1999.

Hart, Janice. "The Family Treasure: Productive and Interpretive Aspects of the Mid to Late Victorian Photograph Album." *The Photographic Collector.* Volume 5. Number 2 (1984): 164–80.

Heathcote, Bernard V. and Pauline F. Heathcote. "The Feminine Influence: Aspects of the Role of Women in the Evolution of Photography in the British Isles." *History of Photography.* Volume 12. Number 3 (September 1988): 259–73.

Heilbrun, Françoise, and Michael Pantazzi. *Album de collages de l'Angleterre victorienne.* Paris: Éditions du Regard, 1997.

Helfand, Jessica. *Scrapbooks: An American History.* New Haven: Yale University Press, 2008.

Hellerstein, Erna O., Leslie P. Hume, and Karen M. Offen, editors. *Victorian Women: A Documentary Account of Women's Lives in Nineteenth-Century England, France, and the United States.* Stanford: Stanford University Press, 1981.

Henisch, Heinz K. and Bridget A. Henisch, *The Painted Photograph, 1839–1914.* University Park, PA: Pennsylvania State University Press, 1996.

Hermange, Emmanuel. "Des Femmes photographes et photographiées." In *Femmes dans la Cité, 1815–1871.* Grâne: Creaphis, 1997.

Hewitt, Jessie. "Women Working 'Amidst the Mad': Domesticity as Psychiatric Treatment in Nineteenth-Century Paris." *French Historical Studies.* Volume 38. Number 1 (February 2015): 105–37.

Higonnet, Anne. "Secluded Vision: Images of Feminine Experience in Nineteenth-Century Europe." In *The Expanding Discourse: Feminism and Art History,* edited by Norma Broude and Mary D. Garrard, 170–85. New York: Icon Editions, 1992.

Holmes, Diana, and Carrie Tarr, editors. *A "Belle Epoque"? Women in French Society and Culture 1890–1914.* No city: Berghahn Books, 2006.

Hopper, Gill. *Art, Education and Gender: The Shaping of Female Ambition.* London: Palgrave Macmillan, 2015.

Horwitz, Margot F. *A Female Focus: Great Women Photographers.* New York: Franklin Watts, 1996.

Hudak, Brittany M. "Assembling Identity: The Photo-Collage Album of Kate E. Gough (1856–1948)." Master's thesis, University of Cincinnati, 2004.

Hudson, Giles. *Sarah Angelina Acland: First Lady of Colour Photography, 1849–1930.* Oxford: Bodleian Library, 2012.

Humphrey, John. *Women of Photography: An Historical Survey.* San Francisco: San Francisco Museum of Art, 1975.

Huneault, Kristina. *Difficult Subjects: Working Women and Visual Culture, Britain 1880–1914.* Burlington, VT: Ashgate, 2002.

Hunt, Lynn. *The Family Romance of the French Revolution.* Berkeley: University of California Press, 1992.

Inselmann, Andrea, editor. *A Second Look: Women Photographers of the Gernsheim Collection.* Frankfurt am Main: Deutsche Fototage, 1993.

Jacob, John P., Alison Nordström, and Nancy M. West. *Kodak Girl: From the Martha Cooper Collection.* Göttingen, Germany: Steidl, 2011.

Jameson, Kathleen V. "Society Matrons, Working Girls, Fair Maidens, and New Women: Frances Benjamin Johnston and the Construction of Gender." Dissertation, University of Delaware, 2004.

Jensen, James S. "'Suicidal Competition': The Rise of Art Photography." *The Photogram.* Volume 34. Number 5 (May 2007): 3–15.

Jensen, James S. "Professional Art: Exhibitions of the Photographers' Association of America, 1880–1900." *The Photogram.* Volume 36. Number 3 (November-December 2008): 3–13.

Johannesson, Lena and Gunilla Knape, editors. *Women Photographers: European Experience.* Gothenburg: Acta Universitatis Gothoburgensis, 2004.

Johnson, Monique L. "Montage and Multiples in Hannah Maynard's Self-Portraits." *History of Photography.* Volume 41. Number 2 (May 2017): 159–70.

Jones, Laura. *Rediscovery: Canadian Women Photographers 1841–1941.* London, Canada: London Regional Art Gallery, 1983.

Jiuzhang, Men and Guo Lei, editors. *A General Introduction to Traditional Chinese Medicine.* New York: CRC Press, 2010.

Kay, Theresa L. "Selling an Image: Interpreting Gender in Eastman Kodak Advertising, 1900–1915." Master's thesis, University of Wyoming, 2001.

Kelbaugh, *Directory of Maryland Photographers: 1839–1900.* Baltimore: Historic Graphics, 1988.

Kelly, Richard. *The Art of George Du Maurier.* Hants, UK: Scolar Press, 1996.

Kelsey, Robin. *Photography and the Art of Chance.* Cambridge, MA: Belknap Press, 2015.

Kerber, Linda K. "Separate Spheres, Women's Place: The Rhetoric of Women's History." *Journal of American History.* Volume 75. Number 1 (June 1988): 9–39.

Krauss, Rolf H. *Die Fotografie in der Karikatur.* Seebruck am Chiemsee: Heering-Verlag, 1978.

Kunard, Andrea. "Assembling Images: Interpreting the Nineteenth Century Photographic Album with a Case Study of the Sir Daniel Wilson Album." Master's thesis, Carleton University, 1996.

Lesko, Scott C. "Aesthetics of Soft Focus: Art Photography, Masculinity and the Reimagining of Modernity in Late Victorian Britain, 1885–1914." Dissertation, University of Stony Brook, 2012.

Lessard, Michel. *The Livernois Photographers.* Québec City, Canada: Musée du Québec, 1987.

Lessinger, Johanna. "Work and Modesty: The Dilemma of Women Market Traders in South Asia." *Feminist Studies.* Volume 12. Number 3 (1986): 581–600.

Lien, Sigrid. "'Last Seen Alone on the Prairie: Migration, Photography, and the Invisibility of Women." In *Photography, History, Difference,* edited by Tanya Sheehan, 104–26. Hanover, NH: Dartmouth College Press, 2015.

Lightman, Bernard. "Depicting Nature, Defining Roles: The Gender Politics of Victorian Illustration." In *Figuring It Out: Science, Gender, and Visual Culture,* edited by Ann Shteir and Bernard Lightman, 214–39. Hanover, NH: University Press of New England, 2006.

London Regional Art Gallery. *Rediscovery: Canadian Women Photographers, 1841–1941.* London, Canada: London Regional Art Gallery, 1983.

Lyden, Anne M. *A Royal Passion: Queen Victoria and Photography.* Los Angeles: The J. Paul Getty Museum, 2014.

MacLeod, Christine. *Heroes of Invention: Technology, Liberalism and British Identity, 1750–1914.* New York: Cambridge University Press, 2010.

Mangan, J.A., and James Walvin, editors. *Manliness and Morality: Middle-Class Masculinity in Britain and America, 1800–1940.* New York: St. Martin's Press, 1987.

Mansker, *Sex, Honor and Citizenship in Early Third Republic France.* New York: Palgrave Macmillan, 2011.

Marder, William, and Estelle Marder. "Nineteenth-Century American Photographic Journals: A Chronological List." *History of Photography*. Volume 17. Number 1 (Spring 1993): 95–100.

Marks, Patricia. *Bicycles, Bangs, and Bloomers: The New Woman in the Popular Press.* Lexington: University Press of Kentucky Press, 1990.

Martin, David F. *Pioneer Women Photographers.* Seattle: Frye Art Museum, 2002.

Martin, Rod A. *The Psychology of Humor: An Integrative Approach.* New York: Elsevier Academic Press, 2007.

Maugue, Annelise. *L'Identité masculine en crise au tournant du siècle, 1871–1914.* Paris: Edition Rivages, 1987.

Mavor, Carol. "Collecting Loss." *Cultural Studies.* Volume 11. Number 1 (1997): 111–37.

Mavor, Carol. *Becoming: The Photographs of Clementina, Viscountess Hawarden.* Durham, NC: Duke University Press, 1999.

McManus, Howard R. "The Most Famous Daguerreian Portrait: Exploring the History of the Dorothy Catherine Draper Daguerreotype." *The Daguerreian Annual* (1995): 148–71.

McMillan, James F. *France and Women 1789–1914: Gender, Society and Politics.* New York: Routledge, 2000.

Meister, Laura I. *Missing from the Picture: Boston Women Photographers 1880–1920.* Master's thesis, Tufts University, 1998.

Mesch, Rachel. *Having It All in the Belle Epoque: How French Women's Magazines Invented the Modern Woman.* Stanford: Stanford University Press, 2013.

Miles, Melissa. "Sun-Pictures and Shadow-Play: Untangling the Web of Gendered Metaphors in Lady Elizabeth Eastlake's 'Photography.'" *Word & Image.* Volume 24. Number 1 (2008): 42–50.

Mitchell, Alexandra. "Middle-Class Masculinity in Clubs and Associations: Manchester and Liverpool,1800–1914." Master's thesis, University of Manchester, 2011.

Moore, Henrietta L. *Feminism and Anthropology.* Minneapolis: University of Minnesota Press, 1988.

Moore, Timothy E., Karen Griffiths, and Barbara Payne. "Gender, Attitudes Towards Women, and the Appreciation of Sexist Humor." *Sex Roles.* Volume 16. Number 9/10 (1987): 521–31.

Moutoussamy-Ashe, Jeanne. *Viewfinders: Black Women Photographers.* New York: Writers & Readers Publishing, Inc., 1993.

Mukhopadhyay, Carol C., and Patricia J. Higgins. "Anthropological Studies of Women's Status Revisited: 1977–1987." *Annual Review of Anthropology.* Volume 17 (1988): 461–95.

Musée d'Orsay and the Musée de l'Orangerie. *Qui a peur des femmes photographes?* Paris: Éditions Hazan, 2015.

Musée Sainte-Croix and Musée de Chauvigny, *Suzanne Tranchant: Photographe et Sculpteur (1861–1942).* Poitiers, France: Musée de la Ville de Poitiers, 1990.

Muzzarelli, Federica. *Femmes photographes: émancipation et performance (1850–1940).* Translated from the Italian by Chantal Moiroud. Malakoff, France: Éditions Hazan, 2009.

Nadar, Félix. *When I Was a Photographer.* Translated by Eduardo Cadava and Liana Theodoratou. Cambridge, MA: The MIT Press, 2015.

Nead, Lynda. *Victorian Babylon: People, Streets and Images in Nineteenth-Century London.* New Haven: Yale University Press, 2000.

Neale, Shirley. "Olive Edis (1876–1955)." *History of Photography*. Volume 16. Number 4 (1992): 371–8.

Neale, Shirley. "Mrs. Beatrice Cundy, Née Adelin Beatrice Connell, 1875–1949." *History of Photography*. Volume 25. Number 1 (2001): 61–7.

Neitz, Mary Jo. "Humor, Hierarchy, and the Changing Status of Women." *Psychiatry*. Volume 43 (August 1980): 211–23.

Nelson, Carolyn C., editor. *A New Woman Reader: Fiction, Articles, and Drama of the 1890s*. Orchard Park, NY: Broadview Press, Ltd., 2001.

Noble, Mary L. "Iowa's Women Professional Photographers." *Books at Iowa*. Number 65 (1996): 2–16.

Orr, Andrew. "'Too Numerous to Be Controlled': Women, Professionalism, and Antirepublicanism in the French Army, 1914–1928." *French Historical Studies*. Volume 39. Number 2 (April 2016): 287–313.

Ortner, Sherry B. "Is Female to Male as Nature Is to Culture?" In *Women, Culture and Society*, 67–87. Stanford: Stanford University Press, 1974.

Ovenden, Graham, editor. *Clementina: Lady Hawarden*. New York: St. Martin's Press, 1974.

Palmquist, Peter E., ed. *Camera Fiends & Kodak Girls: 50 Selections by and about Women in Photography, 1840–1930*. New York: Midmarch Arts Press, 1989.

Palmquist, Peter E., *Catharine Weed Barnes Ward: Pioneer Advocate for Women in Photography*. Arcata, CA: Peter E. Palmquist, 1992.

Palmquist, Peter E., ed. *Camera Fiends & Kodak Girls II: 60 Selections by and about Women in Photography, 1855–1965*. New York City: Midmarch Arts Press, 1995.

Palmquist, Peter E., and Gia Musso. *Women Photographers: A Selection of Images from the Women in Photography International Archive, 1852–1997*. Arcata, CA: Peter E. Palmquist, 1997.

Pateman, Carole. *The Sexual Contract*. Stanford: Stanford University Press, 1988.

Payne, Carol, and Andrea Kunard, editors. *The Cultural Work of Photography in Canada*. Montréal: McGill-Queen's University Press, 2011.

Peacock, Molly. *The Paper Garden: An Artist Begins Her Life's Work at 72*. New York: Bloomsbury, 2010.

Pedersen, Diana, and Martha Phemister. "Women and Photography in Ontario, 1839–1929: A Case Study of the Interaction of Gender And Technology." In *Despite the Odds: Essays on Canadian Women and Science*, edited by Marianne G. Ainley, 88–109. Montréal: Véhicule Press, 1990.

Pederson, Jean E. "French Feminisms, 1848–1949." *French Historical Studies*. Volume 37. Number 4 (Fall 2014): 663–87.

Perrot, Michelle, ed. *A History of Private Life: From the Fires of Revolution to the Great War*. Translated by Arthur Goldhammer. Cambridge, MA: The Belknap Press of Harvard University Press, 1990.

Peterson, Christian A. "Mary A. Bartlett: Illustrator of Children's Books." *History of Photography*. Volume 32. Number 4 (Winter 2008): 337–46.

Plott, Michèle. "The Rules of the Game: Respectability, Sexuality, and the *Femme Mondaine* in Late-Nineteenth-Century Paris." *French Historical Studies*. Volume 25. Number 3 (Summer 2002): 532–56.

Poivert, Michel. *Le Pictorialisme en France*. Paris: Editions Hoëbeke/Bibliothèque Nationale, 1992.

Polidoro, Massimo. "Anna Eva Fay: The Mentalist that Baffled Sir William Crookes." *Skeptical Inquirer*. Volume 24. Number 1 (January-February 2000): 36–42.

Pollen, Annebella. "'The Valentine Has Fallen Upon Evil Days': Mocking Victorian Valentines and the Ambivalent Laughter of the Carnivalesque." *Early Popular Visual Culture*. Volume 12. Number 2 (2014): 127–73.

Prieto, Laura R. *At Home in the Studio: The Professionalization of Women Artists in America*. Cambridge, MA: Harvard University Press, 2001.

Reid, Mandy. "Selling Shadows and Substance: Photographing Race in the United States, 1850–1870s." *Early Popular Visual Culture*. Volume 4. Number 3 (November 2006): 285–305.

Reifler, Sam. *I Ching: A New Interpretation for Modern Times*. New York: Bantam Books, 1981.

Rennes, Juliette. "The French Republic and Women's Access to Professional Work: Issues and Controversies in France from the 1870s to the 1930s." *Gender & History*. Volume 23. Number 2 (August 2011): 341–66.

Richards, Evelleen. "Huxley and Woman's Place in Science: The 'Woman Question' and the Control of Victorian Anthropology." In *History, Humanity and Evolution: Essays for John C. Greene*, edited by James R. Moore, 253–84. New York: Cambridge University Press, 1989.

Riches, Harriet. "'Picture Taking and Picture Making': Gender Difference and the Historiography of Photography." In *Photography, History, Difference*, edited by Tanya Sheehan, 128–50. Lebanon, NH: Dartmouth College Press, 2015.

Ridgeway, Cecilia, and Chris Bourg. "Gender as Status: An Expectation States Theory Approach." In *Psychology of Gender*, second edition, 217–41. New York: Guilford, 2004.

Roberts, Mary Louise. *Disruptive Acts: The New Woman in Fin-de-Siecle France*. Chicago: University of Chicago Press, 2005.

Roper, Michael and John Tosh, editors. *Manful Assertions: Masculinities in Britain since 1800*. New York: Routledge, 1991.

Rosenblum, Naomi. *A History of Women Photographers*. New York: Abbeville Press, 1994.

Rowbotham, Judith. "'All Our Past Proclaims Our Future': Popular Biography and Masculine Identity during the Golden age, 1850–1870." In *The Golden Age: Essays in British Social and Economic History, 1850–1870*, edited by Ian Inkster, 263–75. Brookfield, VT: Ashgate, 2000.

Ruether, Rosemary R. "Women in World Religions: Discrimination, Liberation, and Backlash." In *The World's Religions: A Contemporary Reader*, edited by Arvind Sharma, 145–51. Minneapolis: Fortress Press, 2011.

Salo, Marcia. "The Oedipal West: Two Engendered Photo Histories: Beaumont Newhall's 'The History of Photography' and John Szarkowski's 'Photography Until Now.'" *Genders*. Number 17 (Fall 1993): 151–66.

Saltz, Laura. "Clover Adams's Dark Room: Photography and Writing, Exposure and Erasure." *Prospects*. Volume 24 (October 1999): 449–90.

Sandler, Martin W. *Against the Odds: Women Pioneers in the First Hundred Years of Photography*. New York: Rizzoli International Publications, 2002.

Sandweiss, Martha A. *Print the Legend: Photography and the American West*. New Haven: Yale University Press, 2002.

Schaaf, Larry J. "'Splendid Calotypes' and 'Hideous Men': Photography in the Diaries of Lady Pauline Trevelyan." *History of Photography*. Volume 34. Number 4 (November 2010): 326–41.

Schwartz, Dona B. "Camera Clubs and Fine Art Photography: Distinguishing between Art and Amateur Activity." Dissertation, University of Pennsylvania, 1983.

Scott, Joan W. "Gender: A Useful Category of Historical Analysis." *American Historical Review.* Volume 91. Number 5 (December 1986): 1053–75.

Scott, Joan W. *Only Paradoxes to Offer: French Feminists and the Rights of Man.* Cambridge, MA: Harvard University Press, 1996.

Scott, Joan W. *The Fantasy of Feminist History.* Durham, NC: Duke University Press, 2011.

Seiberling, Grace, and Carolyn Bloore. *Amateurs, Photography, and the Mid-Victorian Imagination.* Chicago: University of Chicago Press, 1986.

Sennett, Robert S. *The Nineteenth-Century Photographic Press: A Study Guide.* New York: Garland Publishing, Inc., 1987.

Sewall, Abbie. *Message Through Time: The Photographs of Emma D. Sewall (1836–1919).* Gardiner, ME: The Harpswell Press, 1989.

Shoemaker, Robert, and Mary Vincent, editors. *Gender and History in Western Europe.* London: Arnold, 1998.

Sichel, Pierre. *The Jersey Lily: The Story of the Fabulous Mrs. Langtry.* Englewood Cliffs, NJ: Prentice-Hall, Inc., 1958.

Siegel, Elizabeth. *Galleries of Friendship and Fame: A History of Nineteenth-Century American Photograph Albums.* New Haven: Yale University Press, 2010.

Siegel, Elizabeth, Patrizia Di Bello, and Marta Weiss. *Playing with Pictures: The Art of Victorian Photocollage.* Chicago: The Art Institute of Chicago, 2009.

Siegel, Elizabeth, and Martha Packer. *The Marvelous Album of Madame B: Being the Handiwork of a Victorian Lady of Considerable Talent.* Chicago: The Art Institute of Chicago and Scala Publishers Limited, 2009.

Simpson, Roddy. "Julia Margaret Cameron and the Photographic Society of Scotland." *History of Photography.* Volume 28. Number 1 (Spring 2004): 82–7.

Skidmore, Colleen M. "Women in Photography at the Notman Studio, Montréal, 1856–1881." Master's thesis, University of Alberta, 1999.

Skyrme, Alison E. "Victorian Women and the Hand-Embellished Album: A Case Study of the Bouverie Album." Master's thesis, Ryerson University, 2007.

Smith, Bonnie G. *Ladies of the Leisure Class: The Bourgeoises of Northern France in the Nineteenth Century.* Princeton: Princeton University Press, 1981.

Smith, Bonnie G. "Gender and the Republic." In *The French Republic: History, Values, Debates,* 299–307. Ithaca: Cornell University Press, 2011.

Smith, Catherine, and Cynthia Greig. *Women in Pants: Manly Maidens, Cowgirls, and Other Renegades.* New York: Harry N. Abrams, 2003.

Smith, Graham, and Mike Weaver. "A Letter by Julia Margaret Cameron." *History of Photography.* Volume 27. Number 1 (Spring 2003): 66–71.

Smith, Lindsay. *The Politics of Focus: Women, Children and Nineteenth-Century Photography.* Manchester: Manchester University Press, 1998.

Smith, Peter, and Carolyn Lefley, *Rethinking Photography: Histories, Theories and Education.* New York: Routledge, 2016.

Smith, Roberts. "The Pastime of Victorian Cutups." *The New York Times,* February 5, 2010, section C25 and C28.

Smith, Shawn M. *American Archives: Gender, Race, and Class in Visual Culture.* Princeton: Princeton University Press, 1999.

Sobieszek, Robert A. "Composite Imagery and the Origins of Photomontage. Part I: The Naturalistic Strain." *Artforum.* Volume 17. Number 1 (September 1978): 58–65.

Solomon-Godeau, Abigail. "The Legs of the Countess." *October.* Volume 39 (Winter 1986): 65–108.

Sowerwine, Charles. "The Sexual Contract(s) of the Third Republic." *French History and Civilization: Papers from the Georges Rudé Seminar*. Volume 5 (2005): 245–53.

Spain, Daphne. *Gendered Spaces*. Chapel Hill: University of North Carolina Press, 1992.

Sparham, Anna, ed. *Soldiers and Suffragettes: The Photography of Christina Broom*. London: Museum of London and Philip Wilson Publishers, 2015.

Stanley, Liz, ed. *The Diaries of Hannah Cullwick, Victorian Maidservant*. Introduction by Liz Stanley. New Brunswick, NJ: Rutgers University Press, 1984.

Strandroth, Cecilia. "The 'New' History? Notes on the Historiography of Photography." *Konsthistorisk Tidskrift*. Volume 78. Number 3 (2009): 142–53.

Surkis, Judith. *Sexing the Citizen: Morality and Masculinity in France, 1870–1920*. Ithaca: Cornell University Press, 2006.

Sykes, Christopher S. *Country House Camera*. London: Weidenfeld and Nicolson, 1980.

Taft, Robert. *Photography and the American Scene: A Social History, 1839–1889*. New York: Dover Publications, Inc., 1964.

Taylor, Roger, and Edward Wakeling. *Lewis Carroll, Photographer*. Princeton: Princeton University Press, 2002.

Tiffany, Sharon W., editor. *Women and Society: An Anthropological Reader*. Exeter, UK: Eden Press Women's Publications, 1979.

Tinder, David V. *Directory of Early Michigan Photographers*. Edited by Clayton A. Lewis. Ann Arbor: William L. Clements Library, University of Michigan, 2013.

Touhey, John C. "Effects of Additional Women Professionals on Ratings of Occupational Prestige and Desirability." *Journal Of Personality and Social Psychology*. Volume 29. Number 1 (1974): 86–9.

Tucker, Jennifer. "Gender and Genre in Victorian Scientific Photography." In *Figuring It Out: Science, Gender, and Visual Culture*, edited by Ann B. Shteir and Bernard Lightman, 140–63. Hanover, NH: Dartmouth College Press, 2006.

Vandello, Joseph A. and Jennifer K. Bosson. "Hard Won and Easily Lost: A Review and Synthesis of Theory and Research on Precarious Manhood." *Psychology of Men and Masculinity*. Volume 14. Number 2: 101–13.

Vissière, Jean-Louis. "Féminisme et caricature à la belle epoque." *Lectora*. Number 4 (1999): 93–106.

Wajda, Shirley T. "The Commercial Photographic Parlor, 1839–1889." In *Perspectives in Vernacular Architecture: Shaping Communities*. Volume 6: 216–30. No city: Vernacular Architecture Forum, 1997.

Warner, Marina. "Parlour Made." *Creative Camera*. Number 315 (April/May 1992): 28–32.

Watson, Roger, and Helen Rappaport. *Capturing the Light: The Birth of Photography, a True Story of Genius and Rivalry*. New York: St. Martin's Press, 2013.

Weimann, Jeanne M. *The Fair Women*. Introduction by Anita Miller. Chicago: Academy Chicago, 1981.

Weisberg, Gabriel P., and Jane R. Becker, editors. *Overcoming All Obstacles: The Women of the Académie Julian*. New York: Dahesh Museum, 1999.

Weiss, Marta. "Dressed Up and Pasted Down: Staged Photography in the Victorian Album." Dissertation, Princeton University, 2008.

Weiss, Marta, André Maurois, and Marianne Nahon. *La Comtesse de Castiglione*. Paris: Éditions de la Différence, 2009.

White, Mus. *From the Mundane to the Magical: Photographically Illustrated Children's Books, 1854–1945 and Beyond*. Los Angeles: Dawson's Book Shop, 1999.

Wilks, Claire W. *The Magic Box: The Eccentric Genius of Hannah Maynard*. Toronto: Exile Editions, Ltd., 1980.

Williams, R.E., ed. *A Century of Punch Cartoons*. New York: Simon and Schuster, 1955.

Williams, Val, and Liz Heron, editors. *Illuminations: Women Writing on Photography from the 1850s to the Present*. Durham. NC: Duke University Press, 1996.

Yevonde, Philonie. "Photographic Portraiture from a Woman's Point of View." *British Journal of Photography*. Volume 68. Number 3182 (April 29, 1921): 251–4.

Young, Carol Wolkowitz, and Roslyn McCullagh, editors. *Of Marriage and the Market: Women's Subordination Internationally and its Lessons*. London: Routledge & Kegan Paul, 1984.

Zackodnik, Teresa. "The 'Green-Backs of Civilization': Sojourner Truth and Portrait Photography." *American Studies*. Volume 46. Number 2 (Summer 2005): 117–43.

Zijdeman, Richard, Marco Leeuwen, Danièle Rébaudo, and Jean-Pierre Pélissier. "Working Women in France, Nineteenth and Twentieth Centuries. Where, When, and Which Women Were in Work at Marriage?" *The History of the Family*. Volume 19. Number 4 (2014): 537–63.

Web sources

Digitized artifacts

Alice Austen Photograph Collection, digitized by the Staten Island Historical Society. Database at http://statenisland.pastperfectonline.com/.

Hole, Lawrence N. *The Yevonde Portrait Archive*. http://www.madameyevonde.com/.

Lewis, Anne C. "Memories of the Home of Grandma Lewis" (1896). Library Company of Philadelphia. https://digital.librarycompany.org/islandora/object/digitool%3A121219#page/1/mode/1up.

Library Company of Philadelphia. *Cassey & Dickerson Friendship Album Project*. [Colorful, intricate, and beautiful mixed-media albums by three African-American women in the early nineteenth century]. http://lcpalbumproject.org/.

Logan, Maria. "Views of Loudoun and Stenton, residences of Maria Dickinson Logan and her brother, Albanus C. Logan, Germantown, Philadelphia" (c. 1900). Library Company of Philadelphia. https://digital.librarycompany.org/islandora/object/digitool%3A123103/pages.

Metropolitan Museum of Art. [Digitized collection of the Photographs of Countess Virginia Oldini di Castiglione (1835–99) taken by Pierre-Louis Pierson]. https://metmuseum.org/art/collection/search#!/search?artist=Pierson,%20Pierre-Louis$Pierre-Louis%20Pierson.

National Portrait Gallery (London). [Digitized collection of Images of Emilie Charlotte ('Lillie') Langtry (née Le Breton)]. https://www.npg.org.uk/collections/search/person?LinkID=mp14015&search=sas&sText=Langtry&wPage=0.

Princeton University Library Department of Rare Books and Special Collections. *Portfolio: Lewis Carroll*. http://libweb2.princeton.edu/rbsc2/portfolio/lc-all-list.html.

Sackville-West, Constance. "Constance Sackville-West/Sackville-West Album." Eastman Museum. https://collections.eastman.org/objects/31228/sackvillewest-album?ctx=2a85a550-b973-4211-aa0a-d1c43d7b3d73&idx=0.

Institutions, news press, and biographical information:

Alice Austen House. Information about the photographer's life, work, and home at Clear Comfort, Staten Island, at https://aliceausten.org/.

Art Institute of Chicago. "The Marvelous Album of Madame B: Being the Handiwork of a Victorian Lady of Considerable Talent." http://www.artic.edu/aic/collections/exhibitions/VictPhotoColl/MadameB1.

Bathurst, Bella. "The Lady Vanishes: Victorian Photography's Hidden Mothers." *The Guardian*, December 2, 2013, Art & Design section. http://www.theguardian.com/artanddesign/2013/dec/02/hidden-mothers-victorian-photography.

Berkeley Art Museum and Pacific Film Archive. "Sojourner Truth, Photography, and the Fight Against Slavery." UC Berkeley Art Museum and Pacific Film Archive, October 27, 2016. https://bampfa.org/program/sojourner-truth-photography-and-fight-against-slavery.

Birr Castle Gardens & Science Center. "Mary Rosse." http://birrcastle.com/photography/.

Brown, Mary. "A Woman's View: 19th Century San Francisco Women Photographers: Historical Essay" [blog]. On *Found: Shaping San Francisco's Digital Archive*, 1997. http://www.foundsf.org/index.php?title=A_Woman%27s_View_19th_Century_San_Francisco_Women_Photographers.

Christie's. Sale 6900: Photographs: Lot 48: Anna Atkins (1799–1871), "*Photographs of British Algæ. Cyanotype Impressions*. Robert Hunt's copy," May 19, 2004 (London). https://www.christies.com/LotFinder/lot_details.aspx?intObjectID=4278518#top.

Clarke, Meaghan. "Sex and the City: The Metropolitan New Woman." Tate Museum, May 2012. https://www.tate.org.uk/art/research-publications/camden-town-group/meaghan-clarke-sex-and-the-city-the-metropolitan-new-woman-r1105659.

Cooper, Martha. *The KodakGirl Collection*. http://www.kodakgirl.com/.

Cosens, Ron. "It's All in the Cartes: Victorian Studios—What Were They Really Like?" *Cartomania* PDF. Third of three articles in *Photographica World* (number 110, no date available in the journal's index). Available on Cartedevisite.co.uk.

Dorchester Atheneum. "Chansonetta Stanley Emmons" [artist biography], May 1, 2005. http://www.dorchesteratheneum.org/page.php?id=547.

Galifot, Thomas. "Parent-elles, partner, daughter, sister of . . .: Women artists and the ties of kinship. Family relations risked by photography? Amateur and professional women in the late 19th and early 20th centuries (France, Great Britain and the United States)." *AWARE: Archives of Women Artists, Research and Exhibitions*. https://awarewomenartists.com/en/publications/parentele-risque-de-photographie-amateures-professionnelles-xixe-siecle-debut-xxe-siecle-france-grande-bretagne-etats-unis/.

George Eastman Museum. [Digitized plates from the album of Constance Sackville-West (British, 1846–1929)]. https://collections.eastman.org/objects/31228/sackvillewest-album/related/24.

Grall, Vanessa. "Found at Auction: The Unseen Photographs of a Legend That Never Was." *Messy Nessy Chic* [blog], February 18, 2013. http://www.messynessychic.com/2016/02/18/found-at-auction-the-unseen-photographs-of-a-legend-that-never-was/.

Griffiths, Alan, editor. Luminous-Lint.com. [World historical database of photography for subscription, including digitized images and essays]. http://www.luminous-lint.com.

Gunthert, André. "L'Institution du photographique: le roman de la Société Héliographique." *Etudes Photographiques*. Number 12 (November 2002): 37–63. http://etudesphotographiques.revues.org/317.

Hardy, Thomas. "An Imaginative Woman" (1894). East of the Web Short Stories. http://www.eastoftheweb.com/short-stories/UBooks/ImaWom.shtml.

Hastings Museum & Art Gallery. "The Brassey Family & Their Collection." http://www.hmag.org.uk/collections/durbar/.

Haworth-Booth, Mark. "What the Lady Saw: The photographs of Clementina, Viscountess Hawarden are now instantly recognizable—but her images only came to light by

accident, as Mark Haworth-Booth remembers." *Bonhams Magazine*. Number 34 (Spring 2013): 52. Available online at https://www.bonhams.com/magazine/12941/.

Holmes, Oliver W. "Doings on the Sunbeam" from *The Atlantic Monthly*. Volume 12. Number 69 (July 1863), 1–15. At A.D. Coleman's Photography Criticism CyberArchive. http://nearbycafe.com/photocriticism/members/archivetexts/photohistory/holmes/holmessunbeam1.html.

Hughes, Jabez. "Photography as an Industrial Occupation for Women," from *London Photo News* (1873). On *Clio Visualizing History*. http://www.cliohistory.org/exhibits/palmquist/occupation/.

Hughes, Kathryn. "Gender Roles in the 19th Century." *Discovering Literature: Romantics and Victorians* [for the British Library], May 15, 2014. https://www.bl.uk/romantics-and-victorians/articles/gender-roles-in-the-19th-century.

Hull, Roger. "Myra Albert Wiggins (1869–1956)." *The Oregon Encyclopedia*, n.d. https://oregonencyclopedia.org/articles/wiggins_myra_albert_1869_1956_/#.Wy1tZKdKg2w.

Jay, Bill. "Julia Margaret Cameron: An Appraisal." Unpublished manuscipt, n.d. http://www.billjayonphotography.com.

Maloof, John. "About Vivian Maier." *Vivian Maier* [blog], 2014. http://www.vivianmaier.com/.

Johnston, Frances B. "What a Woman Can Do with a Camera," from *Ladies Home Journal* (1897). On *Clio Visualizing History*. http://www.cliohistory.org/exhibits/johnston/whatawomancando/.

Lillie Langtry Museum on the Internet. http://www.lillielangtry.com/.

Manuscript Division Staff. Description of the Frances Benjamin Johnston Papers at the Library of Congress. Frances Benjamin Johnston Papers, 1855–1956, 2010. http://findingaids.loc.gov/db/search/xq/searchMfer02.xq?_id=loc.mss.eadmss.ms010298&_faSection=overview&_faSubsection=scopecontent&_dmdid=d22778e21.

Marcel, Veronig. "Geneviève-Elizabeth Francart-Disdéri." Patrimoine-ParisBreton.org, December 28, 2015. http://www.patrimoine-parisbreton.org/genevieve-elizabeth-francart-disderi/.

Marsh, Bruce. *The Cabinet Card Gallery: Viewing History, Culture and Personalities Through Cabinet Card Images*. [The following URL takes viewers to a search for "female photographers"; but the entire site is historically and visually rich]. https://cabinetcardgallery.com/category/female-photographers/.

Massachusetts Historical Society. "Who Was Marian 'Clover' Hooper Adams?" *Marian Hooper Adams: Selected Photographs and Letters*. http://www.masshist.org/features/clover-adams.

McCauley, Anne. "Epouses des hommes et épouses de l'art: la 'Question de La Femme' dans les années 1860 et les photographies de Julia Margaret Cameron." Translated by Marine Sangis. *Etudes Photographiques*. Number 28 (November 2011). http://etudesphotographiques.revues.org/3219.

Médiathèque de l'Architecture et du Patrimoine. "Amélie Galup (1856–1943): femme photographe." http://www.mediatheque-patrimoine.culture.gouv.fr/fr/archives_photo/visites_guidees/galup.html.

Museum of Modern Art (New York). "Pictures By Women: A History of Modern Photography." Summary of museum exhibition, May 7, 2010–April 18, 2011. https://www.moma.org/calendar/exhibitions/1038.

National Museum of Women in the Arts (Washington, D.C.). "Eva Watson-Schütze, 1867–1935." https://nmwa.org/explore/artist-profiles/eva-watson-schütze.

National Portrait Gallery (London). [Rich digital collections and biographical information on portraitists]. Website at https://www.npg.org.uk/.

National Portrait Gallery (London). "Edwardian Women Photographers: Eveleen Myers, Alice Hughes, Christina Broom and Olive Edis," July 8–September 25, 1994. [Press notice to accompany the exhibition]. https://www.npg.org.uk/collections/about/photographs-collection/national-photographic-record/edwardian-women-photographers-eveleen-ayers-alice-hughes-christina-broom-and-olive-edis.php.

Packard, Aaron. "The Meade Bros Daguerreotype Tokens." *Nova Numismatics*, August 14, 2014. http://www.novanumismatics.com/industry/the-brothers-meade-their-daguerreotype-tokens/#comment-16630.

Palmquist, Peter E. "100 Years of California Photography by Women, 1850–1950," 1998. *Women Artists of the American West*. https://www.cla.purdue.edu/waaw/palmquist/Essay1.htm.

Palmquist, Peter E. "Is Anatomy Destiny? Notes from the Historical Record." Women in Photography International Archive. www.womeninphotography.org/archive08-Oct01/gallery3/index.htm.

Rosenblum, Naomi. "The Allen Sisters: An Introduction." *Clio Visualizing History*. https://www.cliohistory.org/exhibits/allen/ forewordnaomirosenblum/.

Saretzky, Gary D. "Charlotte Prosch: New Jersey's First Female Daguerreotypist." *History of Photography*. http://gary.saretzky.com/photohistory/Charlotte_Prosch_New_Jerseys_First_Female_Daguerreotypist_Saretzky_GSL31.pdf.

Saretzky, Gary D. "New Jersey Women Photographers List." *History of Photography*. http://gary.saretzky.com/photohistory/ NJWomenPhotographers.html.

Saretzky, Gary D. "Nineteenth Century New Jersey Photographers. Revision of illustrated article in *New Jersey History*, Fall/Winter 2004." *The History of Photography*. http://gary.saretzky.com/ photohistory/ resources/photo_in_nj_July_2010.pdf.

Schaaf, Larry J., director. *The Correspondence of William Henry Fox Talbot*. http://foxtalbot.dmu.ac.uk/index.html.

Schaaf, Larry J., director. "Tempestuous Teacups and Enigmatic Leaves." *The Talbot Catalogue Raisonné*, June 19, 2015. https://talbot.bodleian.ox.ac.uk/2015/06/19/tempestuous-teacups-and-enigmatic-leaves/.

Scheftel, Susan. "Princess Culture: What Is It All About?" *Psychology Today*, August 24, 2015. https://www.psychologytoday.com/us/blog/evolving-minds/201508/princess-culture-what-is-it-all-about.

Sischy, Ingrid. "Great Pretenders." *New York Times Magazine*, February 24, 2002. http://www.nytimes.com/2002/02/24/magazine/great-pretenders.html.

Spencer, David. *PhotoSeed*. [Stated mission: "PhotoSeed, representing an evolving online record of [the] early fine-art photography movement, is a private archive with simple goals: beauty, truth, scholarship and enjoyment for all who visit]. http://photoseed.com/.

Theislandwiki. "Lillie Langtry." http://www.theislandwiki.org/index.php/Lillie_Langtry.

Tritton, Paul. "'Lost' Archive of Pioneer Woman Photographer's Pictures Found at Kent Archaeological Society." *Kent Archaeological Society Press Release*, November 29, 2013. http://www.kentarchaeology.org.uk/?s=photographer.

Van Wagenen, Lola, Pete Daniel and Raymond Smock. "The Frances Benjamin Johnston Exhibit." [Permanent online exhibit featuring curatorial essays, images, and period sources]. *Clio Visualizing History*. https://www.cliohistory.org/exhibits/johnston/.

Victoria and Albert Museum. "Lady Clementina Hawarden and the V&A." [The V&A has also digitized its entire Hawarden photograph collection]. http://www.vam.ac.uk/content/articles/l/lady-clementina-hawarden-and-the-v-and-a/.

Webb, David and researchers, with the participation of the Museum of London. *photoLondon*. [Detailed directory of nineteenth-century London photographers]. https://www.photolondon.org.uk/#/.

Wisconsin Historical Society. "Wisconsin Photographers Index 1840–1976." https://www.wisconsinhistory.org/Records/Article/CS3528.

Wilhelm, Richard and Cary F. Baynes, translators. *I Ching* (1967). http://www.akirarabelais.com/i/i.html.

Index

Note: When the first name of a woman has been lost but her married honorific survived, I have written the entry with the information available, such as: Breton (Mme.)